DOMINIQUE REPÉRANT

# The Most Beautiful
# Villages of France

THAMES AND HUDSON

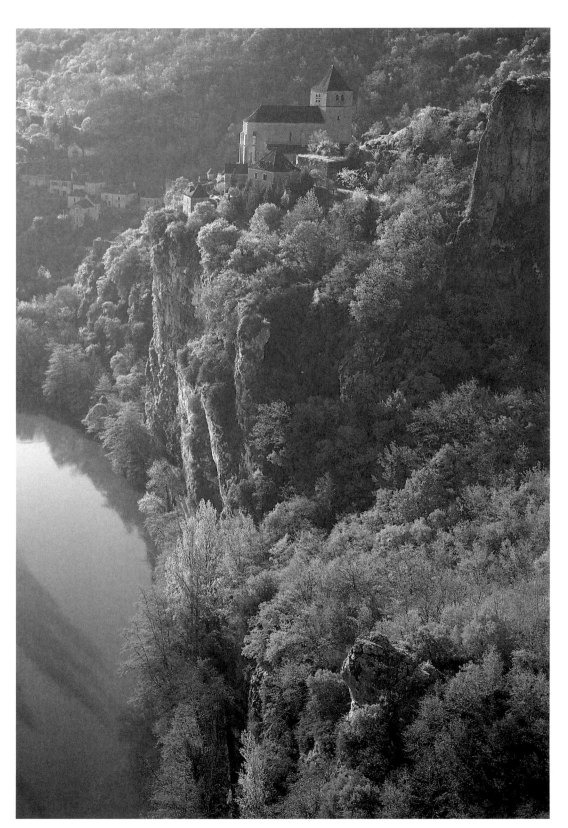

Making one of the most beautiful views in France, the village of Saint-Cirq-Lapopie is built on a steep slope, the summit of which commands a view of the Lot. On the highest point, a rock called La Popie, the keep of a castle was built in the Middle Ages. It was destroyed in 1471 on the orders of Louis XI.

# CONTENTS

# PREFACE

I n this book I have sought to present the most beautiful small medieval towns and villages of France, that is, those with a population of fewer than 1,050 inhabitants. 'The most beautiful' means the best preserved; in other words, those where the old buildings (both private houses and the communal heritage) still predominate, and where the landscape remains unspoilt.

Apart from the picturesque quality of their locations, all these villages have kept their original medieval layout to a greater or lesser degree, as well as preserving their old-fashioned appearance. Some, retaining old buildings of high quality in harmonious relation to each other, are unique architectural treasures. The most magnificent, however, are those in which man-made and natural elements combine to compose a perfectly orchestrated and preserved whole, with the village seemingly 'posed' in its setting. The spell of the Middle Ages is then at its most potent and the most extravagant adjectives spring to mind: here, indeed, is the *loveliest* village in all France!

It will be immediately apparent that this book deals with villages from the architectural, and subsequently therefore the aesthetic, standpoint. The human and socio-economic aspects are briefly touched upon through the study of the communities' history. As was the case with my previous book on the castles and manors of the Périgord region, I have used as a reference the complete list of all the villages in France whose sites are protected by law. It is a living document, as the protection of the national heritage continues to be an important issue. As regards the villages described here, it will be noted that the universally recognized 'hierarchy' of architectural interest applied to monuments, such as castles for example, is equally applicable to villages. So, a village that has undergone too much restoration or reconstruction, or which displays too great a diversity of architectural styles, loses in interest. On the other hand, homogeneous architecture or ruins (abandoned villages – often a remarkable sight) are of major interest. The same is true of the aesthetic criteria: a village is more picturesque when it is perched on the edge of a cliff than when it is situated in a plain. It will likewise appear more attractive if it is not submerged in modern development, if electric cables and telephone wires are concealed, and so on.

I thought it important that the book should begin with a short historical and typological introduction to the two most striking urban creations of medieval France: the walled towns (*bastides*) of the Southwest and the hill villages (*villages perchés*) of the Mediterranean region. I have also included as an appendix the list of the 'best protected' villages in France. This list has been the indispensable guide to my travels throughout the country.

In most cases, the text and the photograph captions are based on publications sold in the villages themselves, although I nearly always also consulted the catalogues in the archives of the *département* concerned. I have tried to maintain a consistent method of presenting the history of the villages, with a brief account of their creation (from the first written mention), through the Middle Ages (the local seigneurs and the Hundred Years' War), the Wars of Religion and the Revolution, to the modern period, with finally, a few words on the population.

Being responsible for both text and image, and therefore making all the selections, I have been able to combine the purely photographic enterprise (light dictates all, the image is free) with the function of illustration (the subject dictates

The Most Beautiful

*Villages of France*

*TO CHRISTIAN, FRANÇOIS AND THEIR MOTHER, ELIN*

Translated from the French *Villages de France* by Augusta Audubert

On the endpapers:

Saint-Bertrand-de-Comminges is situated on an isolated hillock overlooking the valley of
the Garonne. Its location, its past and its monuments make it the foremost center of art and
history in the mid-Pyrenees. It has been described as "Mont-Saint-Michel on dry land." A wealth
of archaeological remains, both Roman and Medieval, has been unearthed on the site, both in the
upper village (seen here from the southeast) and at the foot of the hill where the ancient
Roman city formerly stood.

© 1990 Sté Nlle des Éditions du Chêne

First published in hardcover in the United States of America in 1990
by Thames and Hudson Inc., 500 Fifth Avenue, New York, New York 10110
Reprinted 1991, 1993, 1997, 1999

Library of Congress Catalog Card Number 90-70389

Printed and bound in Spain

# PREFACE

the image, which becomes subservient to the text). The choices dictated by the image for its own sake, and those dictated by the strict demands of the subject-matter therefore complement each other.

All the villages described in this work grew up during the medieval period (5th to 15th centuries), the majority after the barbarian invasions, in the period between the early 11th and the early 14th century. Urban expansion then reached a peak, a phenomenon occurring throughout the land. Nearly all the communities were built around a seigneurial castle or an abbey. The majority retain traces of the walls and/or the fortifications that characterize the 'enclosed towns' of the Middle Ages. They were constructed especially in the period between 1350 and 1450. It is often difficult to dissociate the medieval village from its stone walls or from the feudal castle which dominates the site. All these *bourgs murées* are proof of the insecurity and almost constant wars which took place during the Middle Ages.

That same period, however, was characterized by a complex municipal structure, which governed town life. Furthermore, the majority of communities had a royal or seigneurial charter defining the various 'privileges' of the inhabitants. The settlements often had large populations, in comparison with those of today, and it is difficult for us to imagine the hustle and bustle in their streets during the Middle Ages. Towns that were centres of pilgrimage would have been particularly lively. Their 'village' character is therefore fairly modern, since all these communities have undergone a steady process of depopulation since the Industrial Revolution.

France is a country of astonishing variety: in the richness of human achievement and the great diversity of cultural influences, particularly in the frontier provinces. The richness is reflected in the styles of its villages. In addition to their undeniable architectural interest and obvious touristic appeal, these villages are therefore expressions of regional, or more specifically local, culture and traditions. Builders, for example, would have their own way of using particular materials; local know-how would be adapted to the demands of the site and its environment, and to the necessity for defence.

These villages tell the story of the ancestors of the French nation; their ancient buildings are palpable evidence of people's lives, hopes, dreams, their capacity for greatness and their struggles. A well preserved village is therefore a gift bequeathed to us by its former inhabitants and the chance events of history, a gift which we must cherish. The most perfectly preserved are the most easily appreciated, becoming the last great 'representatives' of a certain skill in building particular to their province. This is what really makes them the loveliest villages in France. The notion of what is aesthetically pleasing can be superficial and arbitrary, depending on individual taste, but these villages offer examples of true, living beauty. This beauty is born of the spirit of the land and the turbulent history of each urban community.

DOMINIQUE REPÉRANT

# BASTIDES

O ne of the most notable urban landmarks in France is undoubtedly the *bastide*. Villages and towns of this type are to be found exclusively in fourteen *départements* of the Southwest: Ariège, Aude, Aveyron, Dordogne, Haute-Garonne, Gers, Gironde, Landes, Lot, Lot-et-Garonne, Hautes-Pyrénées, Tarn, Tarn-et-Garonne and Pyrénées-Atlantiques. This impressive concentration has had a striking effect on the rural landscape of the region between the Massif Central and the Pyrenees, forming the basis of the urban framework. The number of *bastides* planned by royal or seigneurial authorities may be estimated at about four hundred, although only three hundred appear in the contemporary register.

The era of the *bastide* covers a period of roughly 150 years, from 1222 (the founding of Cordes) to 1373 (the founding of Labastide-d'Anjou), reaching a peak in about 1280. The creation of new towns in the 13th and 14th centuries was not confined to southwestern France, however; it was a feature of the populating and colonization of land, linked to demographic and commercial expansion, which was occurring throughout Europe. In France the situation was likewise influenced by economic considerations (the need to develop uncleared land), political expediency (the king sought to weaken the authority of feudal lords) and military matters (the conflict between the kings of France and England). The first founders were the comtes de Toulouse, who initiated a chain reaction among the local nobility (both laity and clergy) and the kings of France and England, usually represented by their seneschals. The phenomenon is remarkably widespread. It is also remarkable for its originality and the characteristics it presents, from the point of view of urban development.

Typical features of the *bastides* are the regularity of their layout (which was of course adapted to each location) and their division into clearly defined plots of land, or 'parcels'. The size of these plots was generally stipulated in the *contrats de paréage* (a signed agreement between the founder, for example the king of France, and the local lord) or in the *charte des coutumes*, which defined the organization of the municipality, the various privileges accorded to its inhabitants, and so forth. The public square is a common feature of all *bastides*, occupying a uniquely important position. It is regular in shape and usually surrounded by houses supported on arcades, which form an attractive covered area. The space reserved for the square is proof of its special significance; it takes up an entire block. It is also notable for its central position (being situated in the very heart of the community) and for its importance as a place of commerce. Here people met and traded with one another; the square was the setting for markets and fairs, events of great importance in medieval life. It usually provided the basis for the town's structure, as its size influenced that of the four blocks or groups of houses surrounding it, thus determining the proportions of all the other blocks within the walls. Here the principal roads crossed at right angles, forming a grid system of main streets (perpendicular for the most part), supplemented by a network of smaller streets known as *carreyrous*. The covered market generally stood in the centre of the square, or in some cases at one side. The size of the market was in direct proportion to the dimensions of the square. The church was normally built in the block of houses diagonally opposite the market, although it was sometimes placed further away.

SAINT-FÉLIX-LAURAGAIS (Haute-Garonne): a *bastide* founded by Eustache de Beaumarchais, seneschal to the king of France (1272–94) following the death of Alphonse de Poitiers, Comte de Toulouse (1271). The main square and covered market.

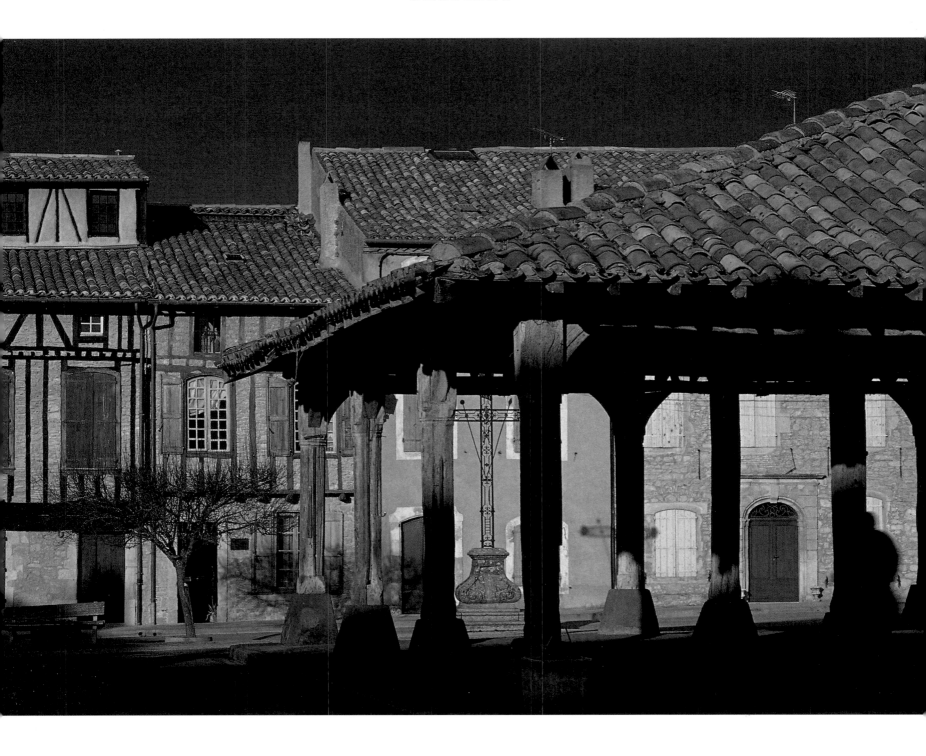

A typical bastide:
MONPAZIER (Dordogne)

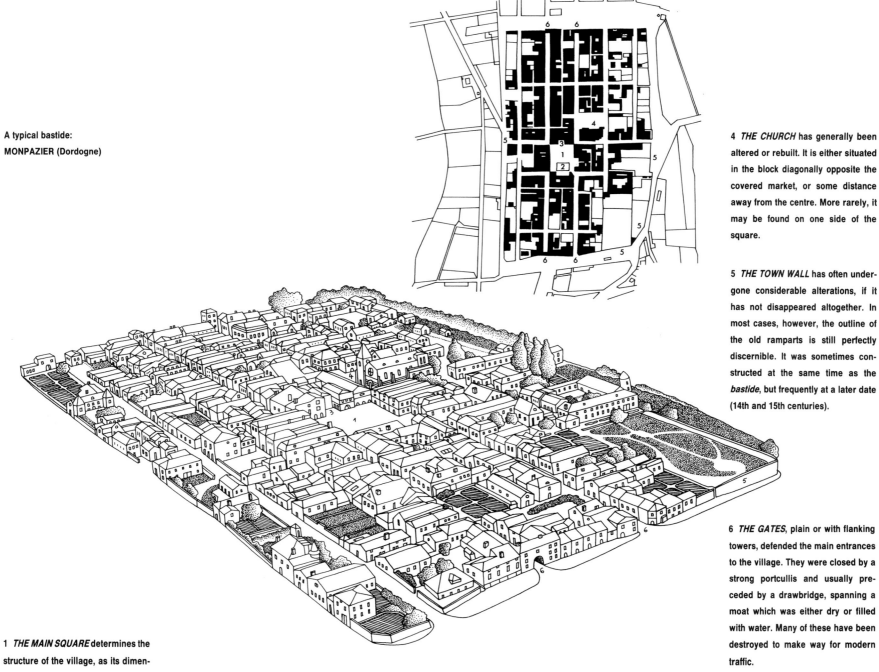

4 *THE CHURCH* has generally been altered or rebuilt. It is either situated in the block diagonally opposite the covered market, or some distance away from the centre. More rarely, it may be found on one side of the square.

5 *THE TOWN WALL* has often undergone considerable alterations, if it has not disappeared altogether. In most cases, however, the outline of the old ramparts is still perfectly discernible. It was sometimes constructed at the same time as the *bastide*, but frequently at a later date (14th and 15th centuries).

6 *THE GATES*, plain or with flanking towers, defended the main entrances to the village. They were closed by a strong portcullis and usually preceded by a drawbridge, spanning a moat which was either dry or filled with water. Many of these have been destroyed to make way for modern traffic.

1 *THE MAIN SQUARE* determines the structure of the village, as its dimensions dictate those of the four blocks or 'islets' surrounding it.

2 *THE COVERED MARKET* normally stands in the centre of the square, but in some cases was placed at one side. Its measurements are in direct proportion to those of the square.

3 *THE COVERED WALKWAYS* were formed by arcades or pillars supporting the overhanging floors of houses which surrounded the main square. In most cases these were built after the creation of the *bastide* itself.

LABASTIDE-D'ARMAGNAC (Landes): a *bastide* founded in 1291 by Comte Bernard d'Armagnac and King Edward I of England. The Place Royale.

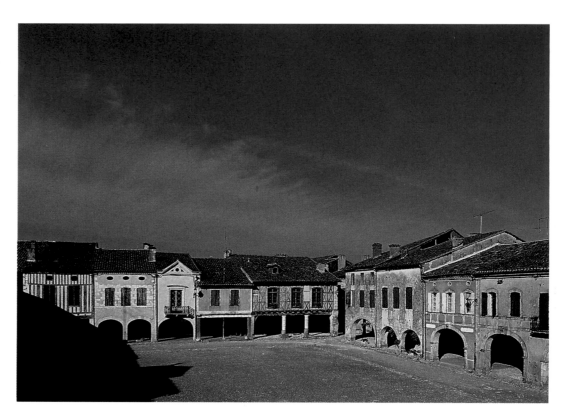

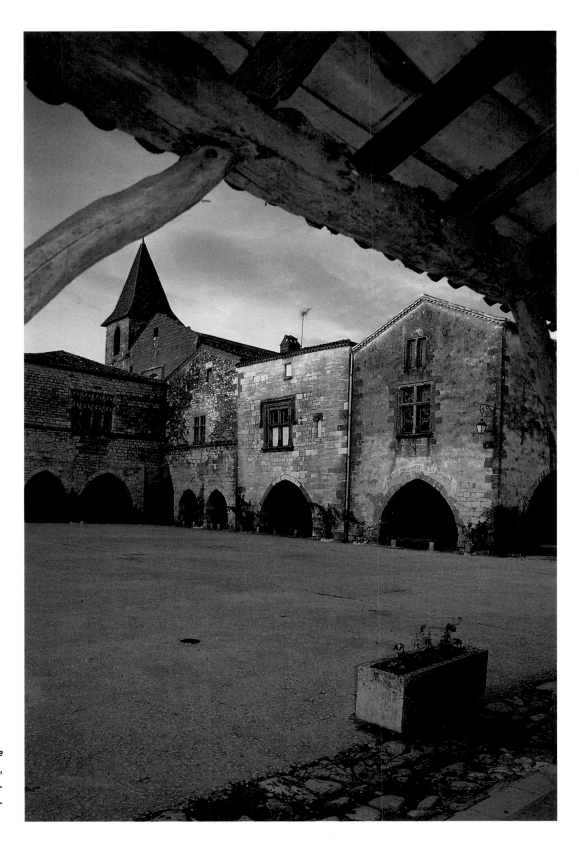

**MONPAZIER** (Dordogne): a *bastide* founded in 1284 by Jean de Grailly, seneschal to King Edward I of England. The main square and old covered market.

# HILL VILLAGES

The hilltop village, or *village perché*, is an essential characteristic of Mediterranean settlement, whether along the coast, in the hinterland or deep in the mountains. Perched in a precarious position, it is difficult to reach and often makes a spectacular sight. These villages have remained a permanent part of the landscape constituting perhaps its most striking feature. Especially typical of eastern Provence (the Alpes-Maritimes), neighbouring regions (Alpes-de-Haute-Provence, Var, Vaucluse, Bouches-du-Rhône and even Corsica) offer similar examples, although these may be less uniform in composition.

The origin of these hill villages dates back to prehistory. Settlements had already been built on high land by the Ligurian era (the end of the last millennium BC). Under the Pax Romana settlement tended to spread out, becoming more scattered. The fall of the Roman Empire, however (AD476), resulted in a wave of invasions by barbarian tribes, in the course of which local inhabitants fled their exposed hamlets, resettling on sites that were easier to defend. The Ligurian *castellaras* were once more occupied and it was during this period that most hill villages were founded. The early 11th century heralded a new era. The Saracens had been expelled from the region in 975: here, and indeed throughout Europe, came the dawning of a period of expansion. This has given rise to the theory of the 'villages of the year 1000', which would have risen above the current settlements, built on the hillside below in the 11th and 12th centuries.

In the period 1380–1400 many villages were depopulated, abandoned or even destroyed as a result of war, famine and outbreaks of plague, some to disappear for ever. They were not rebuilt until the 16th century brought a period of greater prosperity. The villages that suffered least remain on their medieval sites, despite the inconvenient location. Most retain from the Middle Ages, therefore, their site, sometimes a castle (or keep), fortifications (almost invariably built in the 14th century, the principal period for the construction of town walls) and the street layout. The houses, however, are rarely earlier than the 16th century.

Peaks and ridges, characteristic of a mountain landscape, have lent themselves to the two most commonly found types of village: 'circular villages' were built around the peaks and 'long villages' were perched on the ridges, but there are many variations. Although the locations of these villages differed greatly from one another, defence was always the prime consideration, so the layout of the settlements is more or less identical. The buildings are densely packed together on their hilltop sites, each village having to adapt to its environment.

They almost invariably face south, turning towards the sun. The northern slope is left deserted – a dark, cold place, lashed by hostile winds. The summit was crowned with a castle; these have now almost all disappeared. The houses are arranged in concentric circles below, or in some cases, set out in tiered rows. The houses are tall, organized according to a pattern which left little room for the narrow streets and cramped squares. The villages are remarkably well adapted to their hillside locations; the last row of houses doubles as a fortification, the tall façades being closed to the outside, their windows looking only inwards, towards the village.

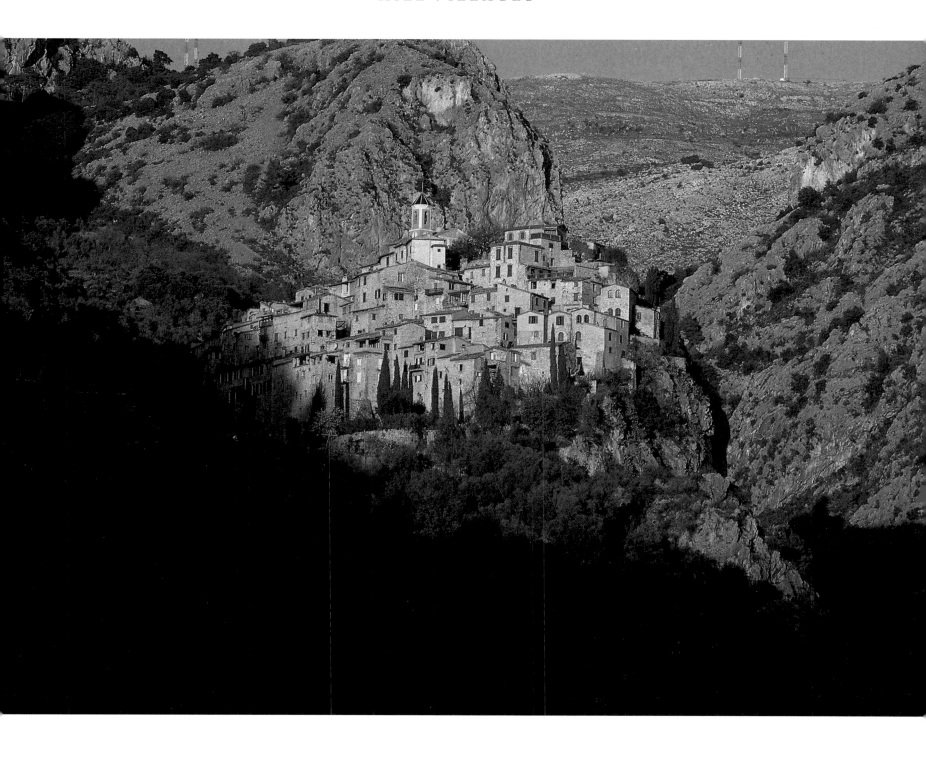

# HILL VILLAGES

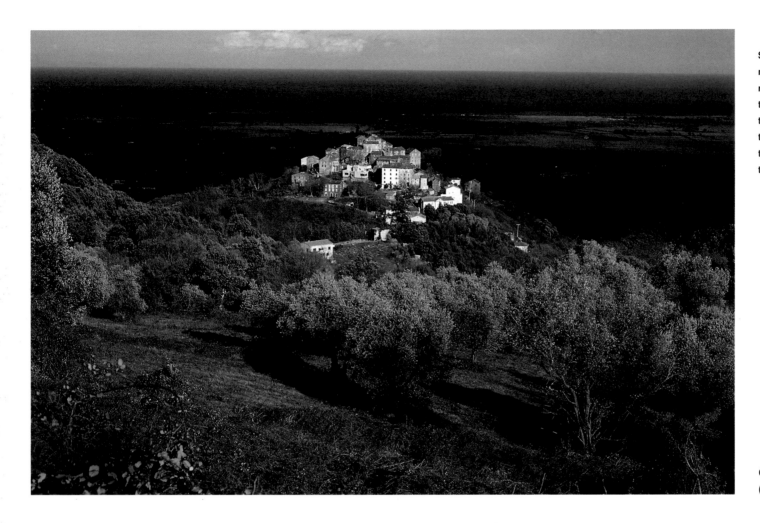

SAORGE (Alpes-Maritimes): a 'monumental village', with its houses arranged in tiered rows on the mountainside. Here the site benefits from the inward curve of the rock-face towards the south, so that the layout of the village resembles an amphitheatre. ►

**CASTELLARE-DI-CASINCA**
**(Haute-Corse)**

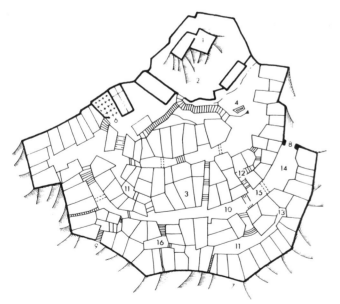

**THE TYPICAL HILL VILLAGE**

 1 – keep
 2 – castle
 3 – village
 4 – fountain
 5 – church
 6 – cemetery
 7 – defences
 8 – gate
 9 – postern gate
10 – main street
11 – service passage
12 – passage
13 – cul-de-sac
14 – square
15 – bracing arch
16 – watercourse

14

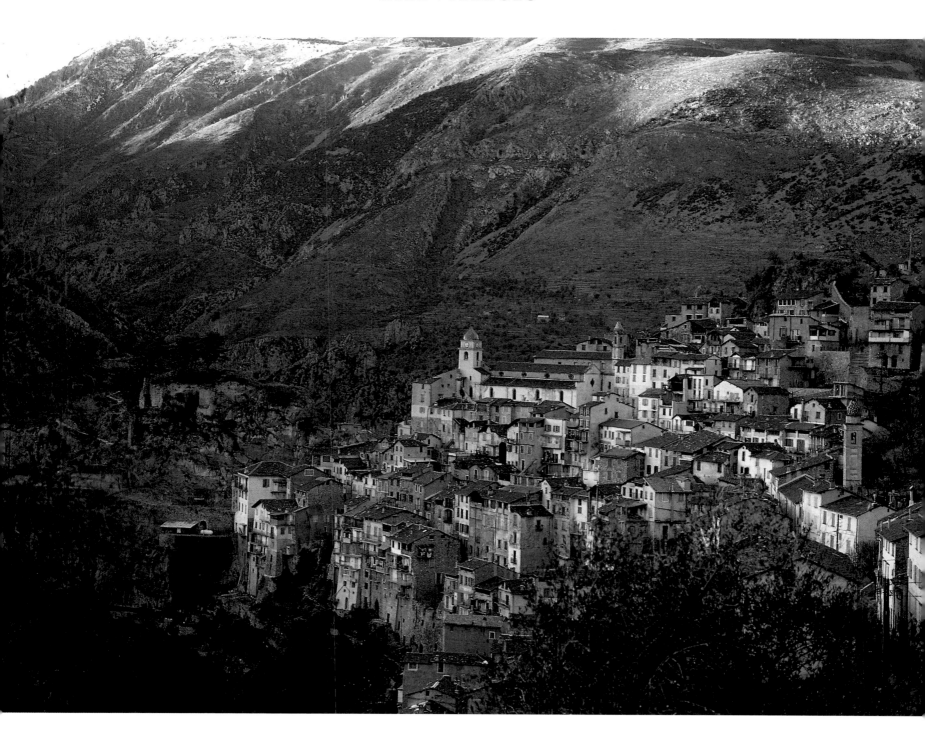

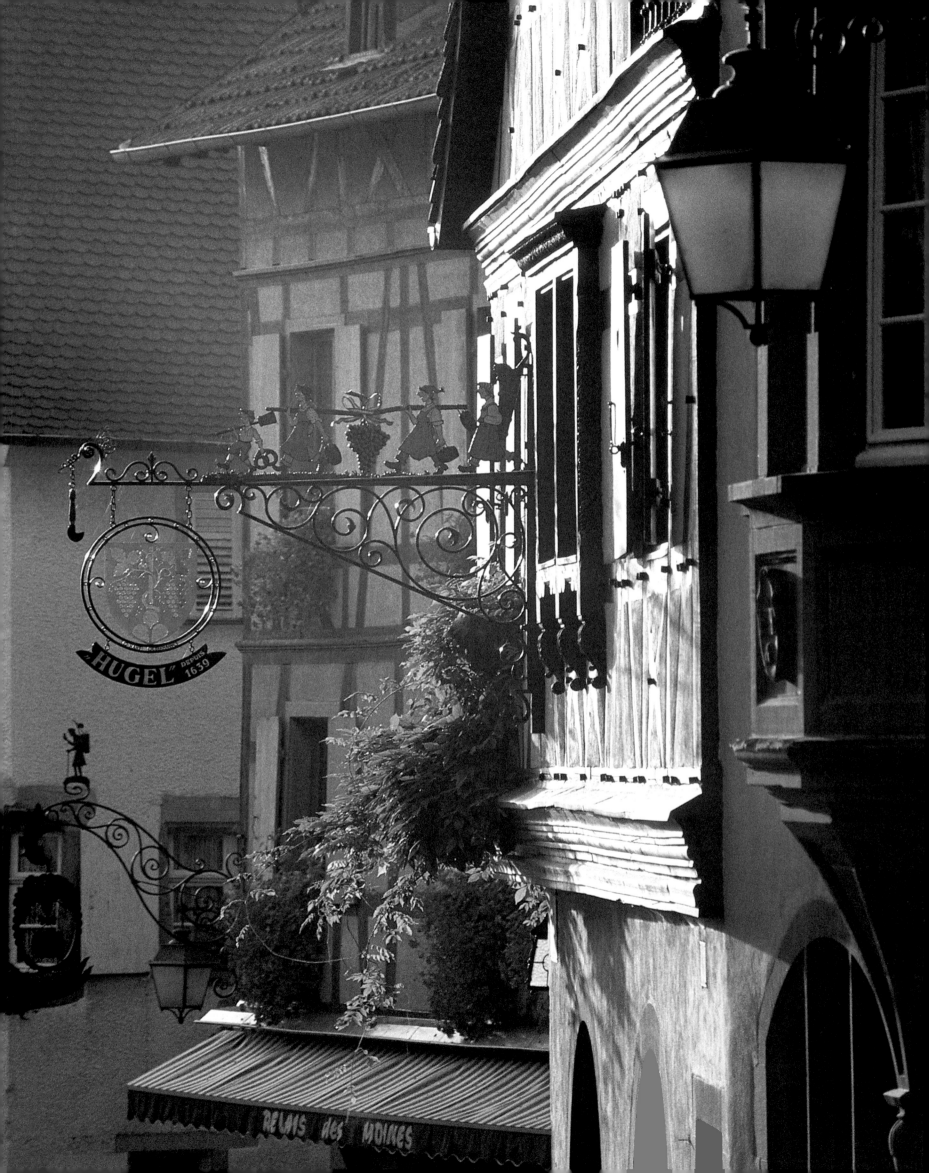

Riquewihr is first mentioned in 1094, but the Merovingian tombs discovered at the beginning of this century indicate that the region had been inhabited for some considerable time prior to that date. The location is remarkably sheltered and Riquewihr was a renowned wine-growing centre in the Middle Ages; it may well have established its reputation in the Roman period. The comtes de Horbourg, who owned the place in the 13th century, had the surrounding wall built in 1291. Riquewihr is described in 1320 as a town. In 1324 the Horbourgs were obliged to sell their lordship to their uncle Ulrich, Comte de Wurtemberg, as they had no direct heirs. From then on the town remained a Wurtemberg possession until the Revolution.

Two important dates mark events which attest to the town's prosperity. In 1489, Duc Henri de Wurtemberg-Montbéliard presented Riquewihr with a charter granting various privileges to its inhabitants. Local usage and custom were then recorded in the *Ratbuch*. The year 1522 saw the establishment of the important Guild of Wine-growers, which consolidated wine production as the dominant activity of the town. In the intervening period a second surrounding wall had been built, in 1500. Unfortunately this was not sufficient to prevent the destruction and pillaging which occurred during the Thirty Years' War (1635). The town's fortunes revived in the 18th century, when vineyards and gypsum quarries brought prosperity. The Revolution was welcomed here, all connections with the duc de Wurtemberg being finally broken with the peace of 1801. The neighbouring villages of Mittelwihr and

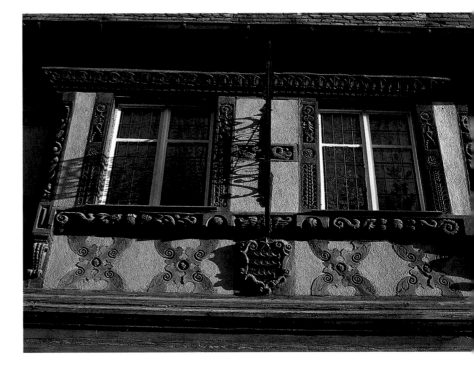

Benwihr were completely destroyed in the furious fighting which raged during the winter of 1944–45. Riquewihr, however, was miraculously spared.

Riquewihr is numbered amongst those villages of Alsace which subsist exclusively on wine-growing. The first written record of vineyards appears as early as the 14th century, although the town is then described as a famous wine-growing centre enjoying a high reputation. This still holds good today; the vineyards surrounding the town, particularly those on the slopes of Schoenenberg and Sporen, are said to produce the finest wines in Alsace. The quality of the vines is carefully safeguarded; various restrictions, renewed in 1575 and 1644, prevented any plant of inferior quality being introduced.

Riquewihr contained about 2,500 inhabitants at the time of the Revolution. The population today has dropped to 1,018, and consists mainly of wine-growers.

**This house was built by the community in 1686, on the site of the former Hostellerie de l'Étoile. It remained a hostelry, retaining the old name. The elegant windows of the façade have finely carved wood frames. The covered entrance to the house leads to the Cour des Vignerons, headquarters of the powerful Guild of Wine-growers from 1522 until 1791.**

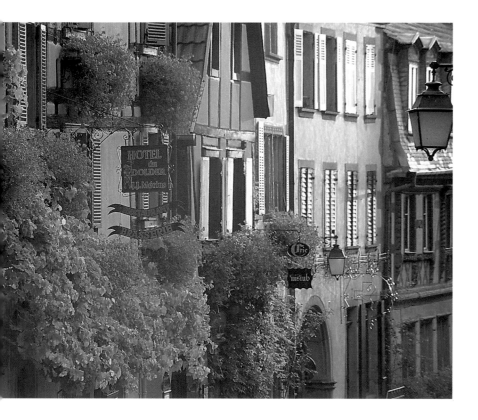

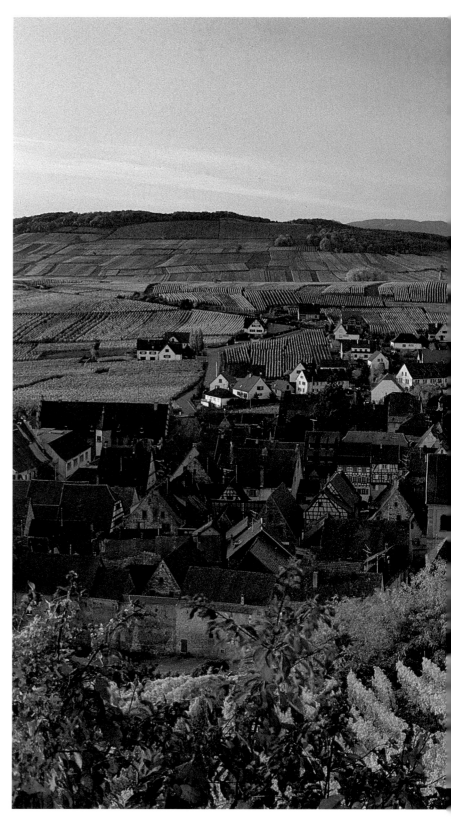

Since the 16th century, the inhabitants of Riquewihr have lived in surroundings that remain almost miraculously unchanged. The citizens have lovingly preserved their town, decorating it with flowers. During the grape harvest, the comings and goings of the wine-growers create a lively, bustling atmosphere. The smell of freshly pressed grapes rises from the vast cellars and the whole town is filled with the fragrance of the new wine.

For further information:

*Riquewihr, son histoire, ses institutions, ses monuments,* by the Abbé Voegeli, produced by the Société d'Archéologie de Riquewihr, 1980

*Riquewihr,* a tourist brochure by Philippe Legin, Éditions SAEP, Ingersheim 1988

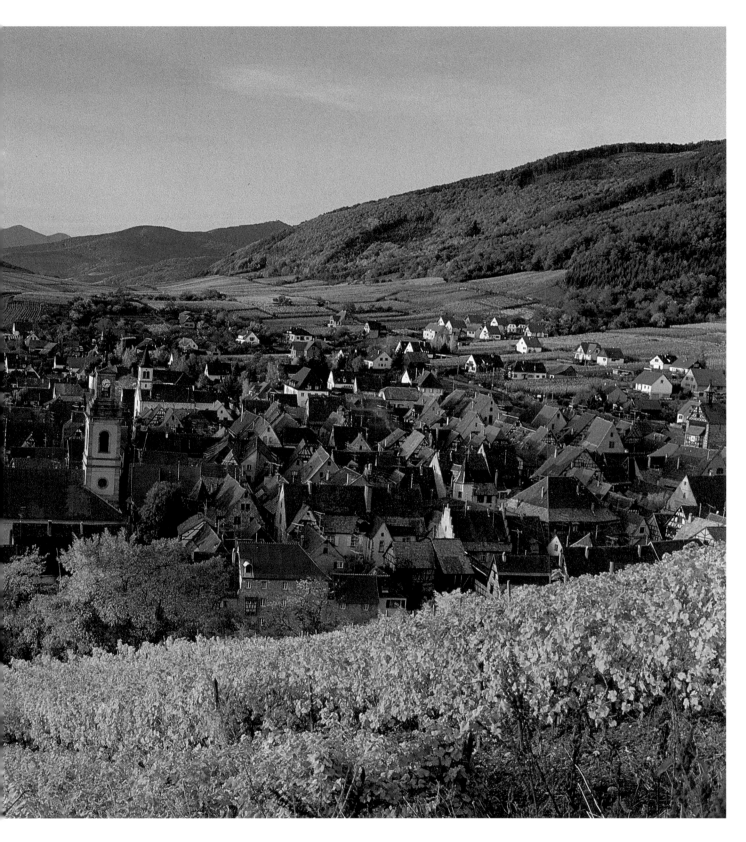

Seen here from the famous Schoenenberg, the charming town of Riquewihr has become one of the greatest tourist attractions in Alsace. Its two rings of walls enclose a community composed of ancient buildings unique in the province. These date largely from the 16th and 17th centuries, a time of great prosperity, before the Thirty Years' War. They offer a wealth of interesting architectural features: inner courtyards, old wells, fountains, gateways, carved wooden window-frames, oriel windows, and so on. On the western edge of the town the Dolder, built in 1291, emerges from the rooftops. This high bell-tower is certainly the most characteristic monument in Riquewihr. On the eastern edge (left), the former castle of the comtes de Wurtemberg (built in 1540), today houses the museum of the history of the Post Office in Alsace.

The picturesque village of Hunawihr is situated five kilometres (some three miles) from Riquewihr. It was also a fief of the comtes de Wurtemberg until the Revolution. The famous fortified church, dating from the 15th and 16th centuries, dominates the village. It is surrounded by a hexagonal wall, the corners reinforced with semi-circular bastions. This served as a refuge for the inhabitants in times of danger. ▶

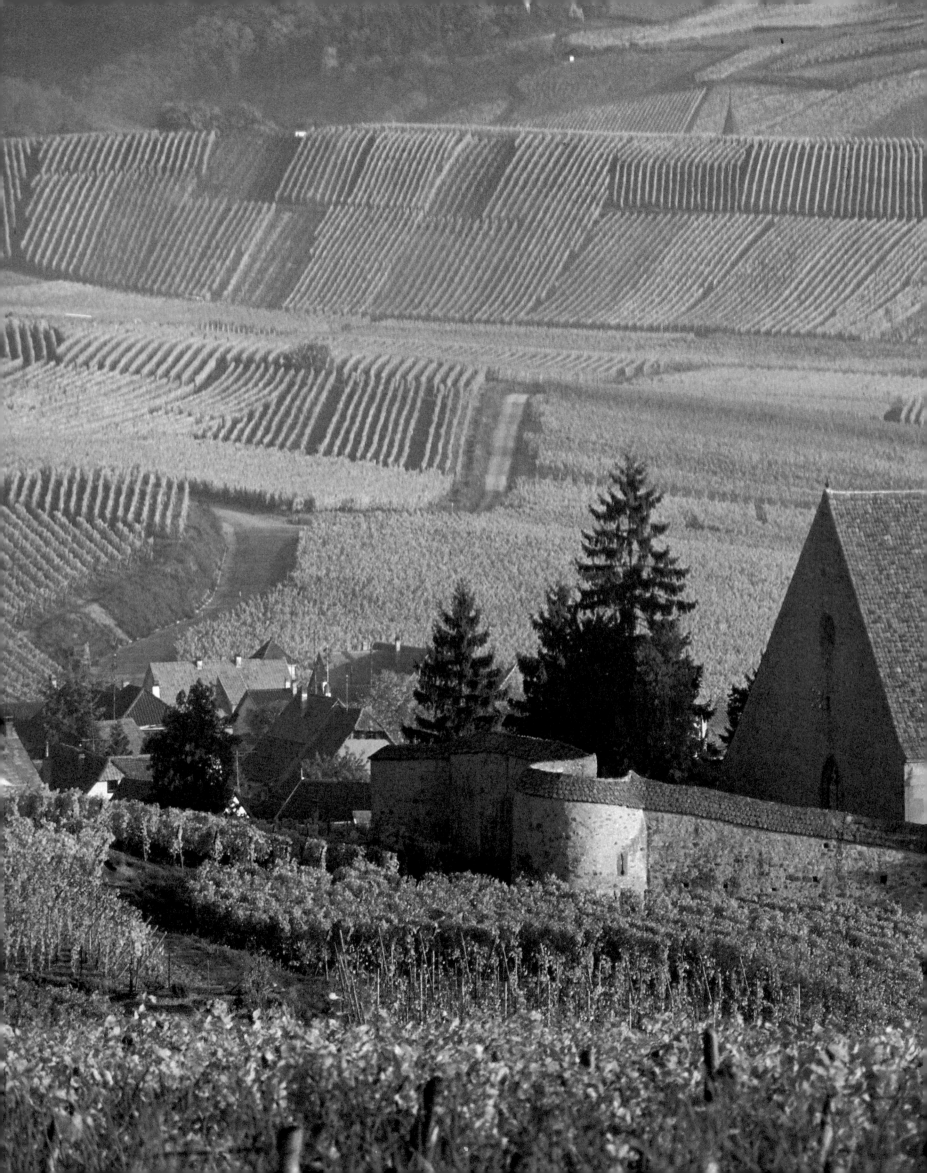

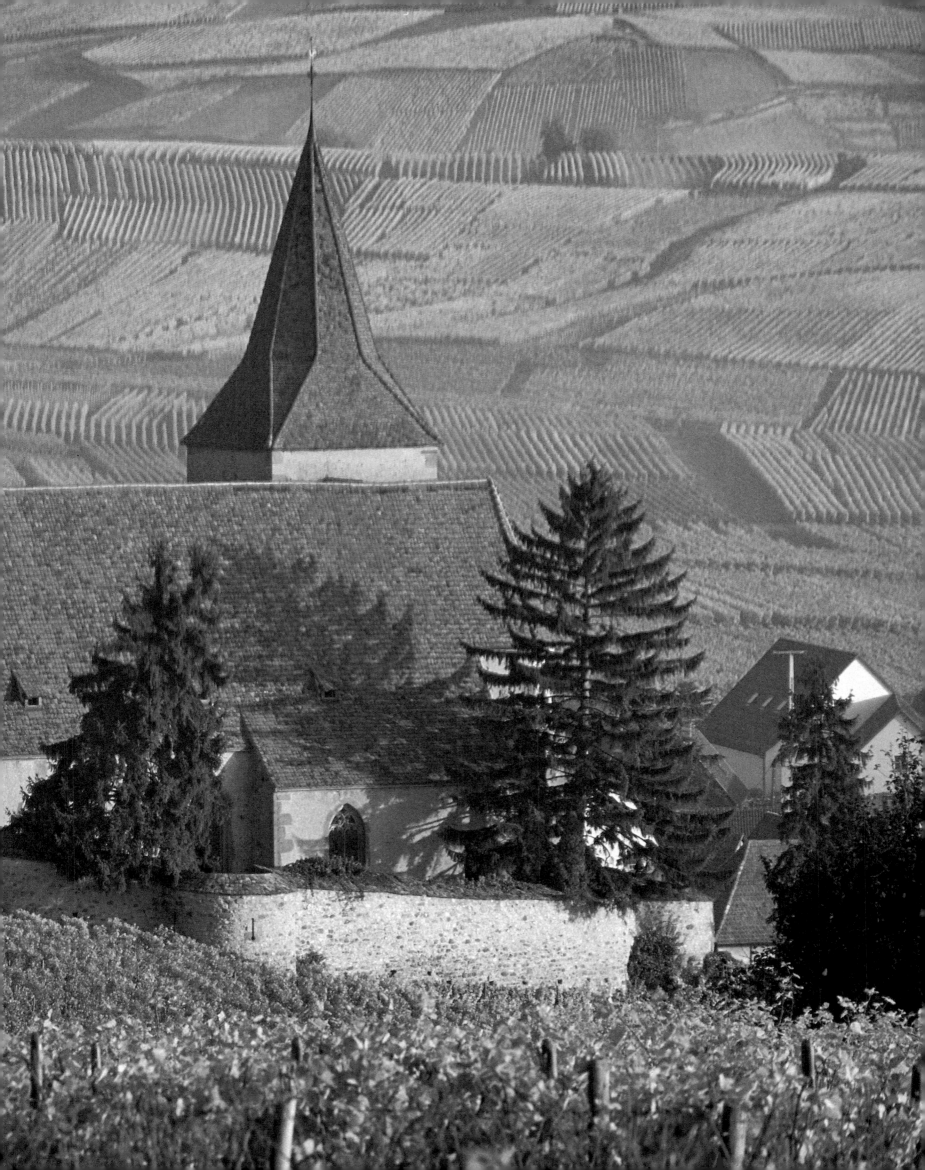

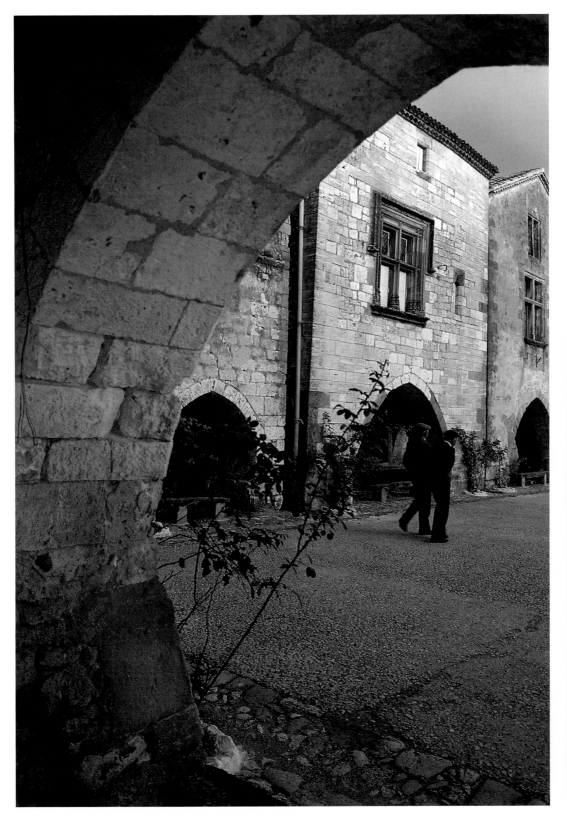

This main square is one of the loveliest in France. It is surrounded by old houses supported on picturesque arcades over four covered ways which line the area. These are sufficiently wide and high for carts and horsemen to have circulated freely. Although the houses have been modified, restored or even demolished (six have gone), they form a remarkable architectural ensemble, often used as a film set.                    ▼

Most of the houses on the main square were reconstructed or considerably altered and elaborated upon in the late 15th century. This façade is a typical example; a large mullioned window stands close to a small trefoil-headed opening which probably dates from the preceding century.

The 1280s marked the most prolific period for the creation of new towns in Southwest France. As a prelude to the Hundred Years' War, the royal houses of England and France felt the need to assert their claims, against each other, as well as against those of their local nobles. In this way, Edward I of England decided to establish himself firmly on the northern frontier of his territories in Guyenne, notably on the wooded plateaux between the Dropt and the Dordogne. He then undertook the construction of the *bastides* of Molières and Monpazier, which together with Beaumont, founded in 1272, formed a system of defence dominating the roads from Périgord to the Agenais.

On 7 January 1284 Pierre de Gontaut, seigneur of Biron, presented Jean de Grailly, seneschal to Edward I, with the site of the *bastide* of Monpazier. The community was to experience much upheaval in the course of the Hundred Years' War, changing hands several times until it finally came under the jurisdiction of the king of France in 1398. Charles VI then granted the inhabitants a pardon 'for the connections they might have had with the English . . .'

Today the *bastide* retains its original layout; a perfect rectangle divided into equal blocks. The concept of dividing walls does not exist in Monpazier, each house being surrounded by streets, alleyways (*carreyrous*) and *androns*, small spaces which were used as dumping grounds or places for cutting firewood. The fortifications were constructed at the same time as the houses, proof of the military importance of the site. The village was enclosed in a double system of ramparts, only a few traces of which remain.

In 1789 the population of Monpazier was calculated at 1,200 inhabitants. Today it stands at just 533.

For further information:
*Monpazier, logis, gens et faits d'autrefois*, by Docteur R. L'Honneur, Imprimerie Contact, Monpazier (n.d.)

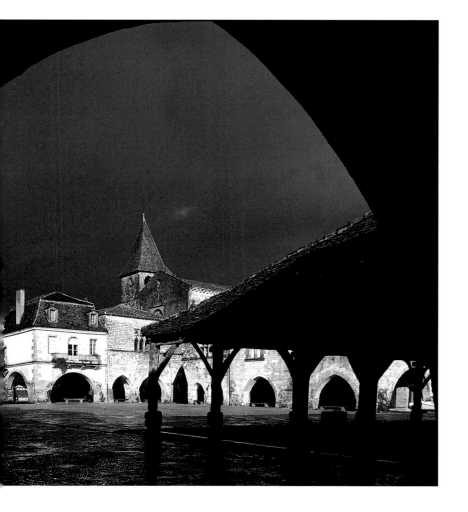

Situated in the very heart of the *bastide*, the main square was the setting for annual markets and fairs. On the south side, the covered market protected the goods on display. The fine timber structure of chestnut has been preserved, together with the stone platform on which measures of grain were packed. The castle of Biron can just be discerned in the distance. It was the fief of the Gontaut family from the 11th century.  ▶

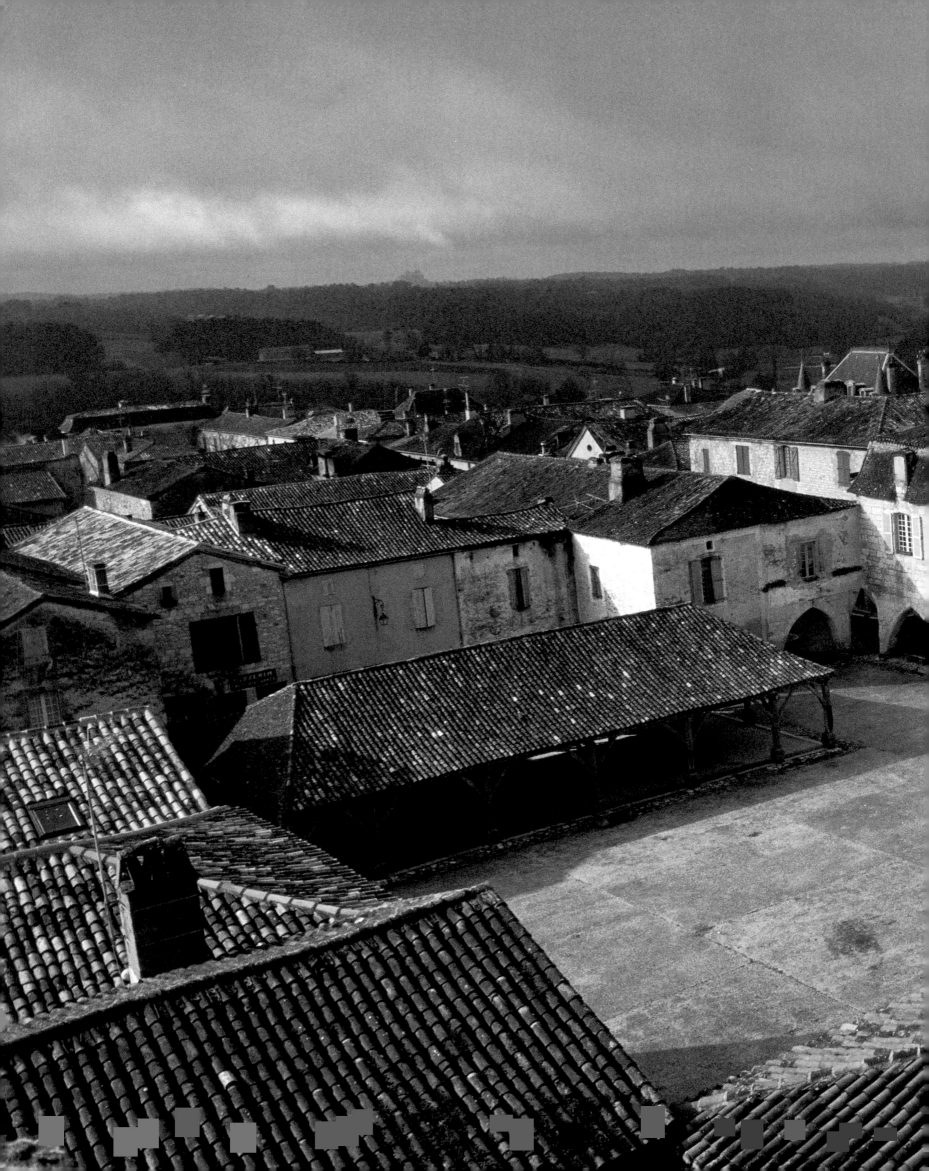

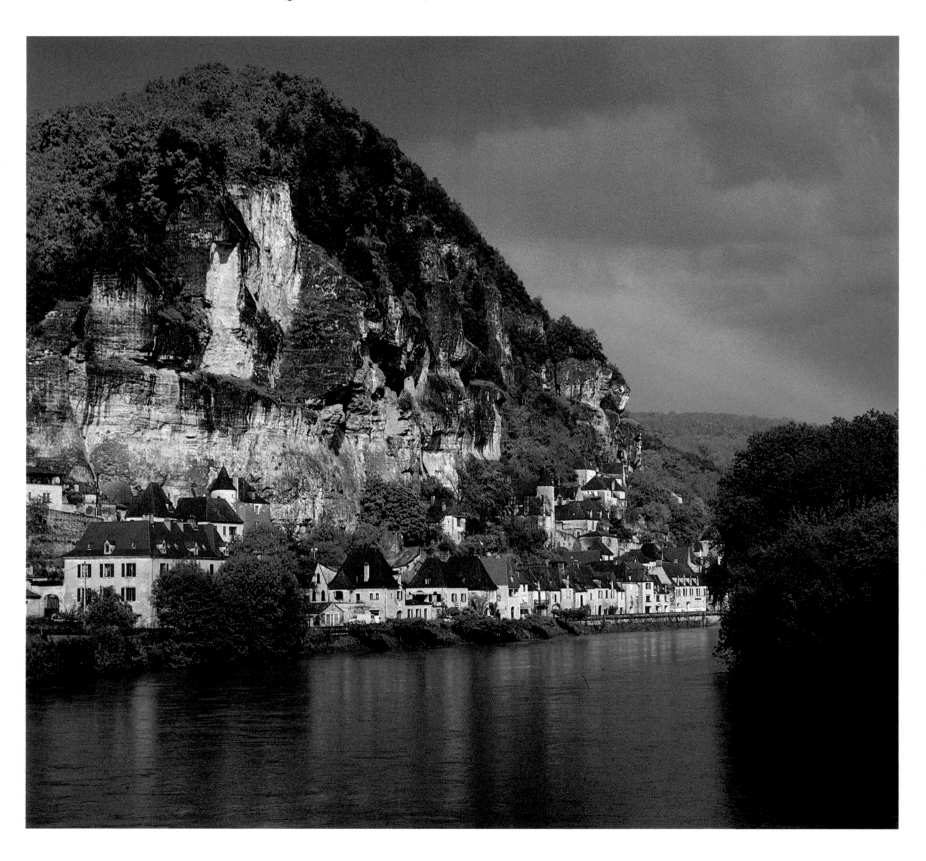

# *LA ROQUE-GAGEAC, BEYNAC* AND *DOMME* DORDOGNE

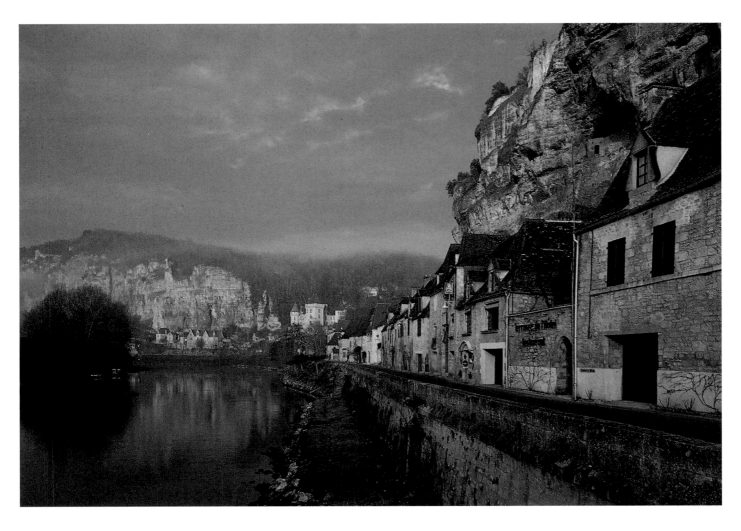

The quays serve as a reminder of the busy life in the *bourg* at a time when boats from up-river unloaded their stacks of wood here, and when cargoes of wine from Domme (much appreciated by the archbishops of Bordeaux) were shipped off to their destination. The castle of La Malartrie, seen in the background, was built in the Renaissance style by the Saint-Aulaire family at the beginning of this century. On the right of the picture, a cave in the cliffs was formerly accessible from the bishop's castle. It was fortified and had a constant supply of water, so that it could be used as a last resort in the defence of the town.

Dotted with castles and picturesque villages, the Dordogne valley between the cliffs of Beynac and Domme is one of the loveliest areas in France. La Roque-Gageac is situated halfway, nestling at the foot of a towering rock-face full of caves. Seen in the foreground, the western part of the village had to be almost entirely rebuilt as a result of two landslides (notice the large pale-coloured patch in the cliff). The first was a natural disaster, which occurred in 1957; the second was caused by an attempted safety measure a few years later.

The town of La Roque-Gageac was founded at the latest in the second half of the 12th century, under the patronage of the powerful abbots (later the bishops) of Sarlat. The first mention of it dates from 14 September 1214. In the 14th century the bishops of Sarlat owned a castle on the site and the little town, of greater importance then than it is now, was fortified. It was among the principal fiefs of the bishopric and its inhabitants enjoyed exceptional privileges. During the Hundred Years' War they supervised the defence of the bishops' stronghold, principally against attack from the neighbouring town of Domme, 'in revolt against the king of France and in the power of the English' since 1346. At the time of the Wars of Religion the famous Protestant Captain Geoffroy de Vivans obtained the surrender of La Roque, after taking command of Domme, on 5 March 1589. One month later Louis de Salignac, Bishop of Sarlat, put his seigneury of La Roque-Gageac up for sale: it brought him very little in the way of revenue and the castle was in ruins. After the turbulent days of the Fronde the fortifications had to be repaired and completed for the last time (1653). The little town subsequently fell into decline. One of its most

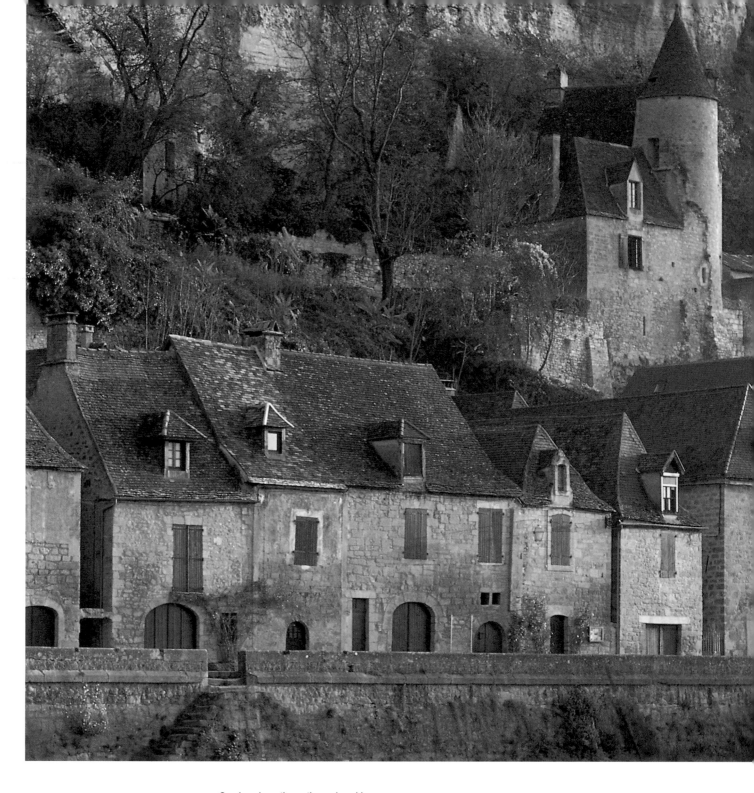

Overhanging the other riverside
houses, the Manoir de Tarde is the
only remaining example of the four or
five noblemen's residences, built
against the rock, which formerly sur-
rounded the castle. The ramparts
have disappeared and the village has
retained only a proportion of its old
architecture. The terraced houses
and the densely packed appearance
of the village nevertheless create a
harmonious impression.

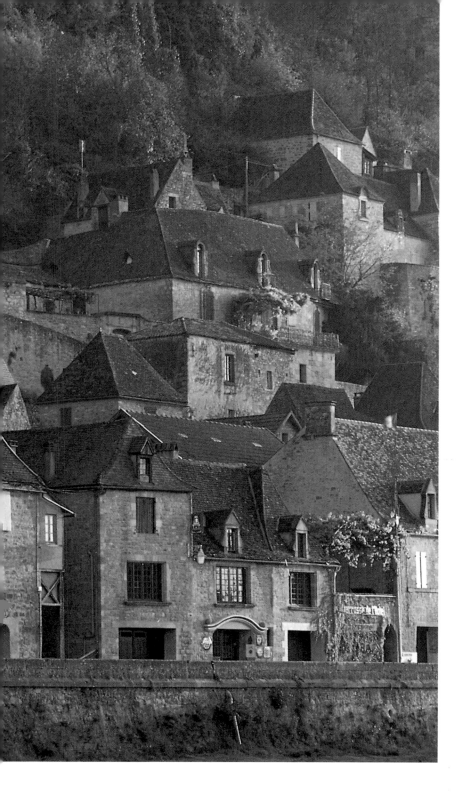

prized privileges – the right to free fishing – was taken away by the king in 1669. On the other hand, the withdrawal of this right opened the river to navigation. The ships which sailed down the Dordogne turned La Roque and several other riverside communities into busy ports, with boatyards where small vessels were constructed. The advent of the railway in the late 19th century caused the gradual decline and disappearance of river traffic. Nowadays the ancient episcopal town is enlivened by the flocks of tourists who descend upon it every summer.

In the Middle Ages the village consisted of just over 100 households, or 'hearths'. This seems a small number, but the town of Périgueux, which was twice the size, numbered 125 households during the same period. The village currently has a population of 402.

For further information:

*Une ancienne forteresse oubliée du Sarladais, La Roque de Gageac, étude archéologique*, by Gabriel Tarde, Périgueux 1881

*Sarlat et le Périgord méridional*, by Jean Maubourguet, 3 vols: Cahors 1926, Paris 1930 and Périgueux 1955

**Five kilometres (a little over three miles) downstream from La Roque-Gageac, the castle and village of Beynac overlook the Dordogne, forming one of the most attractive views in the region. The feudal fortress is perched like an eagle's nest on top of the cliff. It was the fief of the seigneurs of Beynac, and was constructed between the 12th and the late 14th century. Its appearance today is the result of various alterations carried out in the 16th and 17th centuries. The old houses in the village have been reconstructed or restored. Some are grouped together at the foot of the cliff or the ramparts, on the plateau. Others, like these, line the approaches to the castle.** ▶

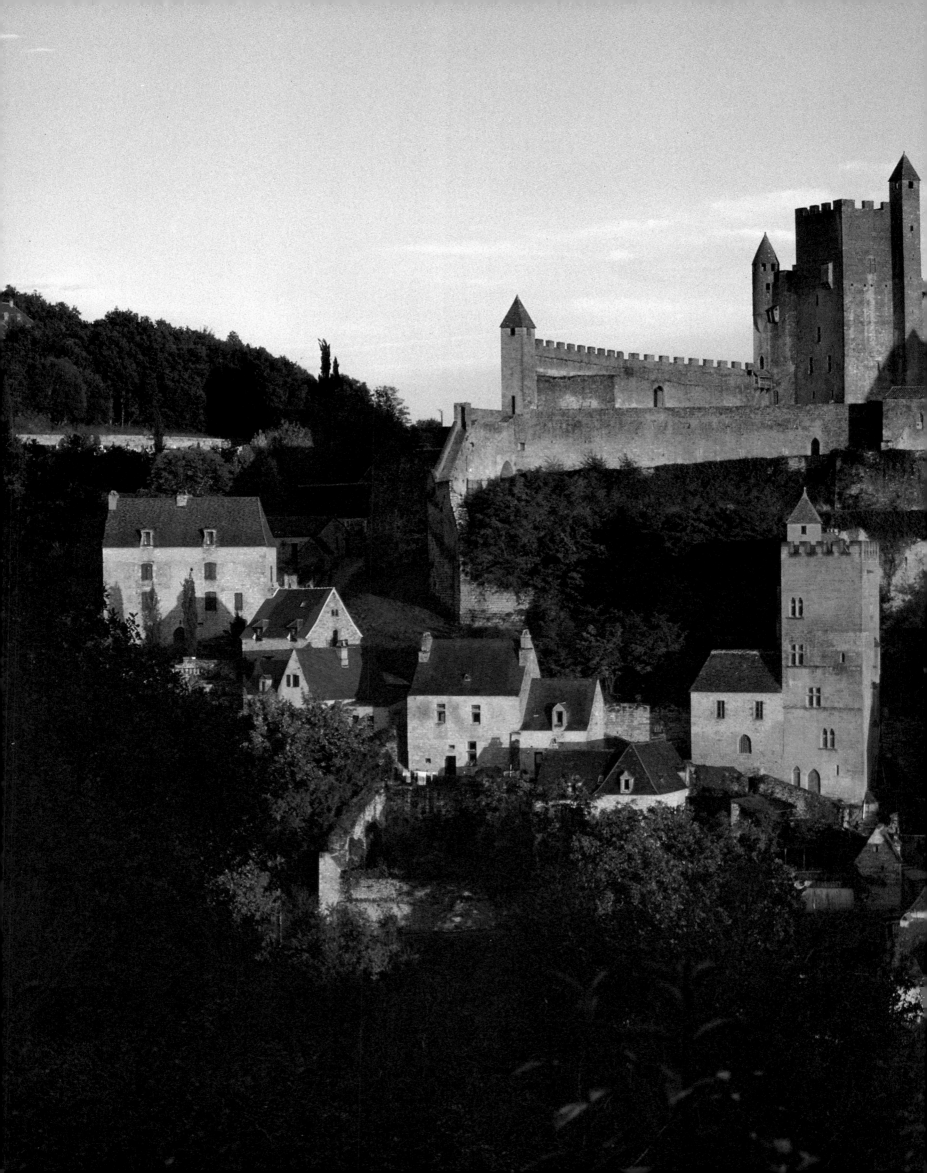

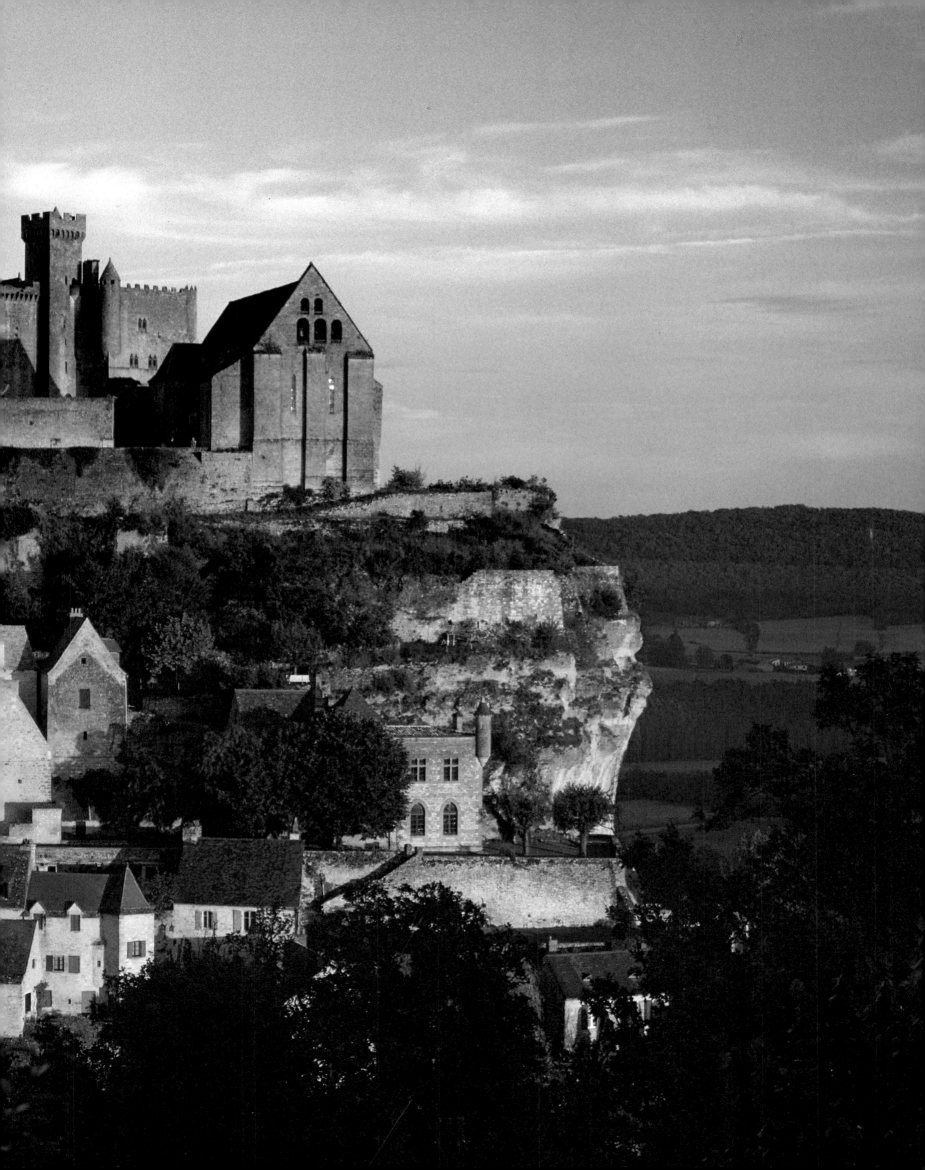

From the Middle Ages to the 19th century, Beynac owed its prosperity to a busy port, its ferry and its fisheries. Some houses roofed with the flat stones known as *lauzes* still stand today. This attractive form of roofing is typical of the Sarlat region. It is gradually disappearing due to the high cost it involves.

## LA ROQUE-GAGEAC, BEYNAC AND DOMME DORDOGNE

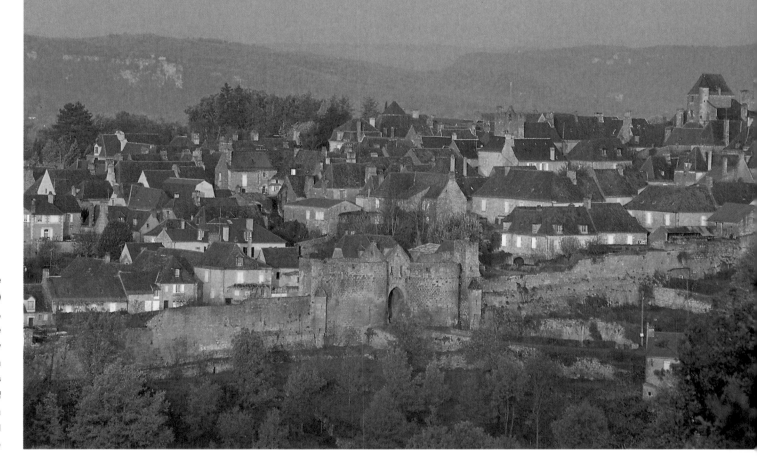

The *bastide* of Domme is situated five kilometres (a little over three miles) upstream from La Roque-Gageac, perched on a cliff overhanging the Dordogne. It was founded in 1281 by Philippe III le Hardi, or 'the Bold', as a defence against the English forces which were then in control of Guyenne. Throughout the feudal era the royal town of Mont-de-Domme and the feudal *bourg* of Domme-Vieille existed side by side on the same rock, each with its own castle. In the course of the Hundred Years' War and subsequently during the Wars of Religion, Domme and its castles were a much sought-after prize, constituting a formidable stronghold, which was said to be impregnable. The castles have disappeared, but the walls encircling Domme (dating from the 1300s) are well worth a detour. Here, the imposing Porte des Tours, so-called for its flanking towers, offers an interesting example of an ancient fortification modernized during the Wars of Religion. In addition, it has some remarkable graffiti attributed to the Knights Templars, who were imprisoned here from 1307.

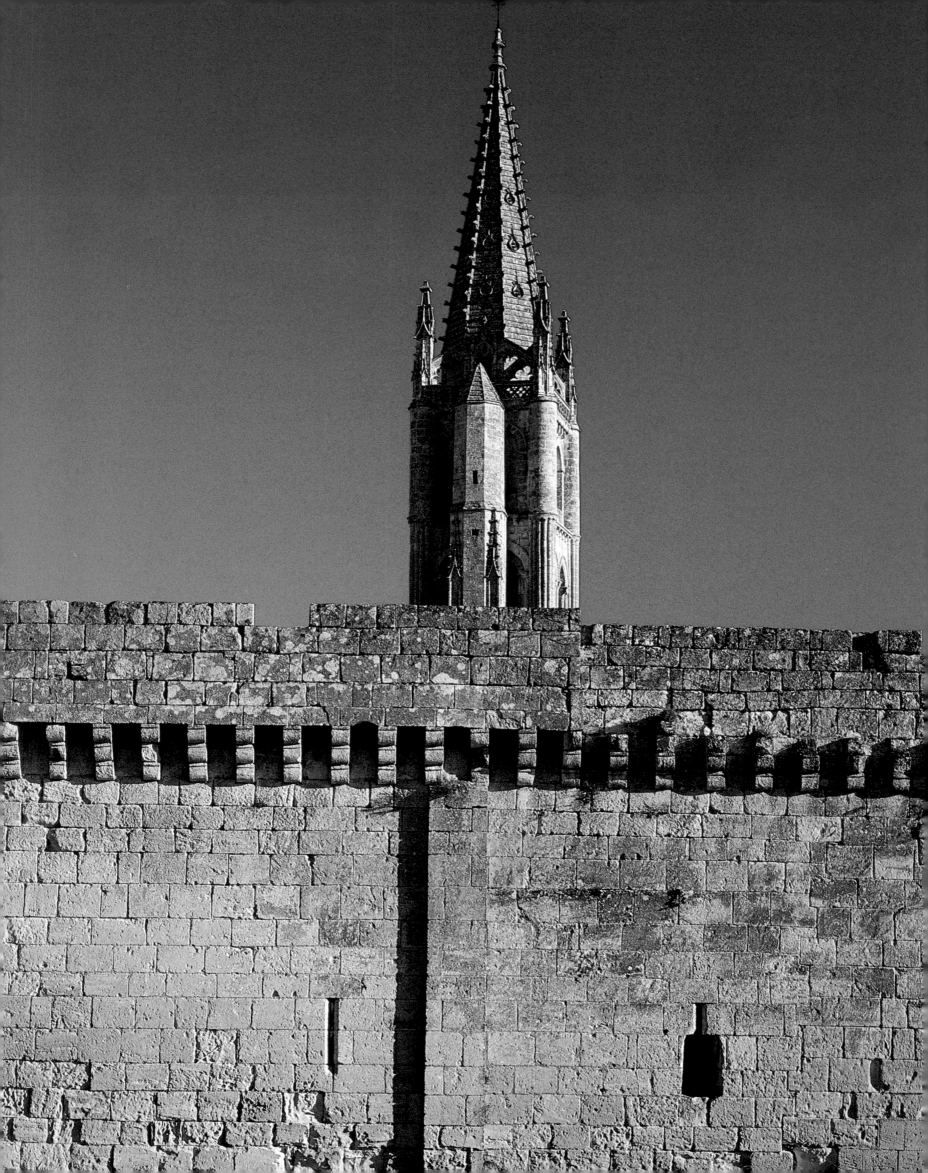

It would appear that a monk from the region of Vannes, known as Aemilianus, Émilian, or Émilion, came to seek sanctuary with the Benedictine monks of Sainte-Marie-de-Fussiniac in the mid-8th century. He gathered together a group of companions, who converted to their use the caves and natural shelters offered by the site here. One of these caves, bigger than the rest, must have served as a church, being enlarged to hold the increasing number of faithful followers. This is doubtless the origin of the extraordinary monolithic church, the only one of its kind in Europe. It was carved out of the rock by the monks, probably between the 9th and the early 12th centuries. A charter dated 8 July 1199, issued by King John 'Lackland' of England, reveals that during this time a municipal organization was founded, forming the origins of the Jurade, which oversees the quality of the region's wines today. According to the words of the charter, this group was to be composed of 'honourable people', who were elected and given the responsibility of administrating (in the widest possible sense) the municipal and commercial business of the community. The commercial interests were already based exclusively on the quality of the local wine. The town developed during the 12th and 13th centuries. New chapels were built, together with large, sumptuous residences for the aristocracy. These were constructed in the upper town. Two great religious orders established communities outside the walls. The town was fortified, a castle being constructed in the early 13th century. Saint-Émilion withstood several sieges during the Hundred Years' War, passing from the English to the French at the end of hostilities. The town had been granted its 'privileges, franchises and *libres coutumes*' by Richard the Lionheart. This charter was confirmed by Charles VI in May 1456. During the Wars of Religion Saint-Émilion was once again besieged and pillaged. In September 1793 Élie Guadet, a member of the Convention and a native of the town, sought refuge here with his friends the Girondins. Today the town enjoys world-wide prestige thanks to its famous wines. The Jurade still works to maintain the quality of the renowned *vin honorifique de Saint-Émilion*.

A charter granted by Louis XI on 22 April 1469 tells us that the population of '2–3,000 households of people from all estates' had fallen to 200 households. There are currently 742 inhabitants.

For further information:
*Saint-Émilion, son histoire, ses monuments, ses vins*, a small volume produced by the Office du Tourisme de Saint-Émilion, Libourne 1972

**The medieval town wall has survived on three sides: it was built in the 13th century, and restored in the 15th and 16th centuries. It is bordered by a wide dry ditch dug out of the rock. The appearance of the wall has changed considerably since its construction, the exception being this area in the northwest corner, which lies between the Porte Saint-Martin and the Porte du Chapitre. There were originally six fortified gates, only one of which, the Porte Brunet, still remains.**

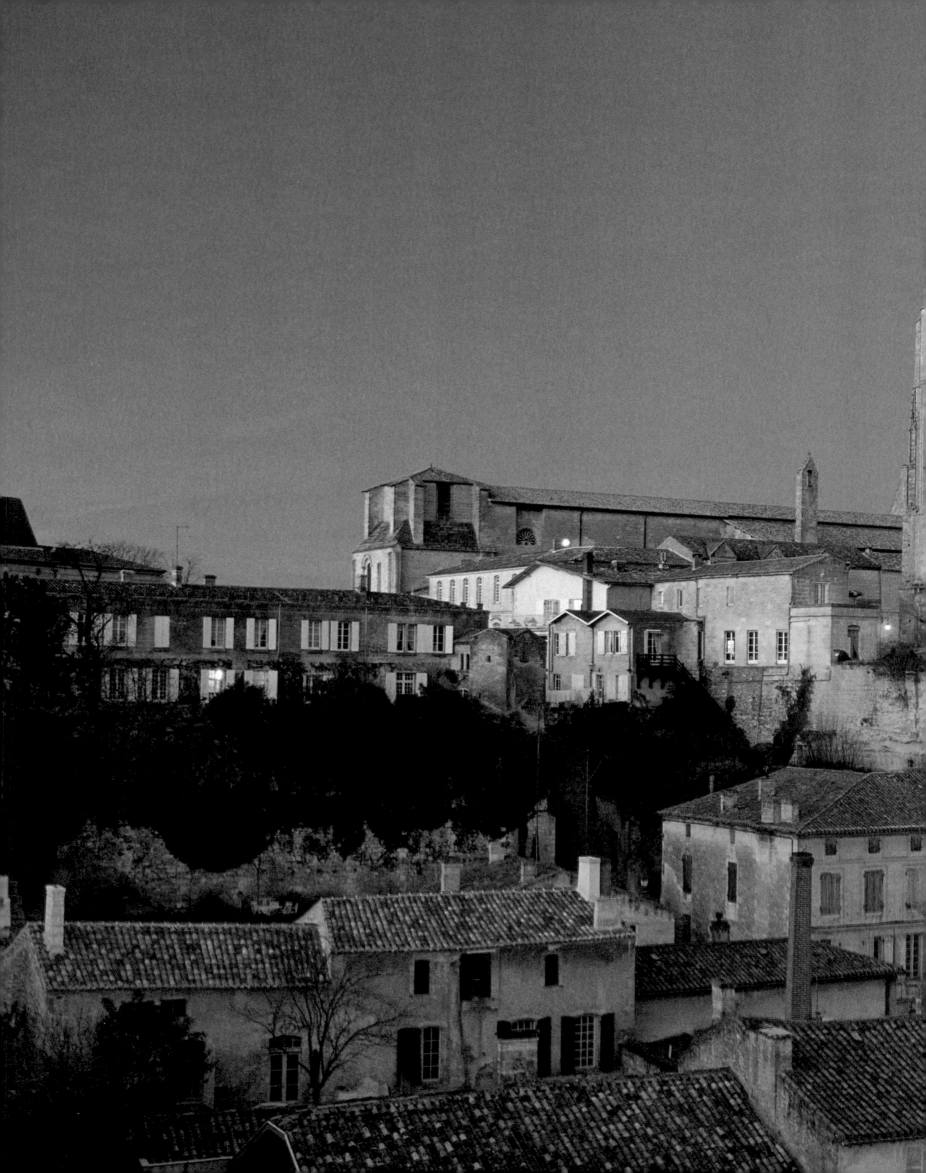

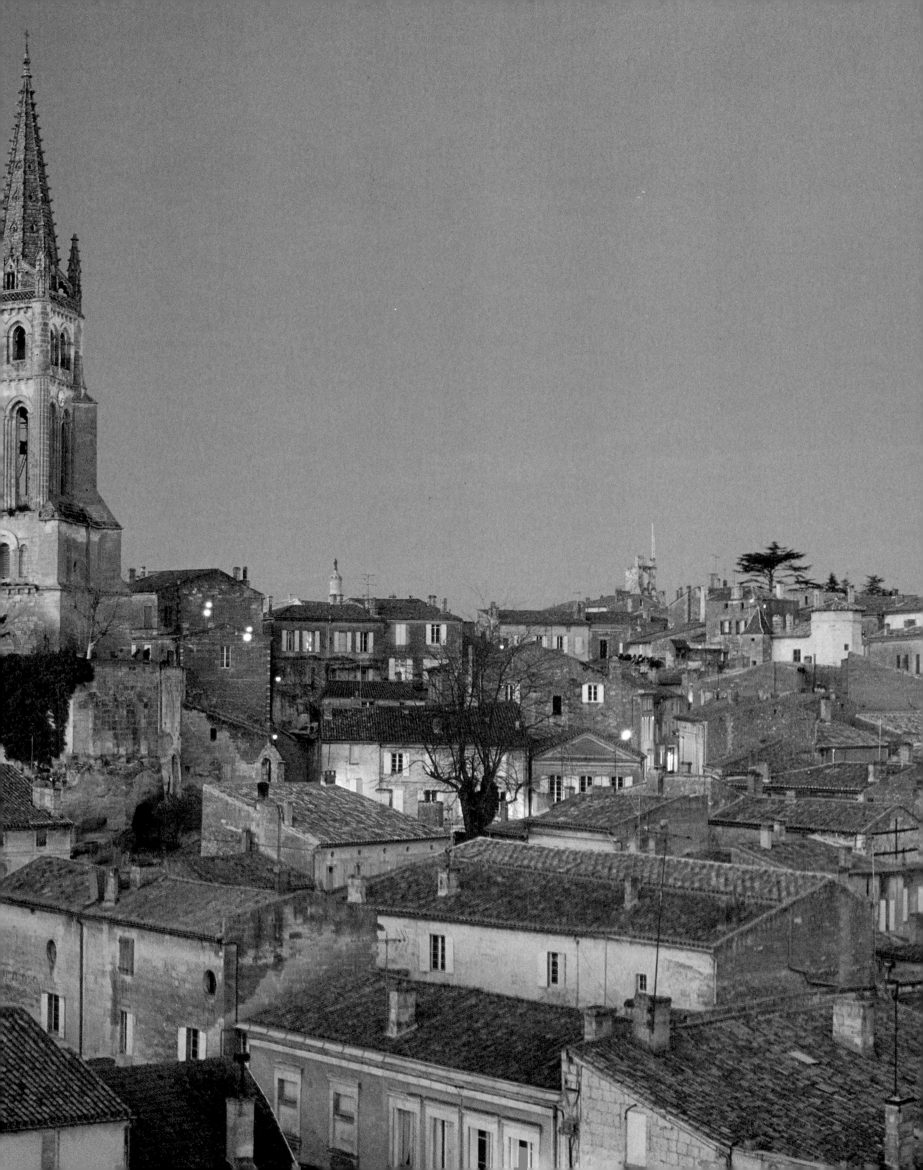

◀

Saint-Émilion has retained many important monuments, principally religious buildings, including the famous bell-tower pictured here. Built on top of the monolithic church, it is the highest of its kind in the Gironde, after the spire of Saint-Michel at Bordeaux. Behind it stands another renowned structure, the vast collegiate church with its truncated bell-tower. This dates from the 12th to the 14th centuries.

The little town, surrounded by its celebrated vineyards, is built like an amphitheatre in a hollow of a chalky hill overlooking the plain of the Dordogne. The community developed during the Middle Ages, growing around the rock that had served as Saint Émilion's hermitage. The houses are built of limestone and are characteristic of the architecture in the Bordeaux region. Most date from the 18th and 19th centuries.

◄

This keep is all that remains of the Château du Roi. It is the only Romanesque keep in the Gironde to have survived intact. Its construction was initially planned by Louis VIII in 1224, during a brief period when his troops were occupying the town. Work was under way in 1237, after the Anglo-Gascons had recovered Saint-Émilion. The keep stands on a cube-shaped rock, which is isolated from the plateau by a wide ditch. It housed the town hall until 1720 and is now the hallowed centre from where judgment is announced on the new wine. This takes place in June. It is also the scene of the Proclamation of the Grape Harvest, which is usually held on the second or third Sunday in September.

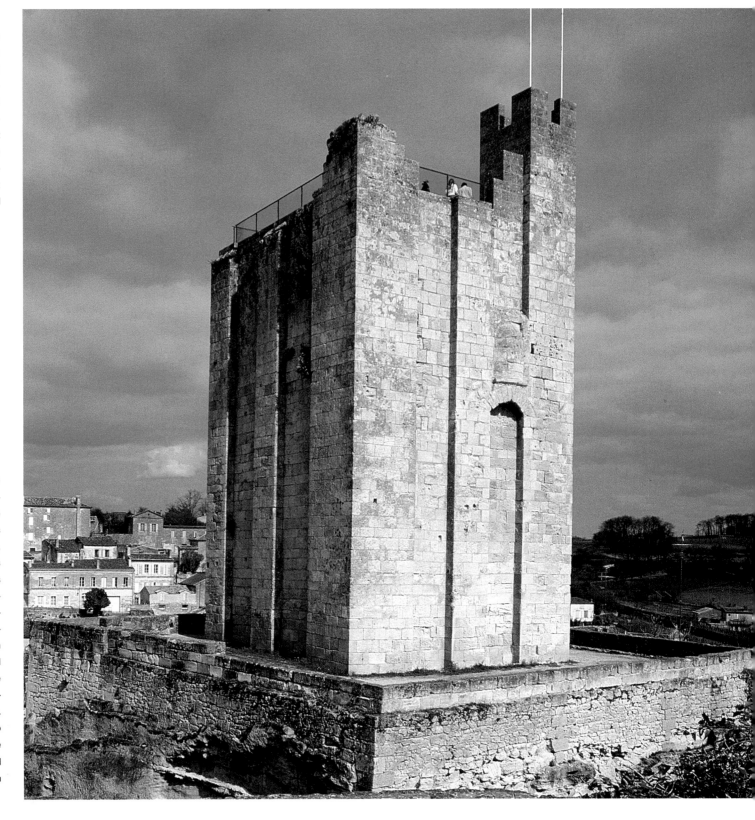

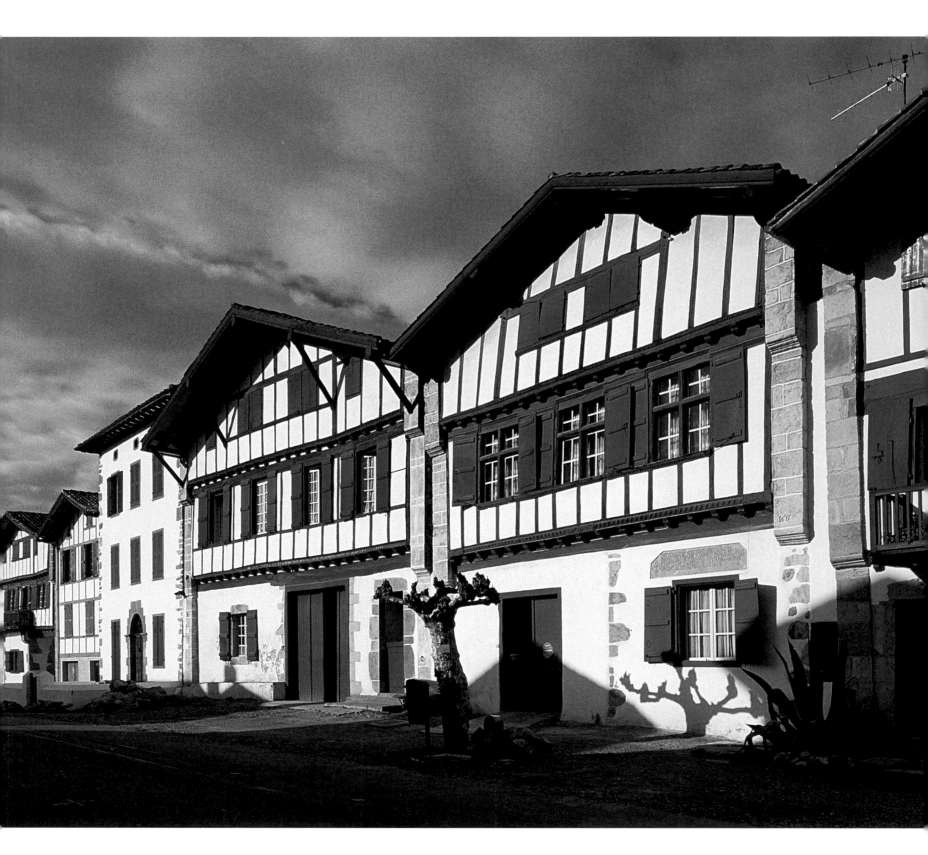

Situated between Bayonne and Pamplona, on the road to Santiago de Compostela, Aïnhoa was possibly founded around 1200 by monks of the Premonstratensian Order from the monastery of Urdax; it was needed to help accommodate the ever-increasing number of pilgrims. In 1238, the sire de Baztan, seigneur of Aïnhoa, sold the toll rights in the village to Thibaut I of Navarre; proof of the very large crowds that used the highway. In 1250 a dispute arose between Navarre and England over ownership of the village, which was situated on the boundary of English territory. On 27 September 1369 the fief of Aïnhoa was finally declared a joint possession of Navarre and England. After the surrender of Bayonne on 20 August 1451, however, the district of Labourd in which it lies was returned to Navarre.

The Thirty Years' War (1618–48) tried the community sorely: the fire or fires which destroyed parts of Aïnhoa probably occurred in 1637. After the Peace of the Pyrenees (1659), the local inhabitants and newcomers (described as *nouvellins* in a document dated 1662) set about reconstructing and restoring their village. Their work gave the place the general appearance it has retained to this day. On 7 March 1793 the Convention declared war on Spain. The ensuing battles spared the village, but the monastery of San Salvador d'Urdax was completely destroyed by French troops, who set fire to the building. During the Spanish campaign (1813–14) Aïnhoa again escaped the worst, but had to suffer pillaging from unruly mobs of soldiers in Napoleon's army.

The *bastide* remained an important border stopping-point for pilgrims and mule-drivers up to the middle of the last century. Now experiencing a more tranquil period, this beautiful site in the Labourd region has 209 inhabitants.

For further information:

'Histoire d'un village basque: Aïnhoa', by Martin Elso, in *Gure Herria*, 1966

'Inscription de la maison Gorritia à Aïnhoa', by E. Goyheneche, in *Gure Herria*, 1960

Set in the heart of the Labourd region, Aïnhoa is built along a single street. The village is dominated by the solid, square bell-tower (dating from 1649) of its church. The church itself was constructed between the 14th and the 17th centuries. The *bastide* has retained its original layout. The houses are spaced at regular intervals, each having adjoining gardens the same width as the buildings. Most date from the 17th and 18th centuries (the oldest from 1629). The village has therefore kept its homogeneous appearance and old-world charm. ▶

Pictured here is the west side of the broad village street: its magnificent old houses are built in the style characteristic of the Labourd region. The ground floor is occupied by the wide storage area, known as the *lorios*; the vertical wooden timbers on the façades are interrupted by two courses of corbels and are shaded by the projecting roofs. The most famous of these buildings is the Maison Gorritia, seen on the right. It bears a celebrated inscription on the lintel of its ground-floor window, dated 1662 ◀

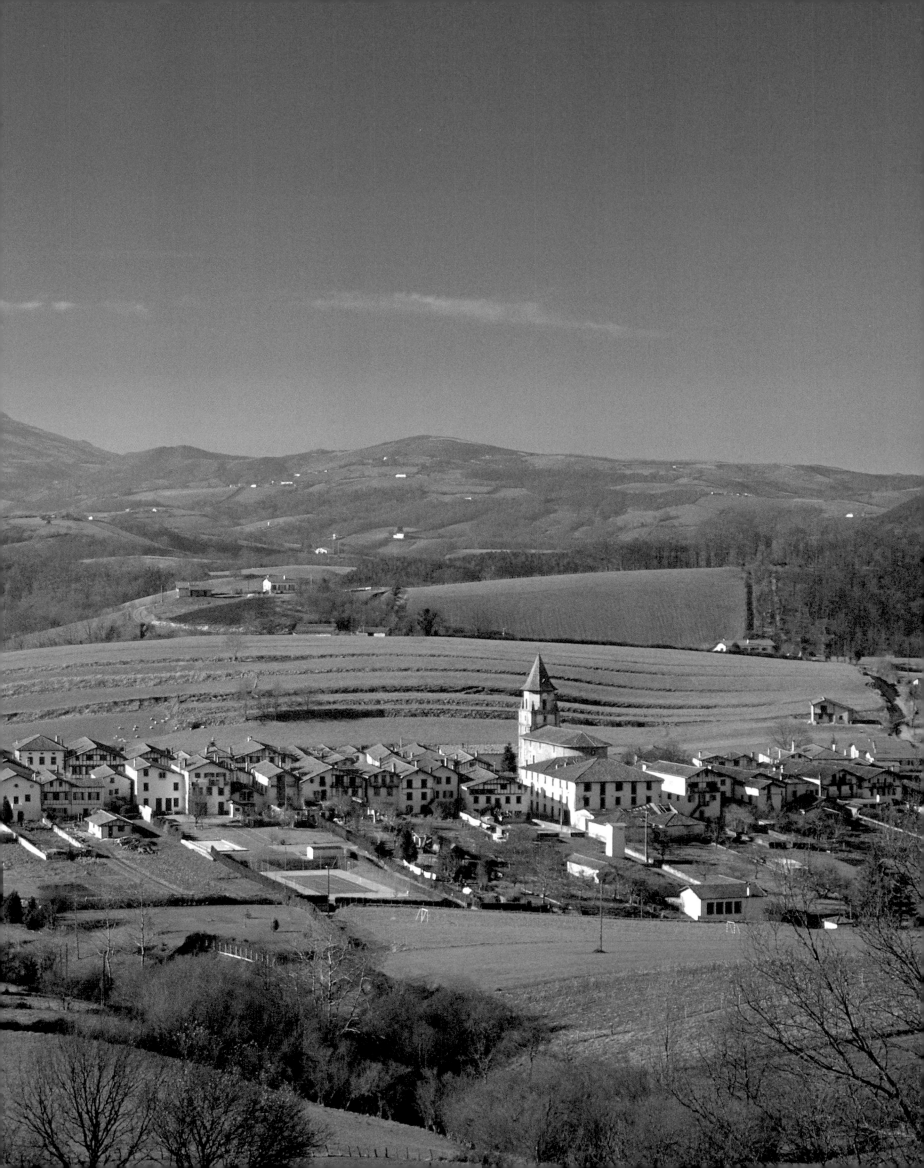

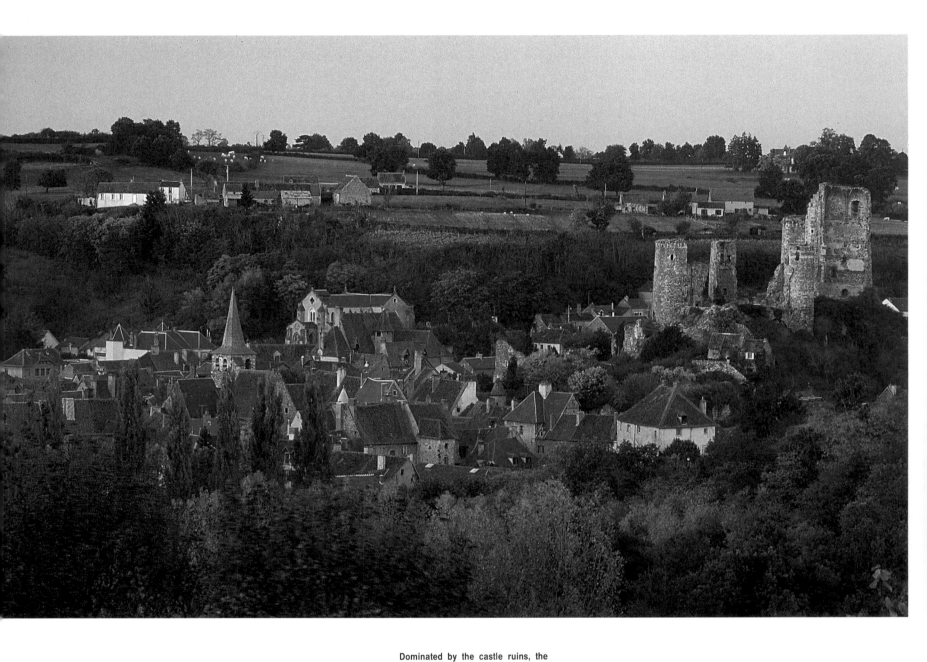

Dominated by the castle ruins, the little town of Hérisson and its environs form one of the most picturesque sites in the Bourbonnais. Situated in a curve of the River Aumance, it was formerly encircled by fortifications. The church in the background was constructed in the last years of the Second Empire. In front of it stands the 16th-century Maison Mousse, named after the family who built it.

érisson occupies a perfect military site and has been a strategic point of major importance through the ages. The Aumance, or rather the Œil, to give the river its original, ancient name, cut through the surrounding granite plateau, creating a gorge. Fortifications were built above the crossing points. This explains the presence of Cordes, a fortified settlement in the prehistoric, Gallic and medieval eras, now known as Chasteloy and situated two kilometres (one and a quarter miles) from Hérisson, towards Meaulne, in a wide curve of the river. The fortifications were subsequently moved and concentrated on the spur of land to the south, with its medieval castle and the little town of Hérisson which flourished in its shadow.

Hérisson, one of the first properties of the ducs de Bourbon, quickly became part of a lordship covering most of the western Bourbonnais. The town was already developed by the 12th century, gaining in importance during the following century when Archambaud VI founded a chapter there (1221), on which he bestowed a generous endowment. In 1381 the little town received its charter, and from 1400 major fortification work was carried out on the castle and city walls, by order of Louis II de Bourbon. This did not prevent it from being attacked by the English several times during the course of the Hundred Years' War. Equal damage was suffered during the Wars of Religion, but it was the turbulent period of the Fronde that caused the greatest devastation. In 1651 Mazarin's troops forcibly dislodged the Frondeurs, who were occupying the castle, then demolished it with the help of the local inhabitants. This created a veritable quarry, which the townsfolk plundered extensively to rebuild their houses.

Today the little town has a population of 658.

**The greater part of the castle as it stands today is attributable to Louis II de Bourbon, who gave orders for its construction in the 1400s, but a castle has stood on the rocky peak overlooking the river since the 11th century. In 1569 it was described as comprising 'eight fine towers linked by curtain walls, with a ninth serving as a keep'. Destroyed by Mazarin in 1651, it appears in a description of 1698 as 'an old castle, quite demolished'.** ▶

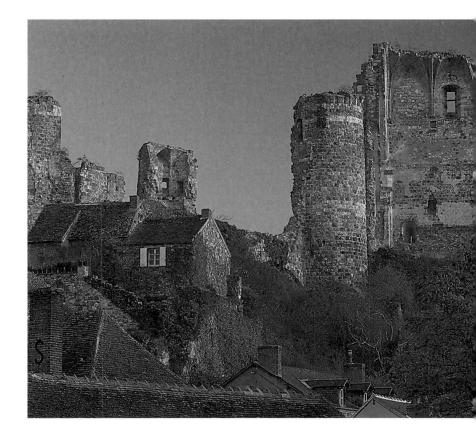

For further information:

*Histoire des communes de l'Allier (Grande Encyclopédie de l'Allier)*, André Leguai ed., Éditions Horvath, Le Coteau (Loire) 1986

*Hérisson, guide pittoresque de la vallée de l'Aumance*, by Louis Grégoire, Éditions Crépin-Leblond, Moulins 1922

The first recorded seigneur of Salers is Astorg de Salers (*Eustorgius miles de Salerni*), whose name appears in 1069. The barons de Salers were joint lords of the fief until 1666, when the barony was bought by the Scorailles. By 1250 Salers was already an important place. It remained devoid of fortifications for some time, however; the inhabitants sought refuge in the castle outbuildings during raids by the English or by pillaging gangs of soldiers. On 25 November 1428, at the request of the inhabitants, Jehan de Langeac, seneschal to the duc d'Auvergne, authorized the

Salers owes its charmingly rustic, old-world appearance to the dark materials used in the construction of its houses: lava-stone was used for the masonry whilst the roofs were tiled with flat stones, or *lauzes*. This picturesque medieval village has an essentially rural atmosphere, although the elegant houses which belonged to the local bourgeoisie create an impression of discreet, aristocratic luxury. Seen here is the turret of the Maison de Flogeac.

◄

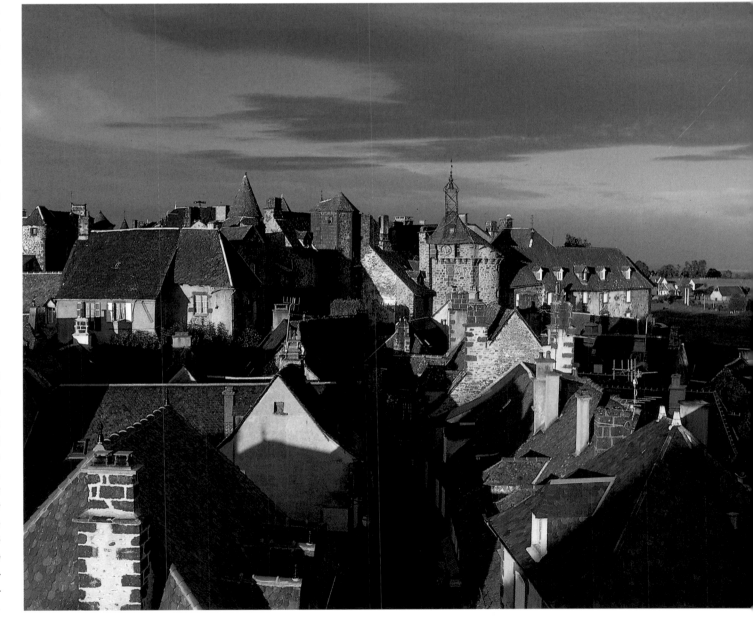

Salers is situated on the edge of a plateau overhanging the valley of the Maronne. Visible in the background, the old part of the village was built on the summit of a basalt outcrop and was surrounded by ramparts. The entrance seen here, on the east side, is known as the Porte du Beffroi (or Porte de l'Horloge), a solid tower surmounted by a fragile belfry. The very centre of the medieval village boasts a remarkable main square (the Place Tyssandier d'Escous) surrounded by noblemen's houses dating from the 15th and 16th centuries.

construction of 'a surrounding wall and fortification, forming a closed town'. The baron de Salers tried to oppose this project, but the parliament rejected his case. This victory of the inhabitants of Salers over their feudal overlord was only the first step towards municipal franchise. In April 1509, Louis XII completed the town's privileges by granting it rights of magistracy. Meanwhile, in 1504, its inhabitants had requested that the seat of the bailiwick should be transferred from Saint-Martin-Valmeroux to their fortified town. An edict issued by Henri II in March 1550 and confirmed by a decree of council in 1564, declared Salers to be the permanent seat of the tribunal.

The fortifications played an important part during the Wars of Religion and protected the town from Protestant attack on several occasions (the sieges of 1586, 1587 and 1589). The baron de Salers was condemned to death by the Grands Jours d'Auvergne. He managed to escape, but his castle was razed to the ground, according to a decree issued on 21 January 1666. The bailiwick was suppressed during the Revolution and Salers then lost its status as seat of the local tribunal, which had done so much to increase its prosperity for over two centuries. Today the little town has 407 inhabitants.

**The castle of Salers stood on a second hill, from where this photograph was taken. It faces the northern side of the village. Down below, a *faubourg* spans the distance between the two hills, separating the castle from the heart of the community.**

For further information:

*Salers – notice historique et descriptive à l'usage des touristes*, by Louis Jalenques, Aurillac 1947 (4th edition)

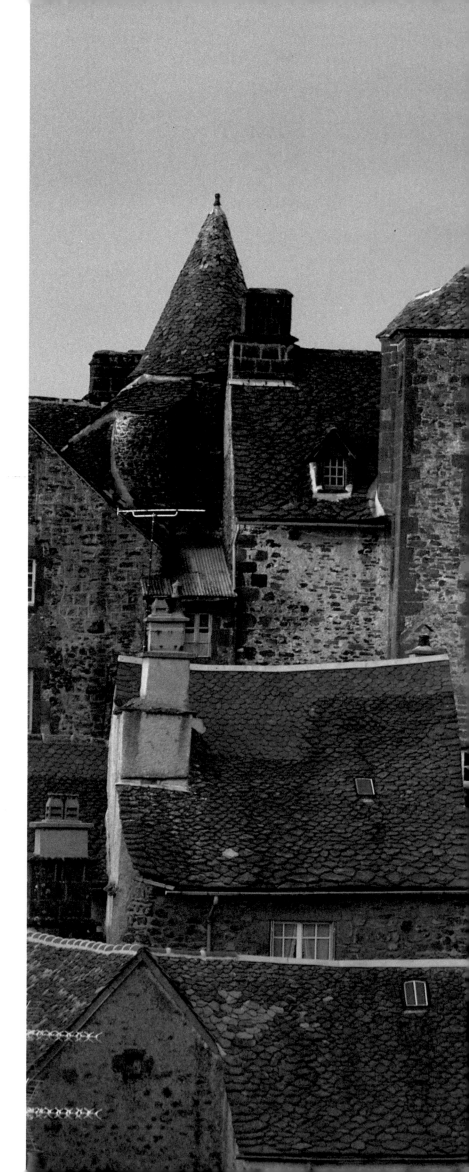

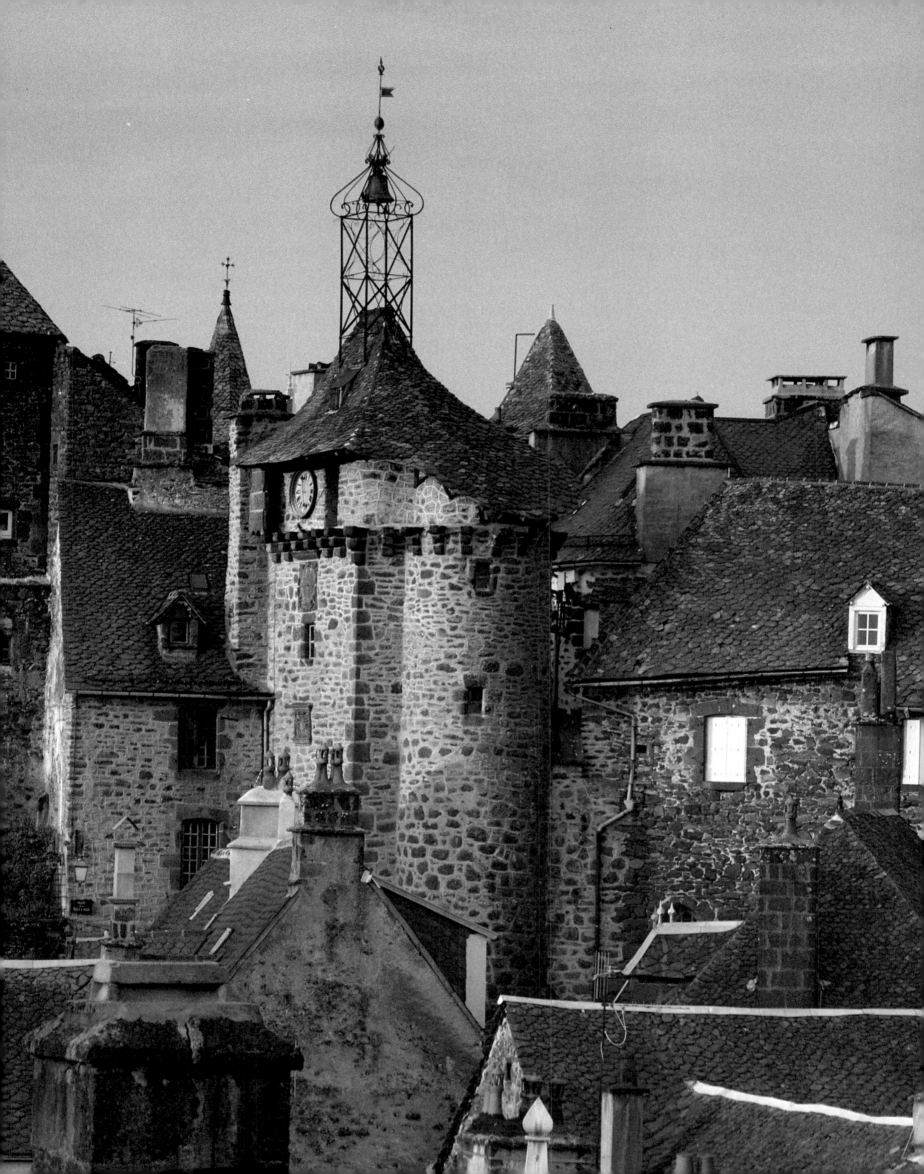

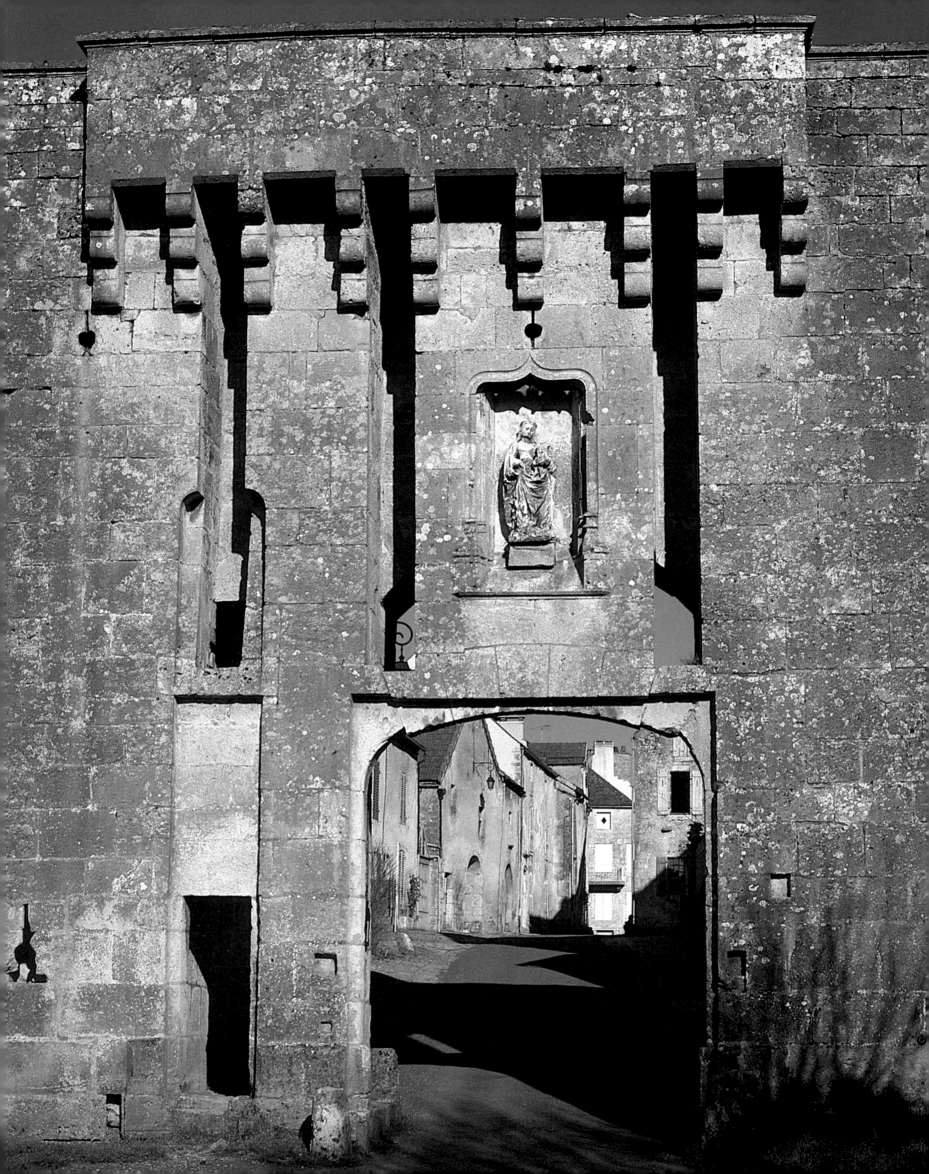

The charm of this old fortified *bourg* is due to the wealth of its architectural heritage. It is rare to find so many ancient buildings – however altered they may have been – in such a small town. In the picturesque Rue Lacordaire seen here, this nobleman's house dating from the 1500s has been skilfully restored. In the background, the 13th-century part of the Maison Lacordaire (otherwise 19th century) was the lodging of the grand bailli of Auxois. During the League this was the seat of the royalist Burgundian parliament (May 1582–April 1592). ▶

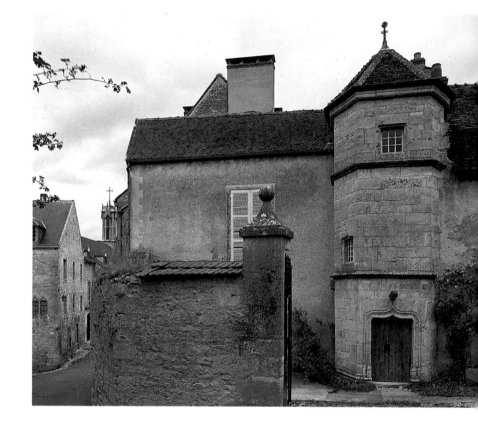

The territory on which the village stands was occupied continuously from prehistoric times through to the Gallo-Roman period. The most famous Roman presence here was that of Julius Caesar; in the course of besieging Alesia in 52 BC, he set up three camps on the plateau of Flavigny. In 719 Widerad, a powerful lord of the Burgundians, founded an abbey on his territory. The act of foundation calls the site *Flaviniacum*, the first written mention of Flavigny, describing it as a *castrum*, or fortification. The abbey became immensely important and in 866 it received the relics of Sainte Reine, or Saint Regina, which had previously been kept at Alise. The *bourg* began to develop in the late 10th century; in 1157 the duke of Burgundy authorized Abbot Renaud II to build a wall, which would protect not only the abbey, but the whole town.

In the 17th century the reformed Benedictines of Saint-Maur embarked upon the reconstruction of the abbey, which work continued until the 18th century. The Revolution brought dramatic changes to the community, with the dissolution of the monasteries. In 1848, however, Lacordaire founded a Dominican convent in Flavigny; this expanded rapidly, necessitating extensions to the buildings from 1874. In the course of the 19th century several religious houses were founded, but the Combes law of 1903 and various laws passed in 1905 caused most of them to disappear subsequently.

The village used to be famous for its aniseed sweets, known as *anis de Flavigny*. Local tradition attributes the way in which they are made to the Ursuline nuns, who established a convent here in 1632. The sisters seem to have had the monopoly of the industry until the Revolution. In the 19th century, however, there were eight factories in Flavigny producing the sweets.

According to the parish register of 1784, the whole site contained 1,311 inhabitants, excluding some Jews and Protestants. Today the population of the little town is 394.

For further information:

*Flavigny-sur-Ozerain, cité médiévale*, a small guidebook produced by the Société des Amis de la Cité de Flavigny, Montbard (n.d.)

◀

Formerly preceded by a drawbridge, the Porte du Bourg dates from the 15th century. It in fact formed part of the abbey defences which, on the southern side pictured here, were the same as those of the town over a considerable length.

Flavigny is perched on the edge of a plateau overlooking three valleys. It occupies a classic 'closed spur', a promontory of land that is easy to defend as there is only one vulnerable side (in this case on the south). Here in the southwest corner of the town, the abbey retains traces dating from the Carolingian era, but it has lost its past grandeur. In the 12th and 13th centuries eight hundred monks sang the *Laus Perennis* here, continually, night and day; the scriptorium produced works of great renown, some of which are preserved in the Vatican Library. The abbey now houses the last factory producing the famous Flavigny aniseed sweets. ▶

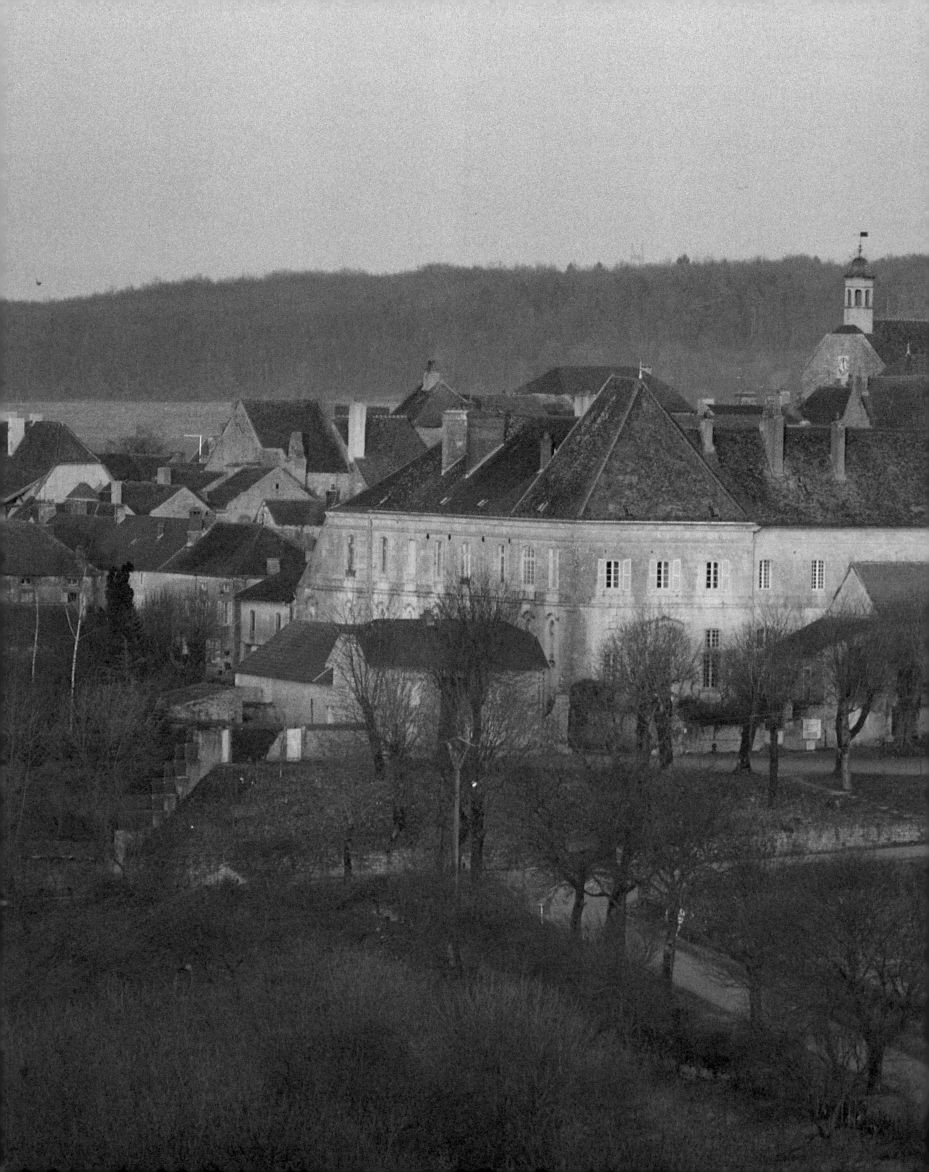

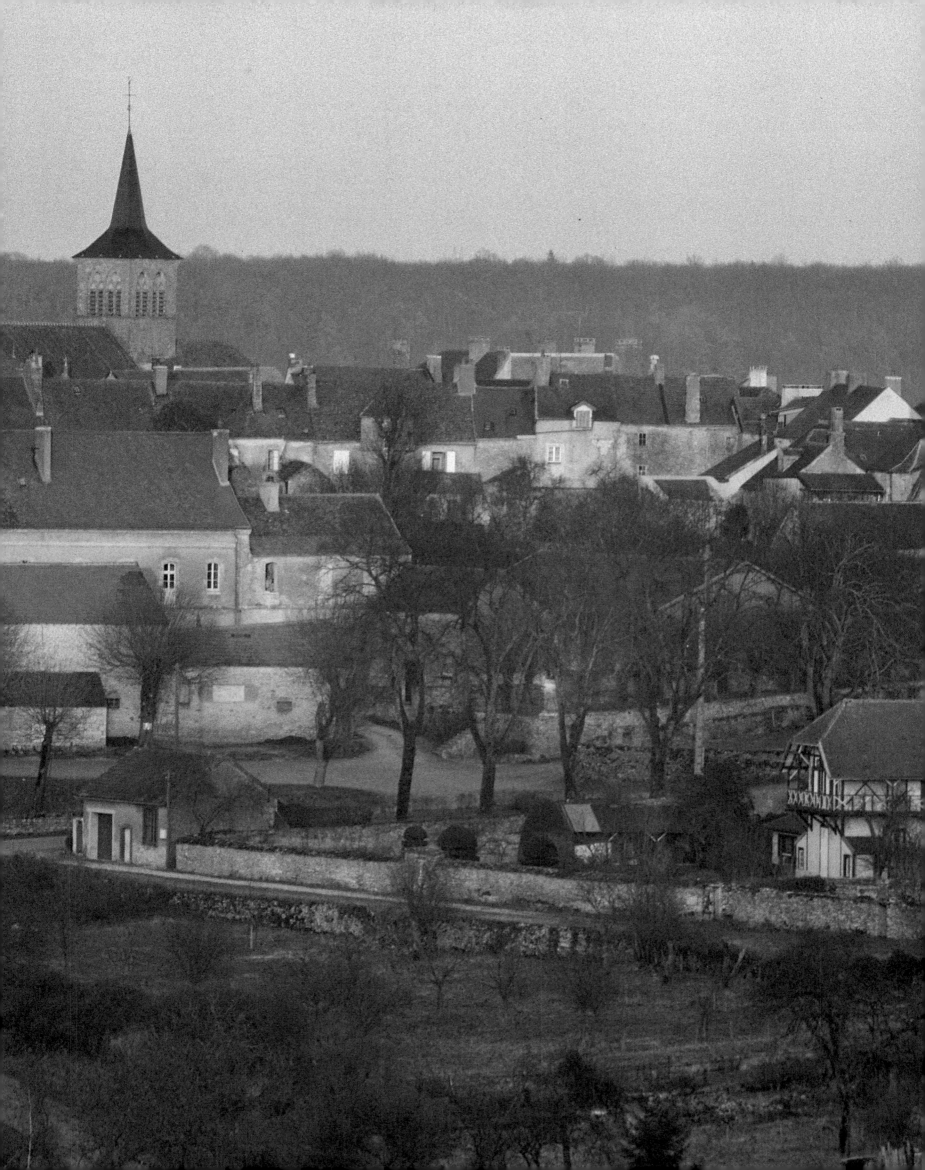

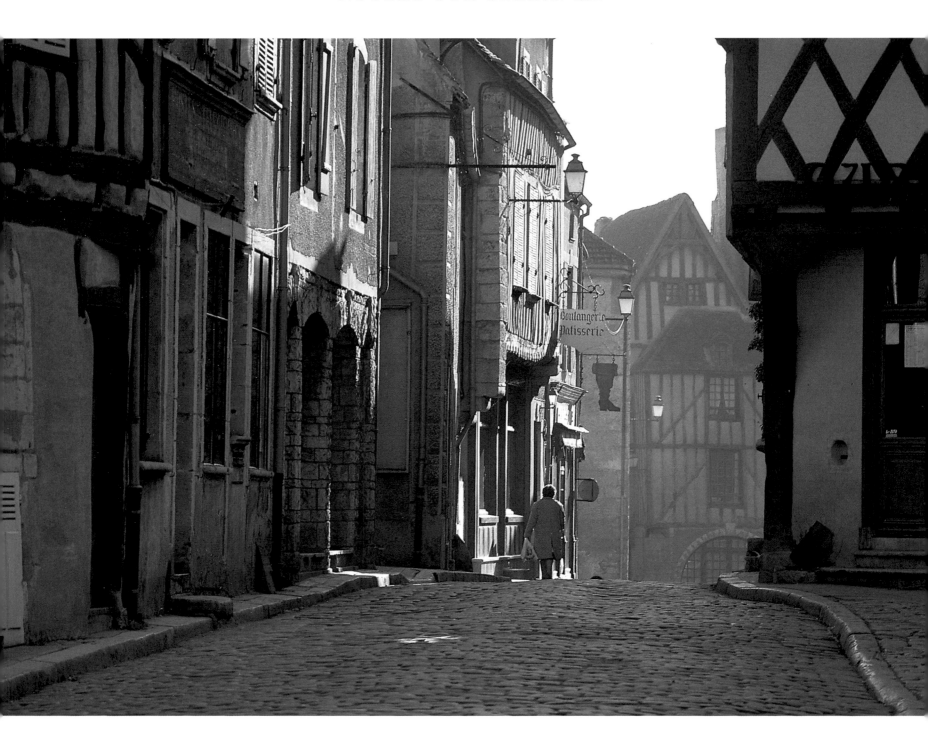

The main street through the village is attractively cobbled and blocked off at either end by a fortified gate. This street was occupied by merchants and the middle classes, whereas the wine-growers and peasant farmers lived in the poorer, lower-lying areas, liable to flooding. In the background, the town square still contains some 15th- and 16th-century houses.

The Porte d'Avallon, also known as the Painted Gate, is the best preserved of the three gates that formerly served to defend the town. Before it stood a drawbridge, constructed in 1491 at the king's expense. It spanned a moat, which has now been filled in. The clock dates from a restoration of 1826.

The banks of the River Serein have been occupied since Roman times, yet the first seigneurs of Noyers are not mentioned until the very early 12th century. Hugues de Noyers, Bishop of Auxerre (1180–1206) is regarded as the principal founder of the village, responsible for its fortifications, the construction of the castle and the appointment of his nephew Milo as seigneur. According to historians, this castle became one of the most important fortresses in Burgundy and 'one of the loveliest castles in the kingdom'. Clérembaud de Noyers carried out work on the building before going on crusade in 1190. More work was undertaken by Hugues de Noyers in about 1195 and by the maréchal de Noyers in 1303, attesting to the fact that this fortified village played a significant role in the defence of the region.

The lordship passed to the duchy of Burgundy in 1423, reverting to the Crown when Burgundy was annexed by Louis XI in 1477. The seigneury of Noyers, now part of the kingdom of France, became the property of the Orléans-Rothelin family in 1508. In 1565 it passed to Louis de Bourbon, Prince de Condé, who came to Noyers to marry Françoise d'Orléans. Condé had become one of the leading Protestants of the day, and for thirty years he was to see his castle the disputed prize in various battles. It was finally taken and demolished by order of Henri IV in 1599. From that time the ruins gradually disappeared, plundered by the villagers as a source for stone.

In 1590 Noyers contained 529 households, with a population of between 2,500 and 3,000. In the mid-19th century there were still over 1,700 inhabitants, both the vineyards and the textile industry providing sources of employment. Today the village numbers only 668 inhabitants.

For further information:

*Noyers*, a guidebook produced by the Association des Amis du Vieux Noyers, Tonnerre 1975

*Histoire du château de Noyers-sur-Serein*, by G. Delagère, published by the author, Tonnerre 1987

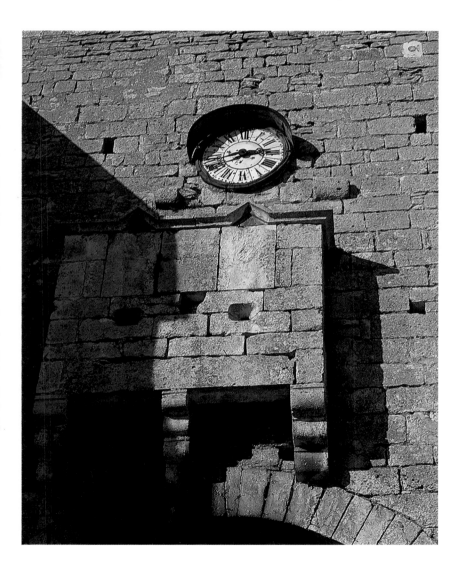

The village is situated in a bend of the River Serein, at the foot of a rocky spur on which the castle formerly stood. It is dominated by the towering mass of the church of Notre-Dame, a typical example of Flamboyant Gothic architecture. The village was encircled by a wall with twenty-six towers, twenty of which still stand today. They are in a damaged state, however, and some have been incorporated into houses. The curtain walls have almost entirely disappeared, as the duc de Luynes had them demolished in 1788, to make way for a promenade around the village. The stone-roofed tower known as La Cave aux Loups ('The Wolves' Den'), can be seen in the foreground. It is the best preserved of all the towers. ▶

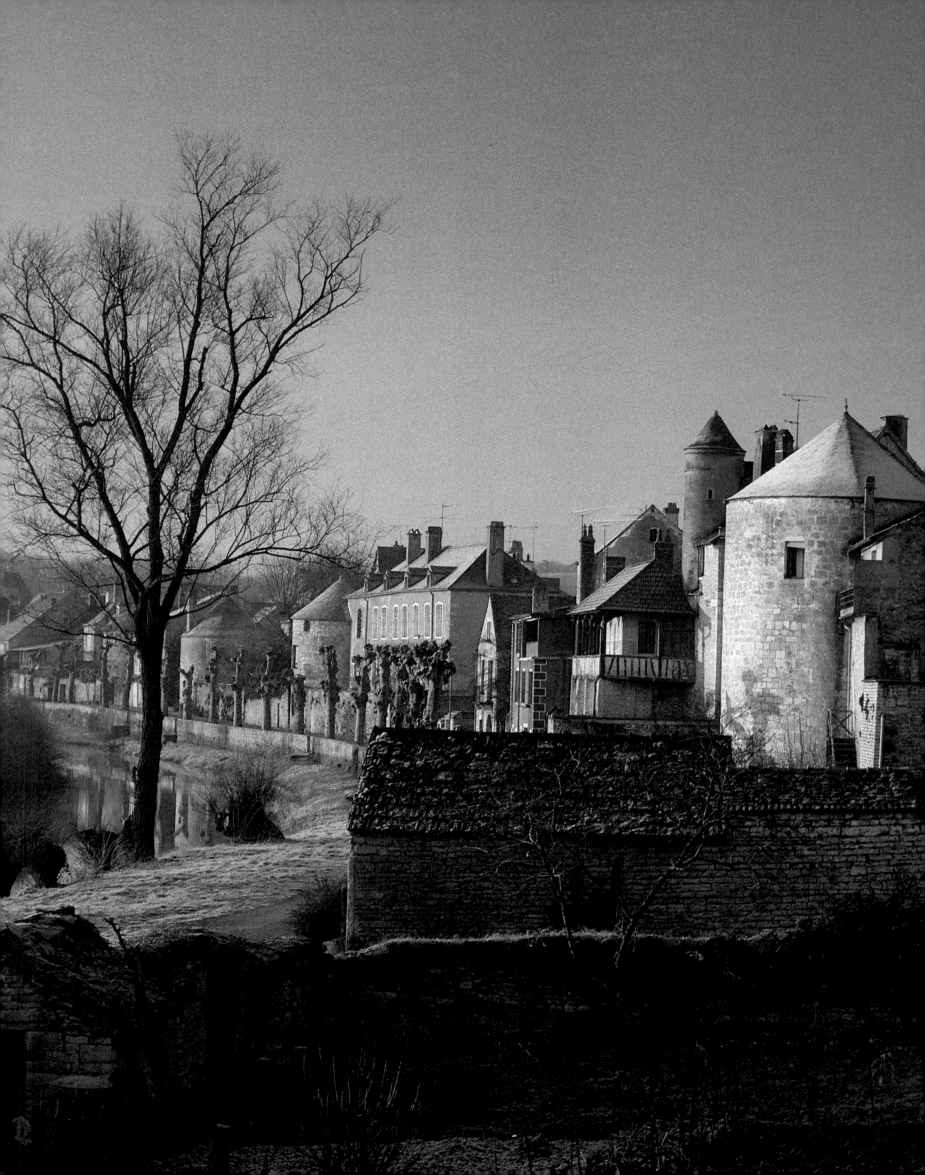

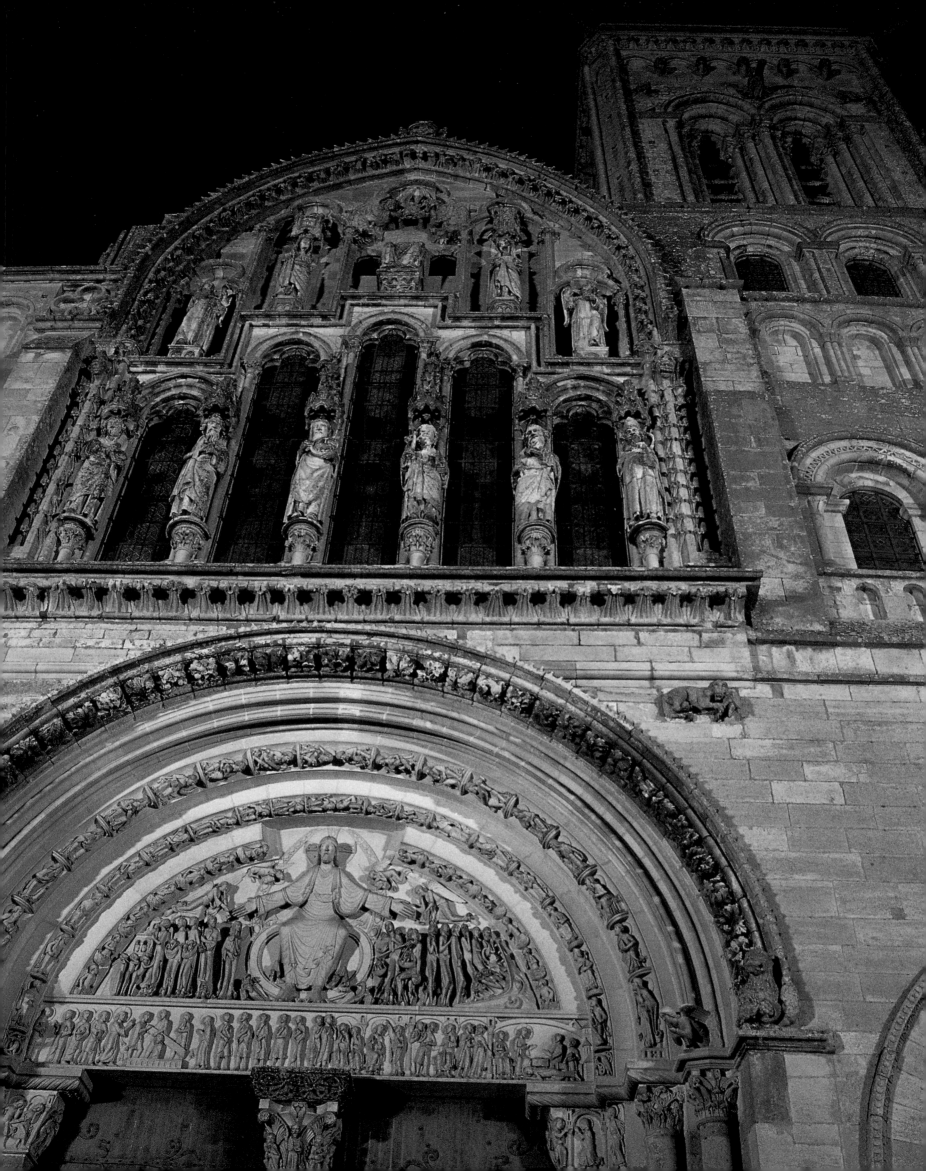

History and legend intertwine concerning the origins of the abbey of Vézelay, around which the *bourg* or town grew up. The history was compiled in the 12th century by Hugues de Poitiers, a monk there; the legend is the popular tale of the deeds of Girart de Roussillon. Together with his wife Berthe, de Roussillon founded two monasteries – one for nuns – in 858 or 859, in the valley of the Cure, where the village of Saint-Père stands today. Faced with the threat of Viking raids, this religious community moved to the hilltop in 887, and Vézelay came into existence.

The period of terror which reigned around the millennium finally passed. Two popes confirmed the authenticity of the relics of Mary Magdalen, formerly at Saint-Maximin-de-Provence, but removed to Vézelay; and Vézelay became a famous place of pilgrimage for almost two hundred years. Between 1096 and 1185 there were a series of projects to reconstruct the abbey, each more ambitious than the last. They were made possible by the huge influx of pilgrims, the prosperity of the abbey itself, the attractions offered by the great local fairs, the development of wine-growing, local commerce, and so on. In spite of conflicts between the abbots and the town's people, which lasted until the 13th century, Vézelay received many illustrious figures, including Philip Augustus, Richard the Lionheart and Saint Louis.

The late 13th century marked the decline of the famous abbey, as doubt was cast increasingly on the authenticity of the relics. Royal protection could do nothing to save the situation, and the historical and spiritual role of Vézelay gradually dwindled in importance during the troubled 14th and 15th centuries. When the Revolution occurred the abbot's palace was in the process of reconstruction; it was never to be

The distinctive façade of the abbey church was altered in the 13th century by the addition to the upper level of statues of saints between high, narrow openings. Above these, on the pediment, Christ is shown surrounded by two angels, the Virgin and Mary Magdalen. Below, the tympanum of the central portal dates from the restoration carried out by Viollet-le-Duc, inspired by Last Judgment scenes of the 12th century.

The town stretches along the ridge of an outcrop of limestone, developing along the length of a single street, the Rue Saint-Étienne seen here. As it ascends the slope towards the abbey church, it is continued by the Rue Saint-Pierre, from which this photograph was taken. The house with large windows on the right was the birthplace of Théodore de Bèze (Calvin's disciple and follower) in 1519. ►

The hill of Vézelay is a renowned centre of Christian pilgrimage, where the Spirit has lingered over the centuries. UNESCO has quite rightly declared that the basilica and hill lie at the very heart of the world heritage. Vézelay is above all famous for its exceptional Romanesque architecture, but it is also a village, born of medieval faith. That faith has seeped through the very stones of the buildings, whose charm has survived to this day.

►

completed. In 1790 the monastic buildings were destroyed: it was only the parochial status of the church of La Madeleine which allowed it to escape the same fate in 1795. The building was in a very sorry state when Prosper Mérimée, the first Inspecteur des Monuments Historiques, came to Vézelay in 1834. The young Viollet-le-Duc had no easy task to restore the church, but the work he carried out between 1840 and 1859 was exemplary. In 1876 the relics of Mary Magdalen were brought to Vézelay once again and in 1920 the former abbey church was elevated to the status of a basilica.

There are only 383 inhabitants in Vézelay today, compared with a population during the Middle Ages of 15,000 strong.

For further information:
*Guide Bleu Bourgogne*, Hachette, Paris 1987
*Sauvons les remparts de Vézelay*, compiled and produced by Les Amis de Vézelay, Vézelay 1984

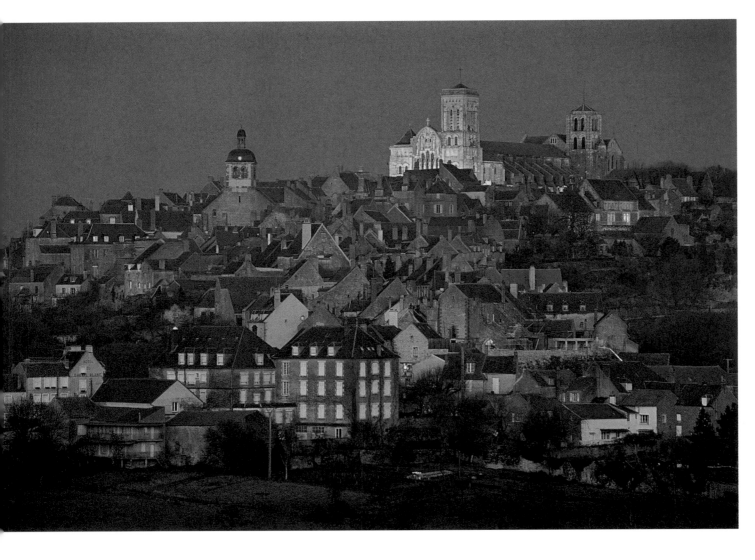

The *bourg* has remained enclosed in its medieval ramparts. In the foreground, the *faubourgs* outside the walls were very small and only developed around the fair, a driving force of the local economy until 1914. The medieval village was not able to expand outwards, so maximum use was made of the area within the walls by building upwards, or down. Underground chambers multiplied the amount of precious space, so that the large crowds of pilgrims and visitors to the fair could be accommodated under the Romanesque residences of the bourgeoisie. About seventy of these subterranean chambers are listed today.

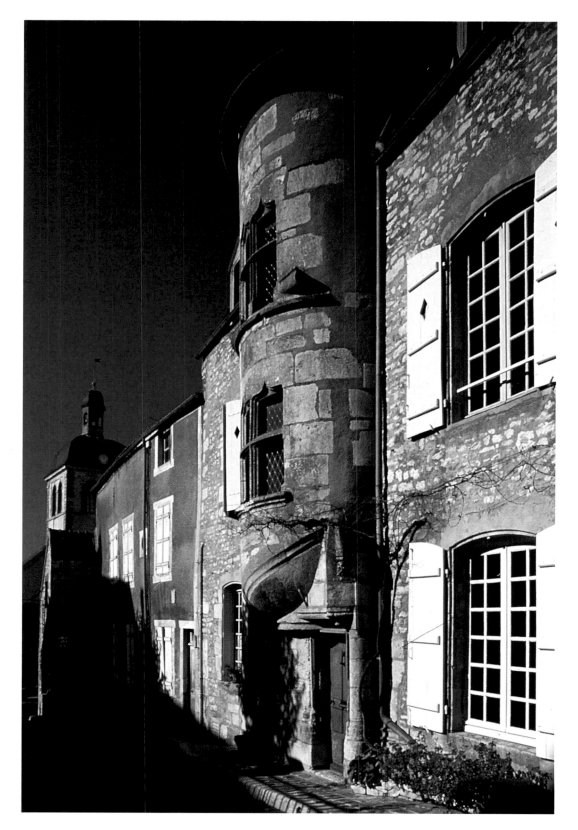

This corbelled stair-turret known as the Tourelle Gaillon, in the Rue Saint-Pierre, is one of the few remaining traces of the prosperity of the middle class in the 16th century. The church of Saint-Pierre was destroyed in 1804. All that remains is the bell-tower, dating from 1689, which can be seen in the background.

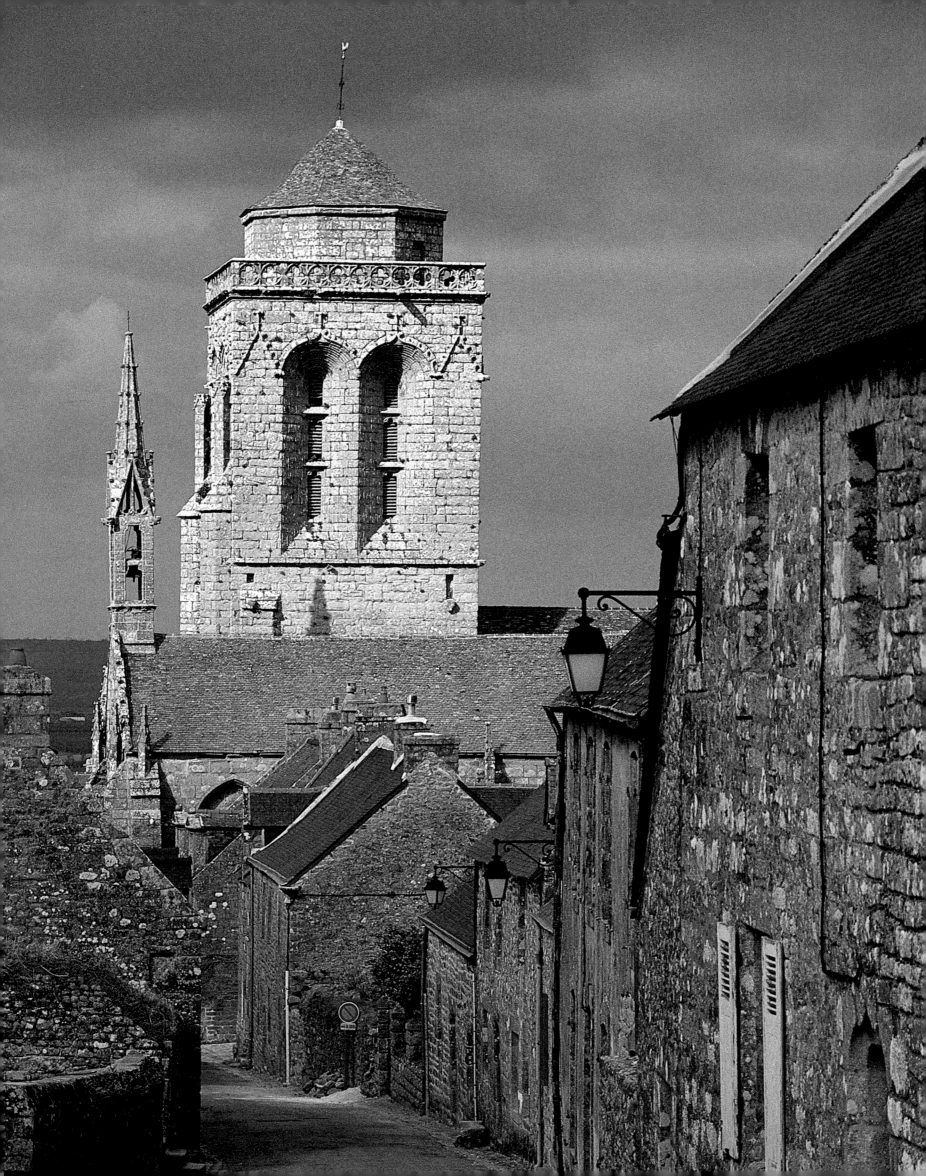

The word *loc* (from the Latin *locus*) means 'sacred place' in the Breton language. Ronan was an Irish saint; the principal sources of information about him are legends and a biography in Latin compiled at Quimper in about 1235. Ronan probably came to Brittany in the 10th century, seeking the solitude necessary for a contemplative life. He reached the coast at Léon and initially settled there, but his fame spread and crowds flocked to see him. He fled southwards to the forest of Névet. He was assisted by a peasant, but the latter's wife Kéban persecuted him with slanderous accusations. Weary of this spitefulness, Ronan left for Hillion (near Saint-Brieuc), where he died shortly afterwards. According to the story, a dispute subsequently arose between the comtes de Vannes, Rennes and Cornouaille, as to which of them should provide a burial place for Ronan. To settle the matter, it was decided that the saint's mortal remains should be carried by oxen and buried where the beasts should happen to stop. The procession headed for the forest of Névet, but stopped at Trobalo and did not set off again until the comte de Cornouaille had made a gift of the very piece of land on which stood the hermitage from where the saint had fled. The tomb became the scene for an increasing number of miraculous happenings. A cult developed and the famous Troménie was born. The word derives from the Breton *tro minihy* ('walk around a monastery') and refers to the ritual processions here. The Grande Troménie is over 12 kilometres long (about 8 miles) and takes place every six years. There were 15,000 participants in 1737 and 40,000 at the beginning of the century. The Petite Troménie is of 5 kilometres (about 3 miles) and takes place every year.

The Troménie kept religious faith alive and provided a living for the clergy and craftsmen working on the church. The vast majority of villagers, however, gained no advantage from the processions. We must therefore look elsewhere to explain the magnificent buildings which give Locronan much of its charm. A sail-making industry existed in the region from the 15th century. It sought to provide the sails, known as *olonnes* or *poldavis*, needed for the ships. Right up to 1636, the canvas woven at Locronan was the most favoured in the English navy and even supplied the Spanish. This prosperous trade enabled the village to survive the austere times during the conflicts under Louis XIV – the War of the Austrian Succession – and later the Seven Years' War. Locronan had weavers who could live exclusively from their craft, but almost half of the material was provided by local farms which produced their own hemp. Important seasonal agricultural work like haymaking and ploughing must have meant a considerable reduction in the amount of canvas available for sale.

The village fortunes were already dwindling during the 18th century and fell into decline in the pre-Revolutionary period. Locronan suffered from competition in Rennes and newly established royal manufacturing industries. The situation became so serious that at one point the number of merchants in the village was reduced to a single woman, the 'sole registered trader'. At the end of the Second Empire the municipal council made a reference to the 'unfortunate inhabitants of this sad village': there were 25 registered weavers in a population of 700. The poverty of the inhabitants

**Until about 1875 the Place de l'Église was blocked off on its west side, although this affords the principal access today. Only two main streets formerly led into the square. These were the Rue Lann to the southwest and on the south side, pictured here, the Rue Saint-Maurice, which was named after a chapel now no longer in existence.**

**This street, with its modest old houses, owes much to the film director Roman Polanski. He financed the operation to do away with the last remaining traces of modern architecture for the making of *Tess of the d'Urbervilles* in 1979.**

The famous Place de l'Église is unquestionably one of the loveliest squares in France. The granite houses surrounding it form a magnificent setting for the church. Filmmakers have been quick to appreciate its merits; its sober, almost austere appearance has a modest yet dignified air. Here, the north side is grouped around the communal well, which was formerly the only source of water in the village. The large house on the right to the north belonged to the representative of the East India Company (17th century). The tall house with a dormer window seen on the left (west) dates from 1669. It was formerly the headquarters of the canvas manufacturing industry, where royal officials appended their mark. ►►

meant, on the other hand, that the village's architectural heritage was preserved. When it is not possible to build anew, the old must be maintained – a task made all the easier when the old is strong and solid. It was left to the 20th century to turn necessity in to a source of revenue. Two men were to save Locronan, by encouraging the preservation of its historic architecture and by working to bring it to public attention. Guillaume Hémon was a working man. He had a farm, played the drum in the Troménie processions and was a municipal councillor from 1896 to 1953. Charles Daniélou, a radical politician, was mayor of Locronan from 1912.

He and his wife were responsible for compiling and keeping files on the classification, restoration and funding of ancient buildings. At a time when so many towns were destroying their old houses, Locronan was salvaging dormer windows from Quimper, repairing its streets and prohibiting demolition. The population of Locronan today is 429.

For further information:
*Guide Bleu Bretagne*, Hachette, Paris 1987
*Locronan*, by Maurice Dilasser, Éditions Ouest-France, Rennes 1981

Visitors should not be deceived by Locronan's beautiful houses. The apparently homogeneous façades often conceal careful reconstruction work. A few façades and several dormer windows, come from the prison at Quimper; others fashioned in imitation of the local style are more recent than one might think. The house at the bottom of the alley pictured here was constructed in 1930, incorporating various old elements. ►

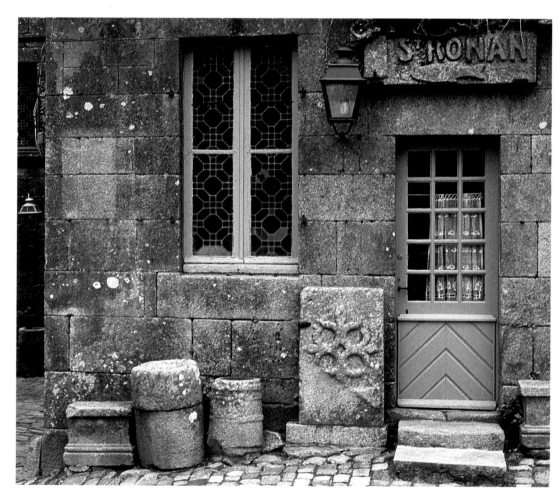

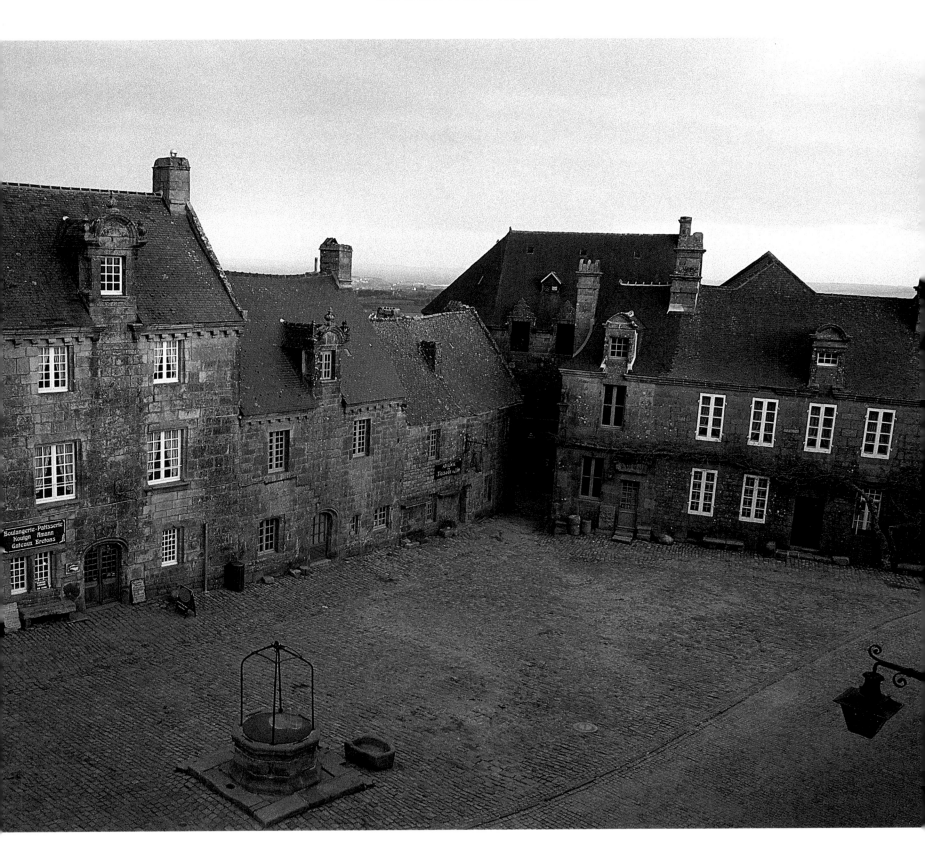

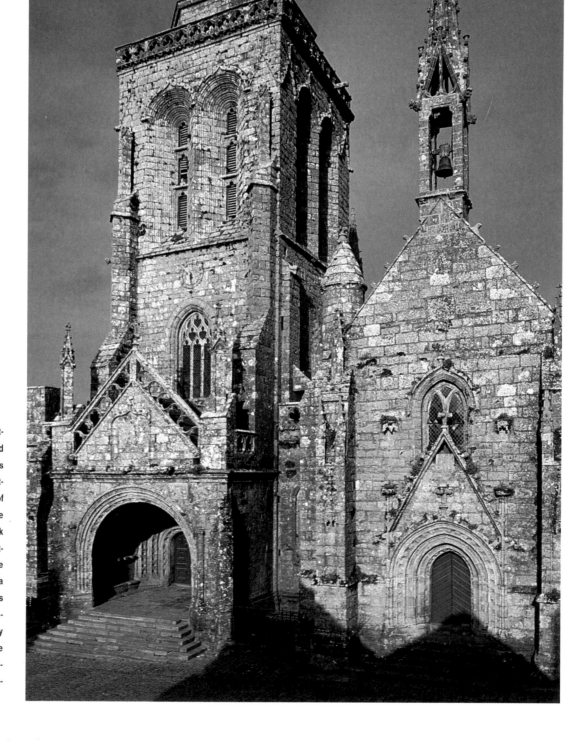

Situated between Armor and Argoët, Locronan occupies the northwest slope of a hill dominating the vast undulating plain of Porzay, which sweeps westwards (left, out of the picture) to the Bay of Douarnenez. Seen here from the south, this remarkable village seems to belong to another age. There is a modern quarter, but it is tucked away out of sight, far from the historic heart of the community.  ▶

The cathedral-like church of Saint-Ronan was built between 1420 and 1444. It has lost its spire, which was struck by lightning in 1808. Saint-Ronan is one of the finest examples of Flamboyant Gothic architecture to be found in Brittany, as the original work commissioned by the dukes of Brittany has been left untouched. The main window alcove was added at a later date (*circa* 1480). The architects then turned their attention to the construction of the Chapelle du Pénity (right) adjoining the church, on the site where the original chapel probably stood. The whole work was completed by the early 16th century.

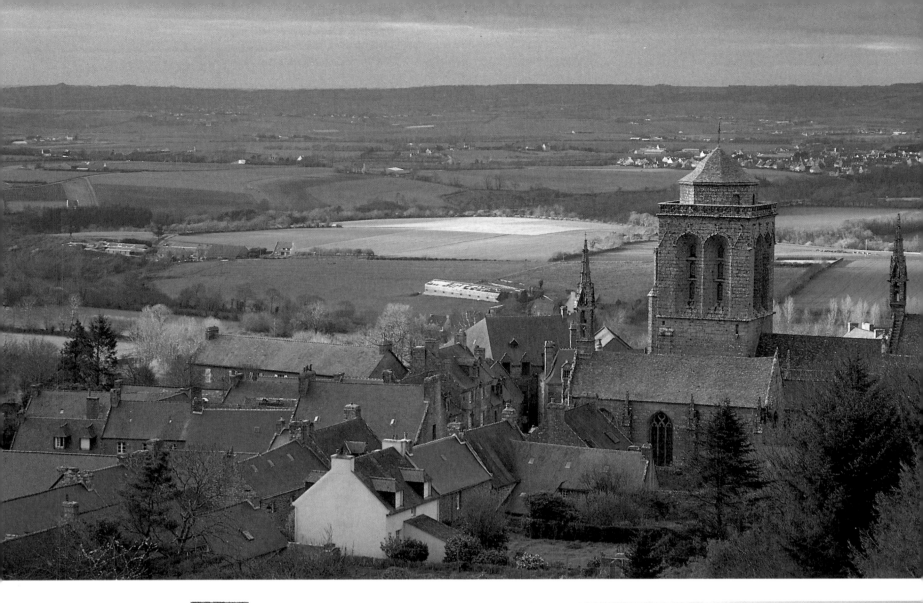

Seen here from the church roof, the houses in the Place de l'Église (those on the north side of the square) attest to the prosperity of Locronan in the great era of sailing ships. It is not surprising, therefore, that the majority date from the 1700s; some were built during the preceding century. They were the residences of agents from the East India Company, royal notaries and rich merchants. Such elegant houses should not, however, detract from the humbler dwellings in the rest of the village. These buildings, which are equally historic, are notably to be found in the Rues Moal, Lann, Saint-Maurice and des Charettes.

The magnificence of the little town's architectural heritage is due to the former power and wealth of the seigneurs of Rochefort. According to a document signed in 1548 by Suzanne de Bourbon, widow of Claude de Rieux-Rochefort, the lordship was then extremely prosperous and influential. It is therefore no coincidence that the loveliest houses date from this period. This house in the Grande-Rue is a typical example; its elaborate window was probably inspired by the Italian Renaissance.

The Romans understood the strategic importance of the site on which Rochefort stands. They built villas and temples here, fortifying their settlement by establishing a camp on its western flank. This was the only side that would be easily accessible to an enemy, as it was linked to the adjacent plateau. The *roche-forte* was born. During the Middle Ages the *castrum* was replaced by the motte of a feudal castle. This was situated to the north of a little village near a ford at an opening into the Gueuzon gap. There was already a keep on the mound by the 12th century and the local seigneurs favoured the construction of an adjacent *bourg* and a church dedicated to Our Lady. The church was to be a spiritual stronghold in a Brittany dotted with fortresses. The Rochefort family subsequently allied themselves to the Rieux and became an important force in the duchy. The community that grew up in the shadow of the castle was surrounded by a wall in the 15th century. The new *bourg* on the hill was the home of tradesmen, clergy and seigneurial administrators. The old village at the foot of the hill was inhabited by tanners, clog-makers, weavers and rope-makers. Some seigneurs of Rochefort were rather too notorious for the good of the community, notably Jean IV de Rieux, Marshal of Brittany and guardian to the Duchess Anne of Brittany (late 15th century). The Coligny family (who ruled from 1567) likewise created problems. Their behaviour led to the fortress being dismantled on two occasions, in 1488 and 1594 respectively. The castle was bought back in 1658 by François Exupère de Larlan, President of the Breton Parliament. The building was reconstructed in the style of the 17th century. After Rochefort had been seized by the Chouans, it was once more demolished, in April 1793. The *bourg* continued to expand, thanks to its textile industry (which produced linen and hemp), its wood and slates. A thriving commercial life necessitated the construction of new covered markets, to the east of the former halls.

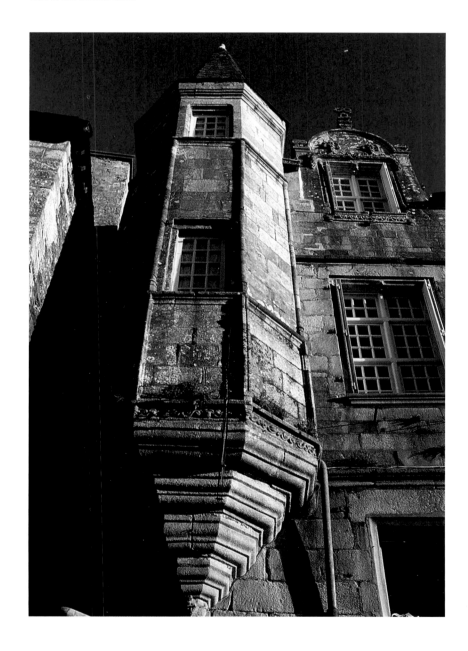

**Superb 16th-century houses are to be found in the Grande-Rue between the Place des Halles (reconstructed in 1627) and the Place des Puits. These buildings were formerly the *hôtels* of seigneurial administrators (the seneschal, the prosecutor, clerks, magistrates, lawyers, notaries and so forth). The house pictured here is the most famous of them. Granite, carefully cut and decorated with mouldings, is used for the façade, as an indication of opulence, but the rest of the building is made of schist. ▶**

The beginning of the twentieth century heralded the arrival of the first tourists. They came to the Auberge Lecadre, which attracted landscape artists and miniaturists particularly. One of their number, the American painter Alfred Klots, bought the castle ruins in 1908 and settled in the outbuildings. From 1911 onwards he organized an annual contest to find the most beautiful flower-decorated house, and presented the village with geranium plants, which he kept in his greenhouses during the winter. The first such contest in France was therefore held in Rochefort. Klots began work on reconstructing the castle in 1927. The *département* bought it back in 1978, opening a regional museum there. Today Rochefort has become a popular tourist centre – the population is 613.

For further information:

*Guide Bleu Bretagne*, Hachette, Paris 1987

*Rochefort-en-Terre*, by Gérard Rineau, Éditions Ouest-France, Rennes 1988

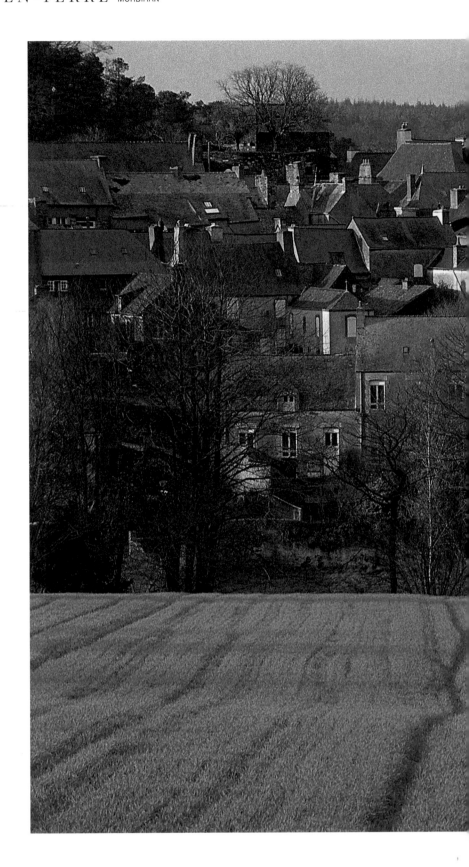

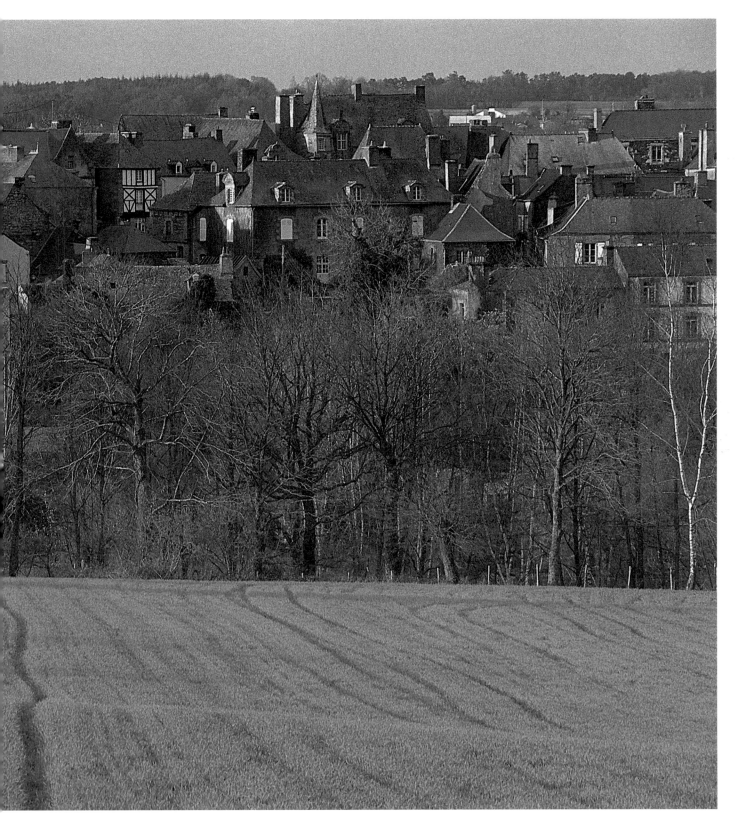

Rochefort-en-Terre is situated in the heart of the Argoët region. It was formerly dominated by its castle (the castle chapel can be seen here on the high ground, behind the tree). The village houses are stretched out on a rocky spur overhanging the valley of the Candré, pictured here from the south. The upper village was inhabited by prosperous folk, in contrast to the 'old village', which was the home of craftsmen. This was the original site of Rochefort, which had been established on the north slope of the spur, overlooking the valley of the Gueuzon.

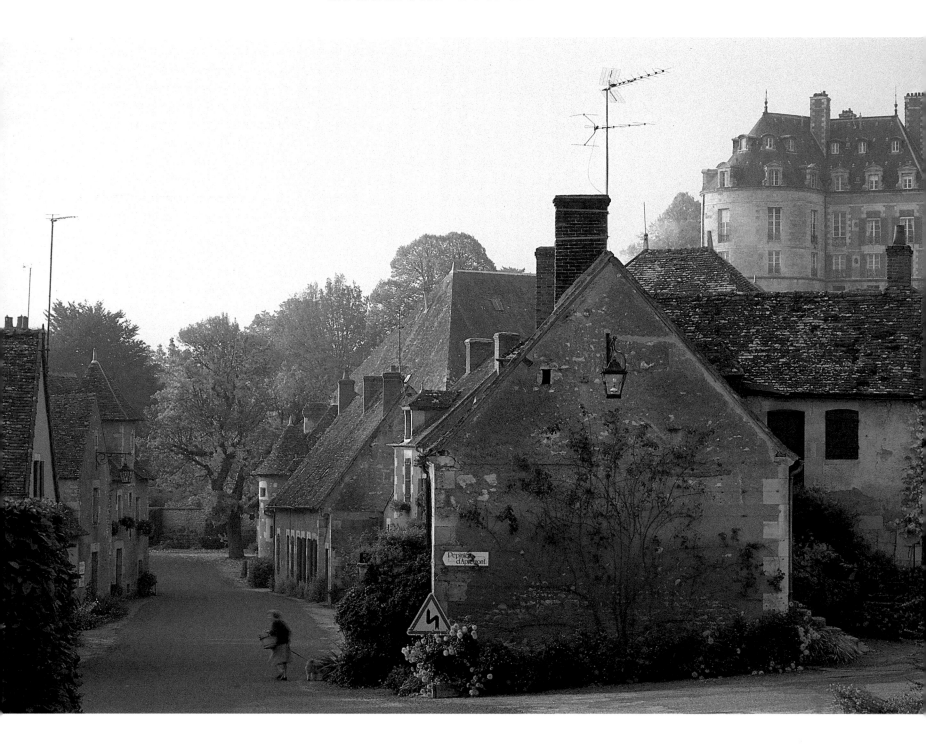

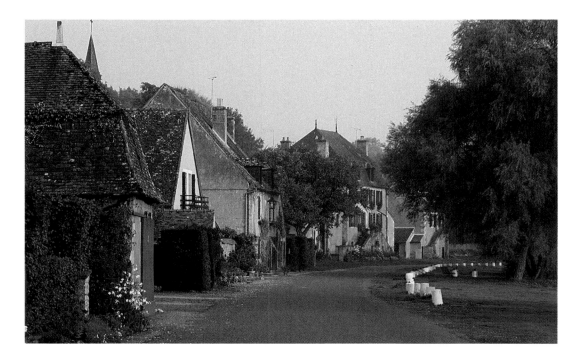

The Allier flows in a majestic curve before Apremont, which gives the location much of its charm and beauty. The loading point for the quarried freestone is no longer in existence. The river, fordable at this spot in summer, is today visited only by salmon fishermen.  ▶

The castle at Apremont is situated on top of a hill on the left bank of the Allier, overlooking the village. It has long dominated the only route which runs alongside the river. It was partly reconstructed by Philibert de Boutillat, Bailli of Nevers and Treasurer of France, who died in 1488. In the 17th century it was enlarged and reorganized; a considerable amount of restoration work was carried out in the 19th century by order of the Saint-Sauveur family, who had owned the property since 1722. This was continued at the beginning of the present century by Eugène Schneider. The village itself is a model of archaeological reconstruction, which explains the extraordinarily homogeneous quality of its architecture, suggesting a stage set.

The roadway running alongside the River Allier has been fortified since the early Middle Ages. In the 15th century, a medieval castle was replaced by a new *bel et nostable chatel*, described in charters of 1409 and 1467. Apremont was formerly a village for quarry-workers; there were several quarries in the surrounding district, all supplying large quantities of good-quality stone, which was cut and then transported down the Allier and the Loire in flat-bottomed boats. The stone was used in the construction of such well known religious buildings as those of Orléans and Saint-Benoît-sur-Loire.

Apremont owes its 'renaissance' to Eugène Schneider, head of the manufacturing dynasty Creusot. In 1894 he married Antoinette de Saint-Sauveur, heiress to the village. He then undertook major building work on the castle. He did not stop there, however; in 1930 he embarked upon a painstaking project of reconstruction, aiming to transform Apremont into a typical Burgundian village. He was assisted in this task by the architect M.de Galéa. They destroyed everything which was either too modern or out of keeping with the location, rebuilding the whole in medieval style. After Schneider's death in 1942, his widow Antoinette continued this work, which was subsequently assumed by their descendants. A flower garden was created in 1971, and in 1976 a museum of horse-drawn vehicles was opened in the castle stables, ensuring the attraction of the village to tourists. Apremont has 55 inhabitants.

For further information:

*Architectures en région Centre (Val de Loire, Beauce, Sologne, Berry, Touraine)*, the *Guide du Patrimoine* by Jean-Marie Pérouse de Montclus, Éditions Guides Bleus, Hachette and Conseil Général du Centre

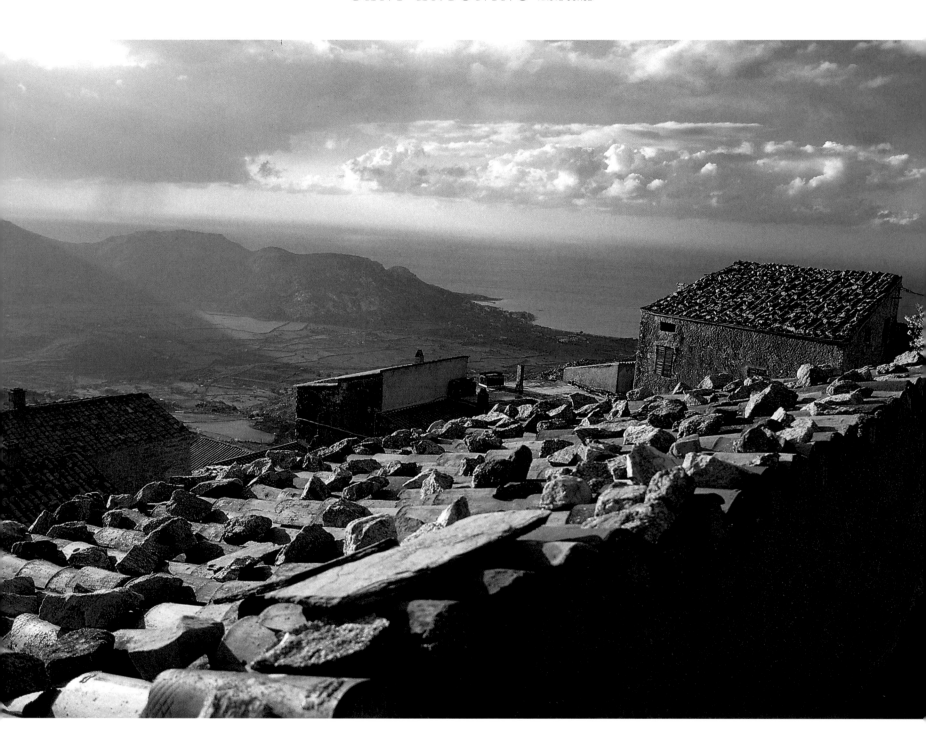

The origins of Sant'Antuninu are obscure, due to a lack of written sources. This is also true of the other villages in the Balagna region. It is likely, however, that *castra*, also called *castelli*, situated at strategic points, first appeared in Balagna in the 9th century. They enabled the inhabitants to scan the valleys and control communications with the coast. Some seigneurial families split into rival factions. The Pinaschis, who were the dominant power in the area, became involved in fratricidal quarrels, with each lord building a fort on a rocky spur – Curbara, Spiluncatu, Sant'Antuninu – pillaging or demanding ransom from the surrounding inhabitants. The revolt of the 'commune' in 1358 put an end to seigneurial rule, which was replaced by that of the leaders of the people, the *caporali*. In Balagna the clans, or *casate*, of Sant'Antuninu and Curbara rose to prominence, quickly reviving the old rivalries.

The periodic confrontation between the leaders of these two villages is a consistently recurring feature of the region's history. The groups would not hesitate to ally themselves with outsiders – foreign lords or powers – in a bid to supplant the rival clan. Links were forged with the kingdom of Aragon, with Genoa and France. In this way Sant'Antuninu participated in some of the major events in the island's history.

The village served as a fortified base for the troops of Sampieru Corsu and their allies during the 'French war' in the 16th century. Anton Paolo de Sant'Antuninu courageously defended Calvi, which was besieged by Franco-Turkish forces. When the Genoese took over the site after their victory in Balagna, they razed to the ground all fortifications belonging to the French partisans. The second Sampieru war (1564–69) impinged slightly on the village, but Sant'Antuninu ceased to be at the forefront of events on the island from the late 16th century.

In 1498, the villagers were grouped into some 45 households. In 1950 there were 151 inhabitants, the population having dropped by over 200 since 1803. Some 75 inhabitants remain today.

For further information:
*Sant'Antuninu (Sant'Antonino)*, with articles by Mlles. Janine Renucci and Évelyne Gabrielli, a small, free booklet produced by the municipality of Sant'Antuninu, Curbara 1983

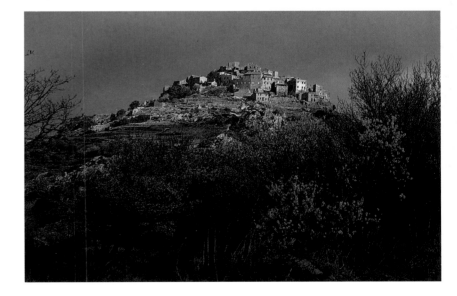

◄

**Sant'Antuninu stands high on the mountain ridge that divides the plains of Reginu and Algajola, situated in the centre of Balagna. It is approximately five hundred metres above sea-level. There are olive groves down below, most of the cereal crops being cultivated on the plain. A survey of 1782 stated that the Aregnu-Sant'Antuninu community was 'the only one in the whole of Corsica' to have all its land completely cultivated, despite the steepness of the slopes on which the village is built.**

**The village overlooks a magnificent landscape, with mountains on one side and the sea on the other. It has gradually been modernized, yet in spite of alterations the Sant'Antuninu of bygone days can still be found in the general structure which stands today. It is the archetypal 'acropolis' village, growing out of the rock on which it was constructed. Its massive houses huddle around the site of the *castrum*, which has now disappeared, rising into the sky to compensate for the lack of space. Their walls almost touch one another, as if to create a rampart, and the narrow little streets thread in and out of the buildings, to form vaulted alleyways here and there below the houses.**

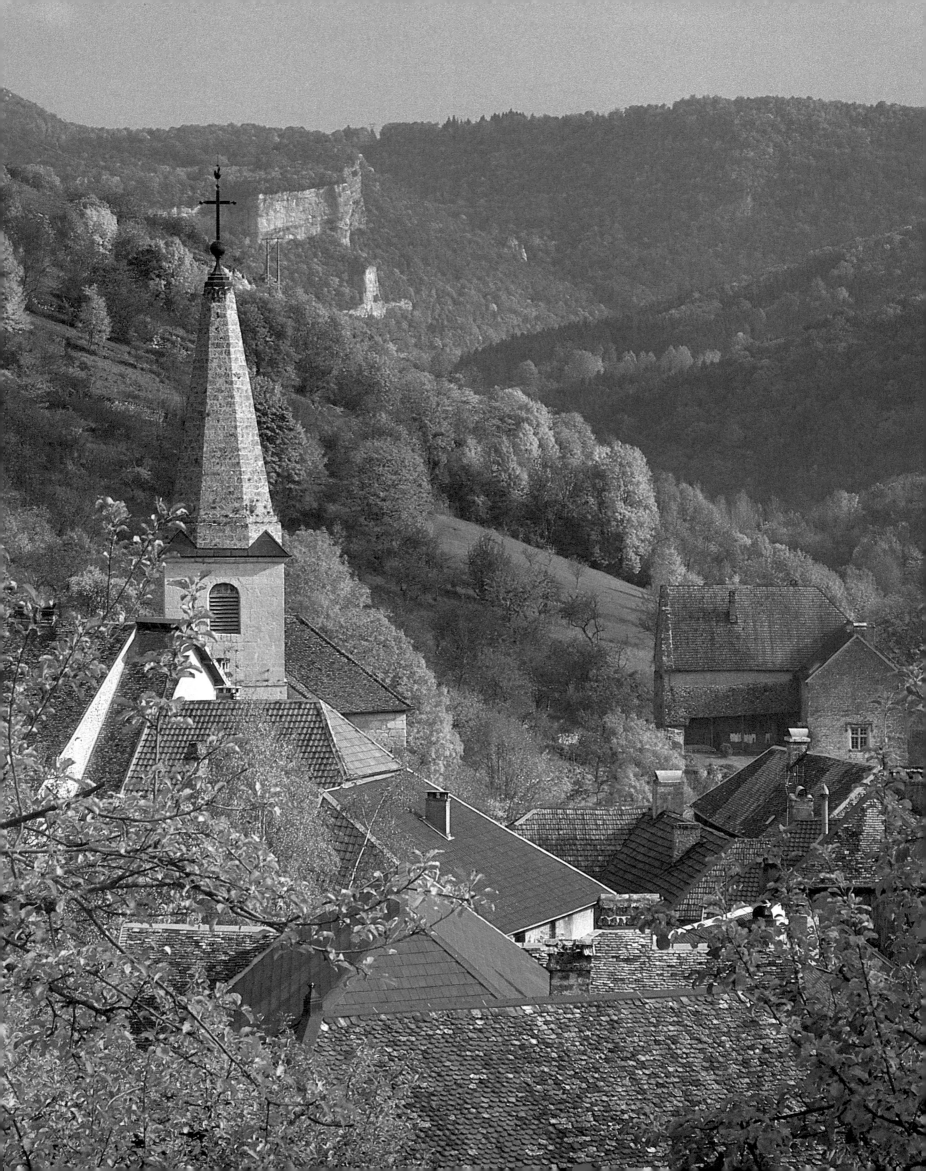

First mentioned in 12th-century texts, Lods is numbered amongst the thirty-two villages that formed part of the seigneury of Châteauvieux de Vuillafans in the mid-13th century. This was set up by the count of Burgundy in favour of his nephew Amadée III de Montfaucon. In 1318 the lordship fell to the comtes de Montbéliard and was then divided up in the late 15th century. In 1758, Guy Michel de Durfort de Lorges became seigneur of Lods by marriage and modernized the rudimentary ironworks that already existed on the banks of the River Loue. For the next 150 years the workshops built there – rolling-mill, wire-mill and nail factory, together with some mills and sawmills – ensured the villagers' prosperity. Wine-growing represented the main economic activity at Lods from the 16th to the mid-19th century, when it reached a peak with about one hundred hectares of vineyards (247 acres). These had been planted initially by monks, who cleared the land, and were subsequently developed by the local lords. The metallurgical industry likewise flourished: the ironworks employed a total of 493 men in the 19th century and was considered to be the second major industry in the region, because of its large workforce. Then came a period of decline. The ironworks ground to a halt, destroyed by the march of progress and its own run-down condition. In 1925 the nail factory stopped production. The rolling-mill then ceased to operate and the factory finally closed down in 1942, followed by the last sawmills in the 1970s.

At the same time phylloxera, competition from the Midi region and the First World War all combined to undermine the wine-growers. By 1925, few could live from their vineyards alone. Today a small museum commemorates the wine-producing business, which has now completely disappeared.

In 1688 the village had 436 inhabitants; in 1866 the population reached its highest figure, with a total of 1,431 inhabitants. Today there are only 321.

For further information:

*Dictionnaire des communes du département du Doubs*, Jean Courtieu ed., Éditions Cêtre, Besançon 1985

**It is difficult to imagine what the village must have looked like in the 1860s, framed by over one hundred hectares of vineyards (about 247 acres), and with almost five hundred workers employed in the industries on the banks of the Loue. The house in the eastern part of the old village (on the right, in the background) belonged to the de Thoraise family, whose presence in Lods can be traced back to 1358.**

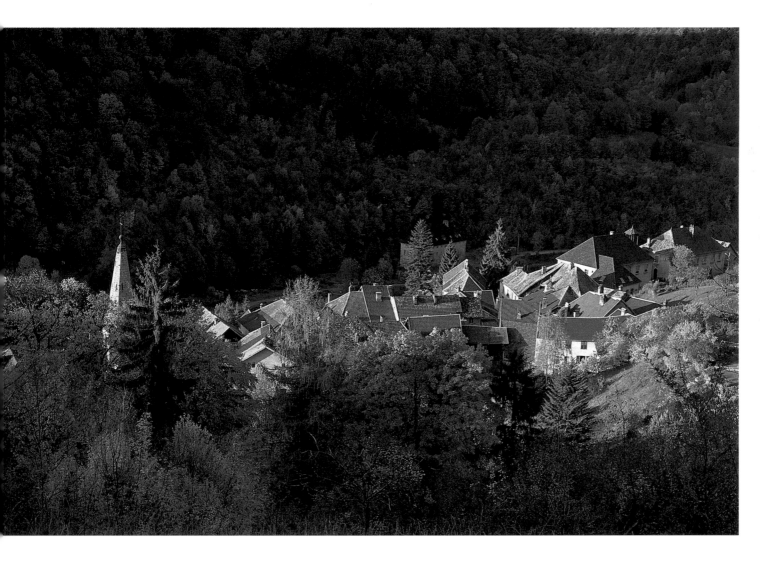

Mouthier-Haute-Pierre, two kilometres (a little over a mile) from Lods, is situated in a remarkably beautiful setting. Many of the famous cherry trees still stand today, the fruit being used to make kirsch. The village is perched on a ledge between the Loue and the mountains. It is composed of narrow, winding streets lined with wine-growers' houses all dating from the 18th century. From the 16th century onwards fruit trees, particularly cherry, began to be cultivated, although wine-growing remained the most important agricultural activity. Kirsch was first made here in the 18th century – a hundred years later it was said that the best cherry-brandy in France was produced in the vale of Mouthier. ►

Set in a magnificent, protected landscape, the village of Lods is laid out in tiered rows of houses at a narrowing of the Loue valley. The distribution of the village still reflects the past importance of its metallurgical industry and of its vines. The 'new' quarter on the banks of the Loue stands shoulder to shoulder with the 'old' upper part of the village, which is composed mainly of wine-growers' houses, the oldest dating from the 16th century.

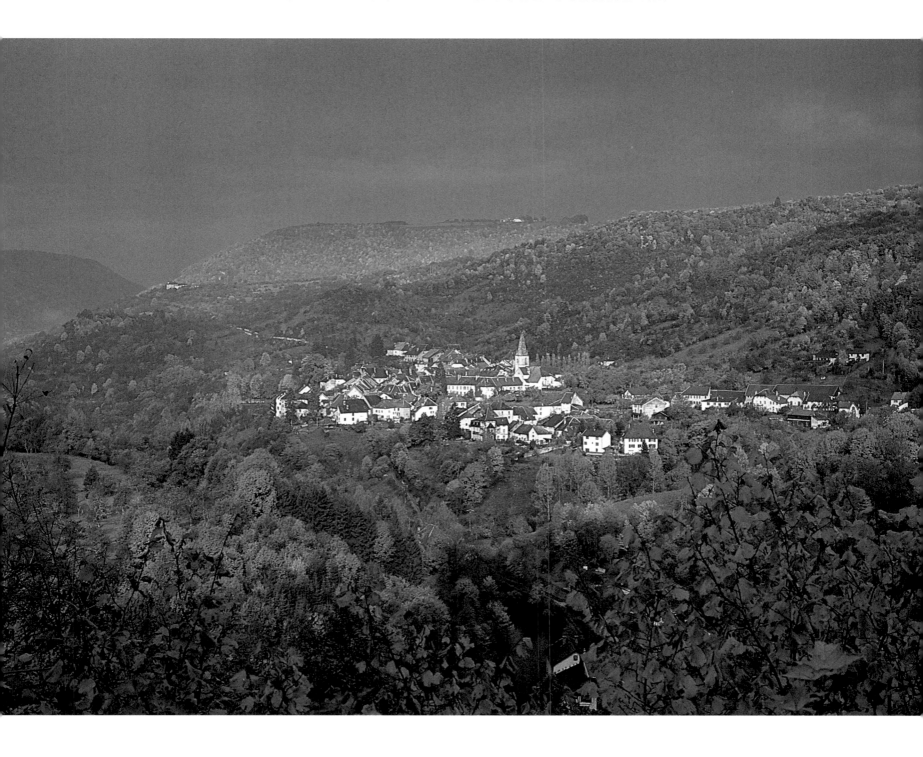

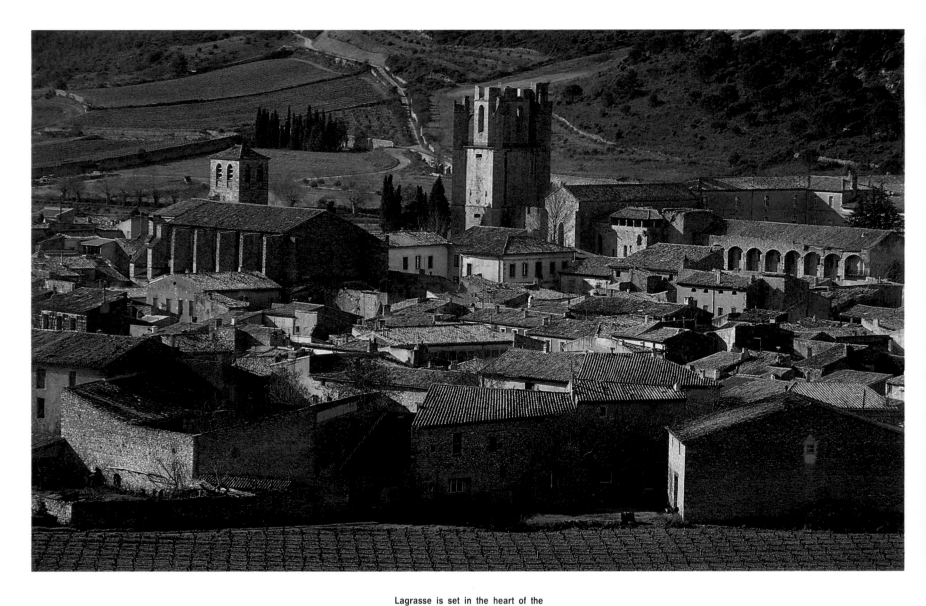

Lagrasse is set in the heart of the Massif des Corbières, amidst an unchanging landscape of arid hills and vineyards. Its renowned abbey has experienced great vicissitudes of fortune over a period of 1,000 years or more. It stands on the left bank of the River Orbieu, still overshadowed by the bell-tower constructed under the rule of Abbot Philippe de Lévis (1501–1537). The spire was never built. Situated on the right bank, the town was surrounded by fortifications, traces of which remain.

These capitals opposite the old covered market have supported the roof of this house for 600 years. One is of stone and decorated with two faces, the other is of carved wood. The two fish on the coat of arms suggest that the house may have belonged to a fisherman, or that a fishmonger's stall was set up here on market days. We know that from 1315 the market took place on this public square. It is also known that, by order of the abbot, the butchers or *mazels* (and therefore the fishmongers) had stalls not far from the covered market.

The earliest document to mention the abbey of Lagrasse is a charter of Charlemagne. It predates the year 800 and is generally described as the foundation charter for the abbey of Sainte-Marie d'Orbieu. In fact, however, Charlemagne's charter simply confirms the foundation of an already existing monastery, which he establishes in its rights and possessions. Considerable endowments were bestowed upon the monastery and it became increasingly prosperous between the 9th and the 12th century, its lands extending from Albigensian territory to Saragossa. Famous abbots of Lagrasse include the reformers Dalmatius, who became archbishop of Narbonne (late 11th century), and Auger de Gogenx (1279–1309). The latter was responsible for new buildings: indeed most of the medieval work, such as the church and the former abbot's lodging with its chapel, was erected during his rule.

After experiencing various difficult periods (in particular the Plague of 1348–49, and the consequences of the Hundred Years' War), the abbey enjoyed a spiritual and intellectual revival as a result of the Saint-Maur reform, introduced in 1662. The situation was further improved in the 18th century with the building of a new abbot's palace, constructed on the orders of the Abbot Armand Bazin de Bezons. He was also responsible for the cloisters which stand today.

During the revolutionary period the monastery was sold in two separate parts (20 October 1792). This division remains today: one part is occupied by a community from the Order of Théophanie, whilst the former abbot's lodgings are under the administration of the town hall. There are currently 612 inhabitants in this little town.

For further information:

*L'abbaye de Lagrasse, guide du visiteur*, by Jean Blanc, Carcassonne 1987

The old bridge at Lagrasse was probably constructed in the 13th century as a link between the religious world (represented by the abbey) and the secular (the town). The arms of Lagrasse show that the bridge was formerly surmounted by three square gate towers, which served as a defence. Its great arch was partially repaired after 1618 and the pitch of the high medieval hump-back was considerably lowered. Traces of the alteration work are clearly visible here.

▶

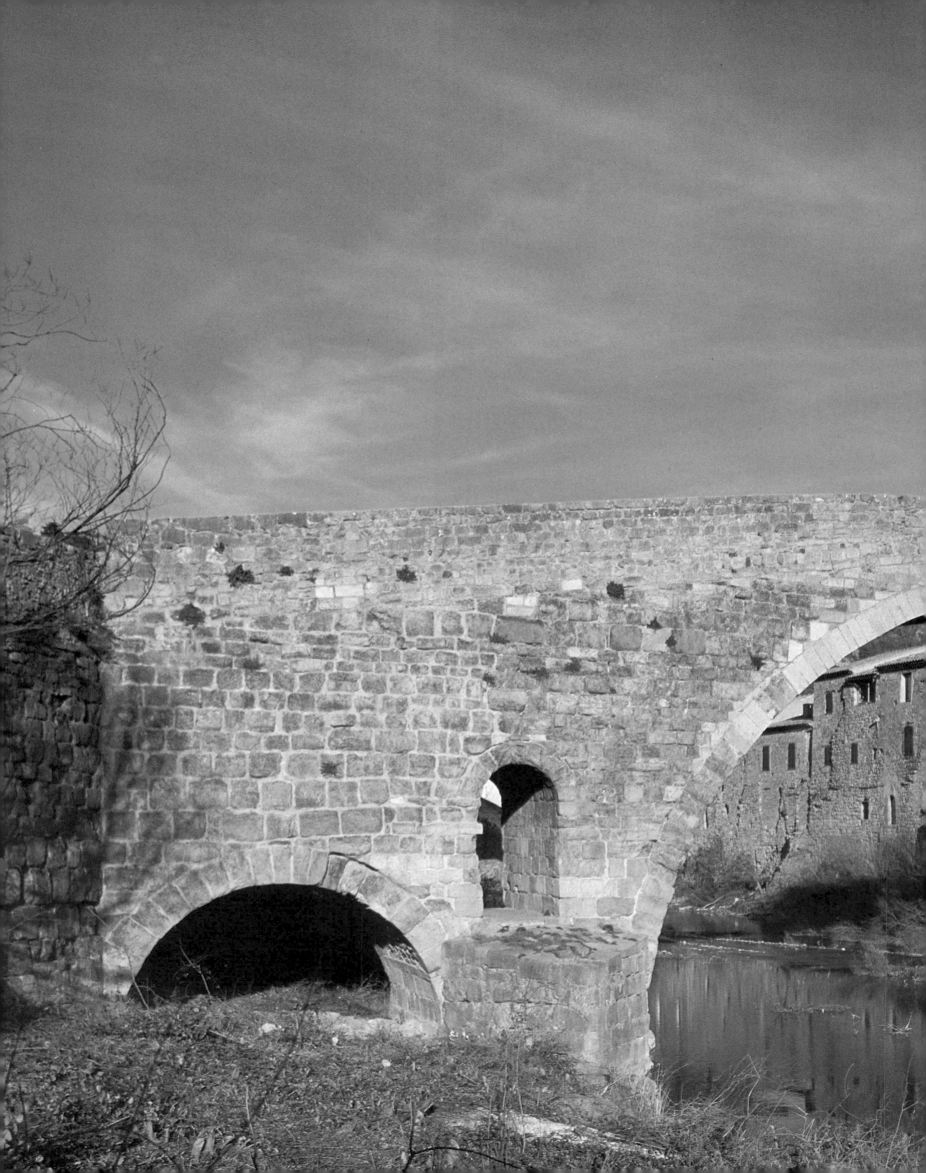

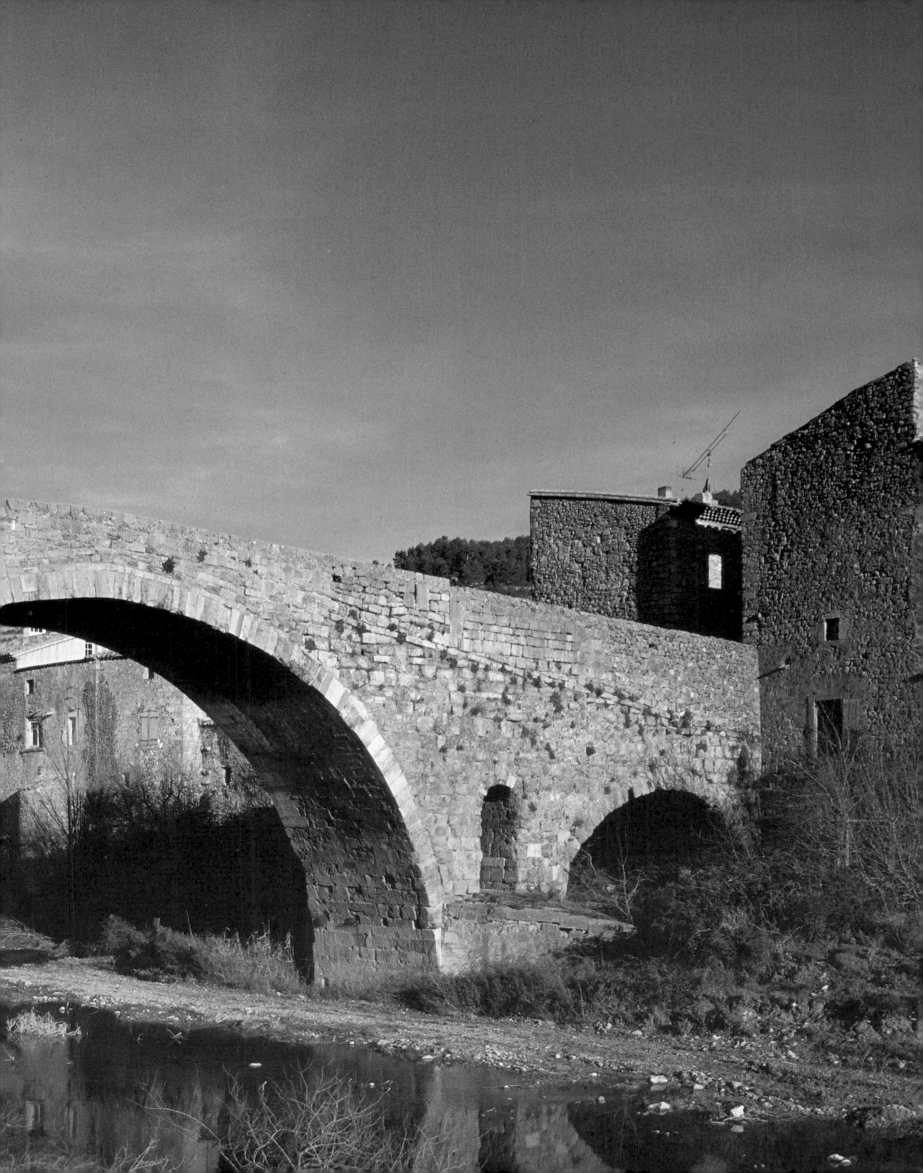

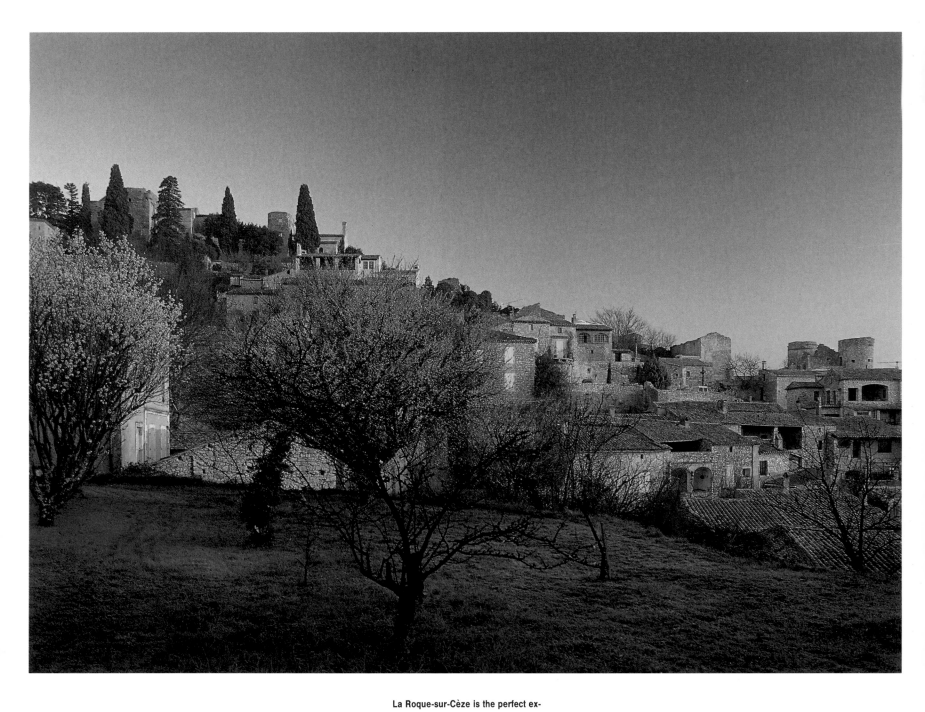

La Roque-sur-Cèze is the perfect ex-
ample of a painstakingly restored
village where the unity of architectur-
al styles creates an overall impres-
sion of balance and harmony. The
streets are restricted to pedestrians
only, which adds to the atmosphere of
old-world charm.

The castle that stands above the village overlooking the valley of the Cèze is first mentioned in the 12th century. It is referred to as the *castrum de Roccha* in 1156. During this period La Roque formed part of the territory owned by the bishop of Uzès, as is proved by a charter of Louis VII dated 1156, confirming the properties of the bishopric. A church (possibly the castle chapel) was built near the château at the edge of the precipice. It probably dates from the 12th century; the village itself may well have been founded during this period. The Romanesque church was dedicated to Saint Michael and subsequently to Saint-Pierre-ès-Liens. It was a priory of the church of Saint-Laurent-de-Carnols in the diocese of Uzès (deanery of Cornillon) right up to the Revolution. During the Wars of Religion the Catholics took refuge at La Roque, but they could not prevent the Protestants from entering the fortress in 1573.

According to a count of 1384, there were only 4 households (about 20 inhabitants) in La Roque at that time. This included Saint-Laurent-de-Carnols. The current population of the village is 118.

For further information:

*Dictionnaire topographique, statistique et historique du diocèse de Nîmes*, by the Abbé Goiffon, Nîmes 1881

*Études d'histoire et d'archéologie romane – Provence et Bas-Languedoc*, by L.H.Labande, vol. I, Avignon and Paris 1902

**The houses in the picturesque hill village of La Roque-sur-Cèze are set out in tiered rows on the southern slope of a hill overlooking the right bank of the River Cèze. Access is afforded by a solid bridge with twelve arches, known as the Pont Charles Martel. It probably dates from the medieval era, and is an additional point of interest.** ▶

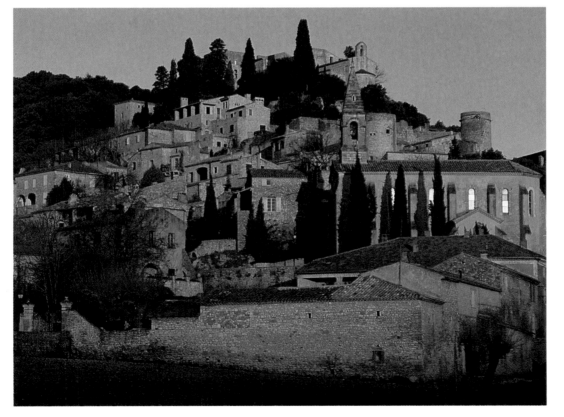

**The village is dominated by the privately owned seigneurial castle and by a small Romanesque church, clearly visible here, built on the edge of the north-facing precipice. This chapel was the parish church until the 1880s, but its perilous location, coupled with the increase in the number of worshippers, prompted the construction of a new church further down the hill, below the village.**

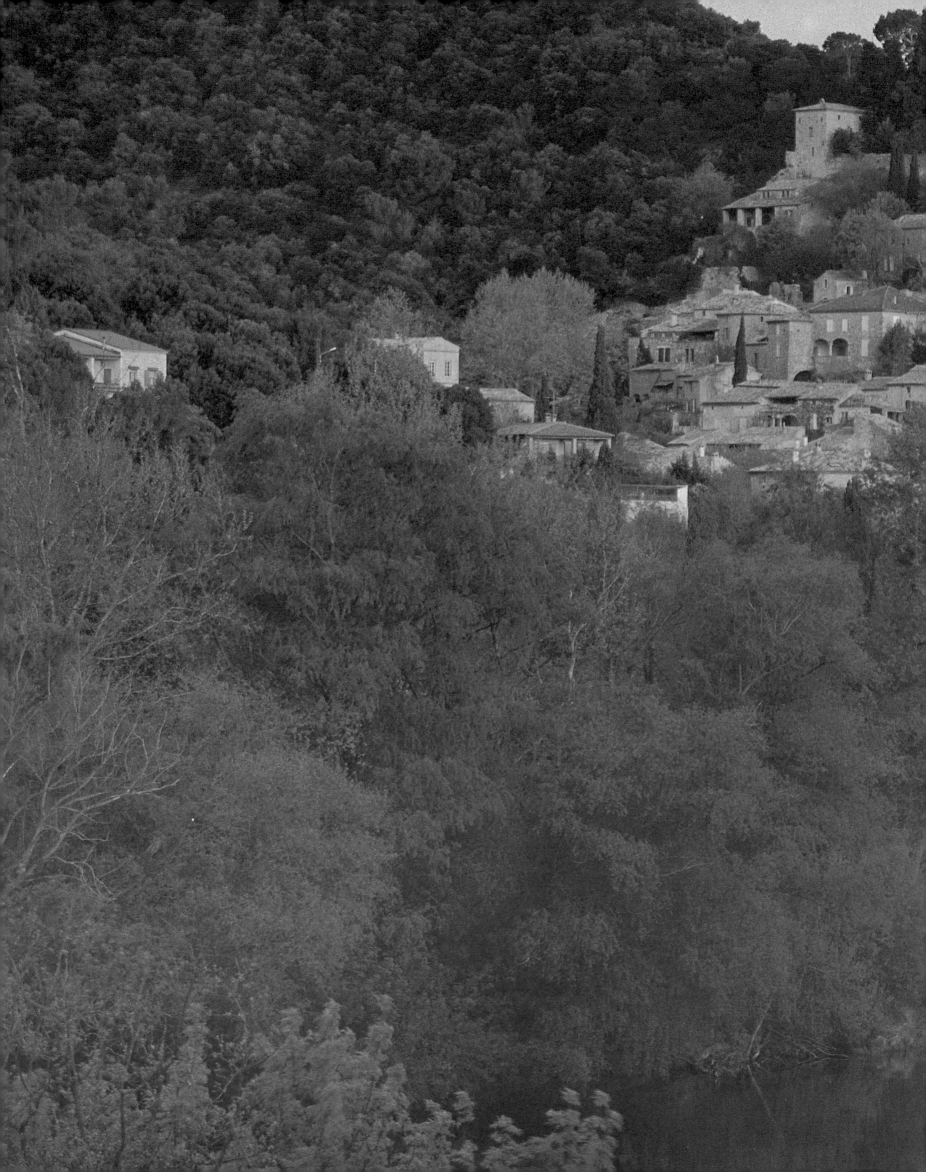

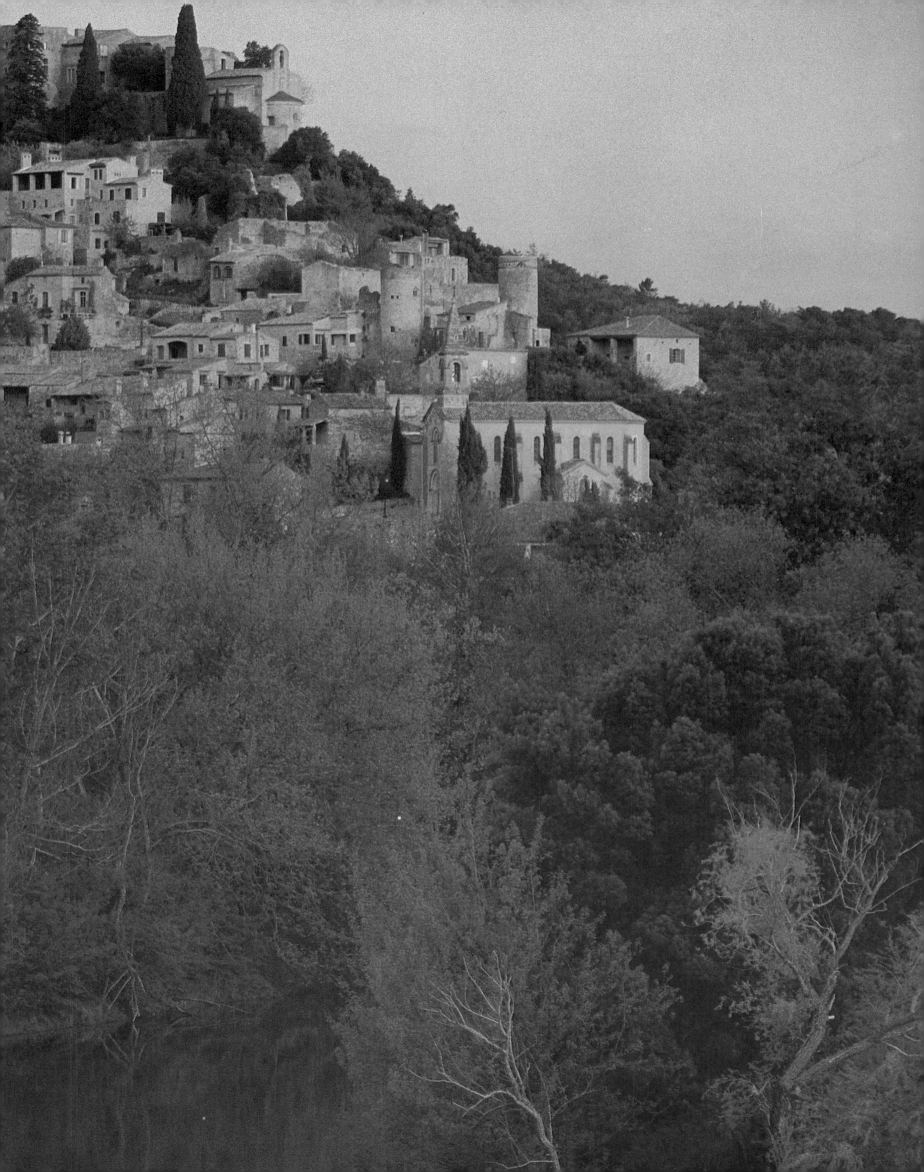

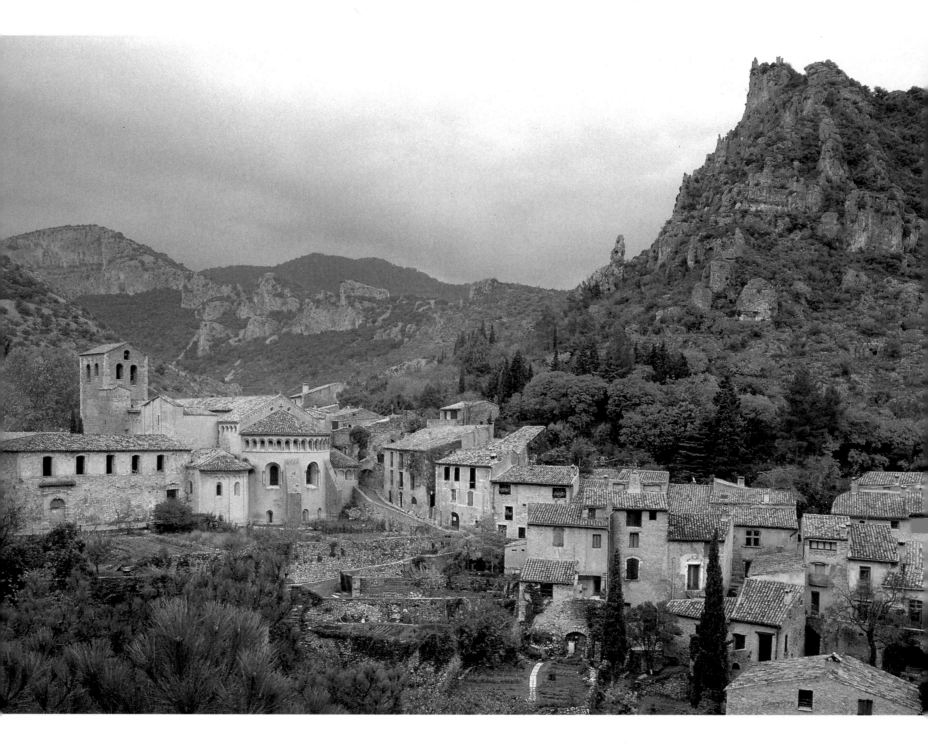

The valley of Gellone is an expanse of steep mountainous slopes, arid and wild. Water is scarce here and the cliffs fall away sharply. In this impressive landscape a little monastic community was established in the early 9th century by Guilhem, Duke of Aquitaine. More than two hundred years after his death the monastery and the church (left) were completely rebuilt under the auspices of the Abbot Pierre I (1050–77), so that the ever-increasing number of pilgrims could be accommodated. The prestige of the abbey enabled the village to expand steadily. It is dominated by the ruined castle of Verdus (or Verdun), seen on the right. This is first mentioned in the early 11th century.

L ittle is known of the person described as Guilhem, a Duke of Aquitaine, who lent his name to the monastery of Gellone and to the village which grew up in its shadow. Guilhem, in the *langue d'oc* of the South, otherwise Guillaume, was born in about 750. He was already at the height of his fame when he met a childhood friend, the Goth Witiza, who had given up everything to become a monk under the name of Benedict. The latter had just founded the monastery of Aniane. Advised and assisted by his friend, Guilhem founded two *cellae* at Gellone in 804, where several monks settled. Guilhem himself died there, a saintly figure, on 28 May 812, and was interred in a corner of the cloister. The abbey then became a place of pilgrimage, whose prestige was enhanced by these precious relics. The monastery's fame spread from the 10th to the 13th century and the epic poem, the *Geste de Guillaume d'Orange* added to its renown.

The first blow to the abbey came with the appointment of the bishops of Lodève as non-resident abbots, which was initiated in 1465. The sole aim of the bishops was to extract the greatest possible profit from the abbey, which had managed to hold out against their covetous designs during the preceding centuries. In 1569 the monastery and church were pillaged by the Protestants, who reduced the tomb of Saint Guilhem to fragments. From then on decline was almost inevitable and the monks were obliged to sell their remaining treasures in order to pay for repairs. In the 17th century an appeal was made to the reformed Benedictines of Saint-Maur to re-establish monastic discipline. The monks remained until the Revolution and saved this great abbey from ruin.

When the abbey was sold at the Revolution it was only a shadow of its former self. Indeed, in 1783, the last non-resident abbot, Mgr de Fumel, Bishop of Lodève, had obtained royal authorization to suppress the abbey and pass all its possessions over to his bishopric. Its buildings were subsequently converted into a cotton-mill, a tannery and several private houses.

One of the charms of Saint-Guilhem-le-Désert is its maze of old houses, several of which have Romanesque façades. Here, in the Rue de la Chapelle des Pénitents, these two adjoining Romanesque houses have been recently restored. The windows are new but the façades have a cornice with a course of chevron ornament, decoration also found on the apse of the church.

The cloisters served as a source for stone; most of the sculptures were sold or dispersed. The church alone survived the massacre, to become the parish church. In the course of building work carried out in 1879 the relics of Saint Guilhem were discovered; they had been hidden during the Wars of Religion.

In the early 19th century the population was close to 1,000. It has decreased steadily to the present number of 223 inhabitants.

For further information:

*Saint-Guilhem-le-Désert et sa région*, a collective work produced by the Association des Amis de Saint-Guilhem-le-Désert, Millau 1986 (new edition)

*Saint-Guilhem-le-Désert, la vision romantique de J.J. Bonaventure Laurens*, a commentary on the drawings, by Robert Saint-Jean, produced by the Association des Amis de Saint-Guilhem-le-Désert, 1980

**Saint-Guilhem today gives an impression of size and harmony, in spite of the considerable damage and restoration work that the abbey has undergone. The bell-tower on the left is in fact a defensive structure erected in the 15th century over a Romanesque porch, which dates from the 1100s. Just behind it, the little tower of Saint-Martin was part of the Carolingian abbey church. According to local tradition, Saint Guilhem's cell was just beneath it; this explains why it was preserved when the church was reconstructed from the 1050s. Seen in the background, covered in scaffolding, the tower known as the Tour des Prisons is one of the few remaining vestiges of the town wall.**

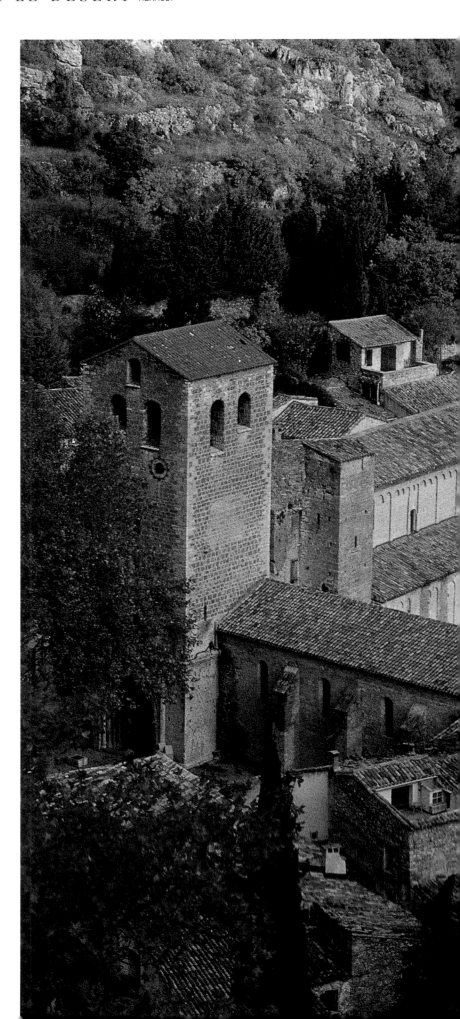

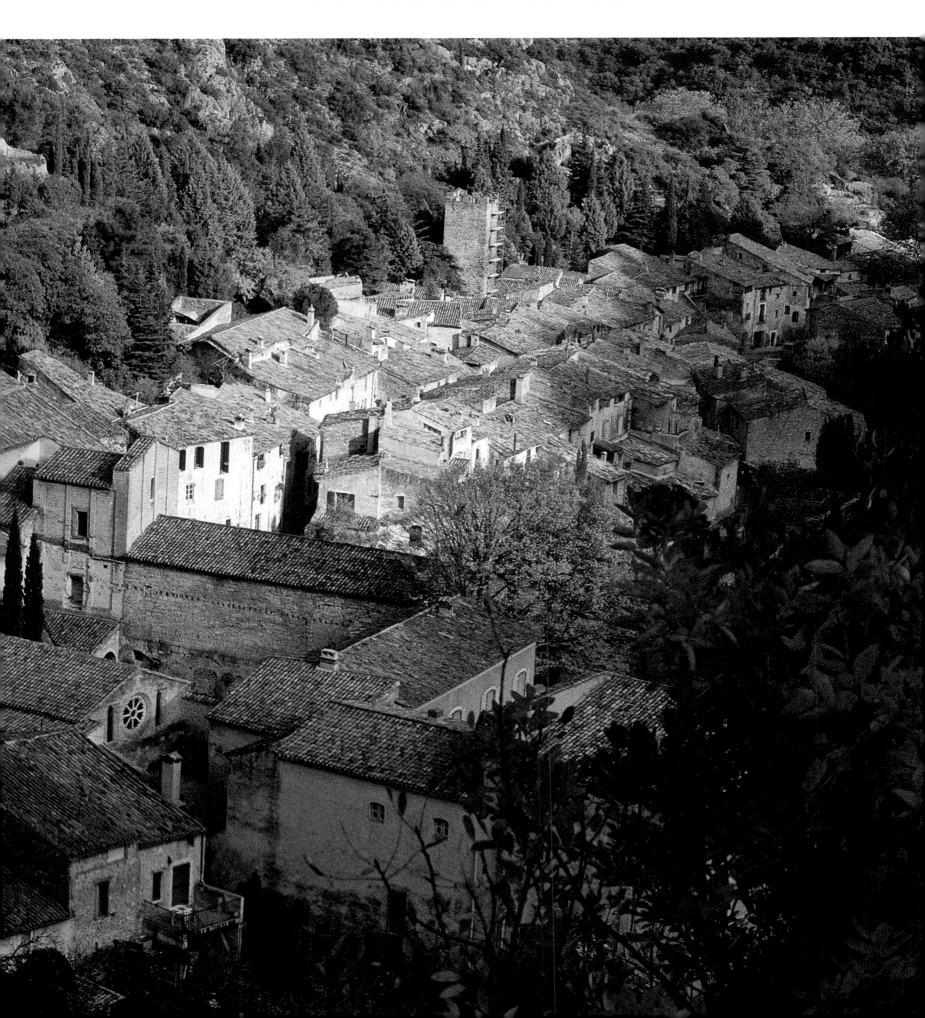

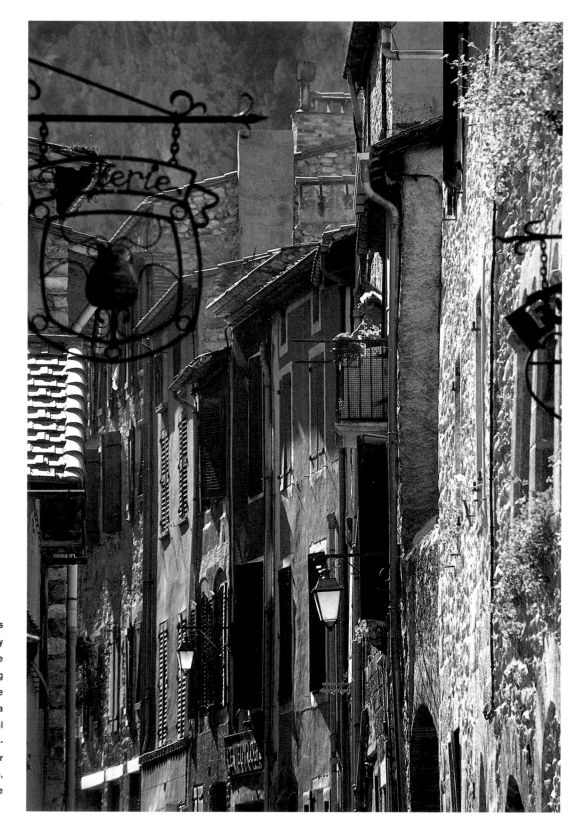

The Rue Saint-Jean was given its name in the 14th century at the very latest, as it contains a statue of the saint in an overhanging niche dating from that period. It is the main village street, or Carrer Major and features a remarkable succession of medieval façades, now sadly very much altered. Several artisans have their workshops in the Rue Saint-Jean, marked by wrought-iron signs made by the local artist J. Claramunt.

Villefranche was founded by Guillaume Raymond, Comte de Cerdagne, in 1092. It owes its existence to a strategically important location, commanding the valleys of the Têt and its tributaries the Cady and the Rotjà.

During the course of the 12th century the kings of Aragon, counts of Barcelona, granted municipal privileges to the towns in the *comtés* of Roussillon and Cerdagne. This enabled them to become prosperous. In 1126 at the very latest, Villefranche became the seat of the regional courts of justice and hence capital of the district of Conflent. The town held this status until 1773, when it was supplanted by Prades.

In 1635 France and Spain declared war. In July 1654 the French besieged Villefranche, which capitulated on the eighth day of the siege. Fearing that the town might once more fall into Spanish hands, they destroyed the medieval fortifications in 1656, although vestiges remain. The Treaty of the Pyrenees (7 November 1659) ceded the *comtés* of Roussillon and Cerdagne to France; in 1667, however, the two countries were again at war. The war minister, Louvois, sent his engineers to Villefranche and from 1669 to 1676 Jacques de Borelly de Saint-Hilaire *ingénieur ordinaire du Roy* supervised the construction of fortifications along the frontier of Roussillon. It was not until March 1679 that Vauban completed the work of Borelly, principally by constructing a castle known as Fort Libéria. This was designed to command the peaks overlooking the town. Various alterations were carried out in the 18th and 19th centuries, but the castle was down-graded in status and finally abandoned by the army at the end of the last century. Since the late 1960s, after long decades of indifference, Villefranche has become one of the foremost towns in France as regards the restoration and presentation of its architectural heritage.

In 1679, Vauban described Villefranche as 'a little village [*villotte*] which may contain some 120 households . . .' In 1718 the engineer Joblot spoke of a town

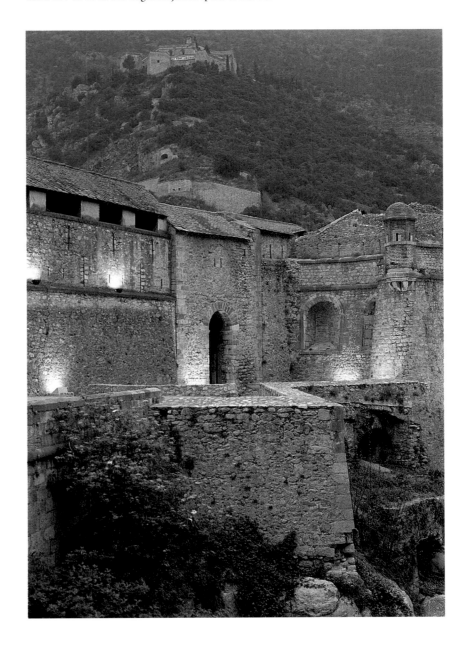

**Villefranche is dominated by a fort which was constructed in 1681, after the fortification of the village. It is the only building on the site designed by Vauban. In 1850 it was linked to the village by an underground stairway, which was completed three years later. Some of the exterior stonework can be seen here, half-way down the slope. Visible in the middle distance, the ancient Porte de France is first mentioned in texts dating from 1287. It was previously surmounted by a square tower.** ▶

with 500 inhabitants, whose barracks could accommodate 300 soldiers. An anonymous report of 1776 describes a town of 611 inhabitants, all living in poverty, which had lost its trade (notably in woollen cloth, previously a thriving business) and which was depopulating with every passing day. Today the little town has 294 inhabitants.

For further information:

'Saint-Jacques de Villefranche', by the Abbé Cazes, in a tourist guide entitled *Conflent*, Prades (n.d.)

*Guides des remparts de Villefranche-de-Conflent*, by Alain Ayats and Guy Durbet, produced by the Association Culturelle de Villefranche and Revue Conflent, Perpignan 1988

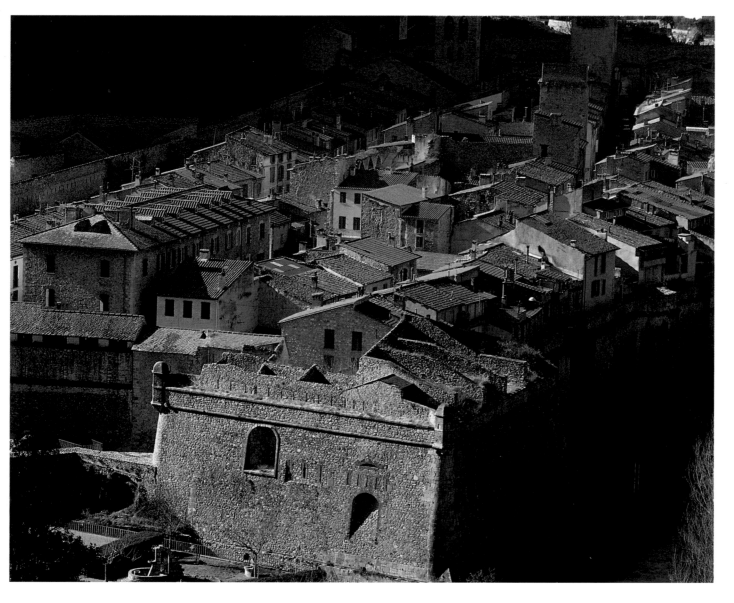

The general appearance of Villefranche-de-Conflent has remained unchanged since the very beginning of the 18th century. This can be seen from a model made on Vauban's orders in 1701, now in the Musée National des Plans et Reliefs in Paris. In the foreground, the Bastion du Dauphin is built on a cliff overhanging the confluence of the Têt and the Cady. The large barracks inside the wall on the left were built in 1770, to the great relief of the local inhabitants, who were still putting up some of the troops in their own houses. The barracks were subsequently converted into public housing, which has recently been renovated.

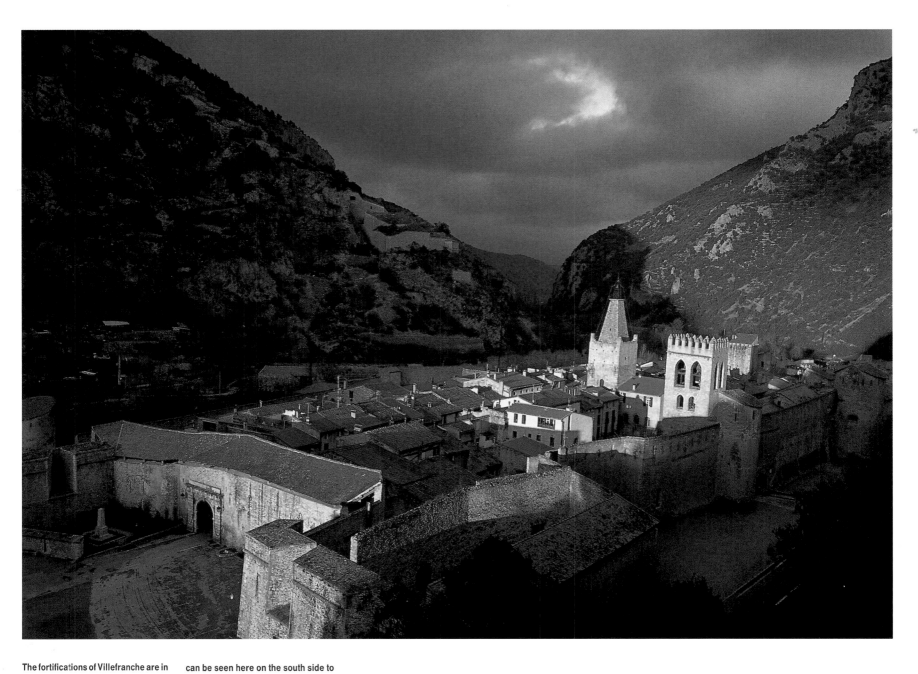

The fortifications of Villefranche are in a remarkably good state of preservation. They display all the characteristics of 17th-century military architecture as promoted by Vauban, the leading figure in this field. These fortifications are of particular interest; not only have traces of the medieval ramparts survived, but they have also been put to use. Two medieval towers can be seen here on the south side to the right of the picture. The Porte d'Espagne (framed by the Bastion de la Reine in the foreground and the Bastion du Roi) was given a facing identical to that of the Porte de France in 1791.

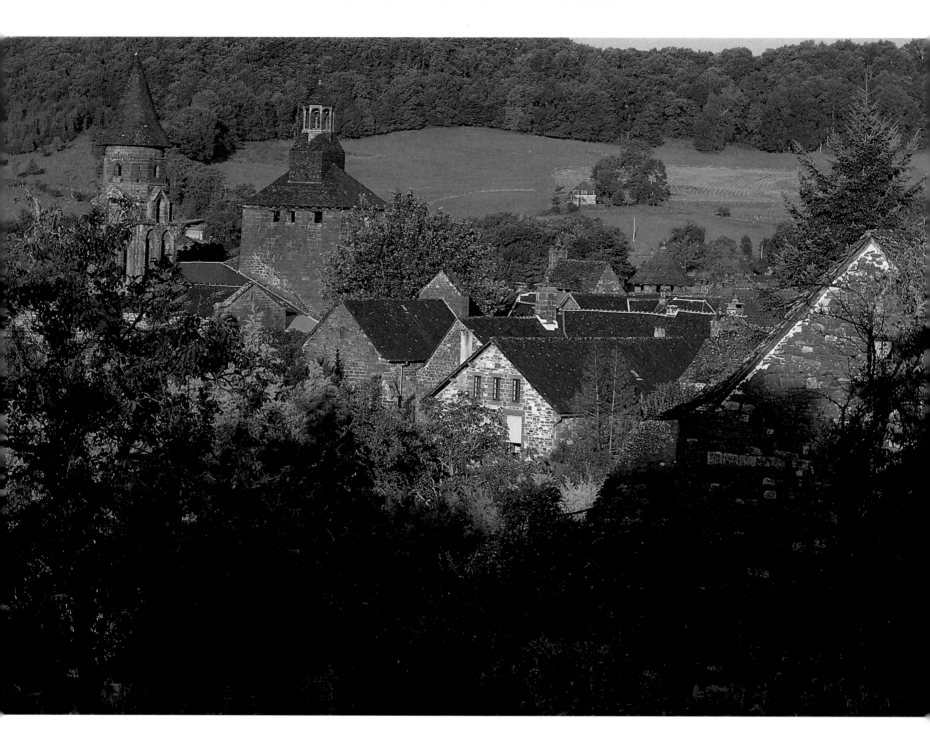

I n the time of Charlemagne, Collonges contained a 'church and annexes', which were presented to the Benedictine monastery at Charroux (Poitou) by Roger, Comte de Limoges, and his wife on 18 June 785. The monks' old community became a priory. When their rights over Collonges were recognized by the king of France, they embarked upon the construction of a church, *circa* 1060–70. The bell-tower and tympanum still remain and are masterpieces of 12th-century craftsmanship.

Houses gathered around the priory, coming under its protection, and the *bourg* was born. During the 1300s the town's people of Collonges were granted franchises and liberties by the vicomtes de Turenne. Collonges then became the capital of a bailiwick and subsequently of a castellany under seigneurial jurisdiction. The vicomtes de Turenne sometimes held their assemblies of provincial representatives (*États*) in the town.

With the end of the Hundred Years' War Collonges was able to resume production of walnut-oil and wine. Prosperity returned to the community. On 21 July 1489 the vicomte de Turenne officially confirmed the privileges, exemptions and franchises conceded to the inhabitants. He conferred titles upon the local bourgeois, who aspired to build residences worthy of their new status: they obtained permission to crenellate and machicolate, in other words to fortify.

The region was devastated by the Wars of Religion. The church was fortified and the 12th-century portal replaced by a simple gate. The tympanum was taken apart and the carved pieces dispersed over the façade; it was not reassembled until the 1920s. The 19th century saw the decline of the little town in favour of its

neighbour Meyssac, which became the capital of the *canton*. Today Collonges-la-Rouge is one of the most popular tourist centres in Limousin.

In the early 18th century there were almost 1,700 inhabitants in Collonges. The population has now dropped to 95.

For further information:
'Collonges en Bas-Limousin', in the periodical *Lemouzi*, Tulle, June 1973
*Collonges, village noble*, by M.M. Macary, Zodiaque, 1972

► The 15th and 16th centuries were the golden age of Collonges. During this period many fine houses were built or modified by those prosperous town's people whom the vicomte de Turenne had recently ennobled. Most of these *castels* have survived, a notable example being the Château de Benges, shown here, and, near the church, the château of the Vassinhac, the most illustrious family in Collonges.

◄ Collonges-la-Rouge stands on the borders of Périgord, Quercy and Limousin, nestling on the southern slope of a wide valley with a gentle escarpment. It owes its charm above all to the brilliant colour of its red sandstone buildings, and to the wealth of architectural treasures it contains. Indeed, few French villages can pride themselves on having saved as many fine old houses as Collonges. The structure of the village is typically medieval: the community is of course centred around the church and extends outwards, enclosing a network of narrow little alleys.

The dawning of the 19th century saw the village semi-abandoned and considerably run-down. Since that time it has gradually been restored. According to local authors about twenty towers, some ramparts and fine old buildings such as the priory have been allowed to fall into decay this century. In spite of this, the old architecture predominates and the use of red sandstone for all restoration projects has maintained a homogeneous appearance. In spite of the variety of materials used for roofing, this remarkable 'red village' has therefore kept its charm. ►

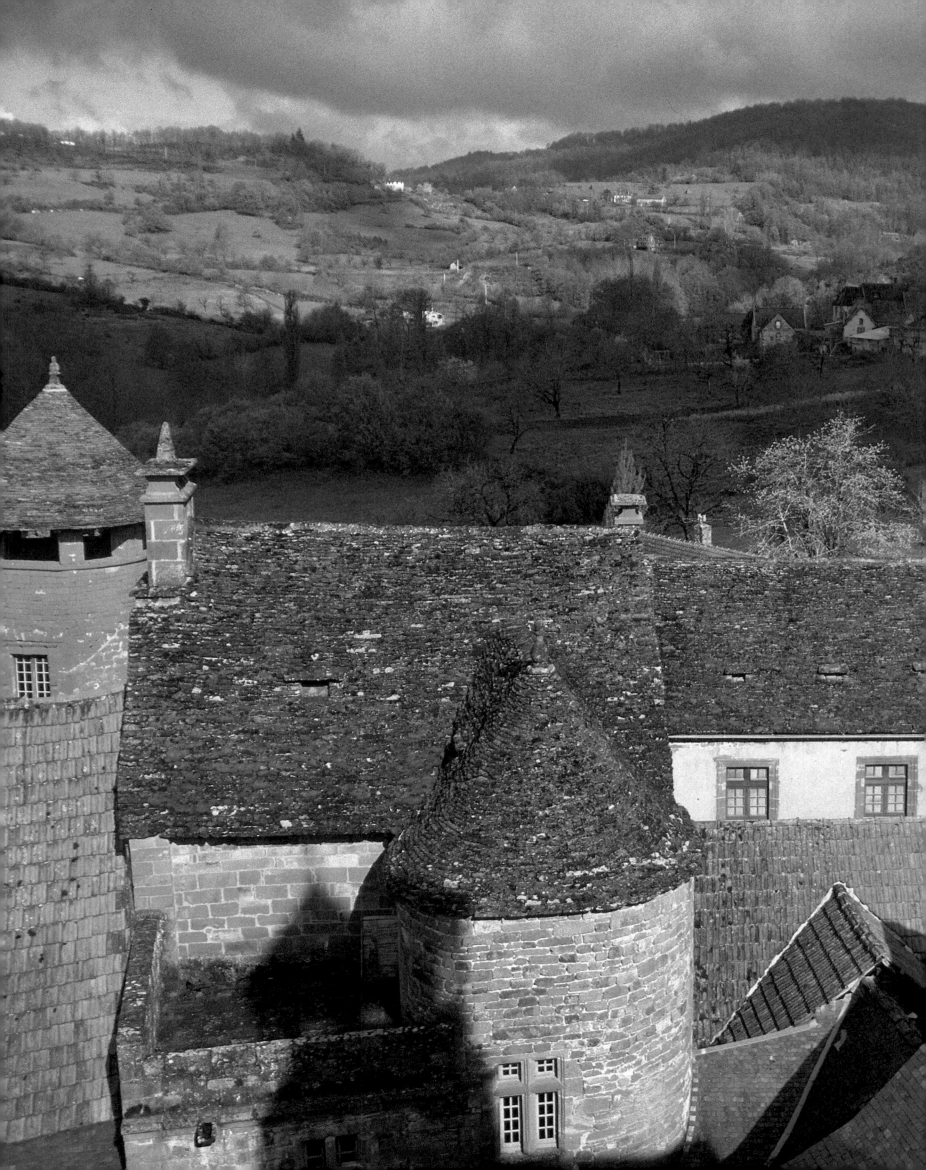

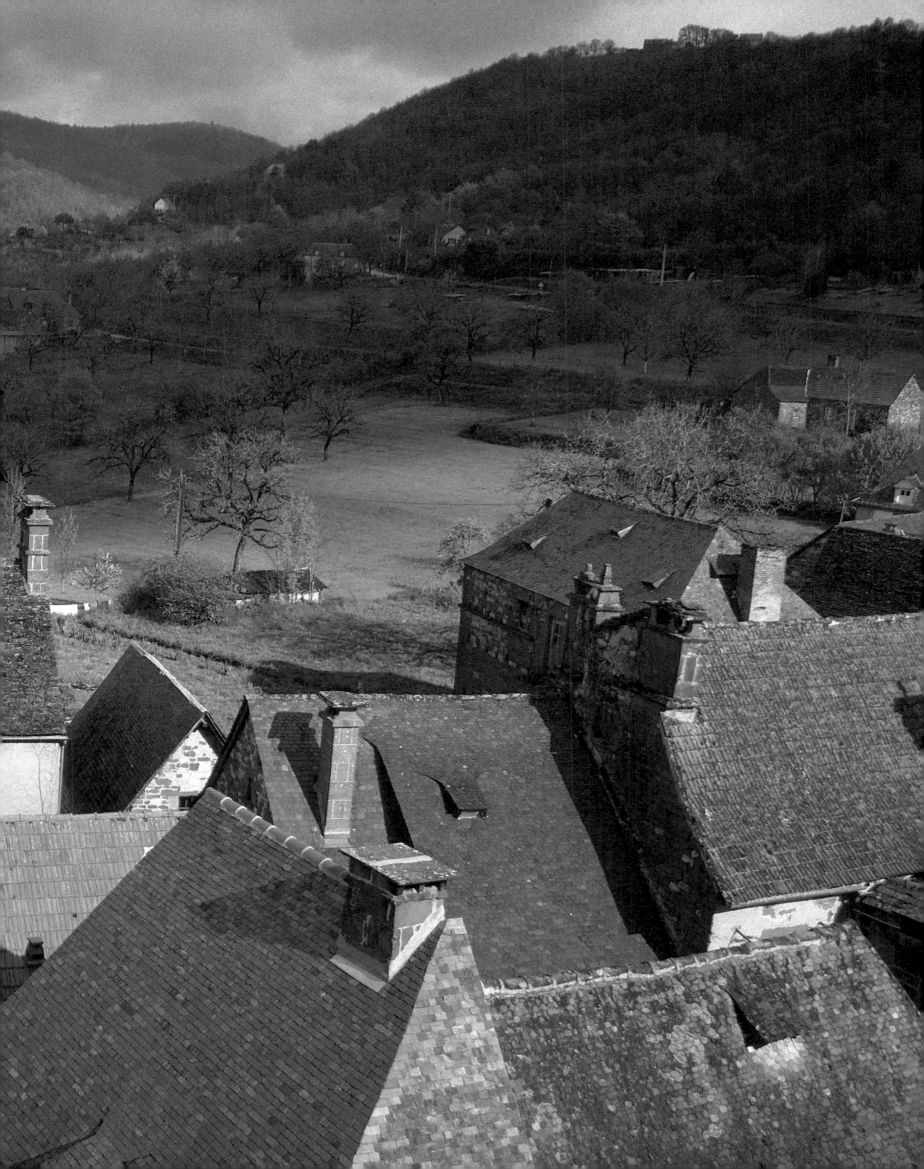

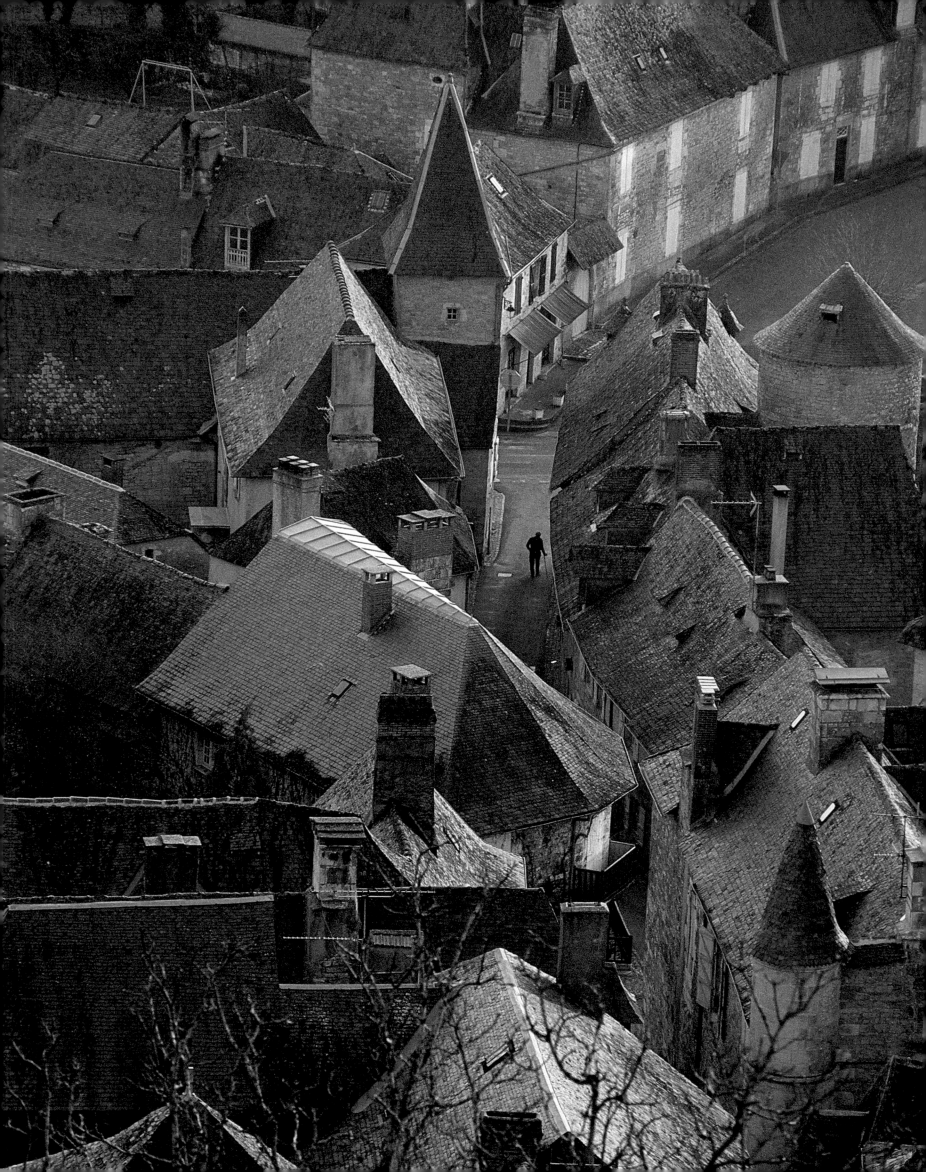

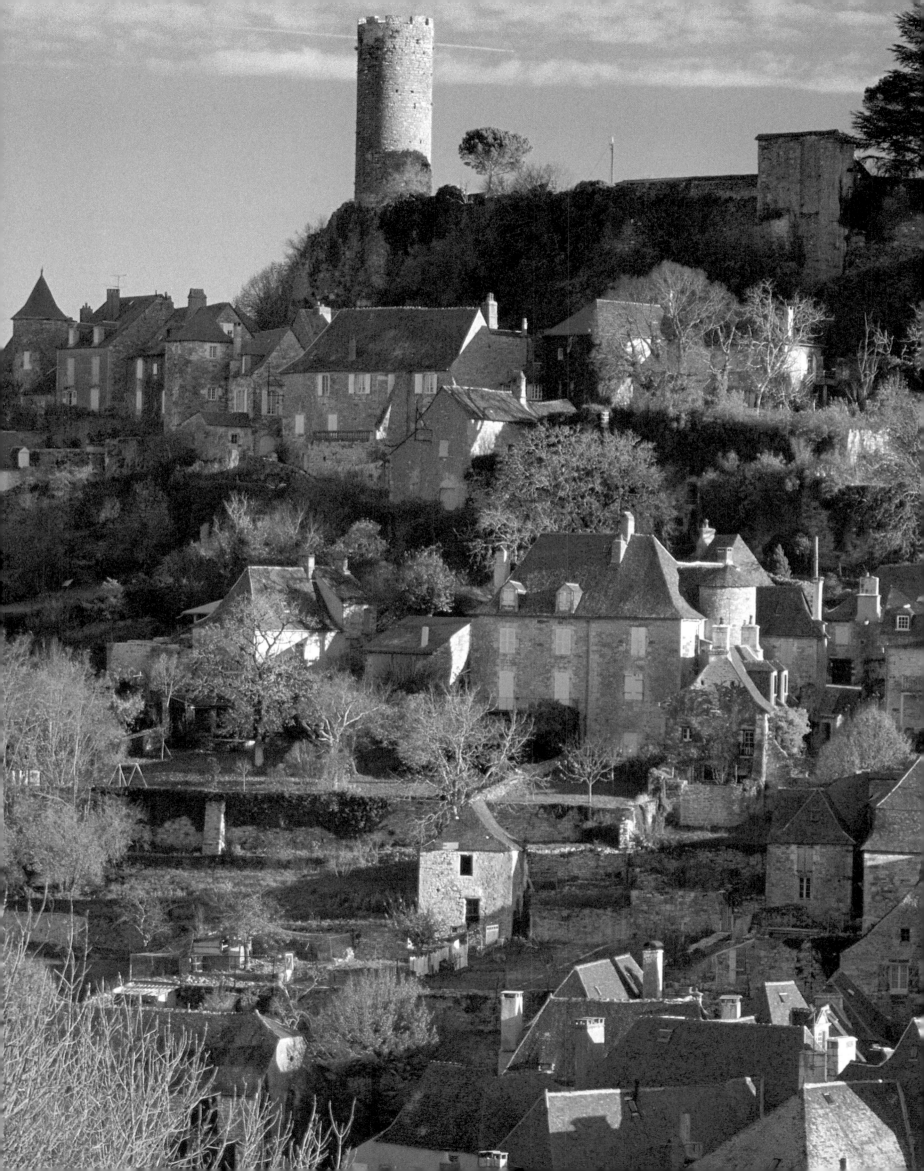

During the 11th century the seigneurs of Turenne, Boson I and Raymond I, chose the present site to erect a feudal fortress. Building continued over nearly four hundred years. It was not, however, the first site in Turenne to be fortified. The earliest stronghold was located on the left bank of the River Tourmente, at the top of the Puy de Gondres and remained in existence until about 1000. In less than a hundred years, this first 'castle' was stormed by three Carolingian kings – Pepin the Short, Louis the Pious and Charles the Bald. Little is known about the so-called 'powerless comtes' of the 9th century. The Carolingian *pagus Torinensis* was governed by a comte who had no *comté*, but was simply a landowner subordinate to the comte de Limoges. It appears that the first official vicomte de Turenne was Adhémar d'Escals, lay abbot of Tulle (940), whose natural son, Bernard I, was recognized as heir to the *vicomté* (950). This therefore became a hereditary fief. Their successors kept the title until the 18th century. In 986 the *vicomté* belonged to the famous house of Comborn, which retained it for 300 years. It then passed to the Comminges family, who held it for 46 years, to the Beauforts, in whose hands it remained for 94 years, and finally to the La Tour d'Auvergne family, who kept it for 294 years. Charles-Godeffroy de la Tour d'Auvergne, the last of the

nine vicomtes of this house, sold his *vicomté* to Louis XV in 1738, to pay off his debts. This ended the independence of the last French fief whose seigneurs had remained sole rulers of their domain.

By the 15th century the *vicomté* of Turenne had expanded to encompass one third of Bas-Limousin, as well as parts of Quercy and Périgord. It contained 1,200 villages and hamlets scattered over 111 parishes; there were 18,500 households, or 100,000 inhabitants. The *vicomté* had seven official walled towns; Argentat, Beaulieu, Gagnac, Martel, Saint-Céré, Servières and Turenne. It enjoyed virtual independence from the French Crown, since it was the seat of the Provincial States General and had its own mint, as well as its own administrative and judicial practices. All of this, together with the exceptional privileges conferred on the *vicomté* by the kings of France, made it the only one of its kind in the land.

In the Middle Ages, Turenne had more inhabitants than Brive. Today, however, the population stands at just 264, that of Brive being over 50,000.

For further information:
*Turenne, son site, son histoire, son château, son église*, a small volume produced by the Association des Amis de Turenne

Turenne owes its picturesque quality to its medieval structure and the quality of its architecture. The village still presents the image of harmony which prevailed at the time of its construction. Seen here from the castle, the roofs are of particular interest. They are all tiled with slate and this, combined with the sight of the interlocking houses extending right down the slope, has created a distinctive 'landscape' of its own.

The castle and the *bourg* are situated on an isolated hillock commanding the valley of the Tourmente. Little remains of the mighty fortress belonging to the vicomtes de Turenne. The village was built at its foot, extending over the hillside from the sloping approaches to the castle. In the same way as its neighbour Collonges-la-Rouge, Turenne has many houses once owned by nobles or prosperous town's people. Constructed between the 15th and the 18th century, they form a homogeneous architectural ensemble, preserved in a natural setting that sets them off to best advantage.  ▶

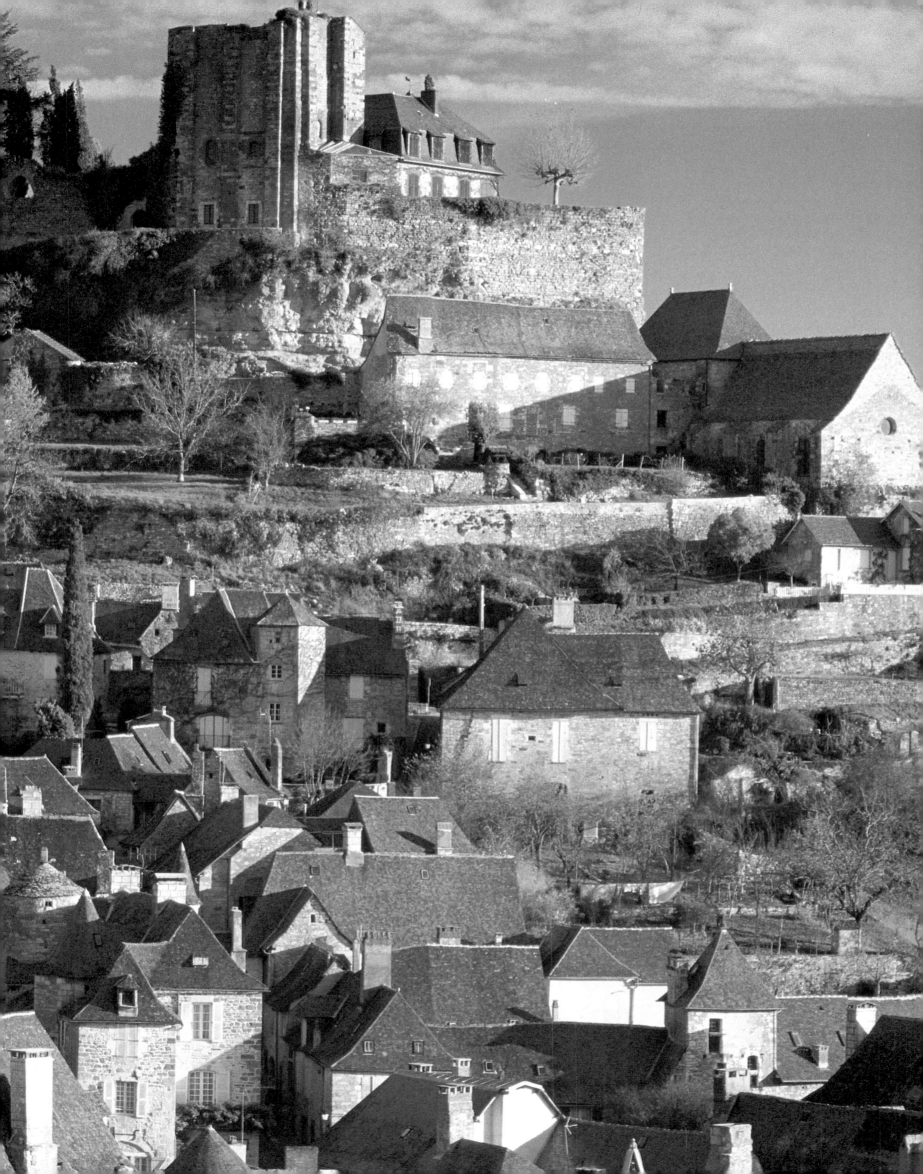

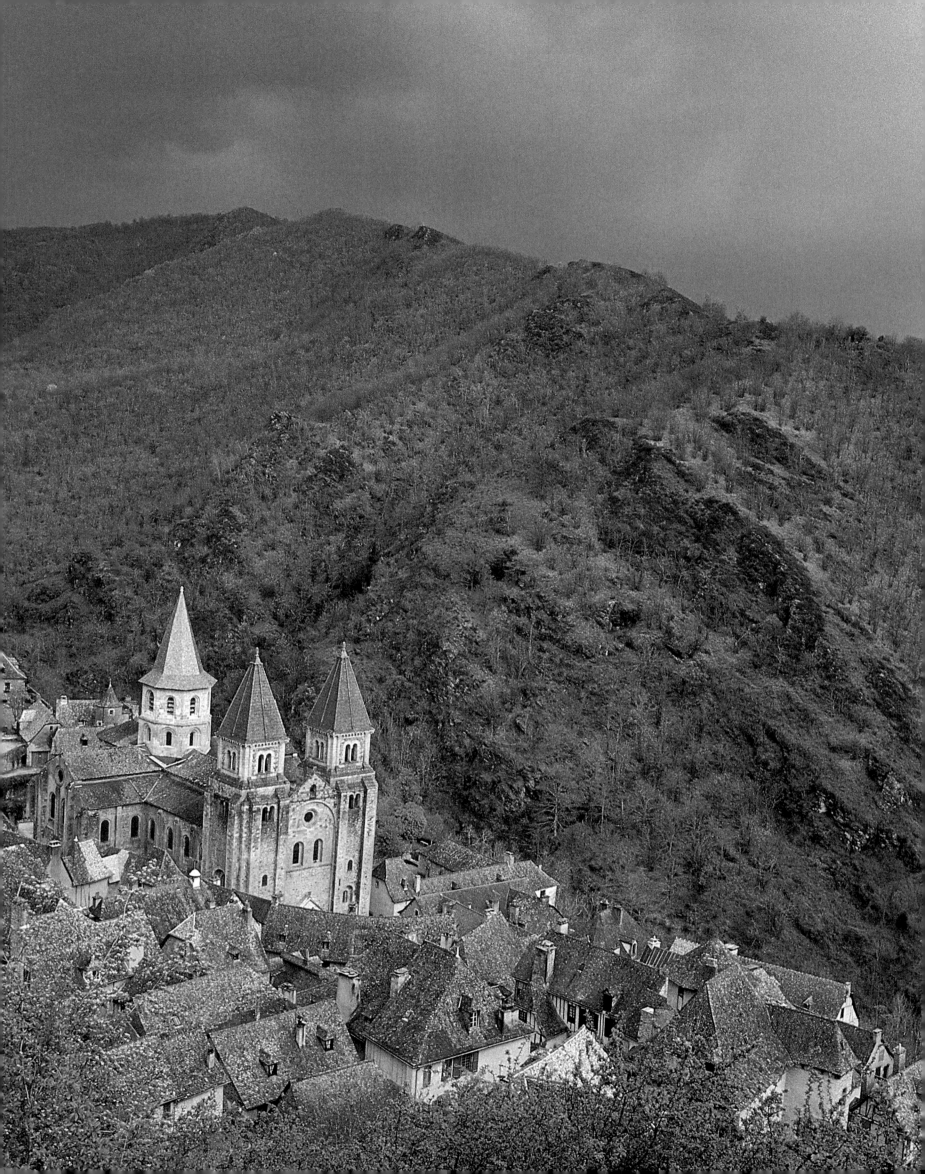

Towards the end of the 8th century, a saintly hermit called Dado chose this deserted spot in which to lead the contemplative life. A small monastic community developed around him. This soon benefited from the protection and donations offered by Carolingian monarchs, particularly Pépin II, King of Aquitaine in 838. The monastery, then dedicated to the Saviour, seems to have experienced a stagnant period later in the 9th century. Conques became famous, however, following the acquisition of the relics of Sainte Foy, or Saint Faith, a young martyr of twelve burned and decapitated in the time of the Emperor Maximian (286–305). To acquire them, one Ariviscus had spent ten years in the monastery at Agen in order to gain the confidence of his hosts. The miracles which occurred when the relics arrived attracted pilgrims and Conques became a stopping-point along the *via Podiensis*, a highway leading from Le Puy to Santiago de Compostela. This was one of the four major pilgrimage routes to the famous shrine. The great era of Conques, from the mid-11th century to the first thirty years of the 12th century, coincided with the construction of the abbey church. Pilgrims flocked here, and the many donations presented to the abbey enabled it to become wealthy and powerful, providing the basis for its artistic achievements. The abbots ruled over a veritable monastic empire and, together with those of Cluny, played an active part in driving the Muslims from Spain, founding churches or appointing bishops to newly created dioceses in Aragon and Navarre. The period of glory was short-lived, however. This was above all due to the competition provided by the new

Cistercian abbeys in Rouergue. In 1155 Conques relinquished its rights to the territories of Bonneval; founded just eight years earlier, the abbey there became the richest in the region. The situation was stable in the 13th century, although decline remained irrevocable. There were a few periods of prosperity, notably in the peaceful era which followed the Hundred Years' War and lasted until the Wars of Religion. The abbey was

then burnt by the Protestants in 1568, and subsequently abandoned and forgotten. The villagers even contemplated destroying the building; the cloisters were demolished in 1836. Fortunately the following year Prosper Mérimée, Inspecteur des Monuments Historiques, saved the church and campaigned for its restoration. Once the Premonstratensian Order had established itself here in 1873, the restoration project began.

The general lines of the Romanesque layout have been preserved despite modern alterations, notably the construction of a road through the village in the last century. The *Livre des miracles de sainte Foy*, compiled by Bernard d'Angers shortly after 1000, already mentions the existence of a 'large town' situated on a hill above the monastery. This was evidently no mere village, but an urban community. It had ramparts (very few traces of which remain, although the two entrances on the western side, the Porte de la Vinzelle and the Porte du Barry, have survived), as well as its own municipal institutions and a variety of commercial activities.

During the 18th and 19th centuries a large number of medieval houses were drastically altered, extensively renovated or even reconstructed, depending on the wealth of their occupants. This phenomenon occurred throughout France and Conques was no exception; some houses, like this one, still show the date of their 'restoration'. This fine door has probably kept its original wooden panels and its particularly noteworthy stone surround, featuring delicate moulding. The decoration includes a scallop-shell, which serves as a reminder of the time when Conques was a stopping-point along the pilgrim's route to Santiago de Compostela.

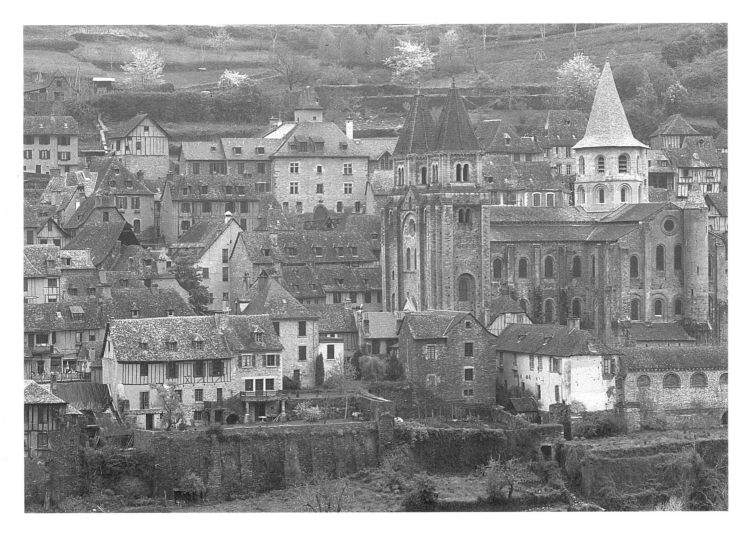

Conques is situated on the southern slope of a type of cirque formed by the widening of the gorge of the Ouche, near its confluence with the valley of the Dourdou. The village takes its name from the site, which is in the form of a shell (Latin *concha*). The Rue Charlemagne, lined with old houses, is clearly visible here as it descends the steep slope to a medieval bridge over the Dourdou. During the Middle Ages it was one of the main streets of the village, together with the *via Podiensis*, the pilgrims' highway leading from Estaing, which cuts through the upper part of Conques. Below, on the right-hand side, the chapel of Saint-Roch was built in the 16th century on the site of a castle no longer extant.  ▶

Few places are so strongly evocative of a bygone era as Conques. Once the lively bustle of the summer tourist season dies down, this modest village situated in the north of Rouergue lapses back into the age-old slumber from which it has momentarily been roused. Seen from the site of Le Bancarel, the old houses of Conques are dwarfed by the massive abbey-church of Sainte-Foy. The buildings form an exceptionally beautiful architectural ensemble.

We do not know how many inhabitants lived in the village at the height of its prosperity in the 12th century, but in 1341 Conques still contained 730 households (about 3,000 inhabitants). By the mid-18th century the population had dropped to under 1,000. The number immediately prior to the Revolution was just 630. There are 178 inhabitants in Conques today.

For further information:

*Histoire et légendes de Conques,* by Jean-Claude Fau, Éditions Dadon GIE, Conques 1982

'Quatre études pour l'histoire de l'abbaye de Conques', by Jacques Bousquet, in *Mémoires de la Société des Lettres, Sciences et Arts de l'Aveyron,* Rodez 1964

'Les plus anciens privilèges communaux de Conques en Rouergue et les débuts de l'organisation municipale (12ème s.–1289)', by Jacques Bousquet in the *Bulletin philologique et historique (jusqu à 1610) du Comité des Travaux Historiques et Scientifiques–année 1961,* Paris 1963

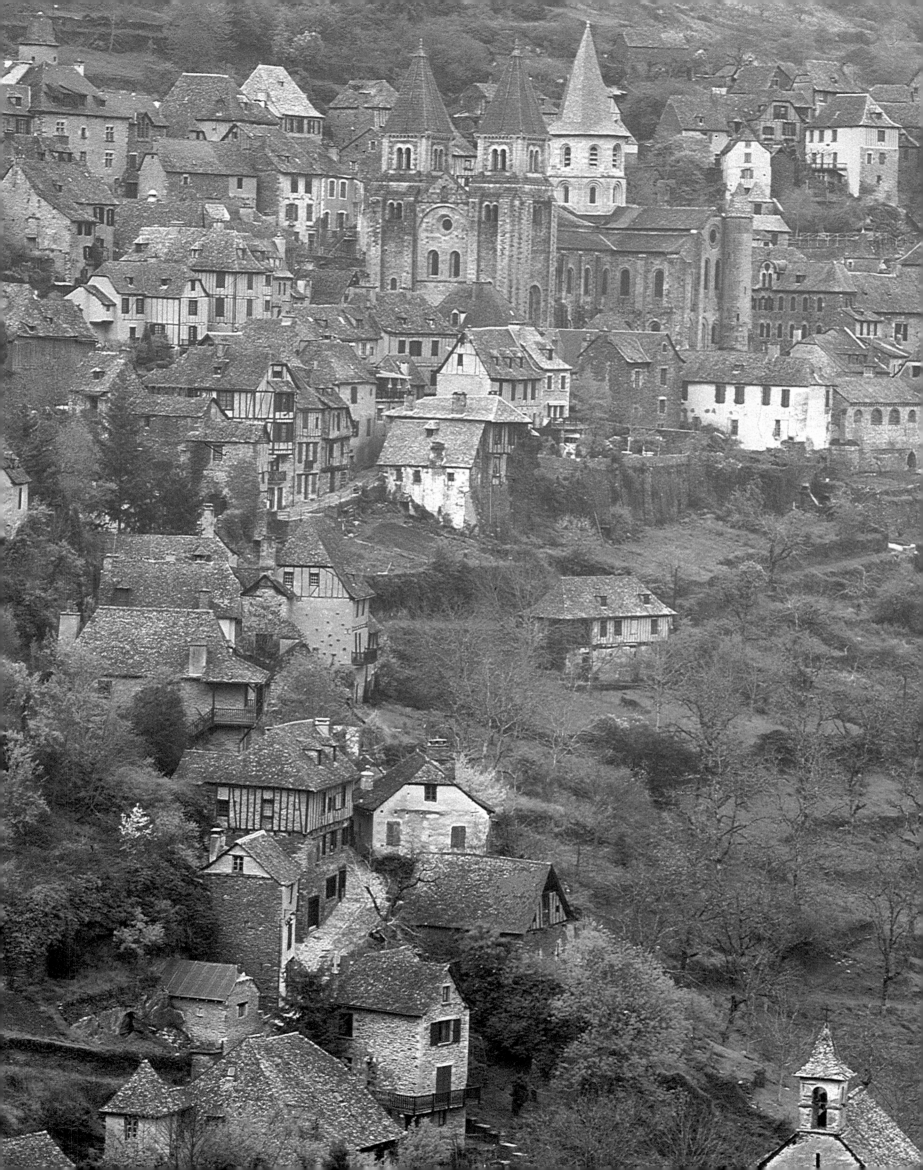

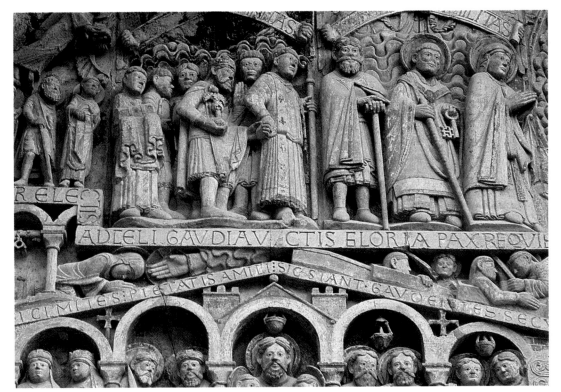

The heyday of Conques coincided with one of the most momentous eras in history, the remarkable spiritual and artistic renaissance that took place from the 10th to the 12th centuries, which gave rise to so many masterpieces. The treasures of Conques, one of the most powerful Benedictine abbeys in Christendom, have survived in a miraculous state of preservation. They include a magnificent wealth of gold work and a famous tympanum showing the Last Judgment, a detail of which is seen here. It probably dates from the early 12th century. Every one of the original 124 figures is still in place after more than eight hundred years.

The oldest houses in Conques date back only to the late Middle Ages. However, the way in which the village is adapted to its hill site, together with the uniformity of the building materials creates a general impression of harmony. Above and to the left, the Château d'Humières was constructed by a noble family in the 16th century. As well as the monks, aristocratic families of very ancient lineage resided in Conques. They are known to have had control over the village markets and to have played an influential rôle in the history of the abbey from the 10th century onwards.

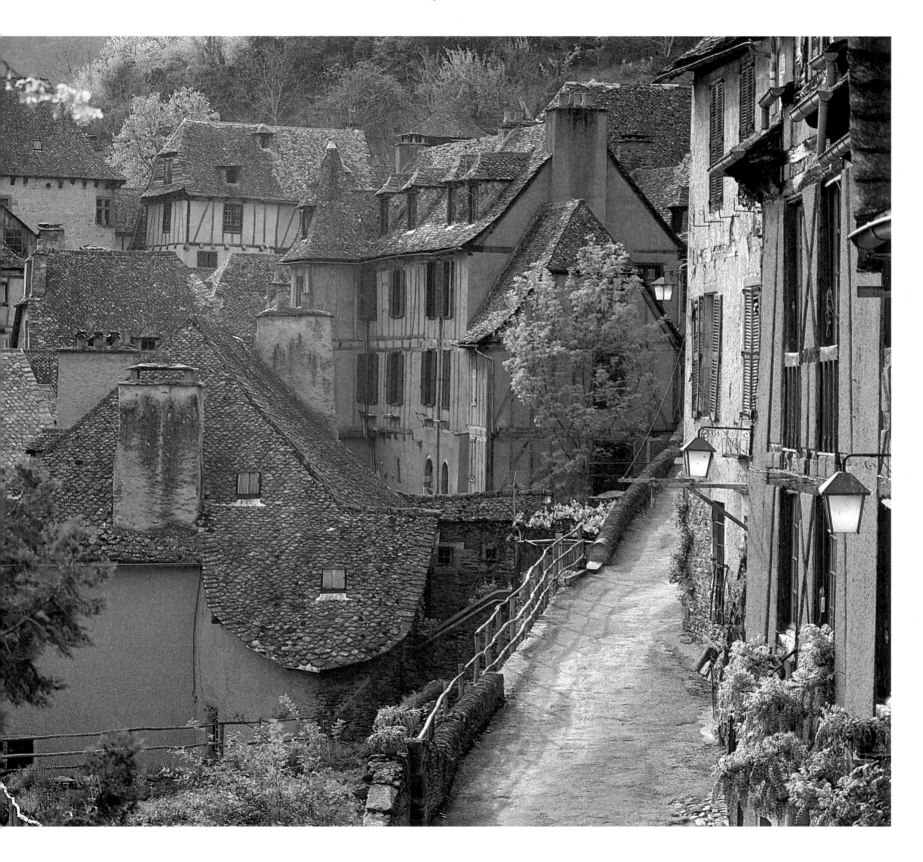

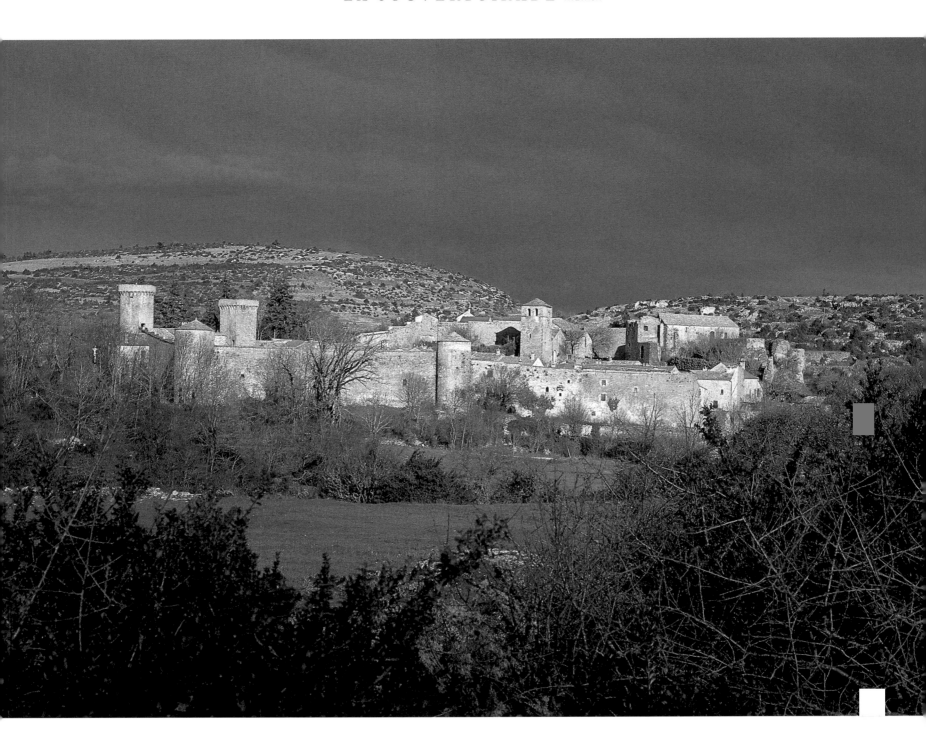

After a brief mention in the cartulary of the abbey of Gellone in the mid-11th century, the church and village are explicitly referred to in a papal bull promulgated by Innocent II in 1135. The arrival and settling of the Knights Templars is not recorded until the end of the 12th century. In 1312 the suppression of the Order led to their entire possessions being handed over to the Knights of Saint John of Jerusalem, known as the Hospitallers and later the Knights of Malta. The seigneurs of Mant pillaged the community during the 13th century. They were followed in the following century by the *routiers*, disorderly groups of soldiers who took advantage of the chaos created by the war with the English to menace the communities of Rouergue.

Faced with increasing instability, the Hospitallers decided to strengthen their major positions. Sainte-Eulalie, La Cavalerie and La Couvertoirade, whose ancient defences had been conceived before the invention of gunpowder, were becoming more vulnerable by the day. On 2 November 1439, the commander of Sainte-Eulalie authorized the construction of ramparts for La Couvertoirade and a contract was signed with a master mason named Déodat d'Alaus. By 1455 the work must have reached an advanced stage, or have been complete, as the bishop of Vabres allowed the inhabitants to build a wall across the cemetery adjoining the church. On 22 November 1562 this rampart was the scene of a battle between Protestant troops and the forces of the bishop of Lodève.

Having survived the Wars of Religion without incurring too much damage, the village was embellished by the addition of some fine houses in the 17th century. This seems to have been the period, when the population was at its highest, of the greatest prosperity in the community's history.

In 1349 La Couvertoirade consisted of 135 households (about 540 inhabitants). There were 149 households in 1581. There were still as many as 500 inhabitants at the beginning of this century, but the population has now dropped to 134.

For further information:

*La Couvertoirade*, by André Soutou, produced by the Association des Amis de La Couvertoirade, Millau 1977

Set in the arid region of the high limestone Causse de Larzac, La Couvertoirade is a breathtaking sight straight out of the Middle Ages. The village is surrounded by remarkably well preserved fortifications, with two main gates. The gate on the left is still surmounted by the high, square tower which served to defend it from intruders. The ruined castle, in the background on the right, is the only building which dates from the days of the Knights Templars (the 1200s). The church was probably reconstructed after the Order had been suppressed (14th century).

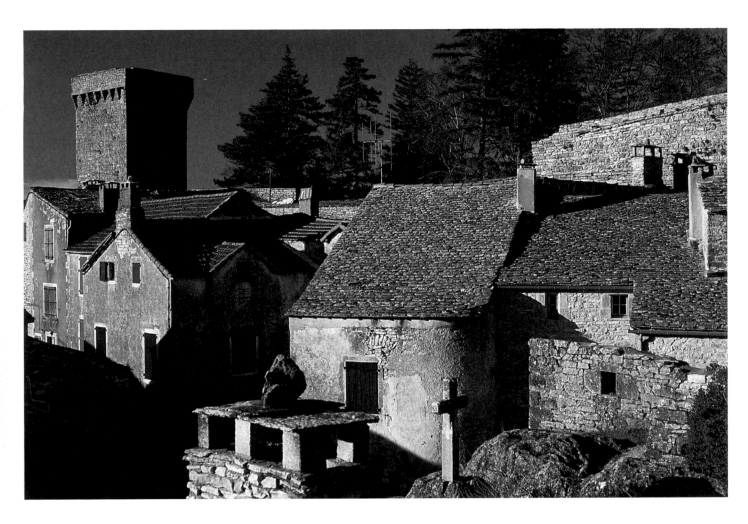

By the 15th century the castle had become too dilapidated to serve as a defence for the village. The intention was then for the ramparts to enclose the whole site, including castle, church and cemetery. Their most important function, however, was to safeguard the main water supplies, these being the natural reservoirs under the church and the large pond (now filled up) in the centre of the village. These sources of water were essential to the community's survival.

▶

The village houses are simple in style, but typical of building in this limestone region. They are unlikely to date from before the 18th and 19th centuries. Particular care was taken with the construction of the roofs, which are covered with flat stones (*lauzes*); as there is no spring or river, the inhabitants depended on rain for their drinking water. The roofs therefore served to collect the rainwater, filling a tank in each house. This method was in use up to 1975.

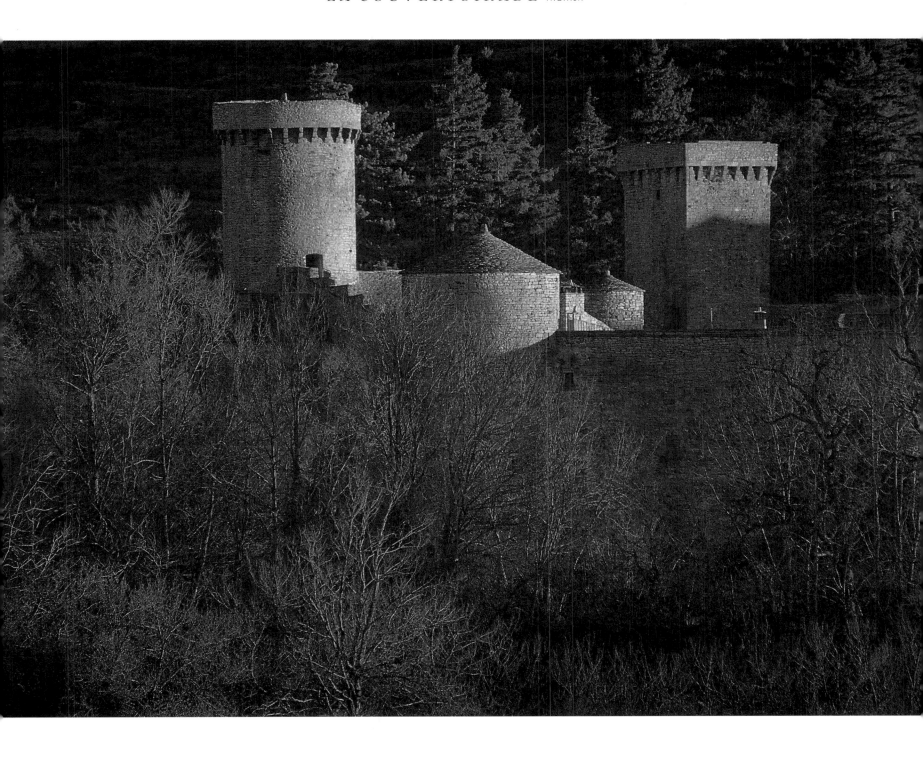

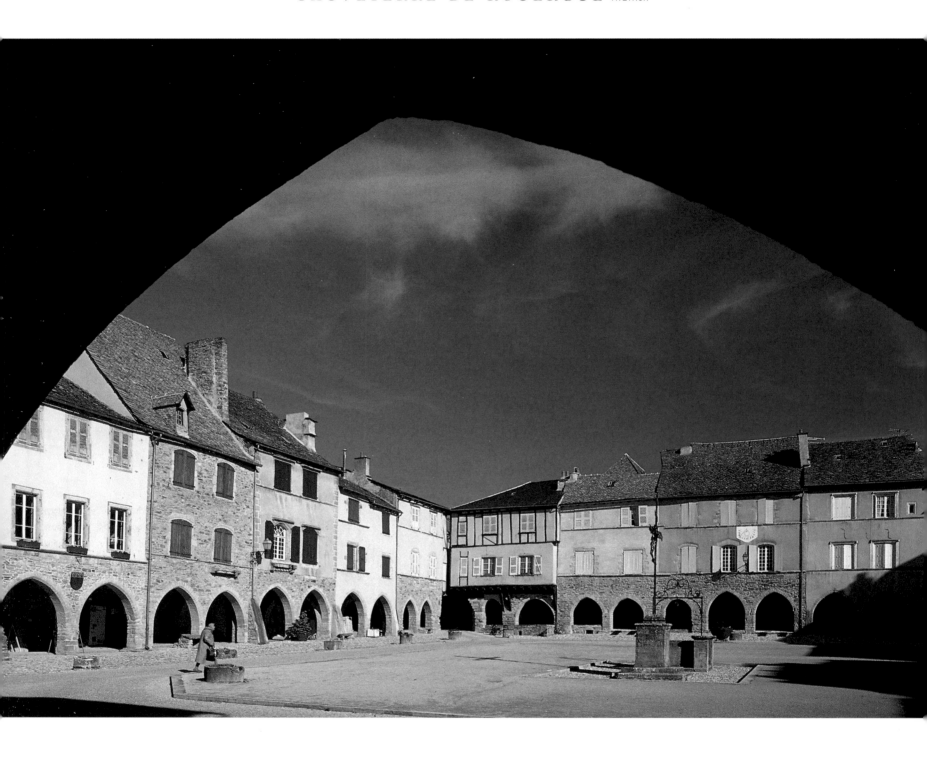

auveterre was founded in 1281 by Guillaume de Mâcon, seneschal of Rouergue, representing the French king Philippe III, le Hardi or 'the Bold'. A *bastide* had, however, occupied the site since at least the early 13th century. This may have been founded by the comte de Toulouse. The king of France, inheriting the land, simply enlarged the site, granting various franchises and privileges to the inhabitants who had come to settle there. Several mysteries surround the 'renaissance' which occurred in 1281, particularly the fate of a certain castle, the Château de Luzeffre. It is mentioned from the mid-12th century, but disappears from the written records after 1281, which may suggest that the *bastide* was built in its place.

In 1319, the village was enclosed by ramparts with four angle towers. A moat surrounded the wall. In 1342 the community was granted the privilege of building butcher's shops (*mazels*) and setting up a cloth-manufacturing centre. During this period the village was financially supported by the Crown; this enabled the crafts to flourish. The art of cutlery-making was especially prominent. From the 16th century onwards, however, the little town fell into a gradual but inexorable decline. The process continued up to the 19th century, exacerbated by famine, plague, isolation, the decline in the craft industries and so forth.

The village had expanded quite rapidly; there were 42 households (*feux*) in 1297, compared with 291 in 1328. Prior to the Revolution the population was about 850. Sauveterre has 371 inhabitants today.

For further information:

*Documents pour servir à l'histoire de Sauveterre-de-Rouergue*, collected by Jean Delmas and Pierre Marlhiac, Éditions ASSAS, Sauveterre 1981

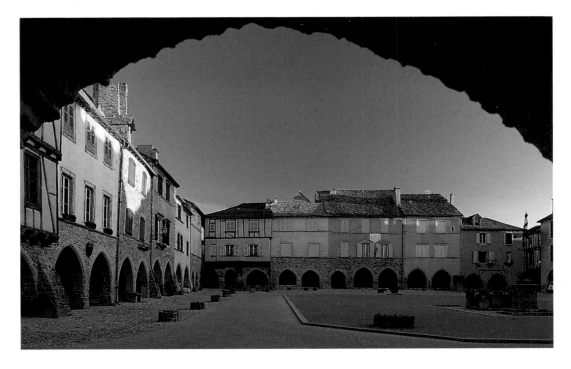

◄

The vast main square forms a rectangle measuring 60 by 40 metres (65 by 45 yards). In the centre there is a communal well and a wrought-iron cross dating from 1782. The square is surrounded on all sides by covered walkways supported on arches, most of which are pointed. These walkways were used to display wares during the weekly markets. Some of the houses here have retained fine old front doorways.

The main square in Sauveterre is unquestionably one of the most remarkable in France. Its exceptionally large size reflects the ambitions of those who founded the community in the Middle Ages. The surrounding houses have been carefully restored; by order of the Ministère de l'Équipement, each has a different type of rendering. Seen in the background, in the northwest corner of the square, the Maison Unal with its unequal pointed arches gives us some idea of the other buildings to be found here during the late Middle Ages. The ground floor is made of freestone, the upper part of wood with cob infilling. The most characteristic feature of all is the façade, with its corbelled construction on two floors.

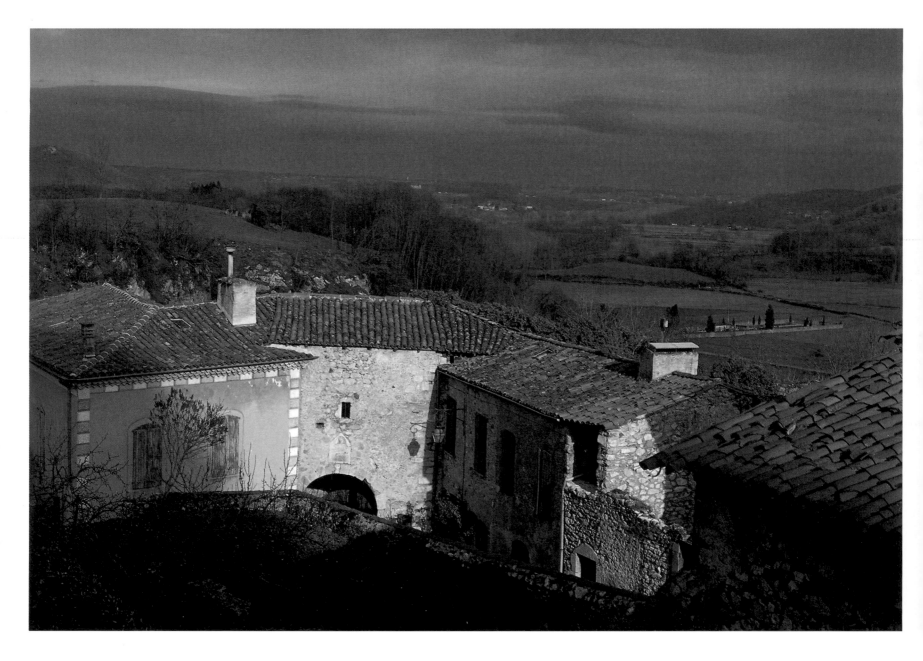

To the west stands the Porte Majou, called the *porta major* in 1207. It was probably the main entrance to the medieval town and housed the prison in the 18th century. The Roman tombstone of a hirer of chariots is embedded in the wall above the arched gateway. The ochre-coloured house on the left stands on the site of the former Hôpital Saint-Jacques, destroyed by the Protestants in 1586. It was rebuilt in the lower village shortly afterwards.

**These two carved Roman stones were set above the Porte Cabirole by Mgr Gilbert de Choiseul (bishop 1646 to 1670). On the left is an inscription (unfortunately incomplete) dedicated to the Emperor Claudius in AD 52: 'To . . . 26 times hailed as Emperor, 5 times Consul, Father of our land, the city of the Convenae.' On the right is the famous she-wolf of Rome.**

The Roman town which preceded the medieval community of Saint-Bertrand-de-Comminges had acquired great importance in the reign of the Emperor Augustus. This has come to light in the archaeological digs that have been carried out since the beginning of this century. It was the capital of the territory of the Convenae, known as Lugdunum Convenarum. The city became extremely prosperous and, before the middle of the 2nd century AD, its status had risen to that of a Roman colony. Partially pillaged by the Vandals in 408, Lugdunum lost its importance after the fall of the Roman Empire in 476. It was finally ransacked by the Franks in 585. The city remained in ruins for five hundred years, before Bishop Bertrand de l'Isle Jourdain rescued it from extinction in the 11th century. Our information about him comes from the *Vita* written by a clerk forty years later. Born *circa* 1050, Bertrand was appointed bishop of Comminges in about 1083. He rebuilt the upper town and its church in forty years, erecting a Romanesque cathedral on the main square, which had been devastated by previous attacks. Around the cathedral he constructed an episcopal city, attracting new settlers. This bishop of the Gregorian reform movement, a builder and miracle-worker, was responsible for the rebirth of the town that came to bear his name. Pilgrims flocked to his tomb and he was finally canonized in 1175, a fitting end to the story. His work was continued two centuries later by another bishop, Bertrand de Got, who rebuilt the cathedral in the Gothic style. He later became Pope Clement V. In this capacity he issued a bull in 1309, declaring a pilgrimage to Comminges and Jubilee. He came to the town in person to conduct the elevation of the relics.

During this period the bishops owned an extensive lordship around the town, as well as several episcopal palaces. They presented the town of Saint-Bertrand with a charter in 1207. Several bishops completed the work begun by their predecessors, most notably Pierre de Foix (1422–51) and Jean de Mauléon (1523–51). The destruction and pillaging rife during the Wars of Religion did not spare Saint-Bertrand, foreshadowing

The church of Saint-Just-de-Valca-brère is surrounded by fields, lost in the heart of the countryside. It is one of the loveliest Romanesque churches in the Pyrenees. The building is surmounted by a solid square bell-tower and reuses much Roman work, blocks of stone, columns, bas-reliefs and inscriptions salvaged from the ruins of Lugdunum, making it a museum of Gallo-Roman antiquities. The high altar was consecrated in 1200 by the bishop of Comminges. Seen in the background, the upper town is still partially surrounded by the ramparts that the Romans constructed against the barbarian threat. This wall was altered in the Middle Ages; it had three gates, the one pictured here being the east entrance, known as the Porte Cabirole, which underwent modifications in the 18th century.

the suppression of the bishopric during the Revolution (1790). The town subsequently began to fall into decline. It lost its status as capital of the *canton* in 1887, becoming a simple Pyreneean village, with just 288 inhabitants. The only traces of its past grandeur are the pilgrims – and, happily, now the tourists.

Today the upper and lower parts of the town comprise a total of only 137 inhabitants.

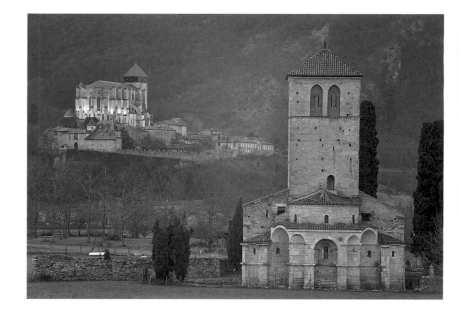

The upper village was known as the *civitas Convenarum* in the 12th century, becoming Saint-Bertrand only in 1222. It is dominated by the massive cathedral (late 11th–16th century), with the famous wooden belfry (*hourd*) to its tower. In the Middle Ages this vast building was surrounded by its own fortified wall, known as the *scepte*. The enclosure also served originally to house the bishop and the chapter. Today only the cloisters remain.

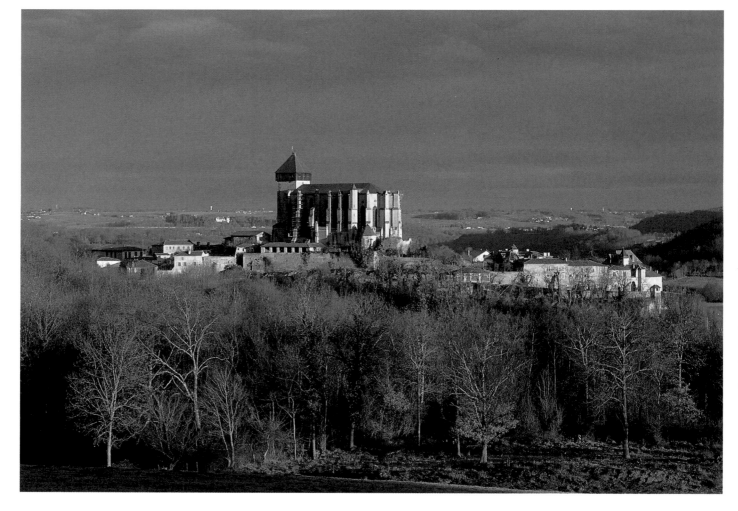

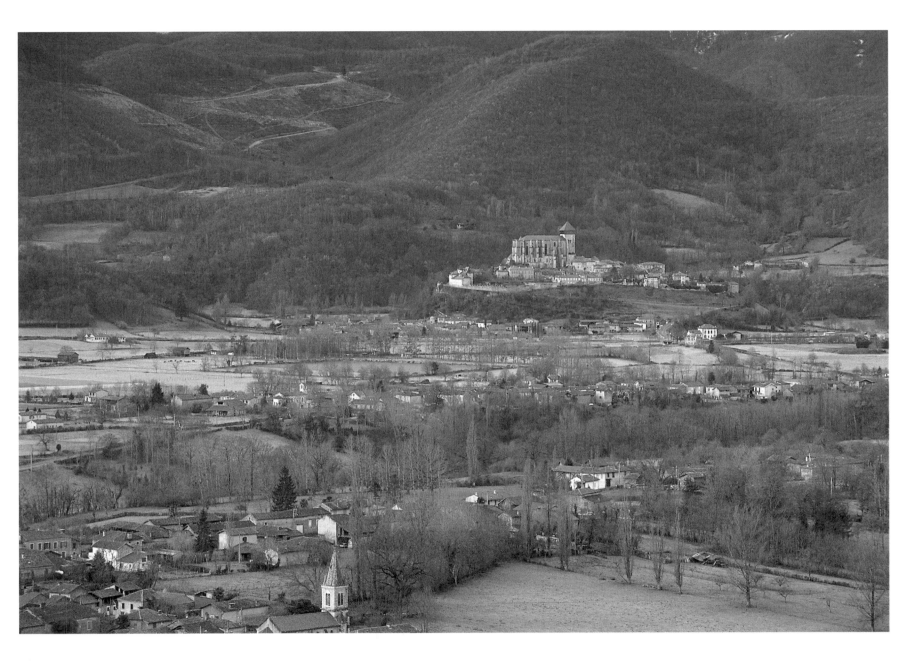

The village of Labroquère can be seen in the foreground of this photograph. In the middle distance, the village of Valcabrère stretches along the Garonne. Between Valcabrère and the hill of Saint-Bertrand, in the distance, stood the Roman city of Lugdunum Convenarum. Its grand centre occupied the foot of the hill. The lower village, which can be easily dis-tinguished here, adjoins the remaining traces of the amphitheatre and the Early Christian basilica (5th century). Like the upper village, the lower village was fortified in the Middle Ages. It was built around a vast public square known as the *foirail*. Fairs and markets were held here from 1309 onwards.

For further information:

*Guide Bleu Midi-Pyrénées*, Hachette, Paris 1989

*Le comté de Comminges de ses origines à son annexion à la Couronne*, by Charles Higounet, 2 vols., Toulouse 1949

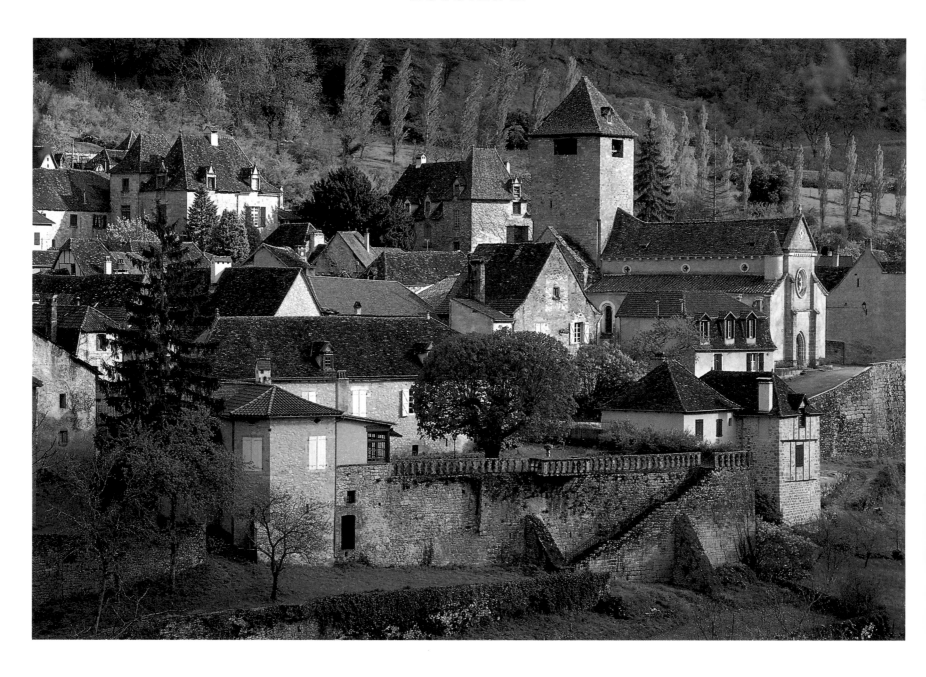

The church, dedicated to St Peter, appears to be the oldest monument in Autoire. It is a Romanesque structure which was enlarged and altered in 1868/69 and later. It was fortified during the Hundred Years' War, forming a single stronghold with the Château des Peyrusse de Banze. The Place de l'Église and the large wall supporting it here, on the west side, are still known collectively as 'the fortress'. The castle, which is now the town hall, can be seen on the extreme right of the picture.

◄

The earliest mention of this village occurs in the cartulary of the abbey of Beaulieu (895). In feudal times the castellany of Autoire formed part of the estates owned by the comte de Toulouse. It then passed to the vicomte de Turenne, as the village was situated on the borders of the vicomte's domain and the region of Quercy. In 1286, Autoire was included in a list of sixty-three fiefs in Haut-Quercy given up to the king of England. During the Hundred Years' War the fort of Autoire (situated a little distance from the village) was

burnt churches and demanded ransom from the local inhabitants. In 1562 Marchastel, Lieutenant of Duras, set fire to Autoire. In 1588 the fort was occupied by one Jean Mollé, an adventurer calling himself Capitaine Vinsou. The vicomte de Turenne summarily ordered him off the premises. The act of surrender was presented to the vicomte by Jean Mostellat, Governor of Saint-Céré. It is still preserved in the archives of the town hall at Autoire.

According to the Danglars register, the parish of Autoire had 500 communicants in the late 18th

Autoire nestles in a little gorge culminating in a cirque which cuts deeply into the limestone plateau of Gramat. The village has retained some large houses built by the bourgeoisie, the majority of which date from the end of the Wars of Religion. These are small châteaux in their own right, and give the village a distinguished, prosperous appearance. ►

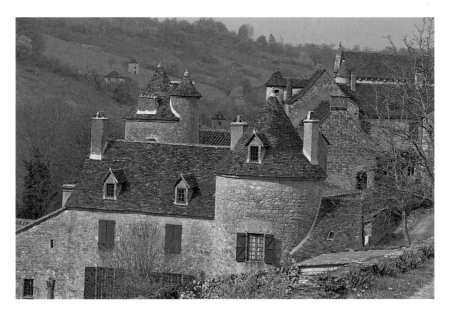

The Château de Limargue (seen here from the south side) is a fine building which dates from the 1500s. According to legend, this little castle was constructed by a certain Lafon, who had been to war in Italy and acquitted himself with honour, doing full justice to the *furia francese*. To reward his brave exploits, Charles VIII (1483-98) gave him a knighthood and granted him the rare privilege of machicolation, that is, of building a residence with towers and battlements.

one of the numerous hideouts from where English gangs and companies of soldiers set out to lay waste the countryside. The fort is now in ruins and known as the Château des Anglais. In 1378 the castle fortress was occupied by Bernard de la Salle, captain of a company and a native Gascon renowned for his prowess at scaling the most formidable walls. The Wars of Religion brought more turmoil to Haut-Quercy: the Calvinists

century. Today the community numbers 233 at the most, 109 of whom live in the village itself.

For further information:
*Monographies du chanoine Albe* (*circa* 1920), departmental archives of Lot at Cahors
'Autoire, vieux souvenirs', by Louis Gineste, in *Bulletin de la Société des Études du Lot*, vol. LXXIV, 1953

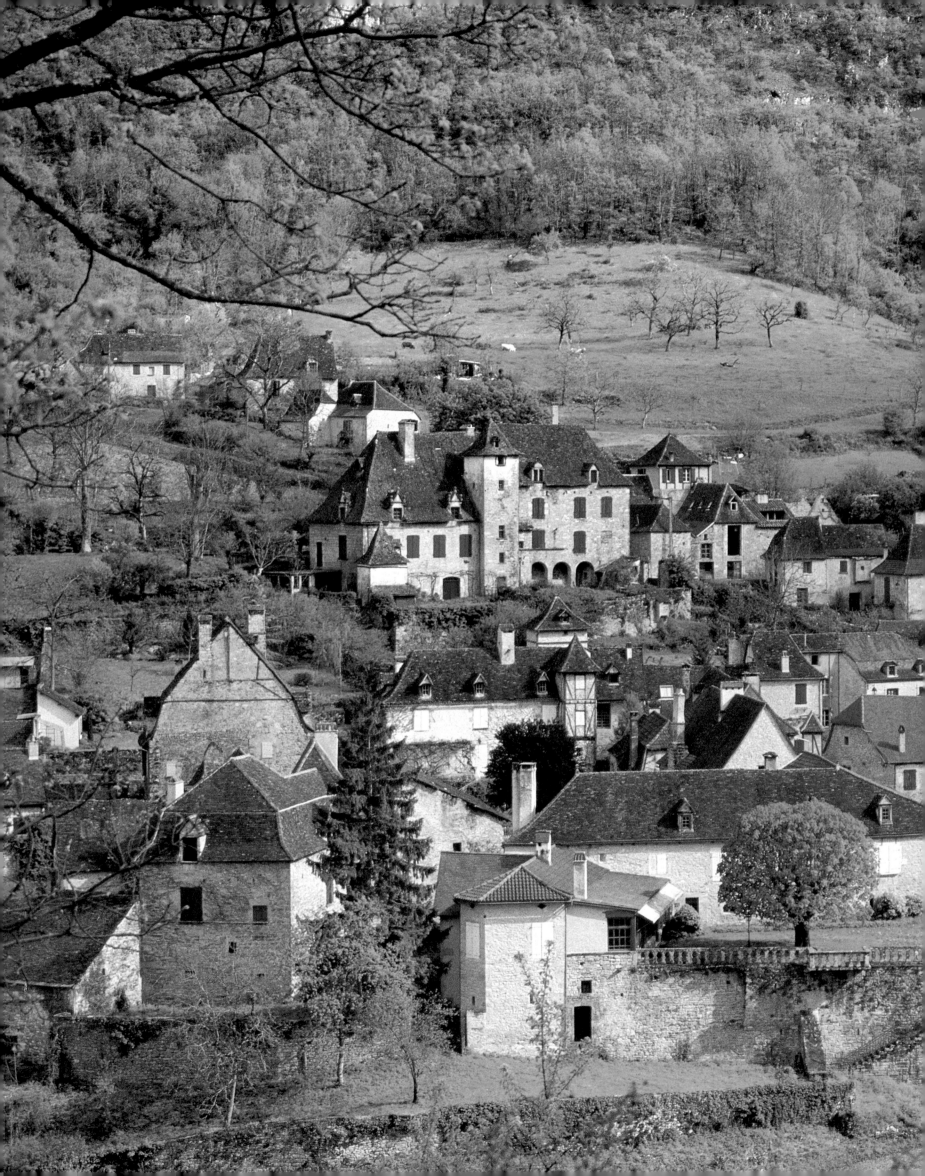

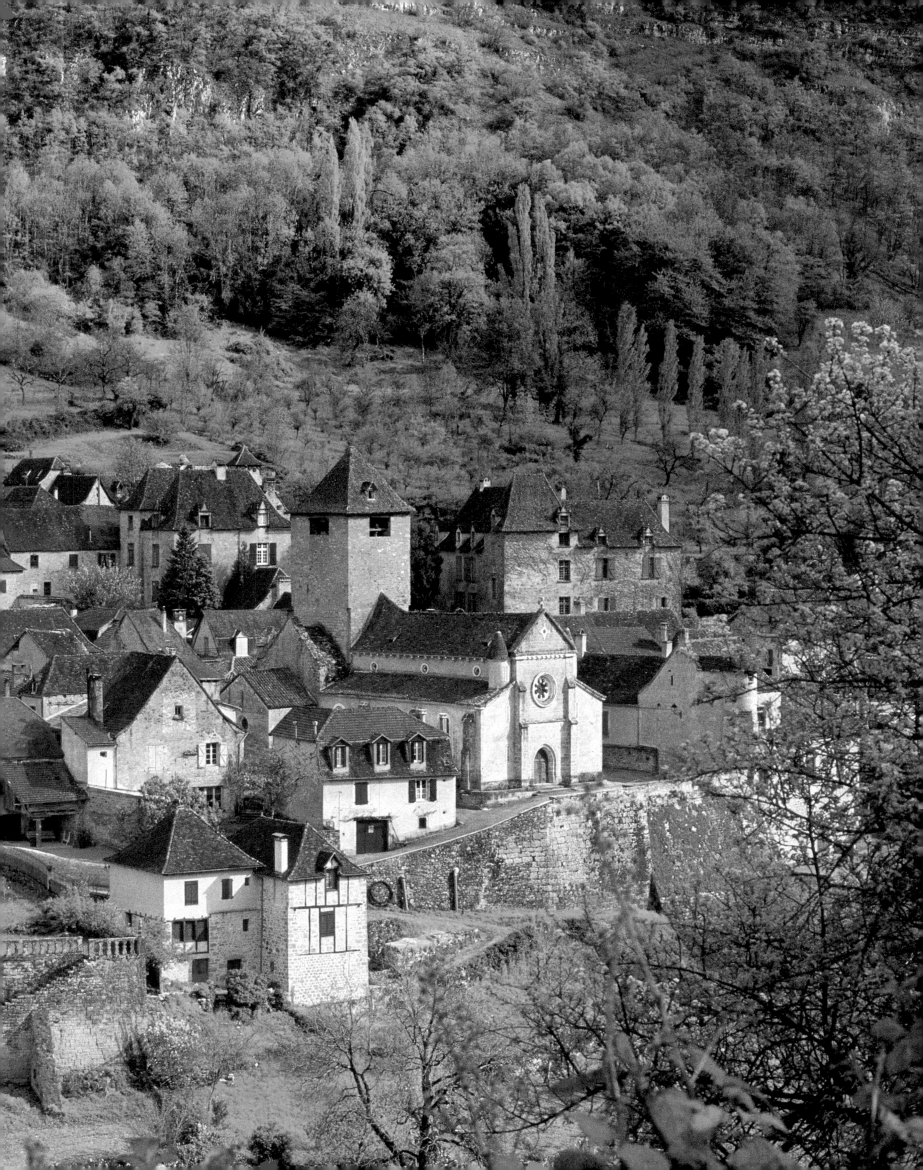

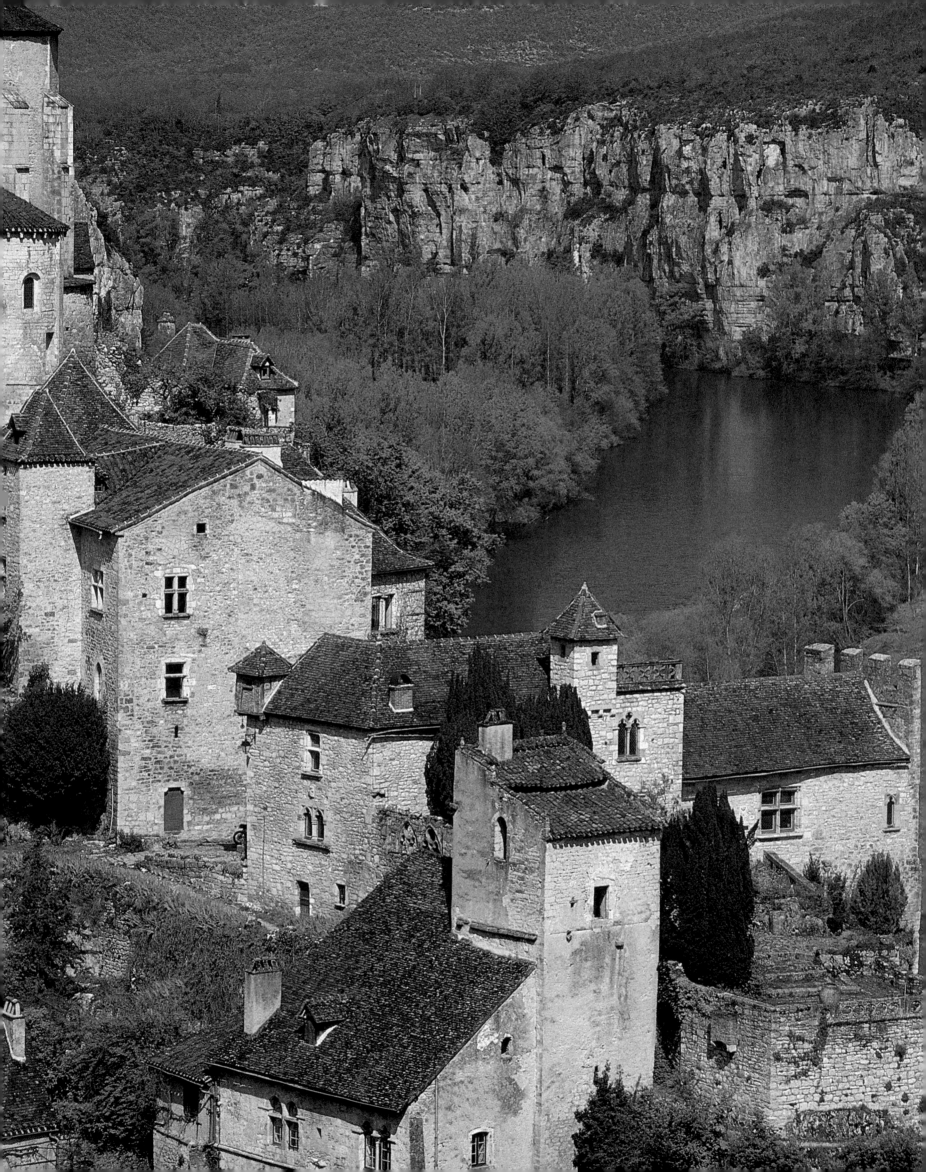

The first recorded event in the history of Saint-Cirq is a vain attempt to seize the fort made by Richard the Lionheart in 1199. It had begun to play a strategic role from the 8th century, however, as it commanded the valley of the Lot. It remained a point of strategic importance until the end of the Wars of Religion. In the Middle Ages the fief was shared between several jointly ruling seigneurs. The first charter of the customs of Saint-Cirq (1231) reveals the names of the three families who jointly owned the fief; the Gourdons, the Cardaillacs and the La Popies (after whom the village is named). Each had their own castle and in the 14th century the village was overlooked by these three adjoining residences. From the highest point rose the keep of the La Popie castle; it was razed to the ground in 1471 by order of Louis XI, as Raymond d'Hébrard de Saint-Sulpice, successor to the La Popie family, had allied himself with the duc de Guyenne. The other two castles stood 'on the slopes of the *pech*'; access from the castle of the La Popie family to that of the Cardaillac was afforded by *une portanelle*. The castle was besieged by the English several times in the course of the Hundred Years' War – notably between 1351 and 1392. It was sometimes taken, but always reclaimed. During the Wars of Religion the Huguenots took the castle, on 10 April 1580. A few months later Henri de Navarre ordered the structure to be 'demolished, razed to the ground and left in such condition that no force from the enemy side can henceforth take advantage of it'. Even after the demolition, however, a garrison remained at Saint-Cirq-Lapopie. In 1591 the Protestants besieged the village a second time, but the Cardaillac family, who had been influential Protestants, converted to Catholicism. In more recent centuries the artisans of Saint-Cirq, skilled in the working of wood, extended the fame of their community far beyond the borders of Quercy, for turning, moulding and tap-making. Commerce and industry subsequently fell into decline and the river transport on the Lot, which thrived during the last century, finally disappeared. Despite this Saint-Cirq is far from being a dead village. Rediscovered at the beginning of this century, the development of tourism here has made the village an obligatory stopping-point for any visitor passing through Cahors.

In the 19th century, when the traffic on the Lot was at its peak, the population of Saint-Cirq-Lapopie reached nearly 1,500. Today there are at most 179 inhabitants in the whole commune.

For further information:

*Saint-Cirque-Lapopie, miettes d'histoire*, by Jean Fourgous (1881–1963), a tourist brochure produced by the Société des Amis de Saint-Cirq-Lapopie

'Notes sur Saint-Cirq-Lapopie', by Chanoine A. Foissac, *Bulletin de la Société des Études de Lot*, vol. LIV (1933) and LV

*Monographies du chanoine Albe* (*circa* 1920), departmental archives of Lot at Cahors

Some of the loveliest countryside in the valley of the Lot can be seen from Saint-Cirq. Its old houses merge perfectly into this remarkable landcape, creating an ensemble rarely found in France today: in this case the setting is truly worthy of the jewel.

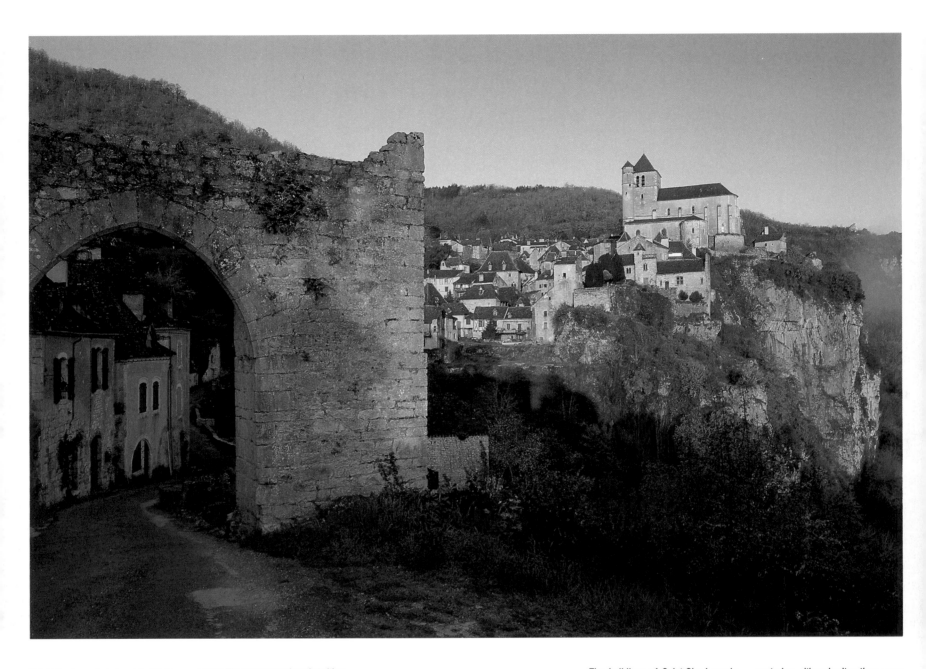

Saint-Cirq-Lapopie belongs to the category of villages set out along a main street, which climbs the steep slope of the valley. The street is known by different names at certain points; here in the lower part of the village, it is the Rue de la Pelissaria, becoming the Rue de la Peyrolerie in the upper section. It was formerly divided into more or less distinct quarters or *barrys*. The street was closed at either end by heavy wooden gates. Little remains of the gateway known as the Porte du Haut, but that at the lower end of the village, known as the Porte de Rocamadour, is still in place.

The buildings of Saint-Cirq-Lapopie constitute an almost perfectly harmonious medieval whole. The village is unquestionably one of the loveliest in France. Exceptional circumstances have favoured the preservation of an almost entirely homogeneous settlement predating the 1550s. The well restored old houses of Saint-Cirq were built between the 13th and 16th centuries, although alterations were naturally carried out at later dates. Most of these houses, like the one shown here, have façades with corbelling (sometimes on two levels) and timbers characteristic of decoration or reconstruction work carried out between the end of the Hundred Years' War and the early 16th century.

▶

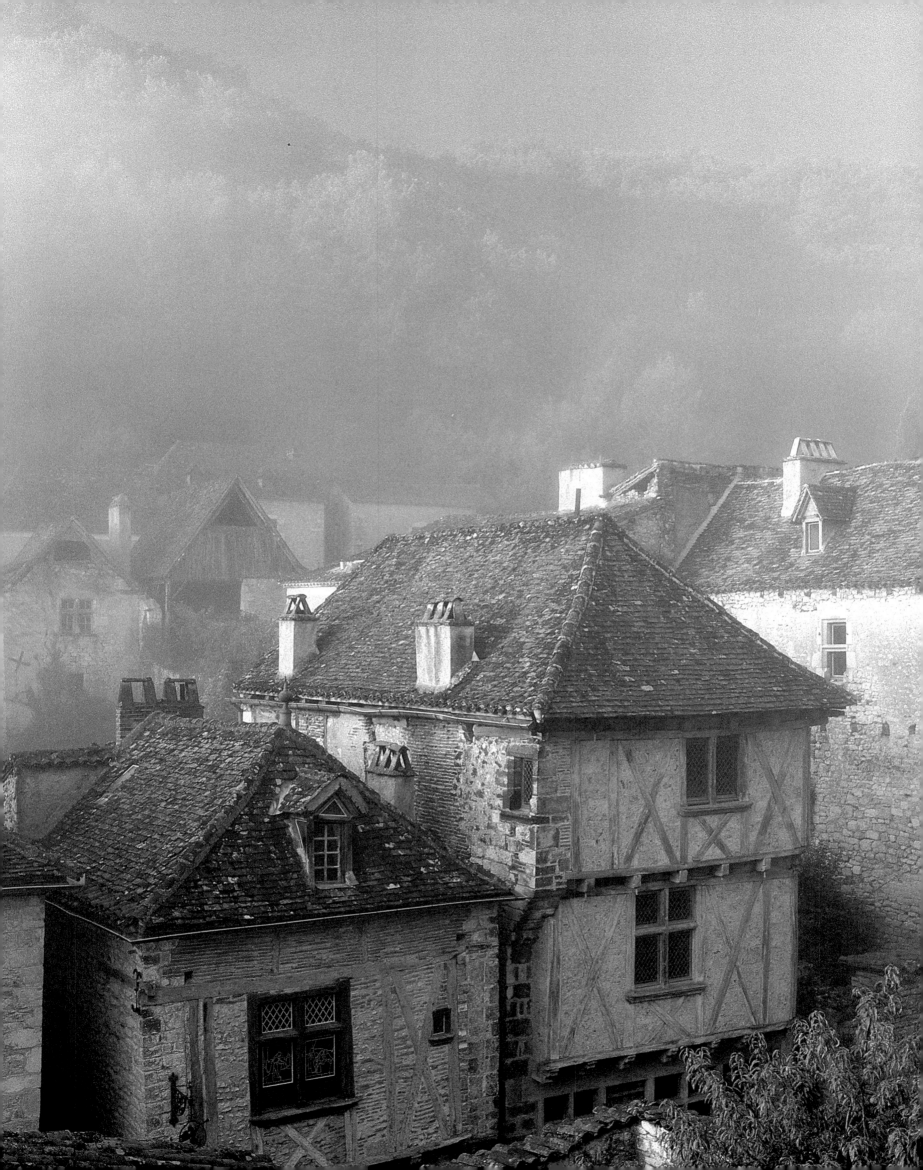

The sturdy Porte de Rous, also known as the Portail Peint (or 'painted gate'), is on the east side of the first wall. As this beautiful window suggests, it was modified in the 1500s. In common with its matching counterpart on the west side (the Porte des Ormeaux), it was closed by two portcullises, on either side of the wooden gates. Today it houses the Musée Charles-Portal, a small museum of local archaeology. The Maison Gorsse in the background is the most beautiful Renaissance house in Cordes.

◄

This photograph of the Grand' Rue descending towards the Porte des Ormeaux shows the pride of Cordes – a group of Gothic façades, which together have no equal anywhere in France. They were built during the period of prosperity in the village, the oldest between 1295 and 1320, the most recent in the mid-14th century, such as the Maison du Grand Veneur pictured here. They have various features in common. The stone used for the façades came from the sandstone quarries of Salles, and they also share certain architectural details – a ground floor with arcades, twinned windows painstakingly decorated, and string-courses joining the capitals and running below the windows. Individual sculptors introduced a wide variety of amusing elements into the carved reliefs, which have specific themes. Each house offers its own version of the common set of architectural features. This individuality is above all apparent in the variety and detail of the carved decoration. ►

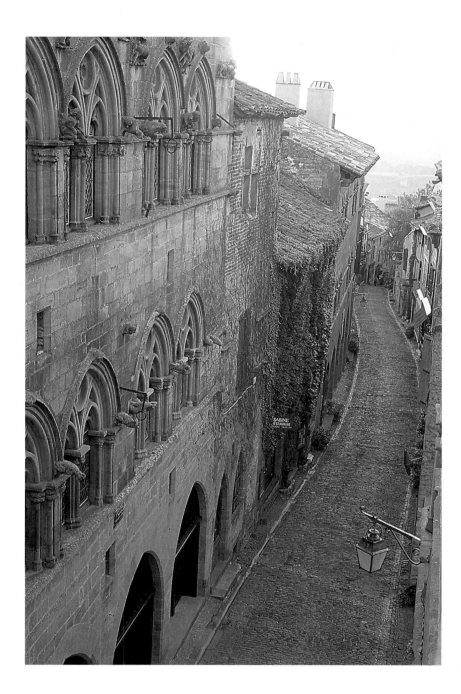

ordes was founded in 1222 by Raymond VII, Comte de Toulouse. The Albigensian Crusade of this period caused havoc in the region. Simon de Montfort's troops burnt the nearby village of Saint-Marcel and the fleeing inhabitants, driven from their homes, were left without means of defence. The foundation of Cordes therefore provided a haven for the homeless inhabitants of neighbouring towns, who had been dispersed all over the region, victims of the crusade against the heretic Cathars.

The new *bastide* soon flourished. Seven years after its foundation, the Treaty of Paris stipulated that the site was to be handed over to the king, together with others reputed to be the strongest fortresses in the region.

Upon the death of Raymond VII in 1249, his estates were bequeathed to his daughter Jeanne. The latter, in accordance with a clause in the treaty, had married Alphonse de Poitiers, brother of Saint Louis. The couple died without issue in 1271 and the Toulouse territories, as stipulated in a further clause in the Treaty of Paris, were repossessed by the Crown. The only seigneurs of Cordes were therefore Raymond VII, his daughter and the kings of France.

Towards the end of the 13th century and during the first thirty years of the 14th century, the community experienced a period of great prosperity. A number of town's people, who had made fortunes through commerce and the leather industry, built elegant houses. Today these are a source of great pride in the village, together comprising one of the finest ensembles of civil Gothic architecture in Europe. In 1353 Jean le Bon authorized the reconstruction of the covered market, no doubt a measure of the success of the leather and cloth industry. These benefited from the period of peace and also perhaps from a temporary weakening or the distant location of competitors. The 15th century marked a decline. In 1439, the future King Louis XI arrived in Languedoc, in order to put an end to the 'theft

The Maison du Grand Veneur ('of the master of the royal hunt') takes its name from this frieze in high relief, of a hunting scene. From left to right: a horseman armed with a hunting-spear (out of the picture) is preparing to strike a wild boar, which a hound has flushed out of the forest; this is depicted as a tree with large fruits. Another huntsman, on foot, is firing an arrow at a hare larger than the hound which is hot on its heels. A third huntsman is sounding his horn to round up the hounds, whilst in the background two wild boar run to take cover in a wood, again represented by a single tree.

and pillaging' perpetrated by the Albigensians. He came to Cordes on 23 October. During the Wars of Religion the village almost invariably upheld the Catholic cause, which led to Huguenot attacks in 1568 and 1574. The fortunes of the village deteriorated relentlessly up to the Revolution, as a result of the plague (there was a terrible epidemic between 1629 and 1632), and a famine which occurred in the early 18th century.

It was not until much later, in 1870, that Cordes was to enjoy a revival. This was due to two local inhabitants who imported a new industry, the manufacture of machine-made embroidery, from the Swiss town of Saint-Gall. The venture proved a brilliant success; three hundred embroidery-frames assured the prosperity of the village. Unfortunately, however, fashions change and in the 1930s Cordes once more became a sad, quiet community. This period nevertheless came to an end ten years later when Jeanne Ramel-Cals, Yves Brayer, Bizette Lindet and Georges Neveu founded the Académie de Cordes-sur-Ciel, attracting the first tourists.

During the golden age of the village, the population was probably between 5,000 and 5,500; as high as that of Albi. Today only 852 inhabitants live in Cordes.

For further information:
*Cordes, notice historique et archéologique*, by Charles Portal, Société des Amis du Vieux Cordes, Cordes 1981

Seen here from the bell-tower of the church of Saint-Michel, the upper part of the village (also known as the Fort) formed the original *bastide*. It was surrounded by two enclosures completed in 1222. The Rue de l'Église (right) and the Grand' Rue, converge on the massive Porte des Ormeaux, built into the first wall. In the background on the left, the Maison du Grand Écuyer (or Maison Séguier) overlooking the Grand' Rue, is perhaps the least ancient of the town's Gothic houses. Its date is suggested by the delicacy and sublime quality of its carved decoration. ▶

▶▶
The village stretches out on an isolated hill (the Puech de Mordagne), dominating the valley of the Cérou. There is a sheer drop on the south side (left) and the others are steeply sloped. In the 13th and 14th centuries, new *faubourgs* were built, clinging to the hillside below the upper part of the village. The new sites were protected by a third wall, then a fourth and even a fifth, built to enclose the area known as La Bouteillerie, seen jutting out in the foreground. This explains why Cordes is sometimes considered a mighty fortress, in spite of the absence of a feudal castle or keep. The history of the village, however, belies this status.

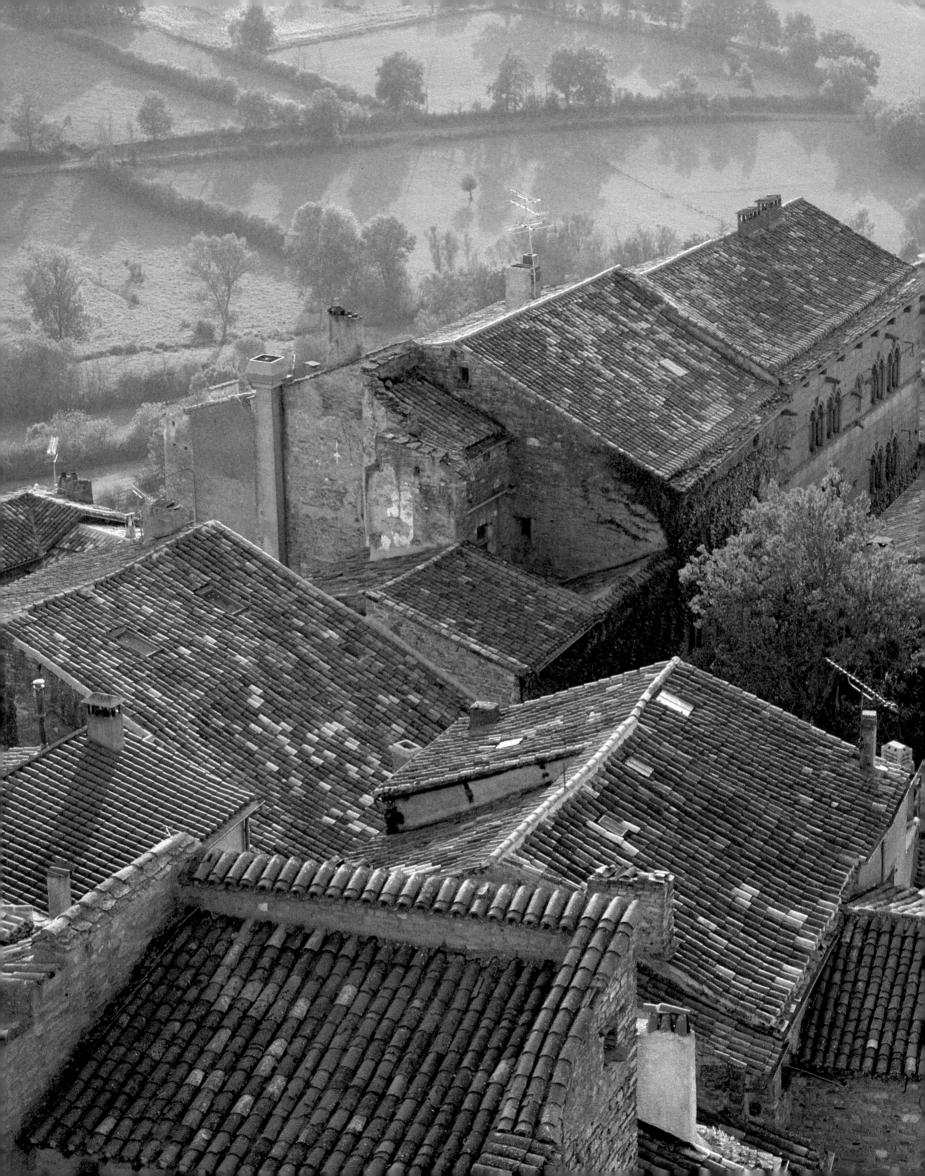

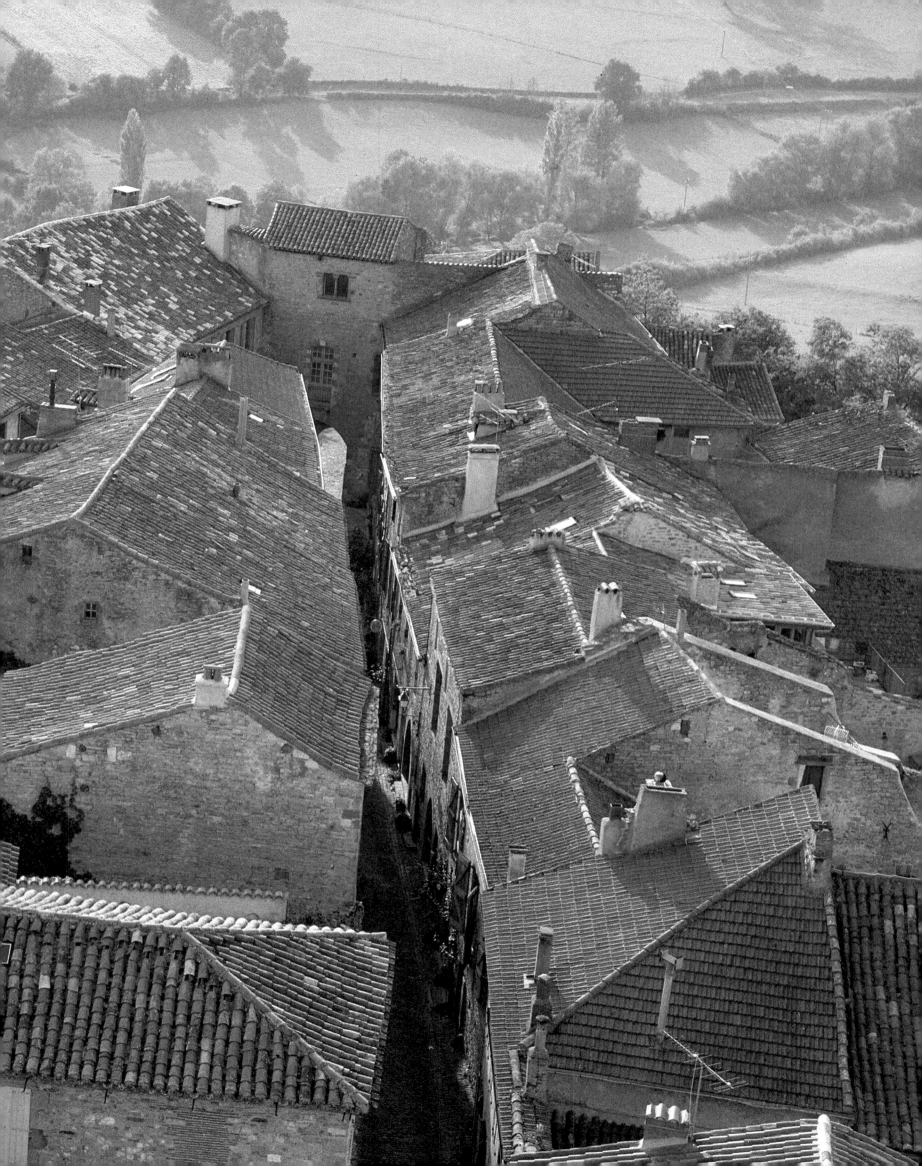

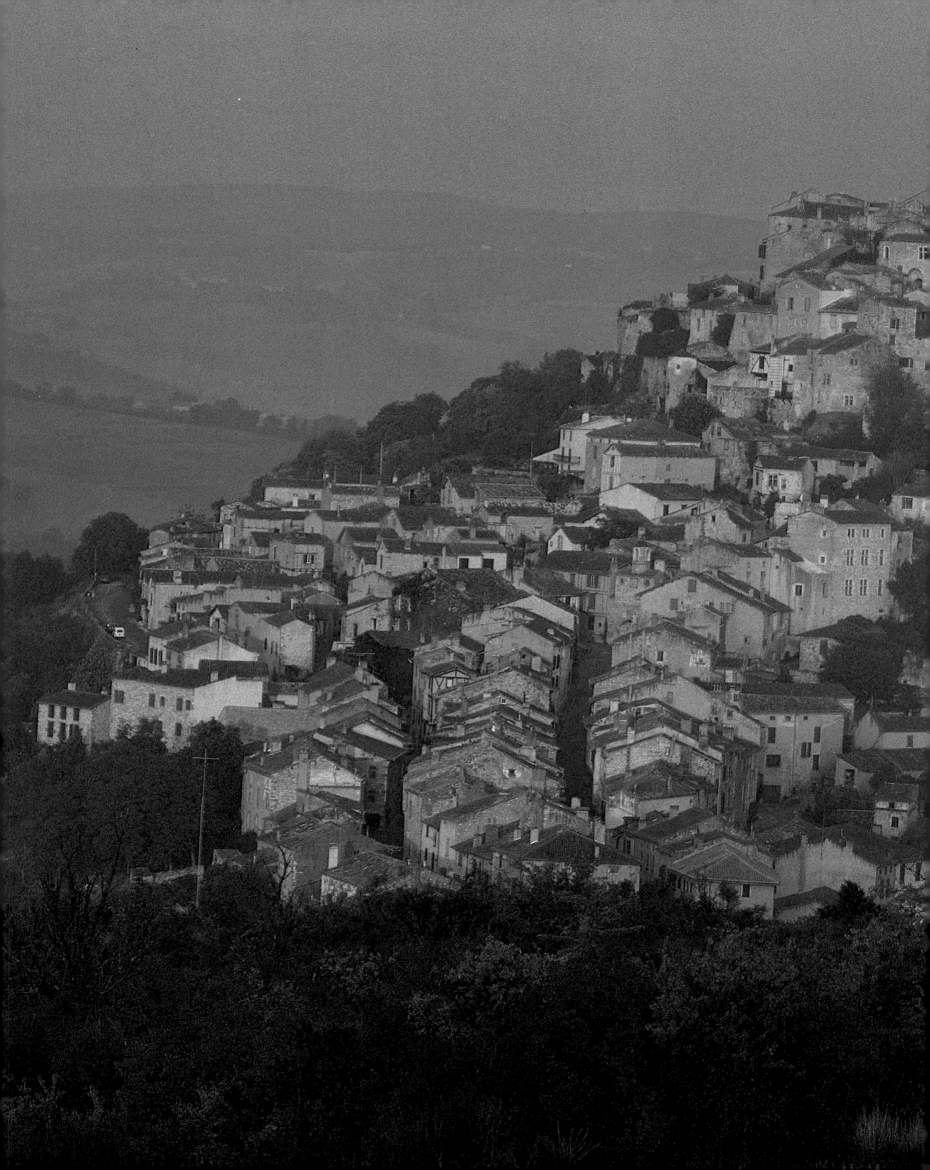

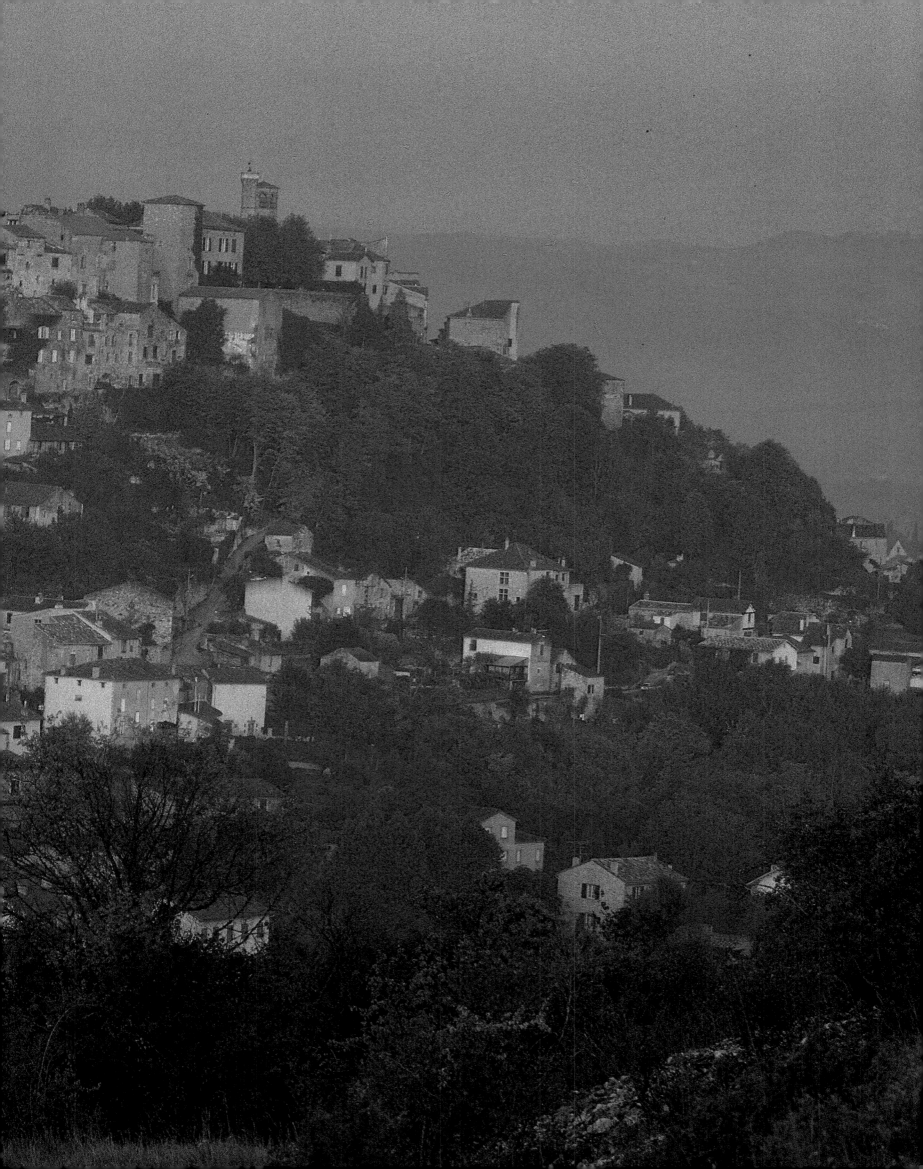

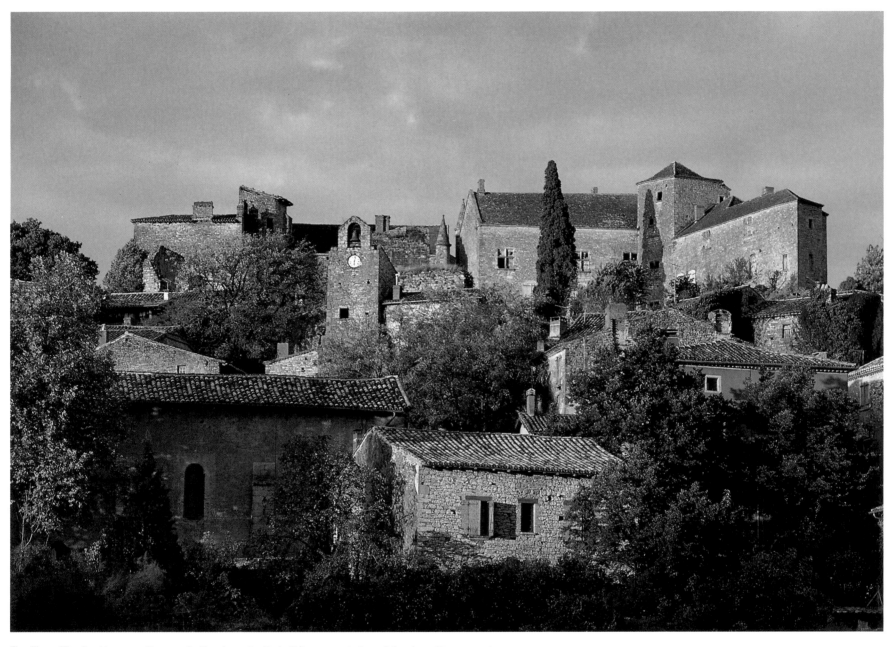

The village of Bruniquel is arranged in tiered rows on the gentle slope of a hill that looks straight down upon the confluence of the Aveyron and the Vère. Two castles crown the summit; the old one on the left hand side and the 'new' one on the right, which was built roughly between 1485 and 1510.

Further down, the Porte Méjanne, surmounted by a bell-tower, opens in the middle of the first surrounding wall, hence its name. This wall enclosed the castle and the original heart of the community, in the upper part of the site. From the 1300s, new *faubourgs* began to develop at the bottom of the slope. These were in turn surrounded by a second wall, which has now almost completely disappeared.

140

The origins of Bruniquel are obscure, as is the case with most of the communities in this region. It appears that the first seigneurs of the village were the comtes de Toulouse. Initially the castle will have been built to survey the crossing of the Aveyron by a road from Cahors to the Albigensian territory. We know that a toll was exacted from travellers crossing the river right up to the 18th century and that the magistrates of Bruniquel kept a *nef* or 'vessel' there. The early 14th century saw the village in a full state of expansion. As the population increased, small developments or *barris* were constructed outside the ramparts. One might even wonder whether the vicomtes, who made distributions of land in 1271, 1307 and 1319, were not engaged upon a type of urban project comparable to our modern housing estates.

The first rights were granted in 1321, quickly followed by others in 1328. The need to protect the recently created *faubourgs* by constructing new walls soon became apparent. In compliance with an order from the royal commissioner, the magistrates of the village awarded the construction of *lo mur et clausura de Bourniquel* for a fixed price on 25 May 1355.

Were the fortifications of the village and the castle ever used? We have very little information on this subject. In February 1363 bands of soldiers were approaching Bruniquel, but they were already far away just a few days later. The only siege which has been reasonably well documented is the last, which Bruniquel was able to withstand; it occurred in 1621–22, following the lifting of the siege of Montauban by Louis XIII. After the Peace of Montpellier (1622) the ramparts almost entirely disappeared, destroyed on the orders of a royal commission. There are 150 inhabitants in the village today.

For further information:

'Un village fortifié: Bruniquel', by Louis d'Alauzier, in *Bulletin de la Société Archéologique du Tarn-et-Garonne*, vol. LXXVII, Montauban 1951

*Penne en Albigeois, Bruniquel en Quercy, deux villes d'Occitanie à travers l'histoire*, by Pierre Malrieu, Éditions La Duraulié, 2nd quarter 1986

**Six kilometres (a little over three and a half miles) from Bruniquel, the village of Penne, built beneath a rock, is one of the most breathtaking sites in the gorge of the Aveyron. The old village houses look most picturesque huddled under the rock, which is crowned by a castle. Now in a state of considerable dilapidation, this was probably built in the second half of the 13th century. Village and castle are surrounded by a wall. Penne played a significant role in the defence of the Albigensian region. The castle was besieged by de Montfort's crusaders, then by the English during the Hundred Years' War. It was severely damaged by the Protestants in 1586.**

▶

**The Rue Droite is the main street in Bruniquel. It cuts across the whole village on the line of a path which ran along the ancient wall and the Porte Méjanne, seen here from the side. These old ramparts in fact form the rear façade of most of the houses lining them, as depicted here. Although some of the buildings in this street disappeared at the beginning of the present century, those which remain create a striking architectural ensemble.** ▶

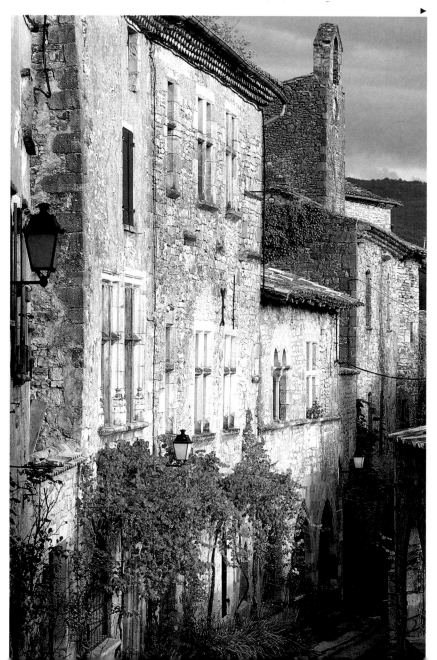

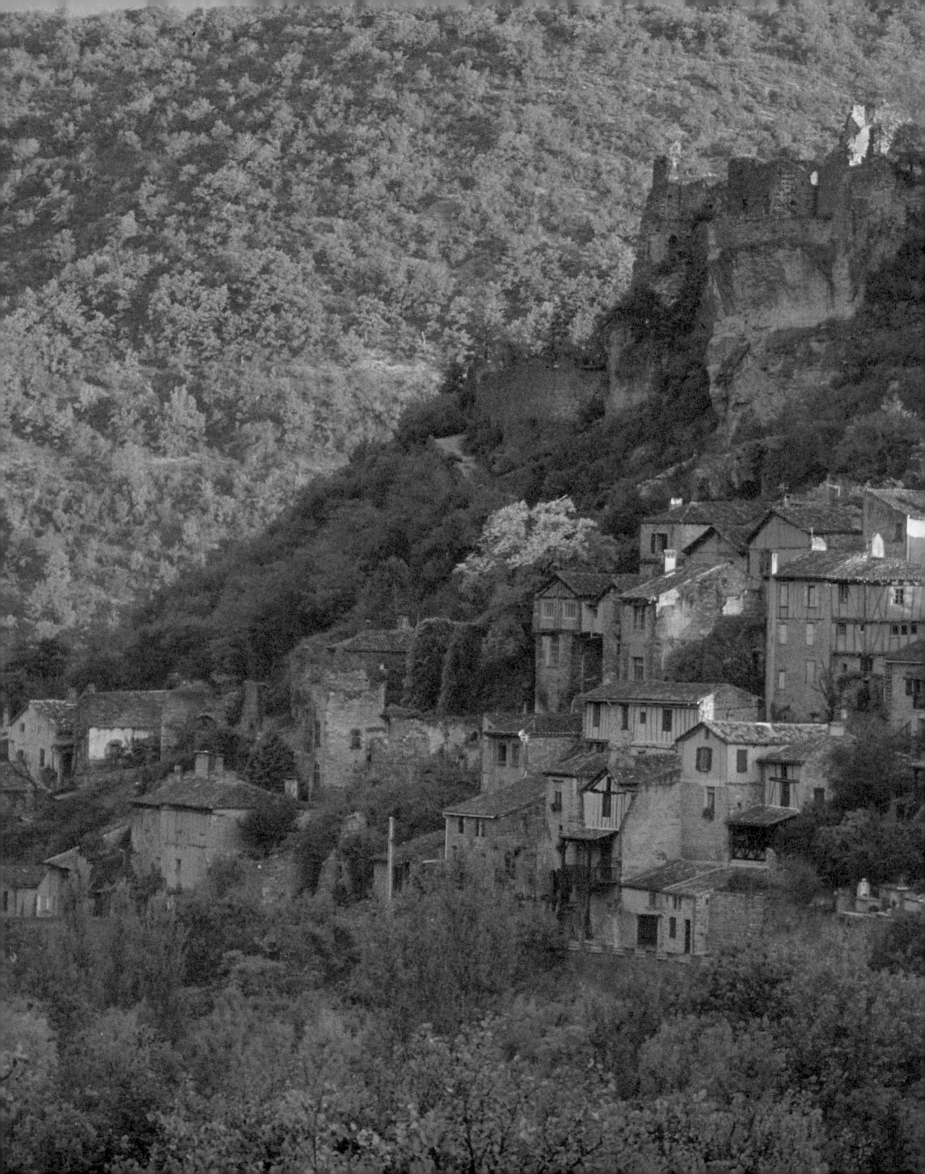

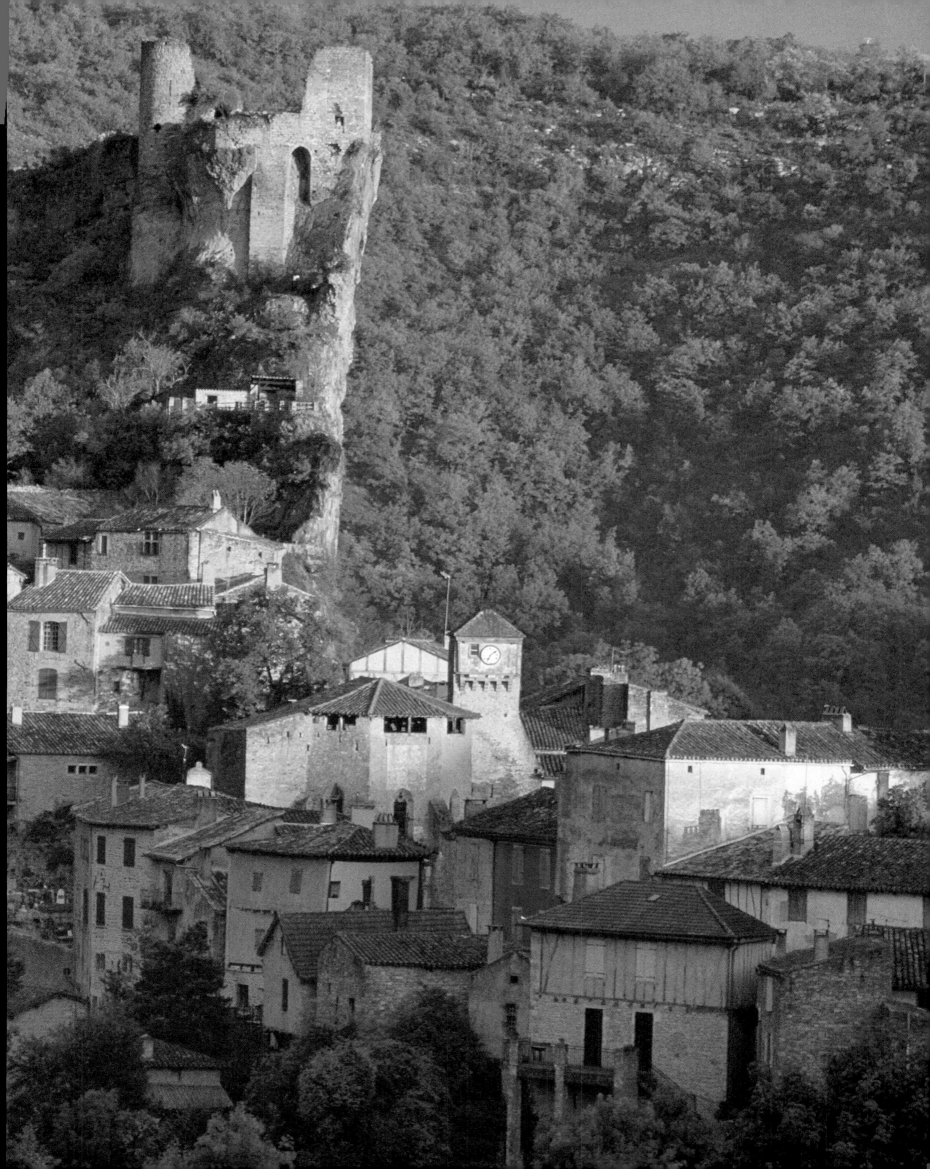

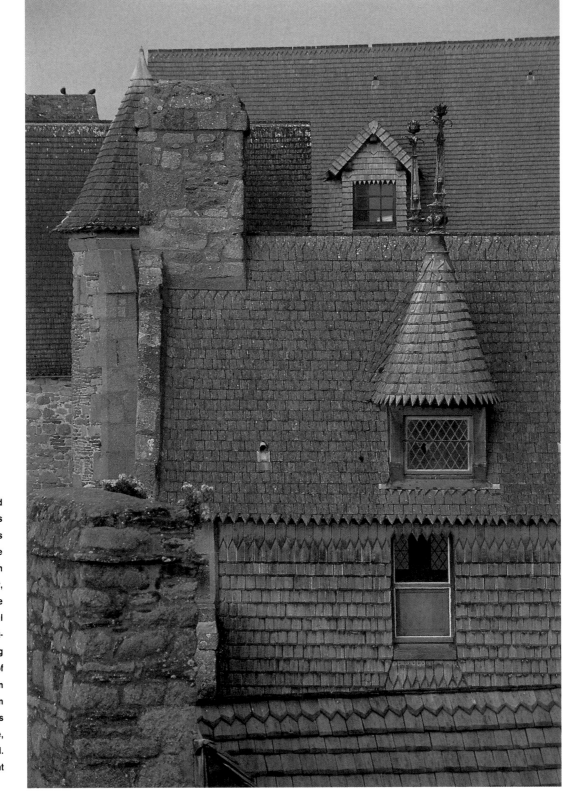

The village has been transformed during this century. Although it has retained its character, many houses have been altered to adapt to the influx of tourists who flock here each year. Care has been taken, however, to use fine materials such as granite and slate, as well as traditional features (wooden panels and chestnut shingles), so that the building work is of high quality. Examples of this policy include the house known as the Artichaut, or 'artichoke', in the foreground, the king's lodgings behind and the Tour de l'Arcade, just discernible in the background. The three buildings form an elegant and harmonious group.

A ccording to legend, it was during the little known era of the last Merovingian kings that the archangel Saint Michael appeared three times to the archbishop of Avranches, Saint Aubert, in his dreams. The archangel asked for a small chapel to be built on the rock which was then known as Mont Tombe. The most ancient texts give the date of these events as 708 and establish a connection between Saint Aubert's chapel and the Italian sanctuary of Monte Gargano, which he may have imitated. He created a cavern below the summit of the rock, where a college of canons observed the cult of the Archangel for two and a half centuries. The turmoil which reigned during the Viking invasions means that this period has remained obscure. It is not until after the duchy of Normandy finally established its western boundary, in 933, that Mont-Saint-Michel emerges from the shadows. The consolidation of Norman power led to the expulsion of the canons in 966. The site was then occupied by Benedictine monks, who converted, or even built, the pre-Romanesque church known as Notre-Dame-sous-Terre. After the year 1000, this little sanctuary no longer fulfilled the needs of the day. The fame of the important Benedictine community and the prestige of its patron the duke of Normandy meant that a new, much larger church had to be constructed. This was to be built on the lines of a great cruciform abbey church. When William of Normandy conquered England in 1066, the monks proved their allegiance by supporting the duke, who gave them an endowment, which enabled them to complete the nave of this church. In the 12th century the power of the Anglo-Norman kingdom was at its height; this coincided with the most illustrious period in the history of Mont-Saint-Michel. Understanding between Abbot Robert de Torigny and the Plantagenet King Henry II led to a new development for the monastery, in both the spiritual and material sense. This harmonious state of affairs ended at the beginning of the next century. The conquest of the duchy of Normandy by Philip Augustus in 1204 put an end to the rivalry between the duke of Normandy, king of England, and the king of France. It marked the re-establishment of royal power against the great principalities. At Mont-Saint-Michel the French conquest led to the construction of the Merveille, conventual buildings in the Gothic style, constructed with funds given by Philip Augustus. It was a way of making good the damage caused by his Breton allies and an act of conciliation towards the Benedictine monks. During the same period, the village emerges from obscurity. Confined to the foot of the abbey, a first stone wall was built around it; the completion of the work was to be financed by Saint Louis. Mont-Saint-Michel experienced a new era of prosperity, although the first signs of decline were becoming apparent: the construction of monastic buildings was abandoned in favour of new lodgings for the abbot, where temporal considerations had precedence over spiritual. The beginnings of the Hundred Years' War in the 14th century were marked by the reinforcing of the abbey defences. The entrance was fortified with a small castle-stronghold. After Henry V's victories, the monks refused to recognize the Treaty of Troyes and from 1420 Mont-Saint-Michel was one of the few fortified communities to resist the English. The importance of the

▶

**The Tour Boucle is a prime example of a bastion. It was built in 1430 by Louis d'Estouteville, at that time captain of Mont-Saint-Michel. The renown of d'Estouteville was such that he could compel the king of France and the Pope to accept a new abbot, this being his own brother, Cardinal Guillaume d'Estouteville. The latter was responsible for reconstructing the choir of the abbey church in 1446, the previous choir having collapsed in 1421. The work is an example of Flamboyant Gothic art, in which elaborate decoration has replaced the former austerity. The style is reflected in these two gargoyles framing a solid buttress, which is itself decorated with finials.**

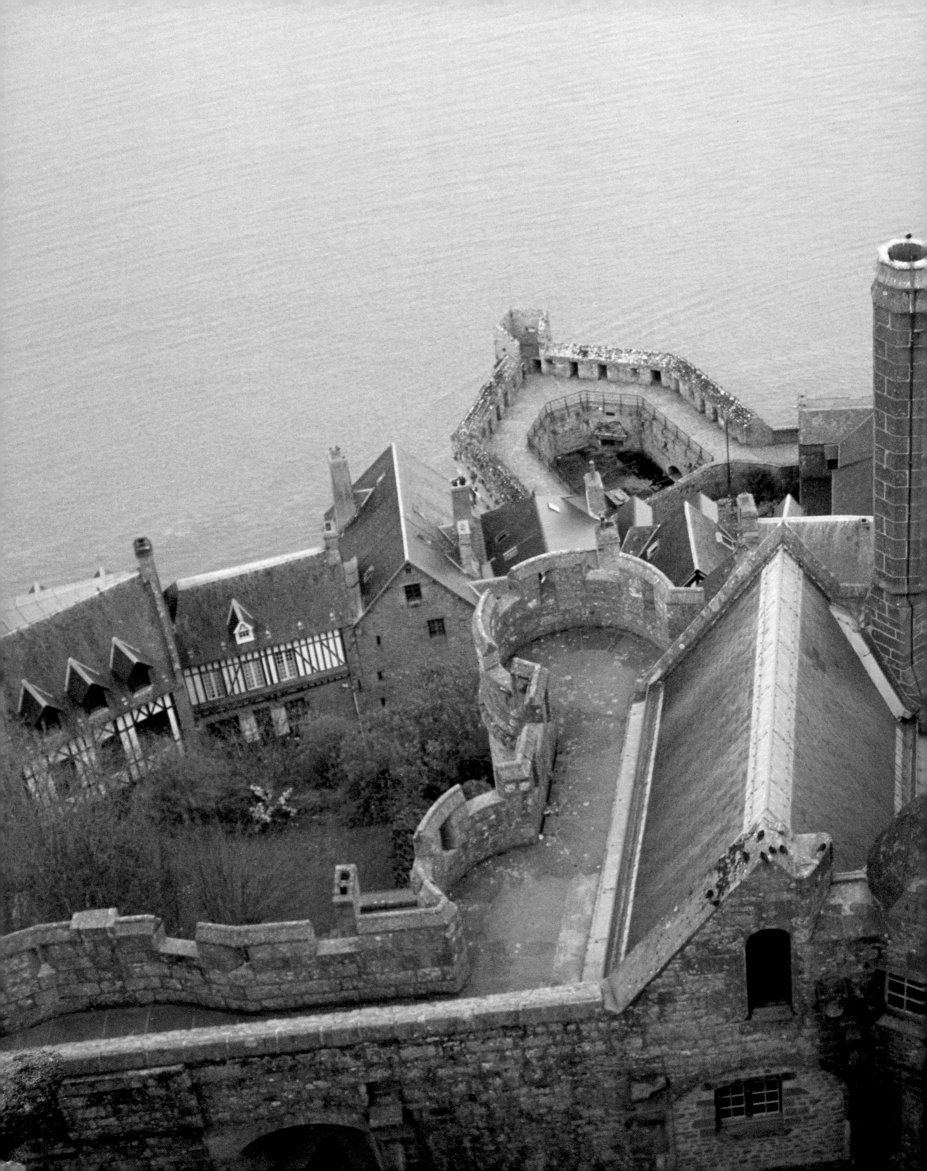

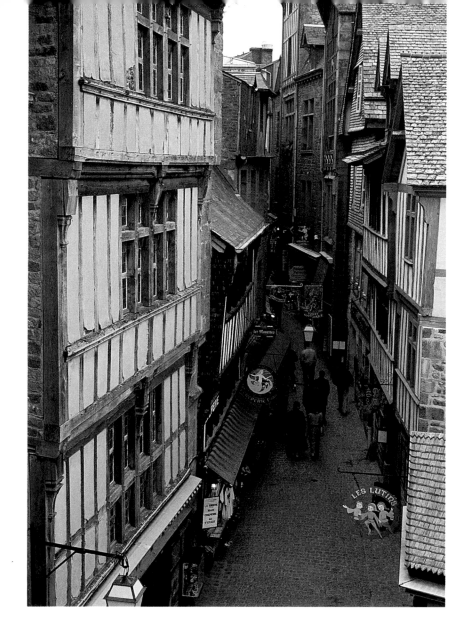

The narrow Grande-Rue is the only street on the Mount; the lower part is pictured here. It leads from the fortified entrance to the abbey and is lined with restaurants, including the famous Mère Poulard, seen here. There are also hotels and souvenir shops; the street is packed with tourists during the high season, recalling in some measure the atmosphere of the great medieval pilgrimages. Tourism is the main activity in Mont-Saint-Michel. It is estimated that one and a half million people visit the monument every year.

garrison explains the development of the village and the extension of its defences. The role played by Saint Michael in the story of Joan of Arc, together with the resistance of the sanctuary bearing his name, combined to make him protector of the nation at a time when the concept of national unity was just beginning to emerge. The great era of construction at Mont-Saint-Michel ended with the Hundred Years' War.

The community had to withstand several attacks during the Wars of Religion. The king of France was quick to imprison victims of the *lettres de cachet* here. They were guarded by the monks, whose observance of the Rule had relaxed. In 1622, the reform of the congregation of Saint-Maur led to an intellectual

revival and the compiling of the first historical accounts of Mont-Saint-Michel. The buildings, however, were neglected and in 1776 the first three bays of the nave were knocked down to make way for the west terrace and the neo-classical façade of the abbey church, which remains today. During the Revolution the last few monks were forced to flee their impoverished monastery. The name Mont-Saint-Michel was abandoned and the site was rechristened Le Mont Libre. It was used as a prison for several hundred priests who refused to recognize the civil constitution of the clergy. This situation was officially established under the Empire, and a central headquarters was installed in the abbey in 1810; it remained there until 1863.

Mont-Saint-Michel was classified as a historic monument by Napoleon III. It underwent a great deal of restoration work, which lasted until the beginning of this century. Two particularly notable reconstructions are the bell-tower and Petitgrand's spire, which has given the Mount its characteristic silhouette. Since 1984 the Mount and the bay have been included in UNESCO's register of the world's cultural and natural heritage.

The population of Mont-Saint-Michel is currently 65.

For further information:
*Guide Bleu Normandie*, Hachette, Paris 1988
*Nous avons bâti le Mont-Saint-Michel*, by Gérard Guillier, Éditions Ouest-France, Rennes 1983

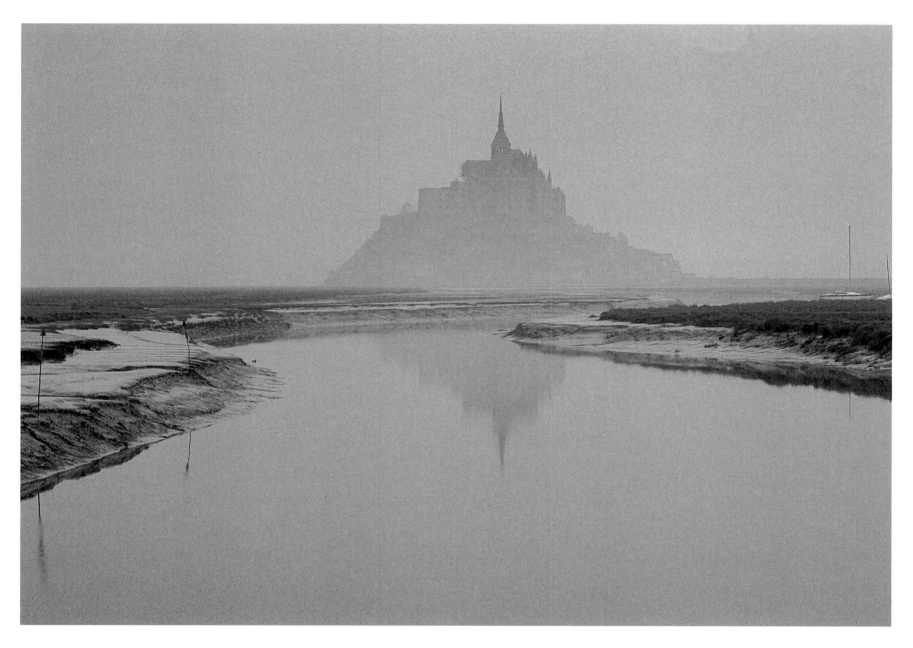

Nature and history have combined to make Mont-Saint-Michel an exceptional site. It is situated on the borders of Normandy and Brittany, traditionally divided by the River Couesnon, seen here. The isolated pyramid-shaped rock rises from the sands, which are regularly swept by the strongest tides in Europe.

The monument presents us with a captivating image of medieval life. No-one could fail to be impressed by this famous sight, which has attracted so many pilgrims and travellers over the years. The monastic buildings are grouped around their church, forming a striking architectural ensemble, with a little town at its foot.

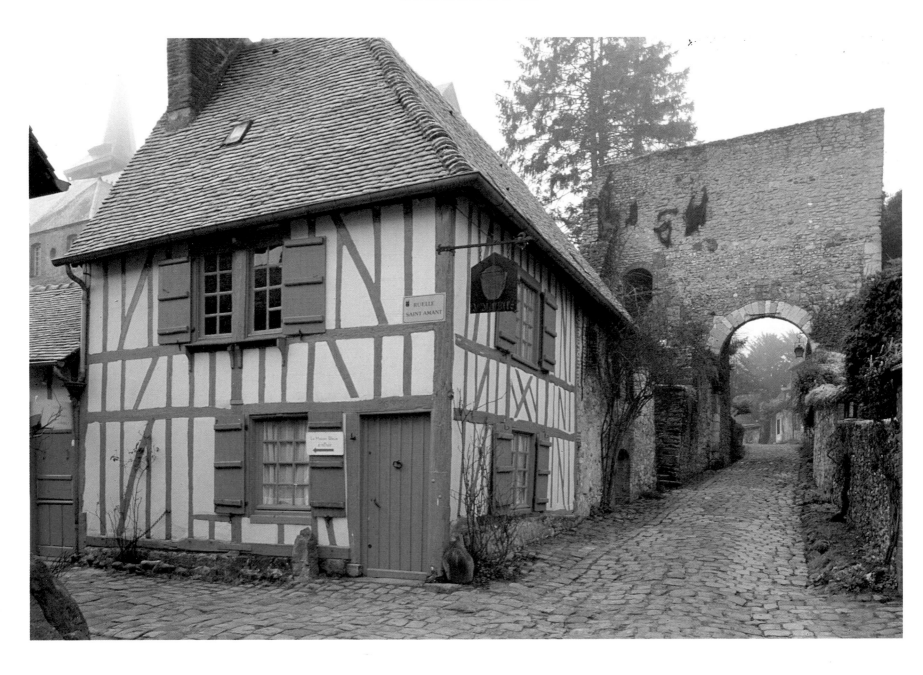

erberoy first appears in historical records as a possession of the bishop of Beauvais administered by his vidame. It was an important *vidamé* from the early Carolingian period. In 992 Francon de Gerberoy obtained permission from the king to build a wall around the town and construct a collegiate church within the castle enclosure, 'so that it could rightly be termed a *vidamé*'. A donation charter dated 1015 states that Gerberoy had a castle (*castrum*), a *bourg* (*burgum*) and a fortress (*firmitas*).

Gerberoy formed the first line of defence for the French territory of Beauvaisis against Normandy, settled by Vikings since 911. The village was a frontier stronghold coveted by both sides from the 10th to the 15th centuries. The first siege took place in 1079. Several others followed, notably those of 1160, 1197, 1428, 1432, 1435 and 1449. The Wars of Religion were another dark period for the village. In October 1592, after the defeat of d'Aumale's forces, Henri IV delivered the town up to the Leaguers of Beauvais, who left the village and its castle in ruins. A terrible fire destroyed almost a quarter of Gerberoy in May 1611. Three other fires followed (in 1651, 1673 and 1694), but after each disaster the inhabitants rebuilt the ruins and refortified the entrance gates. On 27 May 1639 Louis XIII visited Gerberoy: two years later his minister Richelieu, 'journeying to the frontiers, lodged [there] as the king's representative and received the chapter, who came to bow before him, clad in their surplices'. After the Revolution the little community was renamed Gerbe-la-Montagne.

In 1789 there were 287 inhabitants, including '120 citizens'. In 1836 there was no sign of growth, with a population of just 282. By 1909 this had dropped to 240; today the village numbers only 77 inhabitants.

For further information:

*Gerberoy*, by Hélène d'Argœuves, Paris 1963

Built on top of a motte, the fortress of Gerberoy overlooked the approaches to Beauvaisis and Picardy. This key frontier location caused it to be the object of several sieges and destructive acts, which have left little trace of it. The village has retained its original oval shape, the limits being defined by the contours of ancient ditches and ramparts. Half-timbered buildings are much in evidence here, as wood was in plentiful supply. On the borders of Normandy and Picardy, in the Bray region, however, cob is often replaced by brick infilling, a feature characteristic of Picardy.　▶

Today the old tumble-down cottages of Gerberoy – like this picturesque Maison Bleue, dated 1691 – have been restored and rejuvenated by new occupants. Nothing remains of the castle, but this gateway serves as a reminder that it was once enclosed inside a second wall, together with the collegiate church, the school, the prisons, the seigneur's residence and some canons' houses. The picturesque little street of Saint-Amand and the Rue du Château (right) are paved with large slabs of sandstone, mostly dating from the 17th century.

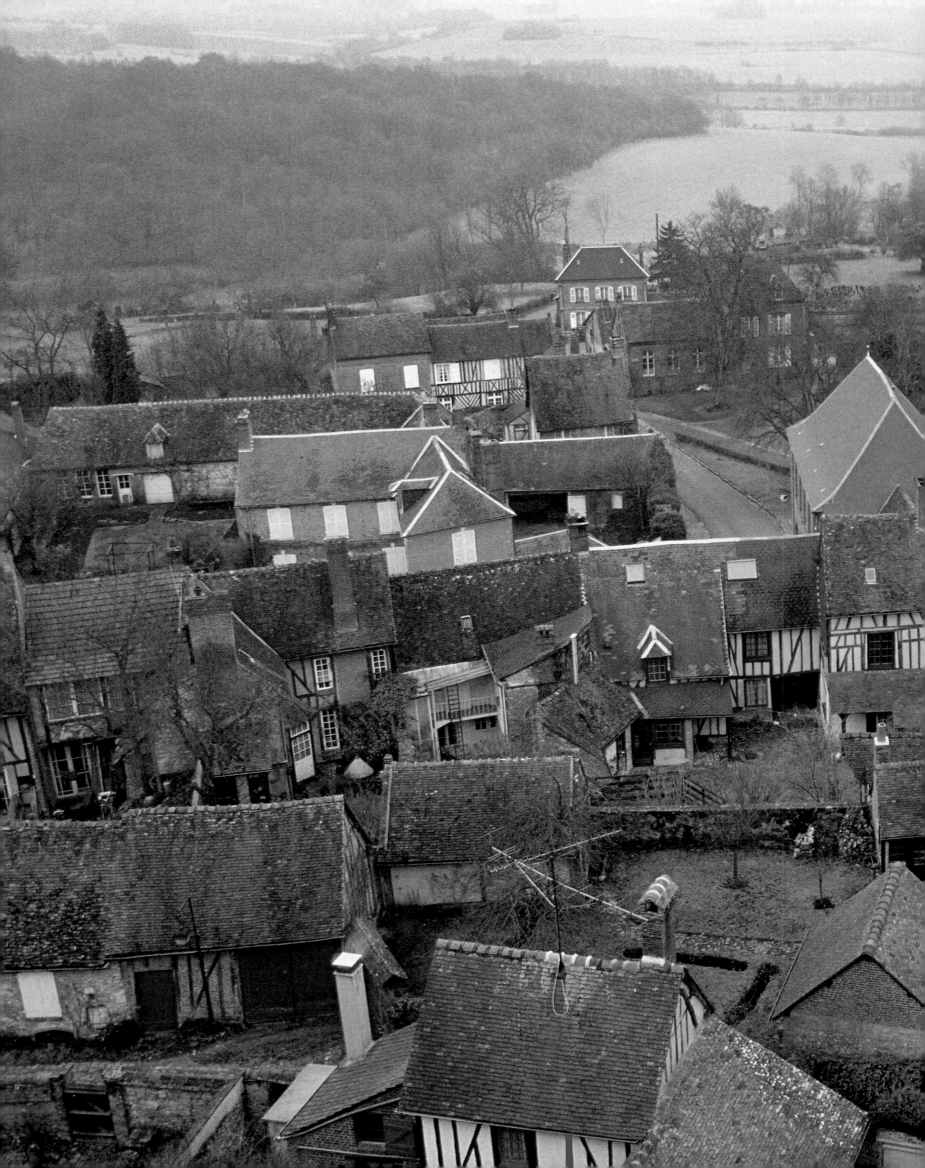

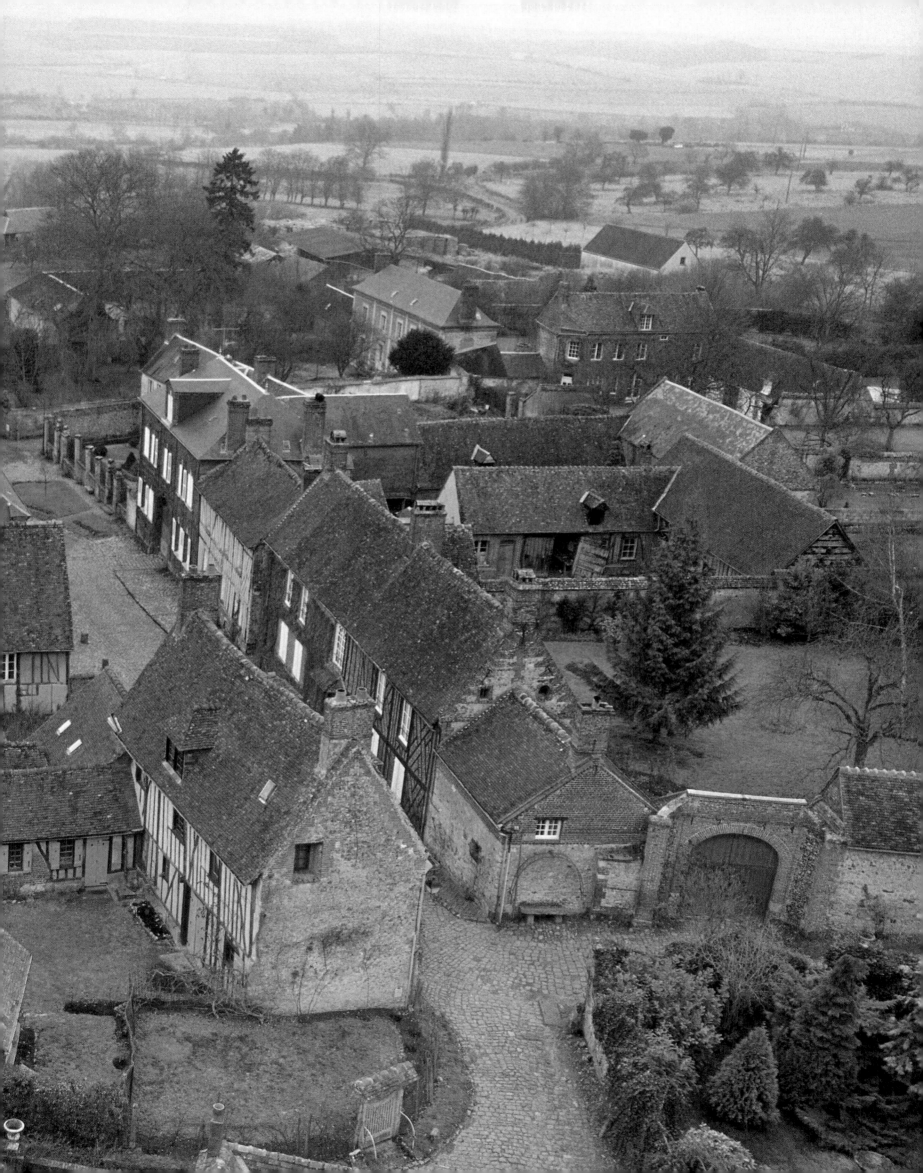

The castle is first mentioned in the cartulary of Saint-Cyprien de Poitiers in 1025. It is referred to initially as *castellum Ingla*, then as *castellum Engli* in about 1070. In the 12th century the bishops of Poitiers established a monastery on the left bank of the River Anglin, beneath the castle. This was the abbey of Sainte-Croix, which quickly became an important religious house. Little of it remains today. The bishops of Poitiers were the overlords of Angles, although their authority appears to have been somewhat restricted by the power of the formidable lords de Lusignan, whom they had enfeoffed with the castellany.

The situation improved during the following century. In 1211, the monks of Sainte-Croix were freed from their dependence on the powerful Benedictine abbey of Saint-Cyprien de Poitiers. Towards the end of the same century the Lusignan family gave up the castle, together with part of their lordship. Indeed, in 1282 the castellany of Angles was entirely dependent on the bishops of Poitiers, forming part of their temporal possessions. By the end of the Hundred Years' War the little town had recovered its prosperity thanks to the bishops and above all to the work of the monks at Sainte-Croix. In 1459 the castellany became a barony, and in 1481 Louis XI encouraged this 'renaissance' by re-establishing the local fairs and markets.

The name of this king conjures up the story of Cardinal Jean Balue, born in Angles of humble parents in 1421. His star rose rapidly; but he abused the trust of Louis XI by selling state secrets to the duke of Burgundy. Unmasked as a traitor, the cardinal was locked up on the king's orders, his prison being one of the uncomfortable iron cages known as *fillettes*, which he himself is said to have invented! This punishment for his act of betrayal lasted eleven years; he was then freed at the Pope's request.

In 1652 the castles of Angles, Dissay and Chauvigny were all described as having been retaken by the duc de Roannez on behalf of the king, acting against the Poitevin partisans of the Fronde. In 1708 the bishop of Poitiers asked the parliament in Paris for permission to abandon the castle, as restoration costs were proving too high. His request was granted. The Revolution turned this remarkable monument into a public quarry. The village acquired fame and fortune in the last century, thanks to the manufacture of fine lingerie and above all to its traditional embroidery.

Today the inhabitants of Angles, known as *les Anglais*, number 322.

For further information:

*Angle-sur-l'Anglin, la ville et le château, essai de reconstitution archéologique et historique*, by H. Gaillard, Société des Antiquaires de l'Ouest, Poitiers 1959

**Previously protected by a wall, which has now disappeared, the village was established on the banks of the River Anglin, on the borders of Poitou, Touraine and Berry. The upper village in the background, on the plateau, is grouped around the church of Saint-Martin, with its bell-tower in the Poitevin Romanesque style, and a large public square. The houses of the lower village on the left bank are tightly packed around the chapel of Sainte-Croix (on the left). Seen on the right, between the river and the plateau, the ruins of the fortress extend along a narrowing spur, cut off from the plateau by a deep ravine. The castle was probably built in the 11th and 12th centuries. It was considerably altered at the end of the Hundred Years' War by Bishop Hugues de Combarel and his successor, Guillaume de Charpagne.** ▶

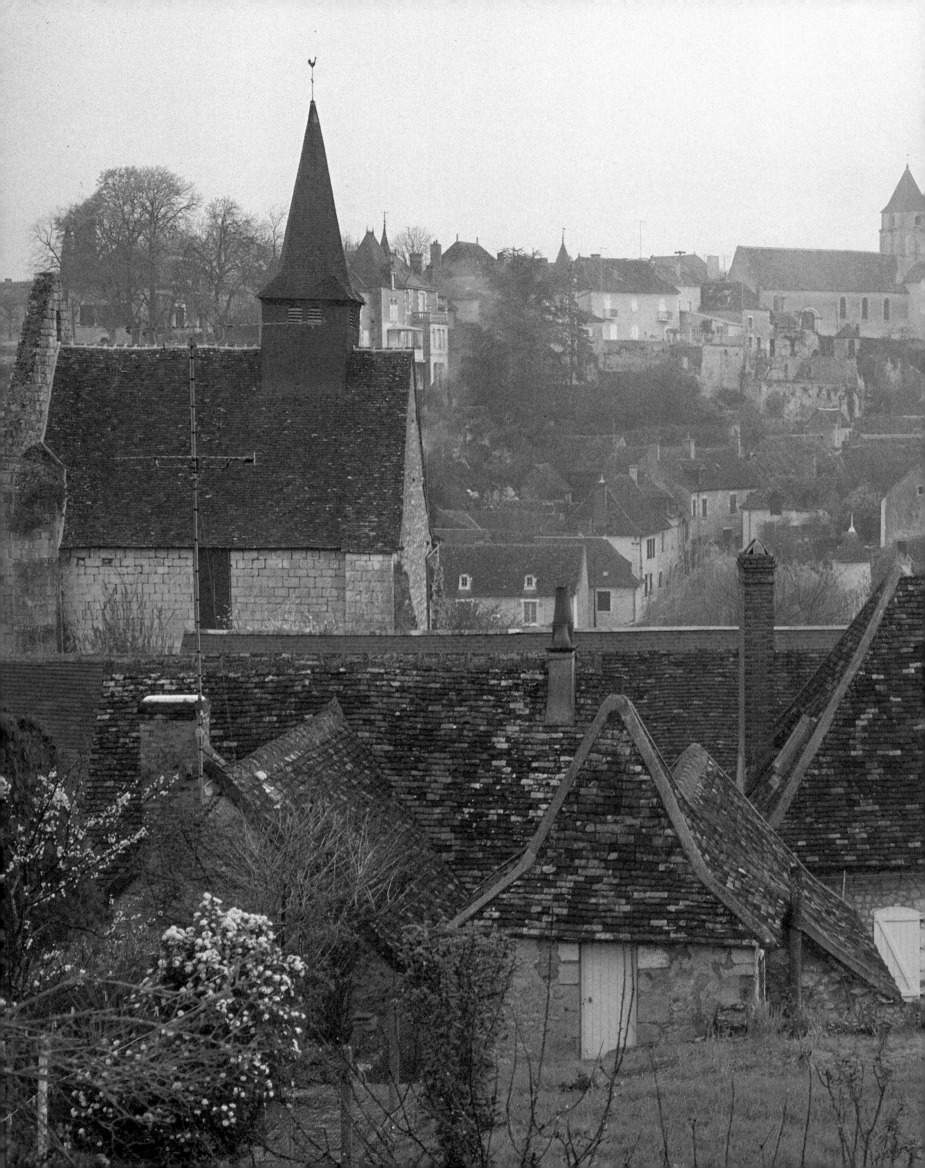

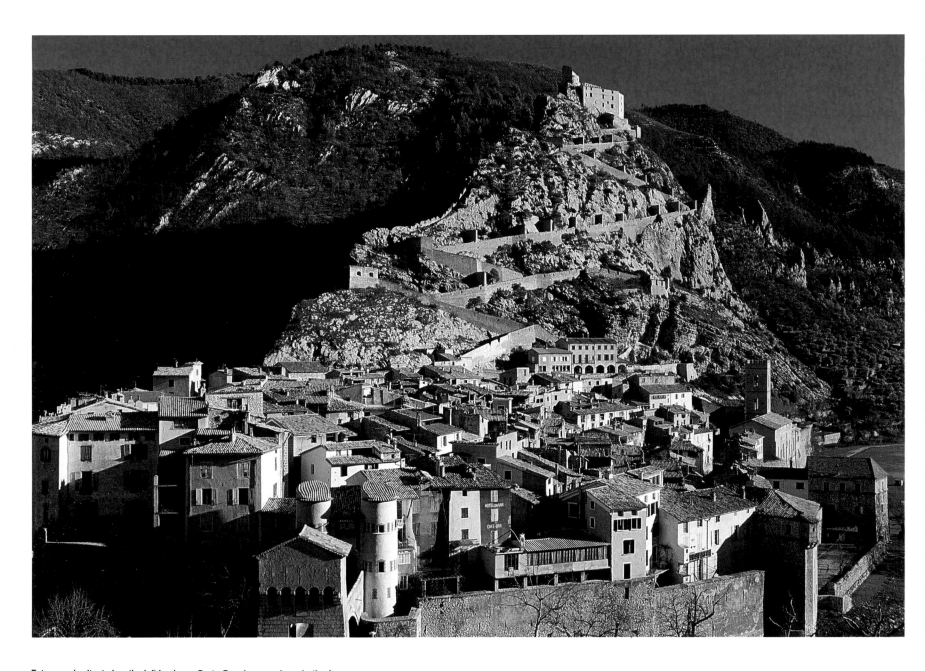

Entrevaux is situated on the left bank of the Var, almost surrounded by a wide loop in the river. It is backed by a towering cliff (650 metres above sea-level; 2,130 feet) crowned with a fortress. Most of the houses date from the 17th and 18th centuries. The village is protected by a triangular-shaped enclosure, which has three gates, each with a drawbridge. The Porte Royale, seen here in the foreground, was the main entrance. The path visible in the background served as a link between the town and the castle, its nine ramps snake up the rock-face, forming a striking spectacle. Vauban had advised the construction of such a system in 1693: the work began in 1697 and took fifty years to complete.

The rock on which Entrevaux stands is situated at the junction of several ancient highways. It blocks the western side of a small plain; during the Middle Ages this was the site of the seigneurial and episcopal town of La Seds. This has now disappeared, in the same way as the *civitas* known as Glandate, or Glanate, which seems to have preceded it. The first mention of Entrevaux (*castrum de Entrevals*) does not occur until the 1200s. It was the principal outpost and dependancy of La Seds. The annexation of the *comté* of Nice to Savoy in 1388 created a profound change in the military position of Entrevaux. Now hemmed in on three sides by Savoyard territory, this little place was henceforth one of the main access points to Provence. It must have been during this period that the local seigneurs built a small fortress on the summit of the rock, and that a wall was constructed around the lower village. In 1536, during the abortive attempt by Charles V to invade lower Provence, Entrevaux was seized and subsequently occupied for six years. The inhabitants then succeeded in taking back their village by force. They presented the keys to François I, King of France and Comte de Provence. In Avignon during that same year, a charter was signed whereby the king accepted Entrevaux 'as part of his patrimony' and granted various privileges to the inhabitants. In 1690 the duke of Savoy joined the League of Augsburg. This reopened the question of the Italian frontier (just one mile from Entrevaux), which had never been a political issue during the long period of peace between France and Savoy. On the orders of Niquet, who was responsible for the fortifications of Provence and Dauphiné, a general plan for the fortification of Entrevaux was drawn up on 31 January 1693 by Vauban. He had not seen the site, however, and when he visited the spot on 5 November 1700 he developed a second plan. The constructions are therefore the result of the original design of 1693, corrected and completed by the modifications of 1700. Brusco, who retired in 1844, was the last in a long line of royal engineers in residence at Entrevaux. He was responsible for the completion of the town wall and reinforcements to the castle defences. Entrevaux was downgraded to a stronghold of the second rank on 10 August 1853, becoming no more than a military depot of little strategic importance.

In the early 18th century this ancient royal town had nearly 1,500 inhabitants. The population today is just 308.

For further information:
*Guide des fortifications d'Entrevaux – vade mecum des monuments d'Entrevaux*, by Roger Greaves, Éditions ACI, Entrevaux 1986

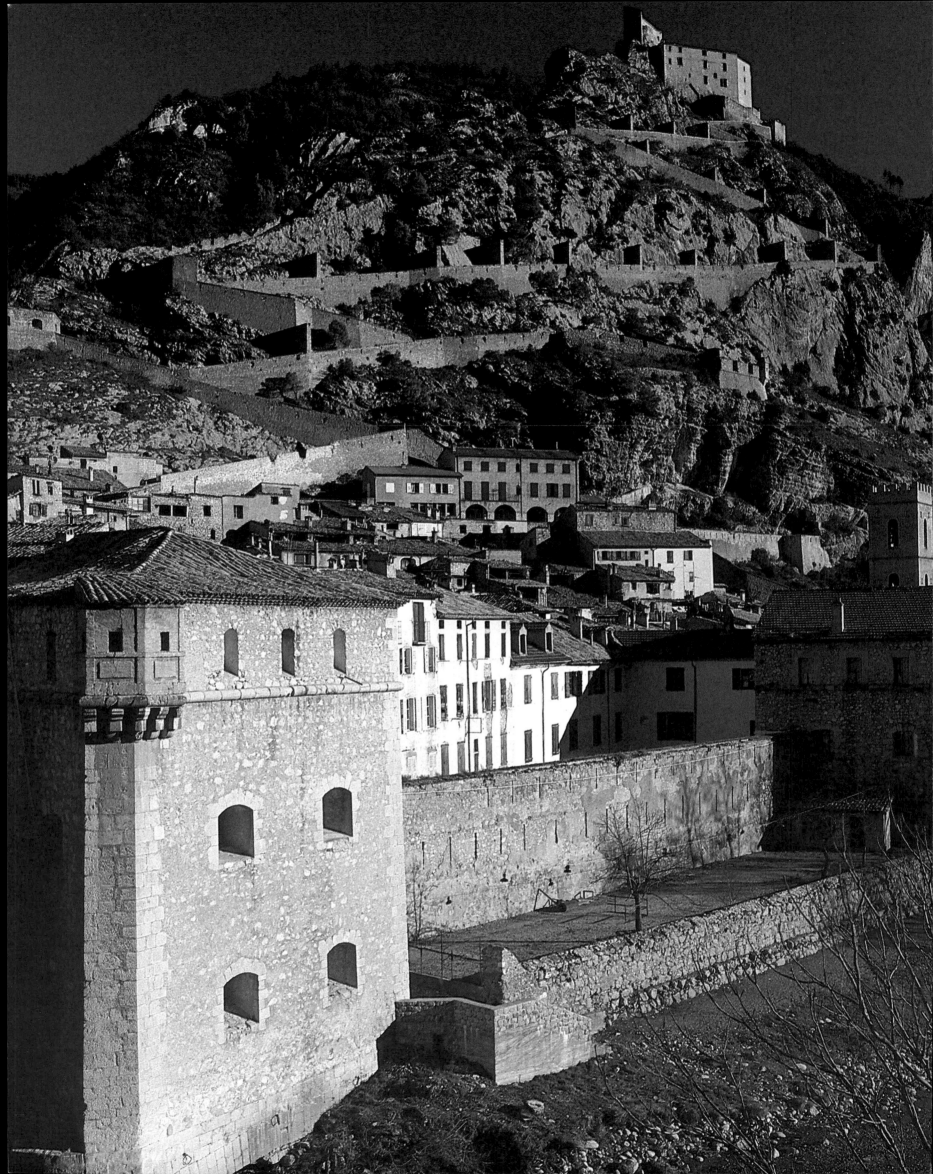

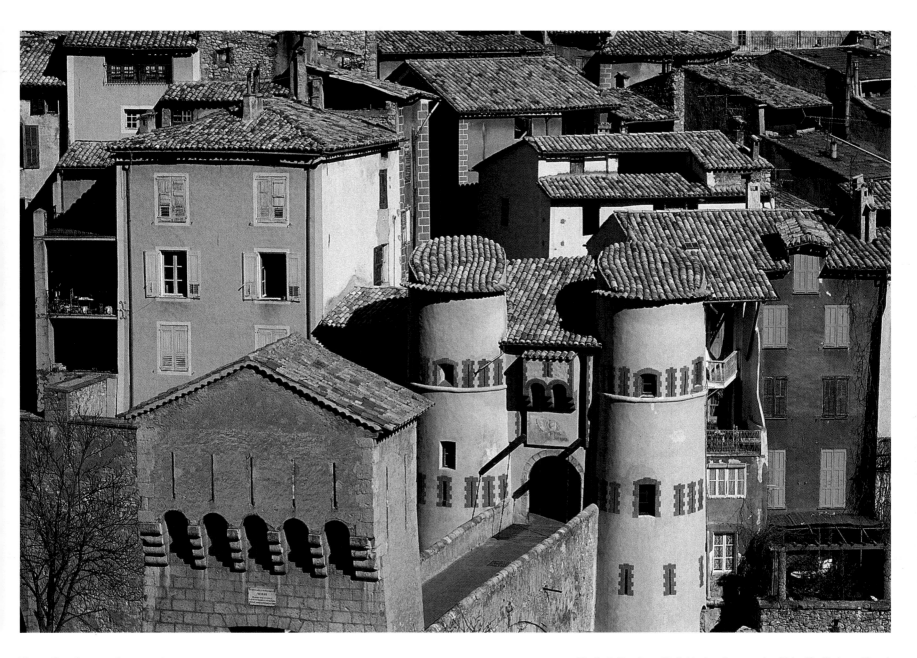

The southern face was the most vulnerable to attack, as the River Var flowing below was often fordable at this point. The defence consisted of two bastions, one being the Portette pictured here. It is the only one to retain its original appearance. Finally completed in 1707, it is the most characteristic example of the fortifications designed by Vauban at Entrevaux.

The Porte Royale and its 'bridgehead' were constructed between 1690 and 1705. The two round towers commanding the entrance were at least a century behind the times in the art of building fortifications. They were severely criticized by Vauban, although he did not succeed in having them replaced. Note the highly unusual arrangement of the original wooden drawbridge, which can be raised to reveal a gap in the bridge itself.

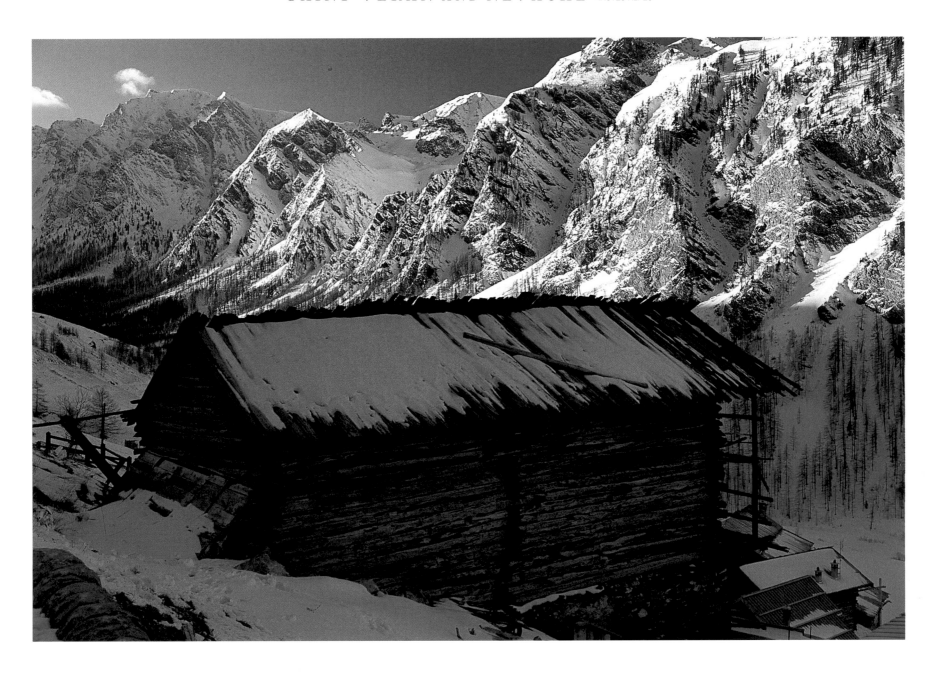

Saint-Véran, the highest community in Europe, is situated on the south face of a gentle slope of schist. It stands 2,040 metres (6,700 feet) above sea-level. The main hamlet has been nicknamed Le Travers, as it extends over a distance of nearly one kilometre. It comprises several small settlements (such as Le Villard, pictured here), which were formerly isolated from one another in order to diminish the risk of spreading fire. The wooden houses of Saint-Véran are traditionally roofed with large slabs of schist or, as in this case, with larchwood planks. They form a particularly fine architectural ensemble, despite the addition of a few modern facilities.

◄

Saint-Véran, a village in the region of Queyras, and Névache in Briançonnais, became closely linked when the two regions came under the rule of Guiges I, Count of Albon, in about 1000. The comte's descendants were later known as the dauphins de Viennois. Briançonnais was a prosperous area and was therefore able to buy back its independence (by a charter dated 29 May 1343) from Humbert II, who was in financial difficulty: he was, in fact, the last of the comtes de Dauphiné. This heralded the birth of the famous République des Escartons a name derived from the verb *escarter*, to distribute or disperse. It was one of the first republics of its kind in Europe, together with the Swiss *cantons* and the Austrian *Länder*. At that time there were five *escartons*; two on the French side (Briançonnais and Queyras) and three on the Italian. This transaction was not sufficient, however, to revive the declining fortunes of Humbert II, who negotiated the sale of Dauphiné to the king of France in 1349.

The Wars of Religion created considerable turmoil in Queyras up to 1598. The Revocation of the Edict of Nantes in 1685 brought great changes to the communities in this region. Its Protestants, who were persecuted and threatened with slavery in the galleys, fled to Switzerland and Germany. The number of emigrants has been put at 3,700, from a total population estimated at 11,000. This religious strife turned the whole region into a bloody battleground. Fighting continued right up to the Revolution. The Treaty of Utrecht in 1713 deprived Briançon of its Italian *escartons*. The French Revolution finally put an end to this state, which was incorporated into the French Republic on 4 August 1789.

There are 213 inhabitants in Saint-Véran today. The population of the village reached its height in 1836, with 831 inhabitants.

For further information:
*Le Queyras, guide été/hiver*, M. and S. Antoine, 1988
*Guide Bleu Provence-Alpes-Côte d'Azur*, Hachette, Paris 1987

The wooden houses of Saint-Véran are exceptionally fine examples of rural architecture. They have remained unspoilt despite the addition of modern facilities here and there. They are almost all large buildings, on stone bases, surmounted by picturesque *fustes*, a word derived from the Latin *fustis*, meaning 'wood' or 'beam'. These *fustes* create enormous wooden balconies, where hay was put out to dry. Most of the houses date from the second half of the 18th century, as in the case of these two adjoining buildings in Pierre-Belle. The house on the left was constructed in 1787, the other in 1791.  ►

The valley of the Clarée is also known as the valley of Névache (from *annevasca valle*, or 'snow-covered valley'). It is not far from Briançon. The unspoilt country and traditional architecture make it one of the loveliest spots in the region. After Plampinet the valley opens out to form a wide expanse. Here, well situated on a south-facing slope, stand Névache and its hamlets. The principal community is Ville Haute, pictured here. The church was built in 1490, on the former site of a feudal castle (*castrum Navaschia*). A tower dating from the 11th century was retained as a base for the bell-tower.  ►

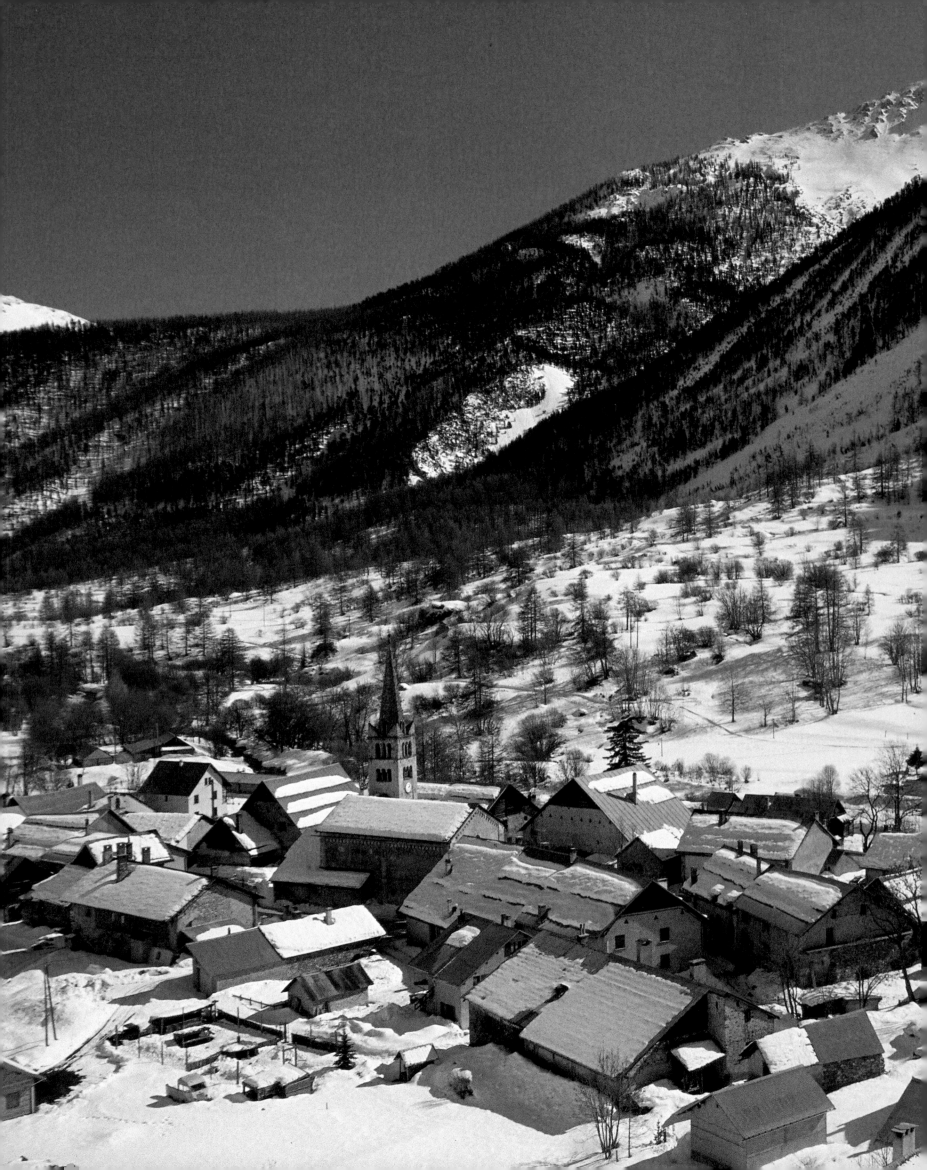

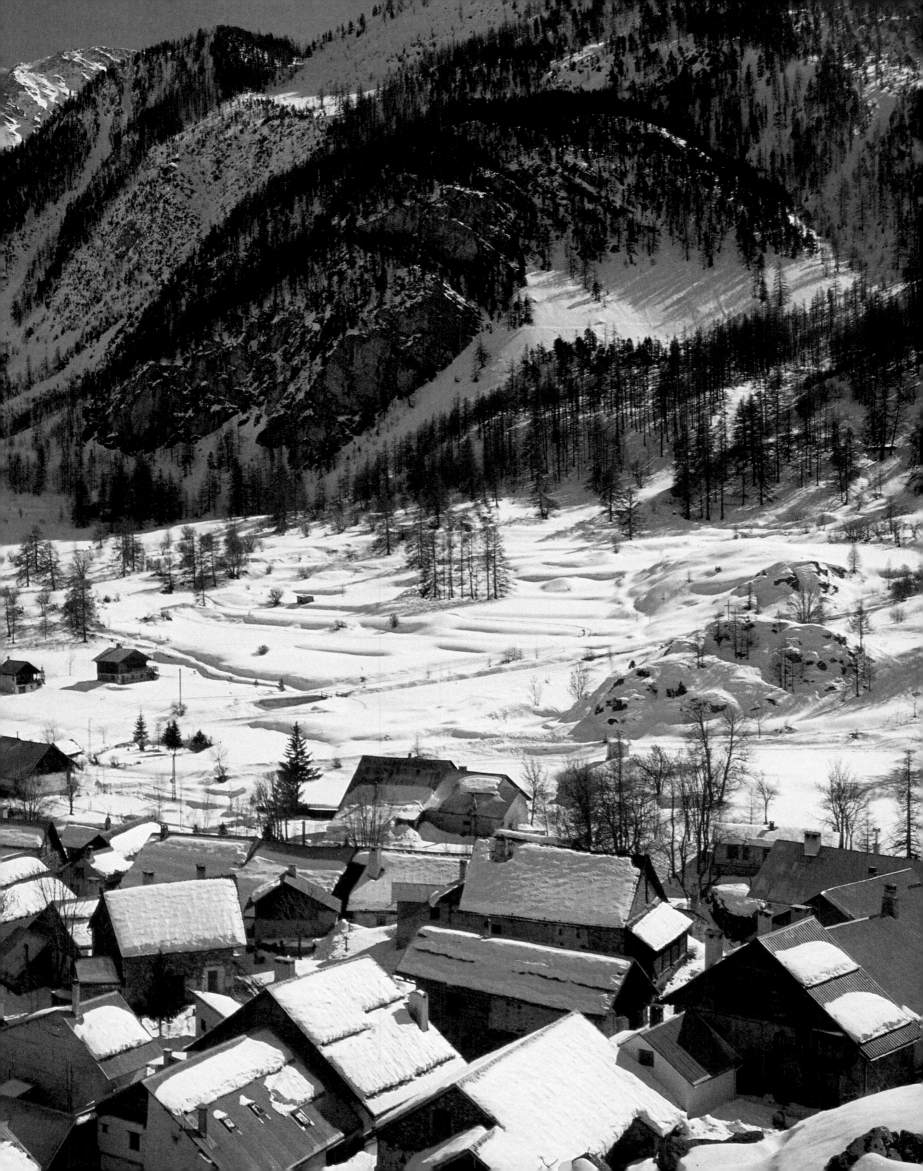

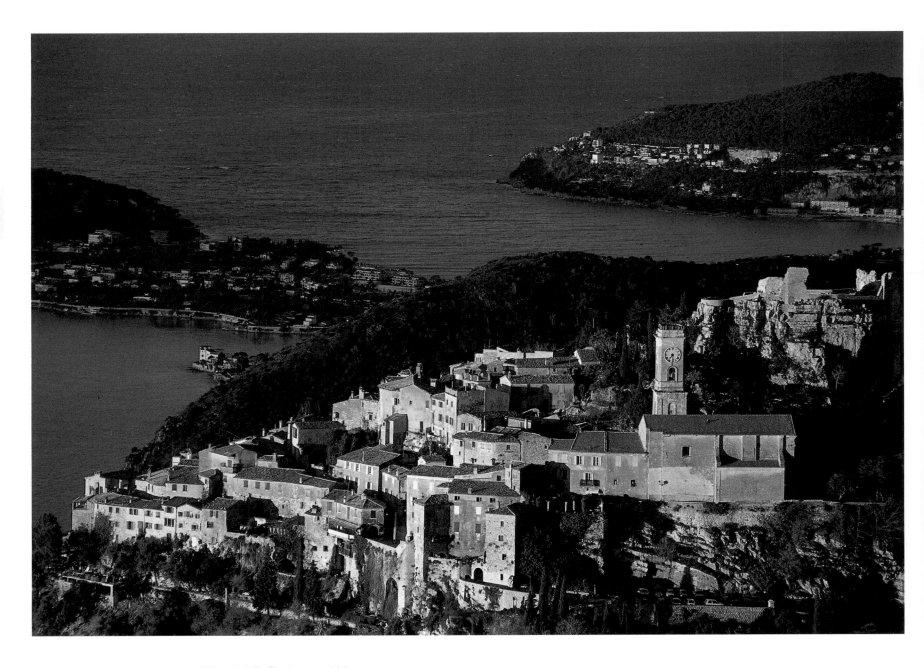

Despite its coastal location and proximity to Nice, Èze has kept a period charm, set against the deep blue of the Mediterranean. Access is still afforded by the village's only entrance, a fortified double gate dating from medieval times. It was formerly preceded by a drawbridge (in the foreground, centre). Pictured on the right, the church was rebuilt between 1764 and 1772. The houses, which have been well restored, surround a picturesque maze of narrow little streets and pedestrian walkways.

Archaeologists have identified the site of the village of Èze as that of a *castellara* from the late Bronze Age. Common in this period, such structures were 'simple enclosures, solidly built and firmly established' in prominent positions. Abandoned under the Pax Romana, they were occupied once more at the time of the barbarian invasions, between the 5th and the 10th centuries. Most hill villages were born at this time. The mountain site of Èze was then reoccupied (if, indeed, it had ever been abandoned) and fortified. The first mention of Èze occurs in 1050 and its earliest known seigneurs, the Riquier family, are first mentioned in the 13th century. In the late 14th century the *comté* of Nice, which included Èze, broke away from Provence to place itself under the suzerainty of Savoy. As Savoyard territory, the *comté* was obliged to suffer the historical consequences of this choice. In 1543 the French, who had allied themselves with Turkey, besieged Nice, having anchored in the harbour at Èze. In 1691 the French laid waste the countryside and held Èze to ransom; in 1706 Louis XIV ordered the destruction of all the fortresses in the *comté* of Nice. In 1742 there was another war and the French, now allied with Spain, reoccupied the region: Èze was once more held to ransom. In 1792 the Revolutionary troops seized Nice without encountering opposition; they arrived at Èze the following day. The region had by now suffered numerous French invasions and periods of military occupation. There were several more setbacks; by the Treaty of Paris, the *comté* of Nice once more became Savoyard territory, in 1814. It did not become French until 1860.

Today Èze has only about 100 inhabitants. Half of these use it as a second home and are mostly non-locals. The number of native villagers is 10 at the very most.

**The site is crowned by a remarkable exotic garden, partly visible here, which contains succulent plants and rare species. It was created in 1949 on the site of the castle. Until the 1970s the village subsisted on the growing of citrus fruits (the *mandarine d'Èze* is famous) and carnations. Today, tourism has taken over.**

**Seen here from the Grande-Corniche (the main coast road), the village of Èze is one of the most picturesque sites on the Riviera. It is perched on a hill in the former *comté* of Nice and lies mid-way between Nice and Monaco, set in some of the loveliest countryside on the Côte d'Azur. Stretching between Cap-Ferrat, on the left and Cap d'Antibes in the background on the right, the Baie des Anges is as famous as Nice and its Camin dai Anglès, or Promenade des Anglais. The only part of the town itself visible here is the airport runway.  ▶**

For further information:

*Guide de Èze et Laghet*, in the *Découverte* series by Alain Amiel, Éditions A.M., Nice 1984

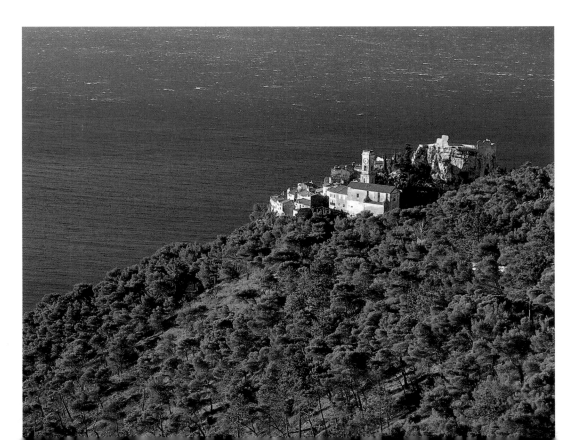

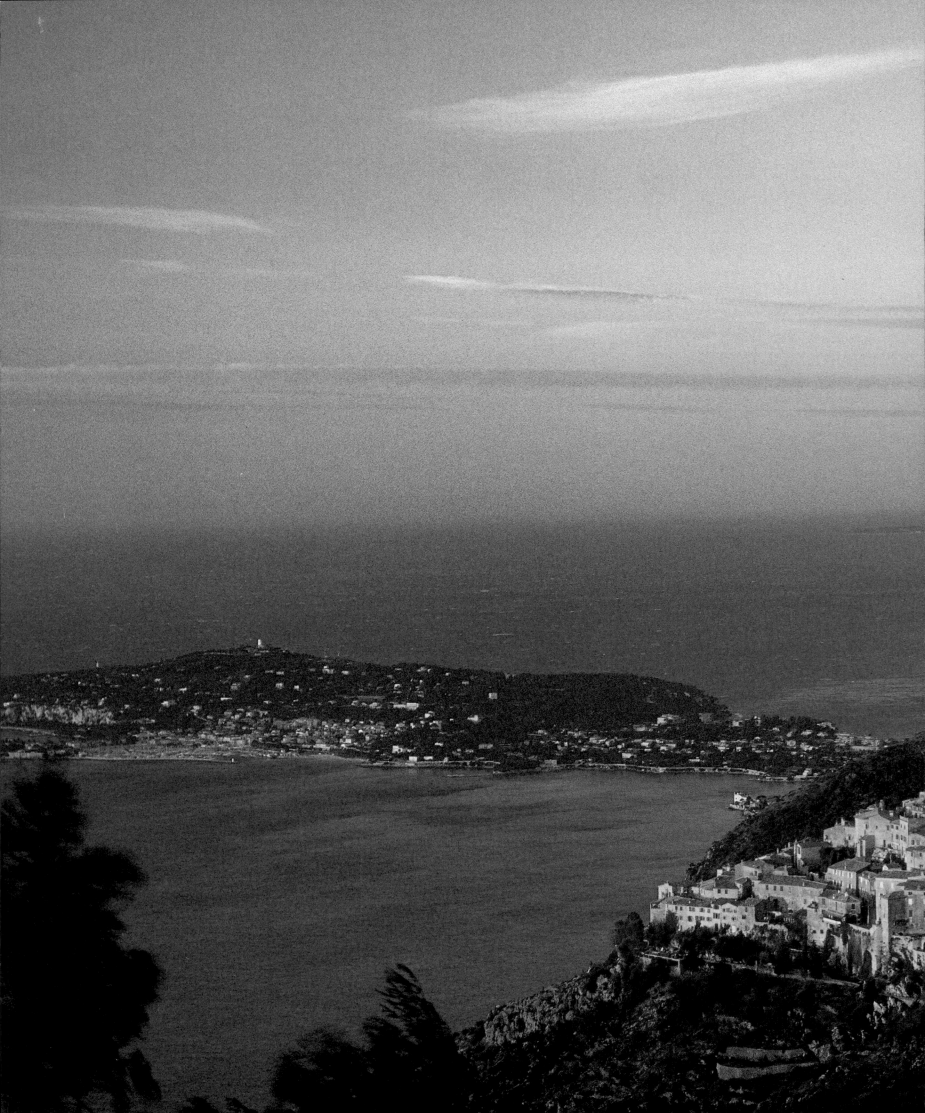

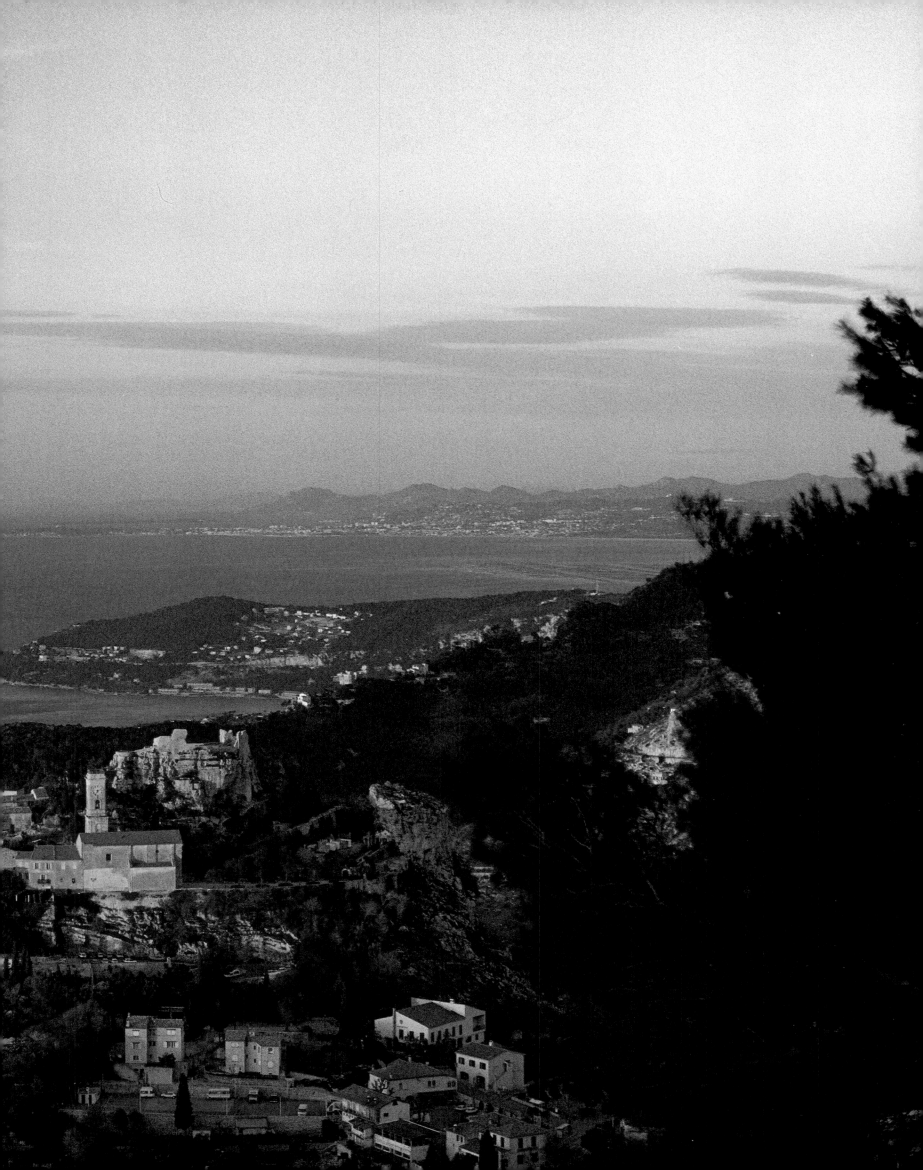

The impressively high walls required extremely solid foundations which were dug as deeply as possible into the rock itself. They were supported and reinforced by stone buttresses known as *pounti* or *pountins*, as seen here in the picturesque Carriera Soutrana, the lowest street, which runs along beside the rampart-houses. These buttresses, thrown across passageways, are amongst the most charming features of Mediterranean and Provençal villages.

◄

The first mention of Peillon occurs in two 12th-century charters pertaining to the former cathedral at Nice. The peak on which the village stands, however, had probably been occupied from the Celtic-Ligurian period. During the Middle Ages *Polleno* formed part of the bailiwick of Peille and was under the jurisdiction of Nice. The fief was jointly ruled by several seigneurs owing allegiance to the comtes de Provence. In the late 14th century, together with the whole of eastern Provence, the castle and the *villa de Pellone* came under the suzerainty of Savoy. Peillon then shared the fortunes of Nice, although its secluded position (and probably its minor strategic interest) protected it from the fighting that raged through the *comté* of Nice until the reunion with France.

The brotherhood of the Pénitents Blancs of Peillon was founded on 18 March 1661 and it was still in existence in 1809. Situated at the entrance to the village, the chapel which bears their name has retained frescoes devoted to the Passion of Christ executed by Giovanni Canavesio in 1485.

During the last century the principal sources of income were the vineyards and olive trees.

In 1315 Peillon comprised 31 households (about 130 inhabitants). In 1754 the population was 354. In 1809 the inhabitants totalled 408 – of this number 311 lived inside the village. Today the population of the whole community is 1,038, including 372 inhabitants in Peillon itself.

For further information:

*Peillon, sur l'éboulis de la montagne*, a joint work, Éditions Sous le Signe de l'Olivier, Nice 1955

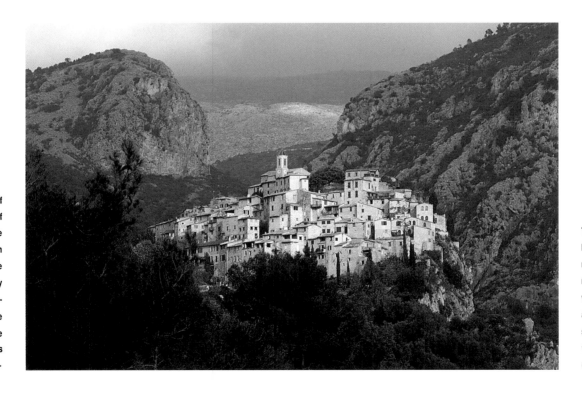

Perched like an eagle's nest on top of a peak, the picturesque village of Peillon is unquestionably one of the most beautiful hill communities in eastern Provence. It may justifiably be taken as the archetype of this variety of settlement and makes a breathtaking spectacle tightly packed on the summit of its hill, dominated by the church and surrounded by houses which double as ramparts.  ►

The village ends with a last row of houses which together served as a rampart. Their tall façades were almost completely closed to the outside world, the only openings being towards the village. The row of houses shown here contained the only medieval gate, which stood beneath the ochre-coloured building.  ►

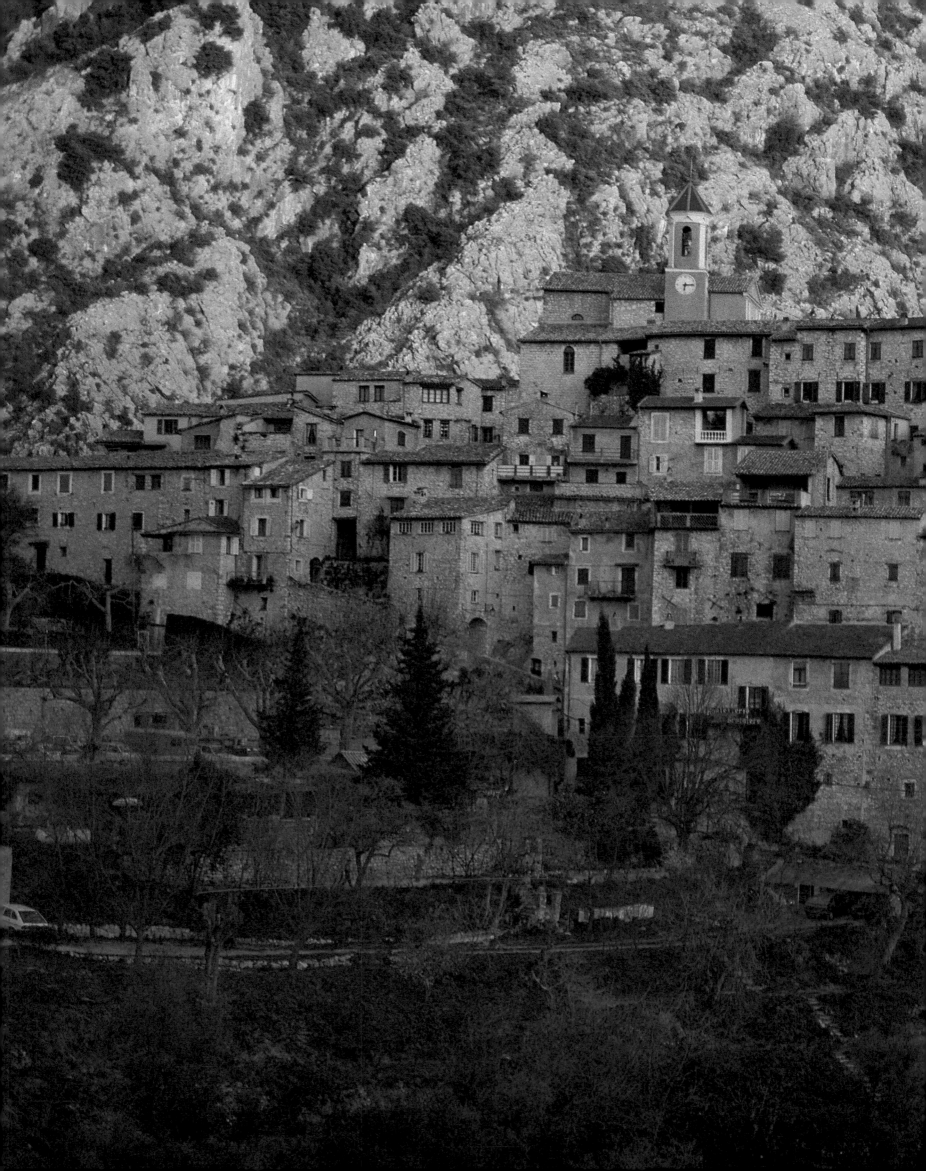

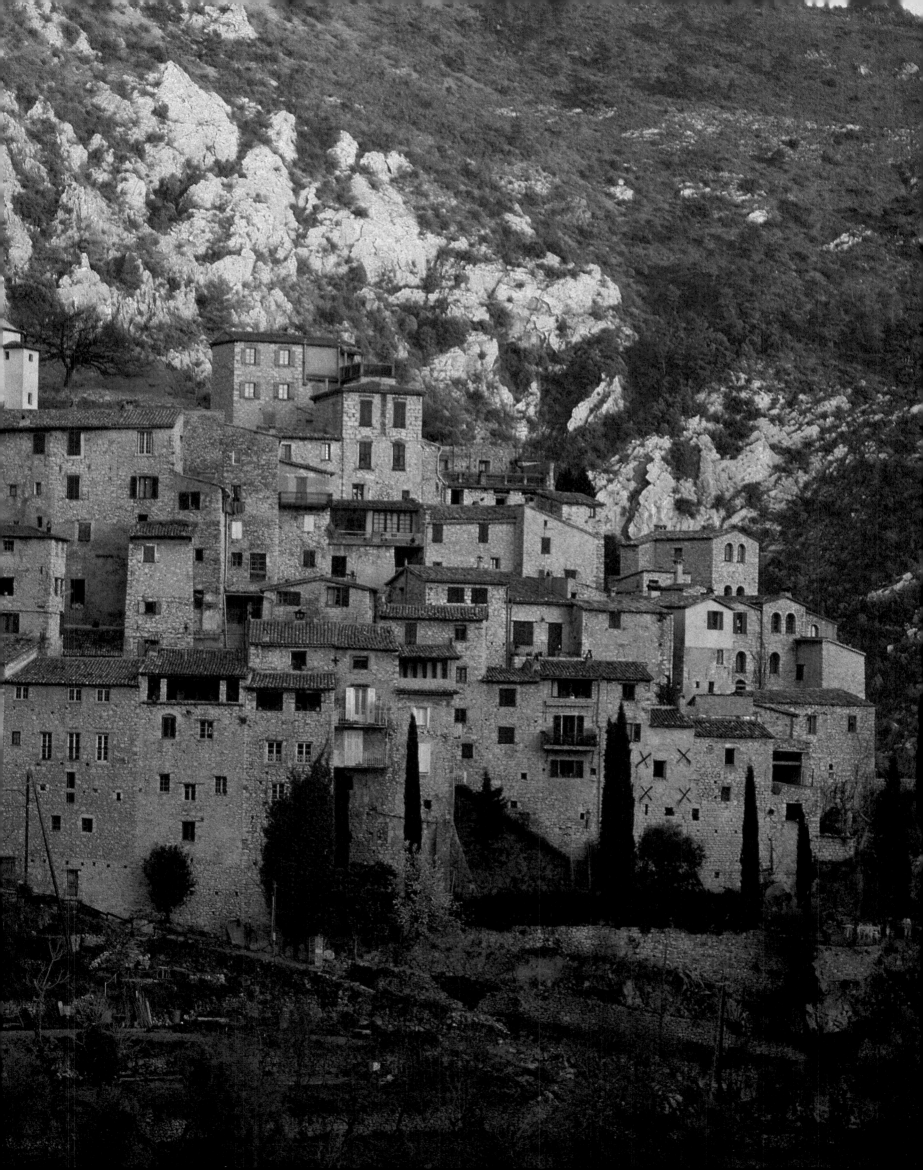

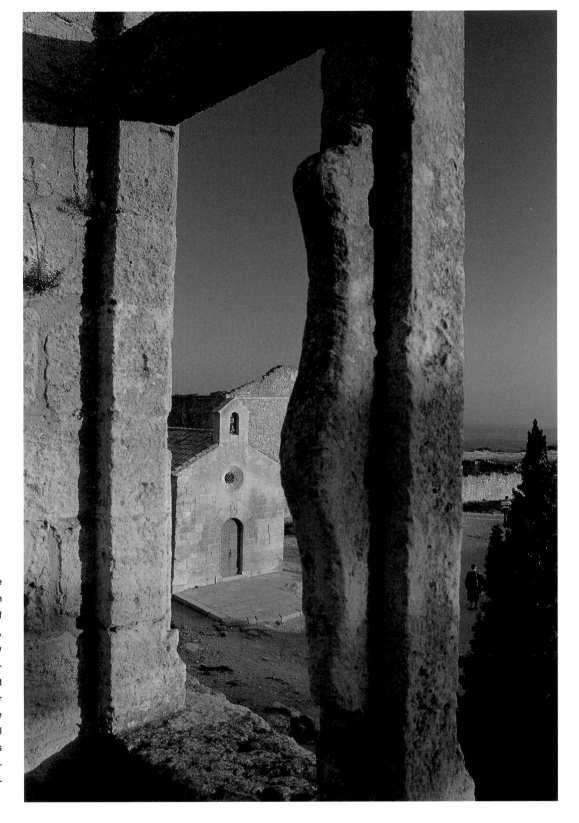

This photograph was taken from the former Hôtel de Glandevès (14th-15th century), which is at the upper end of the Rue du Trencat. The building, described as half ruined in 1677, now houses an archaeological and geological museum. In the 15th century it became the property of the de la Tour family, also known as du Brau. The house affords a fine view of the chapel of Saint-Blaise (12th century). This adjoins the ruined Hôpital Saint-André, founded by Jeanne de Quiqueran in about 1584.

This site has been permanently occupied for three thousand years, although the village enters history only in the late 10th century. At that time a powerful feudal family related to the vicomtes of Marseilles and Avignon affirmed their supremacy in the Lower Durance region. In the 11th century the seigneurs of Les Baux, now solidly established on the rock of the same name, built a *castrum*. The family claimed to be descendants of Balthazar, one of the Three Kings; they adopted a sixteen-pointed star as their emblem, and rejected the rule of the comtes de Provence and the Emperor. Their power extended to seventy-nine fiefs scattered throughout Provence from the Drôme to the Var. These were known as the *terres baussenques*. Despite the numerous feudal battles of this period, the de Baux family seat was the centre of a splendid and elegant circle during the 12th and 13th centuries. This was the great era of the troubadours, who included some of the seigneurs themselves.

In the 14th century this ambitious family took advantage of the troubles surrounding the succession of the so-called Reine Jeanne de Baux to hatch new schemes. They declared themselves to be against the Pope and the comte de Provence, claiming to support the Antipope at Avignon. The sinister Raimond de Turenne, last but one of the seigneurs de Baux, raged through Provence with his followers, putting the whole region to fire and sword. He had dispossessed Alix des Baux, who recovered her estates in 1392. She died in 1426, the last in the long line of the proud de Baux family. In 1427 the lordship was annexed to the *comté* of Provence, coming under the jurisdiction of the French king in 1481. It remained the property of the Crown until 1642 and was administered throughout this period by captain governors. Louis XI had the castle

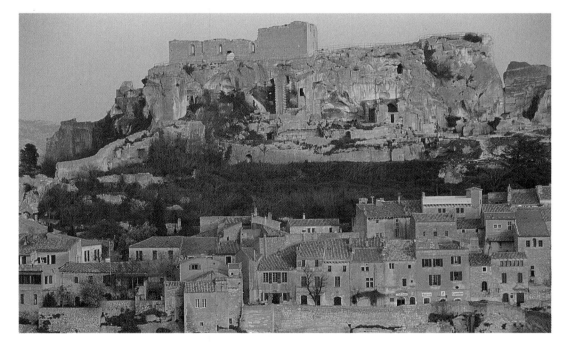

The keep which stands on the summit of the crag is the best preserved section of the castle. Partly embedded into the rock, it was built in the 13th century, no doubt on the site of an older building. At the foot of the rock, the so-called *terras* of the castle resembles a vast farmyard surrounded by stables, storehouses, outbuildings and so on. A little to the right and leaning against the rock, the ruins of the former castle chapel mark the entrance to the castle. The chapel, known as Notre-Dame-du-Château, dates from the 12th century. This whole area was isolated from the village by ramparts reinforced with a ditch. There were also a few private houses on the perimeter.

Situated on the southern edge of the Provençal alps, the region of Les Baux looks like a piece of molasses worked into wierd shapes, which gives the landscape its highly distinctive character. This remarkable rocky landscape has been used as a quarry over a long period. The crag on which Les Baux stands resembles a vast jagged ship, overlooking the stony plain of La Crau, which stretches to Vaccarès and the sea. The summit is crowned with a ruined castle that was virtually unassailable, until the development of artillery. It was one of the most renowned in Provence. The village stretches along the cliff, occupying only a part of the ground to the west and south of the castle. ▶

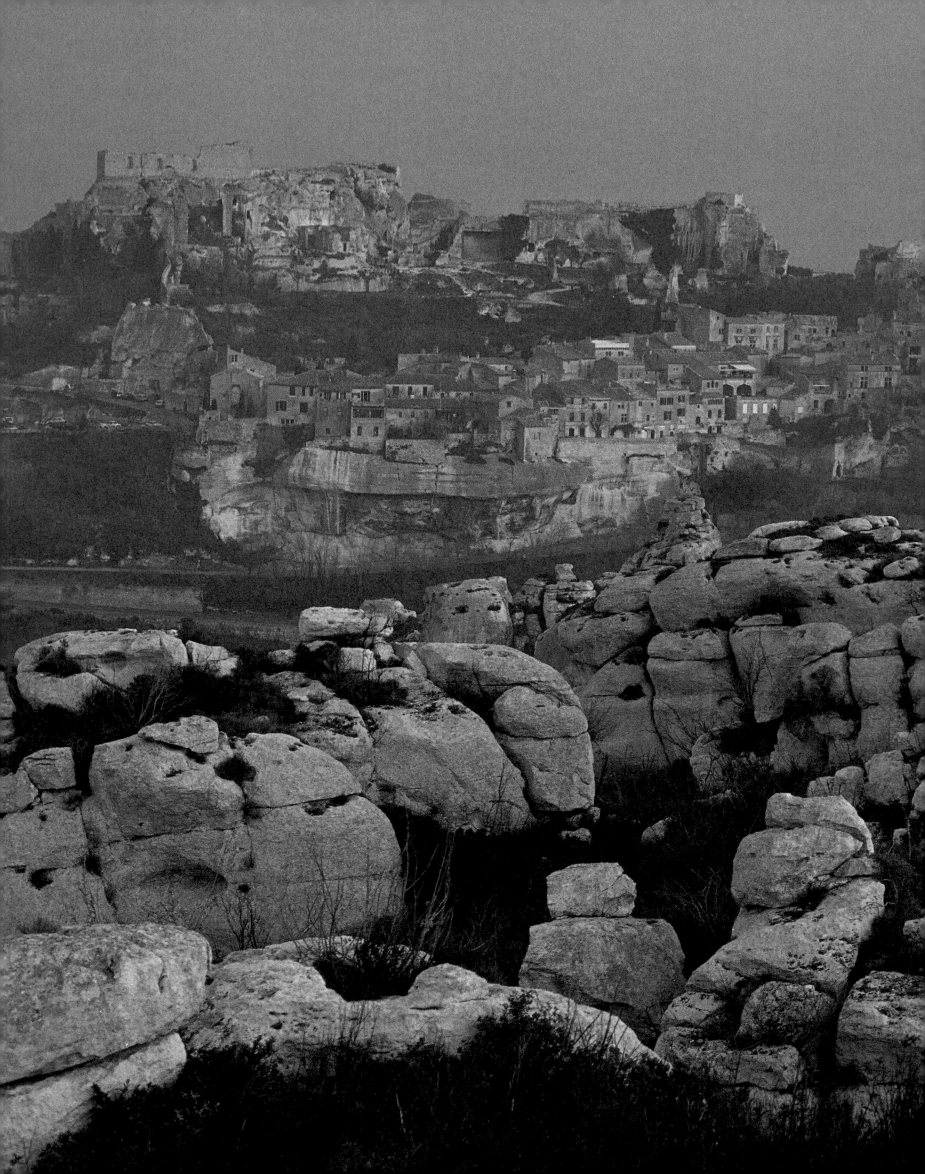

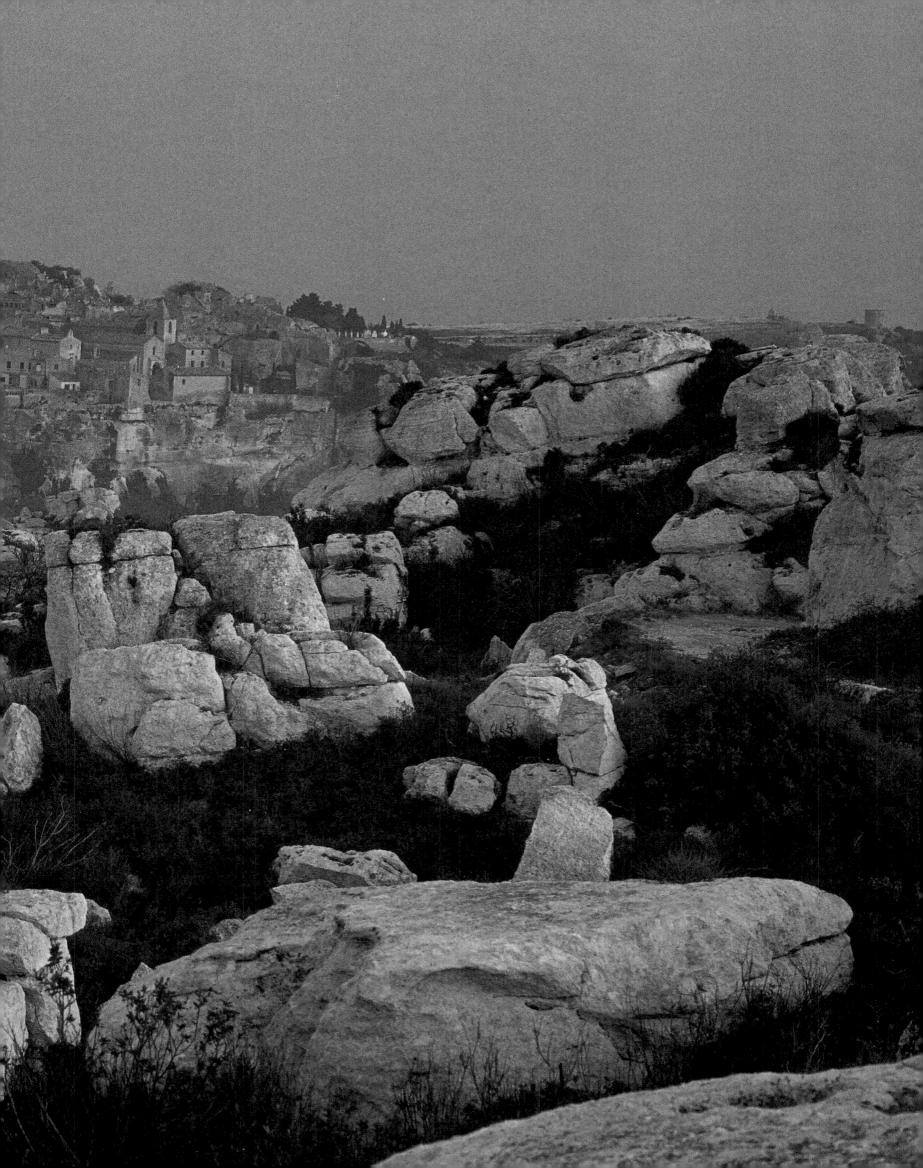

demolished in 1481, to preserve peace in the land. The seigneury lost its territories and was made a humble barony, becoming just another property to be granted to the rich and powerful. In 1528 it fell to the Constable of France Anne de Montmorency, who revived the golden age which had reigned three centuries earlier. The castle and its fortifications were restored, new private residences were built and so forth. After 1540 ideas of the religious Reform began to create divisions amongst the noble families. The Protestants were turned out of the castle in 1562 by Jean de Quiqueran, whose wife is famous for having built the Pavillon de la Reine Jeanne, as well as for founding a hospital. In 1630, the last viguier or magistrate of Les Baux sided with the duc d'Orléans against Louis XIII and the local inhabitants received the rebels from Aix, who were opposed to Richelieu's edict on taxation. The village was then occupied by order of the king. In August 1631, the ramparts and castle were destroyed, at the inhabitants' request, and the seigneury of Les Baux was bought back by the community. In 1639, however, the town found itself in great financial difficulty and implored Louis XIII to exercise his rights of repurchase. Three years later the king finally granted this request. Having elevated the barony of Les Baux to a *marquisat*, he presented the territory to Hercule de Grimaldi as a token of gratitude for driving the Spanish out of Monaco (18 November 1641). The Grimaldi family, who still hold the title of marquis des Baux, kept the fief until the Revolution.

The town contained only 42 houses in 1420. By the beginning of the 16th century the population had reached a peak, with 150 houses and nearly 3,600 inhabitants. In the 17th century they gradually began to leave, settling instead in the villages of Maussane and Mouriès, on the plain. The population is now 62.

**Almost the whole area of Les Baux is officially protected. It forms an unusual mixture of ruins and restored buildings. Although the restoration work has been carefully carried out, it does not recreate a homogeneous appearance. Les Baux has been reconstructed stone by stone and tends to make one think of a stage set. The most characteristic houses on the site date from the Renaissance. The most beautiful is the Hôtel de Manville (now the town hall), seen on the right. It was constructed in 1571 for Claude III de Manville.**

**Directly overhanging the valley of La Fontaine, the Place Saint-Vincent underwent a considerable amount of alteration in the last century. This was the work of the architect Revoil, who carried out a restoration of the church and the surrounding area. Seen on the right, the church of Saint-Vincent has been the parish church of Les Baux since 1481. It dates from the 12th century, but was enlarged and altered between the 16th and the 19th century. The Chapelle des Pénitents Blancs, on the left, was built in 1622. It was restored in 1935, then again in 1975. The walls are completely covered with frescoes by Yves Brayer.**

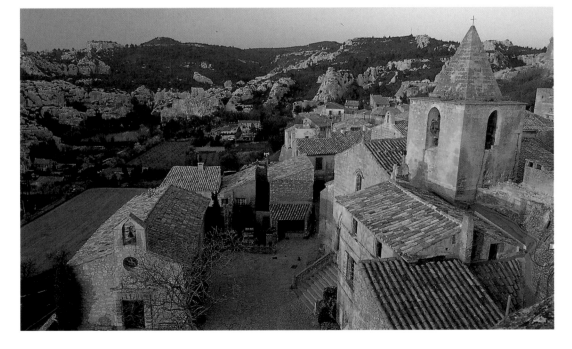

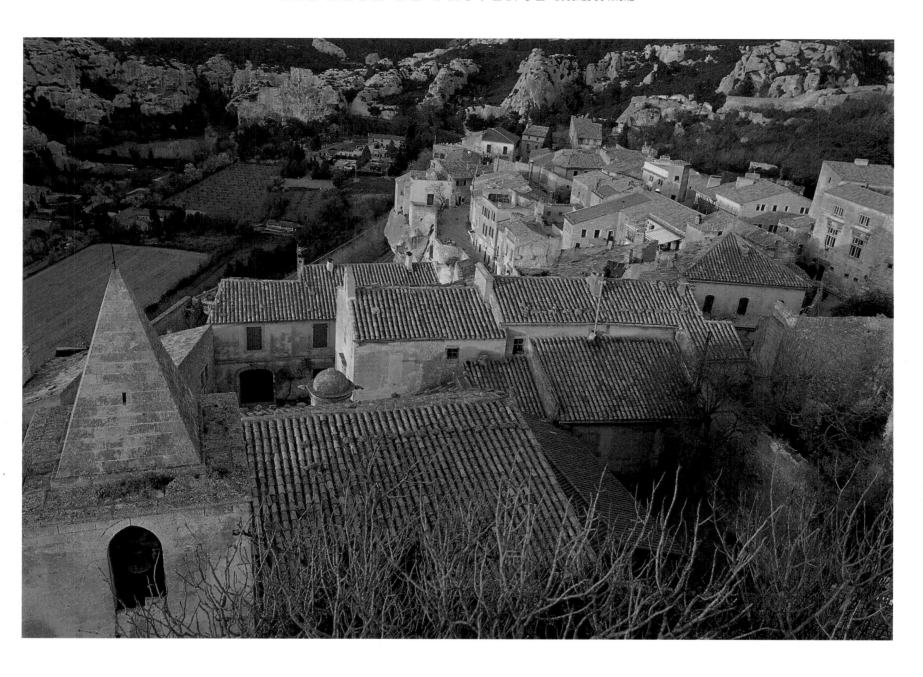

For further information:

*Les Baux*, by Paul Pontus, Nouvelles Éditions Latines,
Paris 1971

# BARGÈME VAR

In the early 12th century, the seigneurs of Castellane were the overlords of Bargème. They lost their rights to the Pontevès family in the following century; in 1293 Foulques de Pontevès bore the title of seigneur de Bargème. The history of Bargème is therefore linked to that of this ancient Provençal family, who have featured in the archives of Saint-Victor de Marseille since the early 11th century.

In the course of the Wars of Religion the Catholic troops of Jean-Baptiste de Pontevès mercilessly pillaged the neighbouring town of Callas. As a result, the inhabitants nurtured an implacable hatred against the family, which lasted almost an entire generation. This gave rise to a series of crimes which exterminated a considerable proportion of the clan between 1579 and 1595. The inhabitants of Bargème took up the cause of their neighbours in Callas. Disturbed by the large number of outrages, the parliament at Aix-en-Provence issued a decree ordering the inhabitants of Bargème to build the chapel of Notre-Dame-des-Sept-Douleurs as a penance. Sossy, the lieutenant of a troop of foot-soldiers attached to the Protestant army, and ringleader of the group who massacred Jean de Pontevès and his sons, was hanged in 1592.

In the early 19th century the duc de Sabran married the village heiress, daughter of the marquis de Pontevès-Castellave and comte de Bargème. Their descendants now reside in the castle of Ansouis, in the *département* of Vaucluse, but visit their ancestral château every year.

In the early 14th century Bargème had 320 inhabitants. The population was 200 in 1471, then 350 in the late 18th century, 440 in 1821 and 104 in 1939. The inhabitants numbered 58 in 1962. A figure of 74 represents the population of the whole community today, which is grouped into eight hamlets.

For further information:

*Le cas de Bargème*, a study by Maurice Perrier, UER from the Faculté des Lettres et Sciences Humaines, Nice University 1981

The medieval wall has disappeared, this gate known as the Porte du Levant being the last remaining trace. It was still used as an entrance to the village as recently as 1892. The nearby Quartier de l'Arcade also contains several ruined houses.  ►

The village comprises only a few houses. Since the beginning of this century it has struggled with the problem of depopulation, the inhabitants preferring to move to less isolated spots on the plain. Nearly all the farmers have abandoned the village, deterred by its remote location, the steepness of the site and the barrenness of the soil. Since the Second World War the inn, the grocery shop and the bakery have all shut down for lack of custom: the school closed in 1955. Today the village is practically deserted. It refuses to die, however: the touristic appeal of the region, the general liveliness of the summer season and above all the ever-increasing number of those possessing a second home here, offer hope for its future.

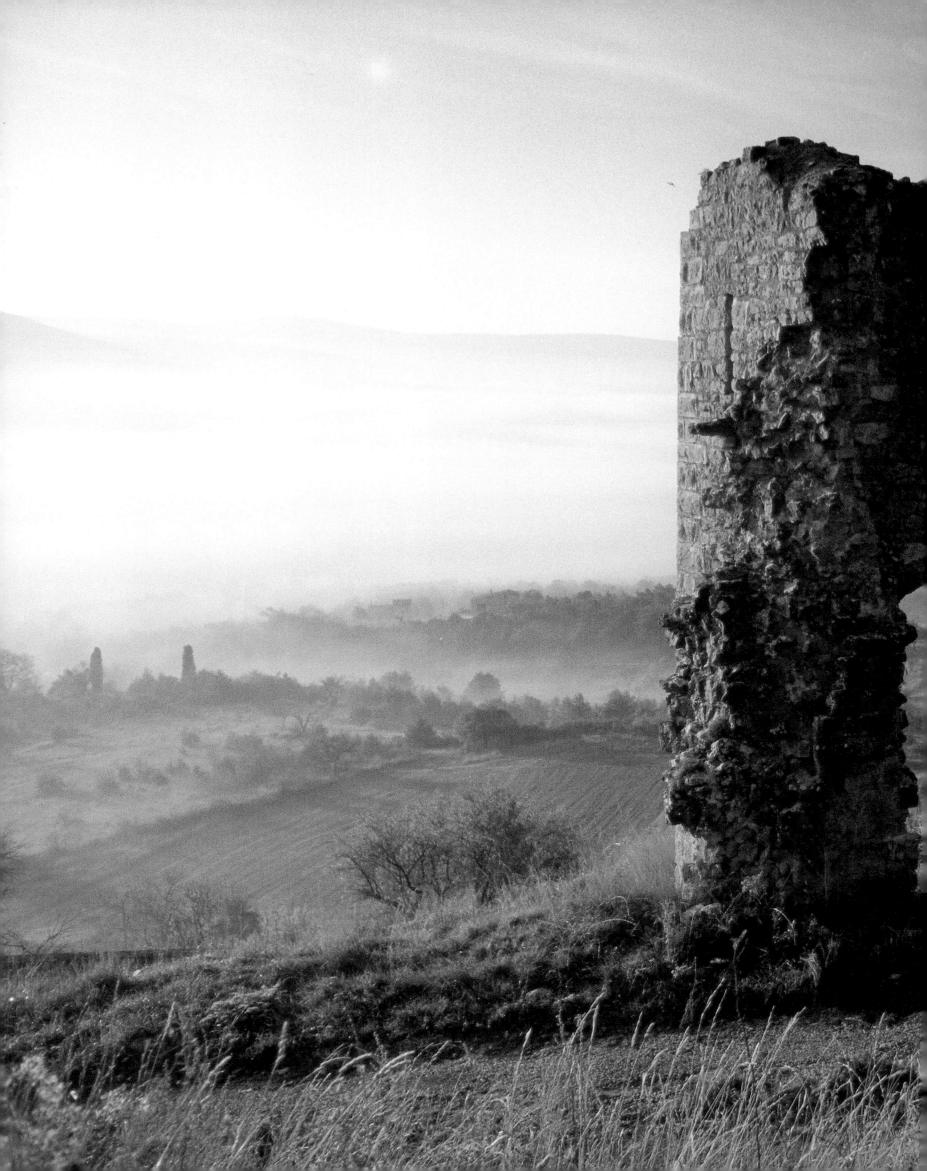

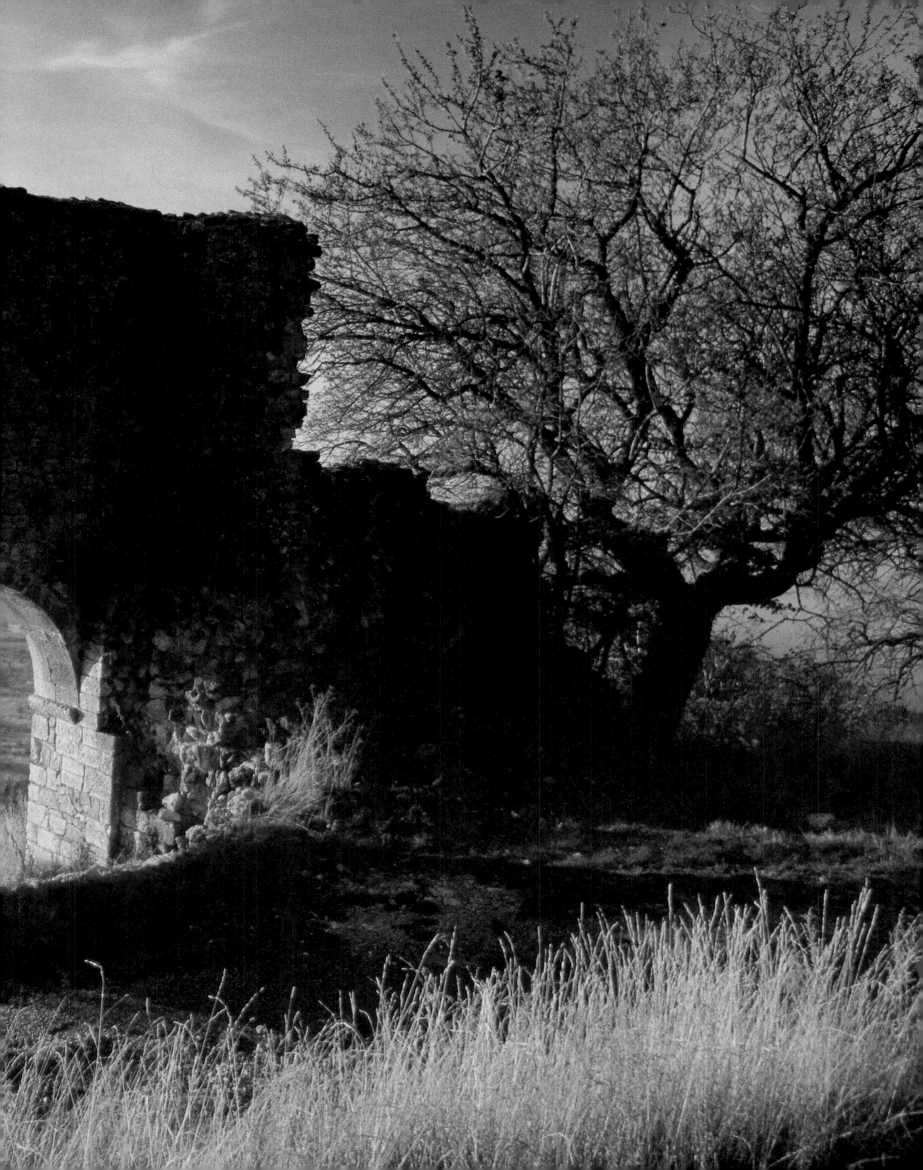

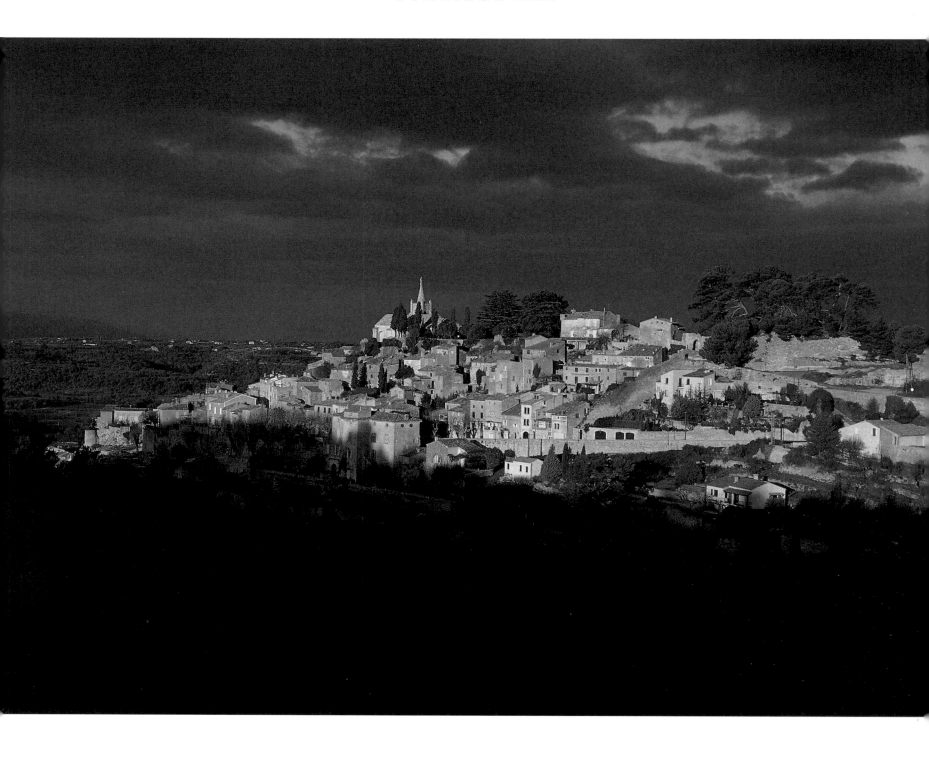

Facing the village of Lacoste, the houses of Bonnieux extend along the edge of a plateau, which stretches from the valley of Apt to Luberon, in superb countryside. The village was enclosed by three walls, which developed as the community expanded. Considerable traces still remain. The *castrum*, the ancient fort mentioned in 10th-century texts, rose on the summit of the mountain on the right, where the pinewood now grows. This rocky spur was surrounded by a first rampart; its only entrance, known as the Portail des Chèvres, can be seen here. It probably dates from the 12th century. A second wall, not visible on this photograph, was built in the mid-1100s to encompass the large community that developed below the *castrum*.

Between 966 and 972 the cartulary of Apt mentions vineyards *sub castro Bonilis*, presented by the bishop of Apt to Notre-Dame d'Apt. Fortifications have therefore existed at Bonnieux since the 10th century. This is one of the earliest mentions of a fortified castle in Provence, where such constructions generally appeared at a later date.

The first seigneurs of Bonnieux came from the powerful Saint-Mayeul family, but in 1125 the *comté* of Venaissin – in which Bonnieux lay – fell to the comtes de Toulouse. On the death of Alphonse de Poitiers in 1271 the king of France (Philippe III, le Hardi or 'the Bold') seized the Venaissin, keeping it for three years before giving it up to Pope Gregory X, who claimed it as his territory. Bonnieux, in this special position as an enclave in the middle of Provence, was therefore linked to the fortunes of the Papacy for 517 years. In 1545 this staunchly Catholic village was a victim of the Waldensian repression in Luberon; about 3,000 people were massacred and 600 sent to the galleys. Nineteen villages near Bonnieux – the most famous being Lacoste – were destroyed. In 1573 the 'siege of Ménerbes' conducted by the Huguenots wreaked fresh havoc in the lands bordering on Bonnieux. On 14 September 1791 a decree passed by the Constituent Assembly declared that 'by virtue of the laws of France and in accordance with the wishes of the majority of the commons, the two states of Avignon and the Comtat-Venaissin were to become incorporated into the French Empire'.

In 1572 there were about 3,479 inhabitants living on the territory of Bonnieux; from 1600 until 1793 the situation remained virtually static, with an average population of about 2,400. It seems to have reached a peak in the 1850s, with 2,674 inhabitants. Today the population in the district of Bonnieux numbers only 1,385, with just 501 residing in the village itself.

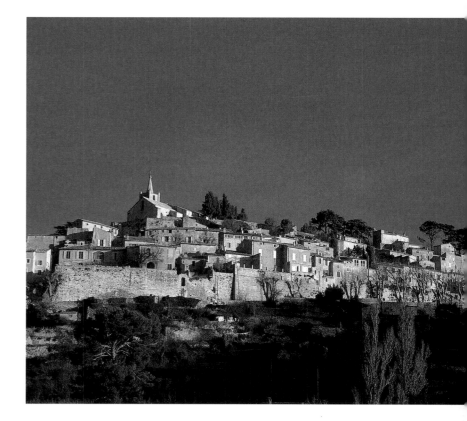

For further information:

*Bonnieux, histoire et vie sociale d'une ancienne enclave pontificale en terre de Provence*, by René Bruni, Éditions Études, Apt 1989

The construction of a third, much larger enclosure began in 1368. It had stronger ramparts with towers. Here, on the south side, the outline of this long 14th-century wall is still perfectly discernible, where it runs alongside the Chemin de Lourmarin. The finest remains of the wall, however, are to be found to the north and west.

Bonnieux has retained some private houses, or *hôtels*, dating from the 16th, 17th and 18th centuries; they are relics of an opulent past. The old church overlooking the village was formerly the castle chapel. It is a 12th-century Romanesque building, enlarged and altered between the 15th and the 18th century. In 1865 a statue of the Virgin, executed by the local sculptor Audibert, was erected on top of the bell-tower. ►

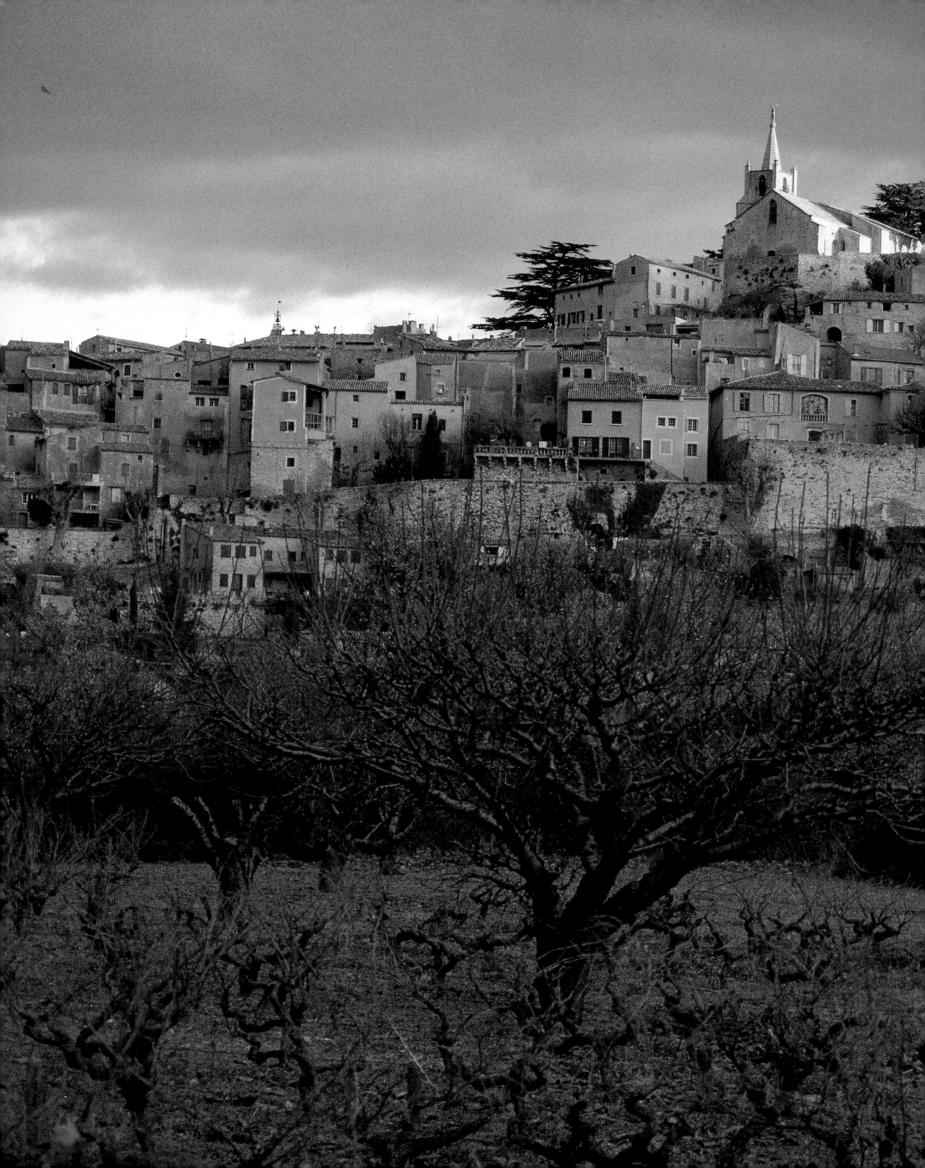

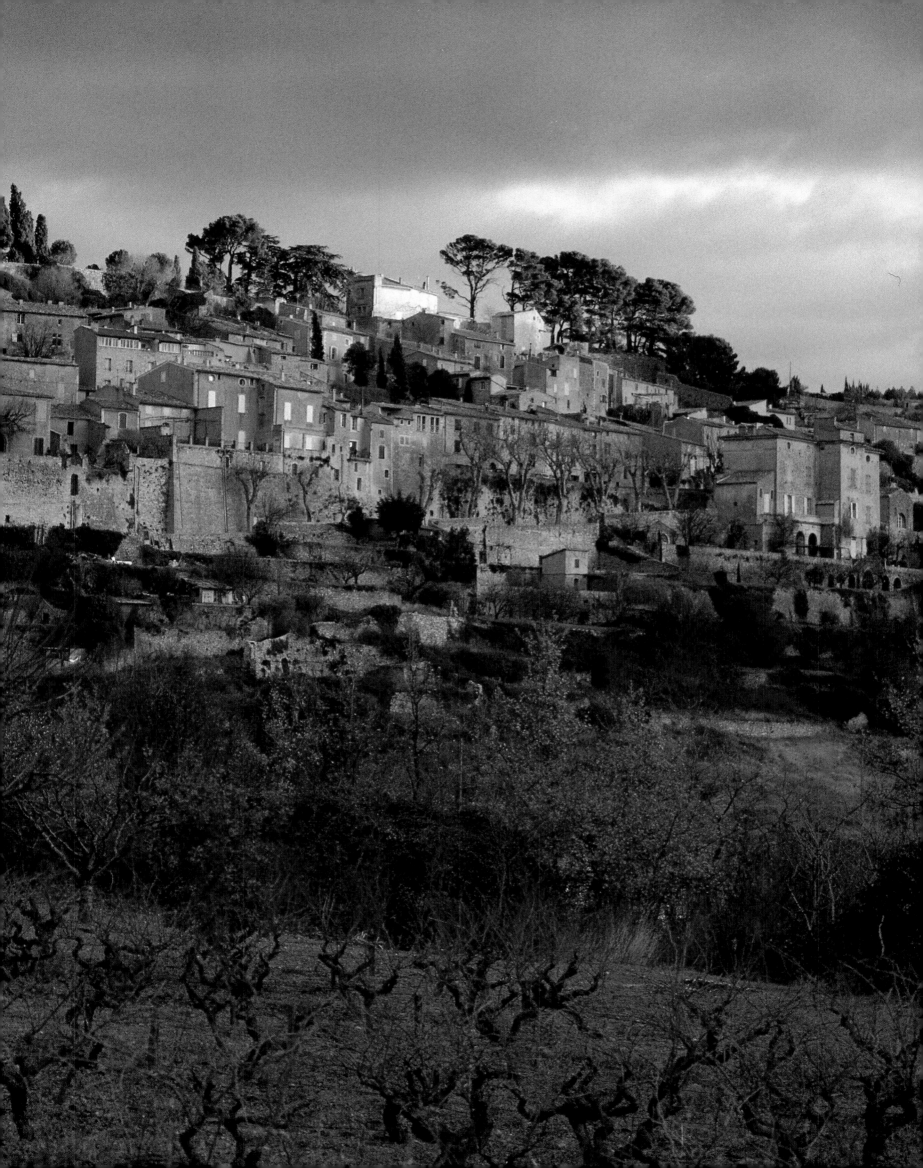

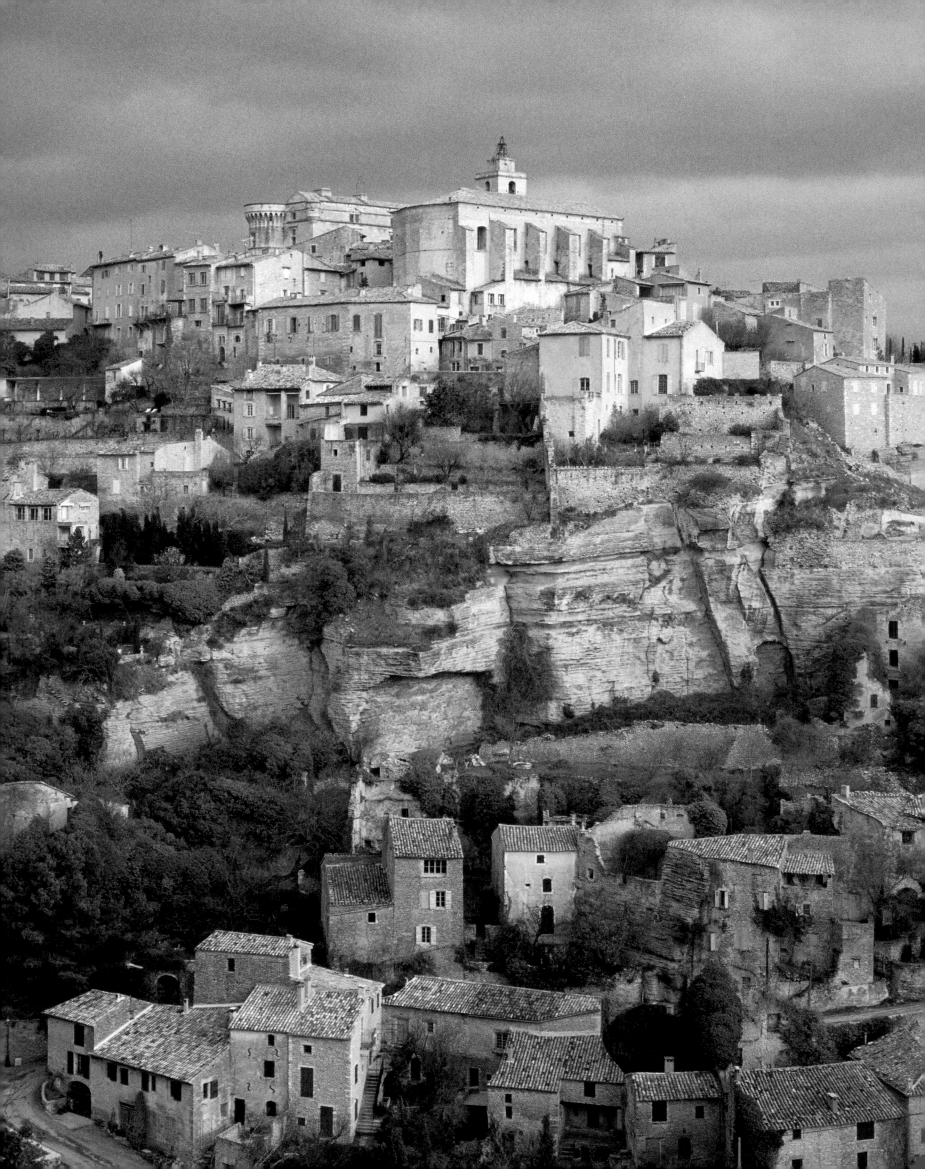

The expulsion of the Saracens heralded a period of revival throughout Provence. Their invasion had left Apt and the surrounding region in a state of almost total ruin from the 8th to the early 11th century. Around the end of the 10th century the inhabitants began to settle in clusters around protective *castra* and within fifty years the whole region was covered with buildings. The village of Gordes is mentioned in two charters pertaining to Saint-Victor-de-Marseille, dated 1031 and 1035. The fief of Gordes was owned by two branches of the same family, the Agoults and the Simianes, for over seven hundred years. It is interesting that the majority of their archives refer to the continuing friction between their family and the inhabitants of the village, the subject of the conflict being municipal franchise.

During the Wars of Religion the baron des Adrets sought to seize possession of the village, but he was betrayed by one of his own soldiers, a native of Gordes who wanted to save his compatriots. The inhabitants prepared to defend themselves against attack, which caused the baron to abandon his plan. During the Second World War the village was an active centre of resistance; it was bombarded in 1944 and awarded the Croix de Guerre on 11 November 1948.

In the early 19th century the population was over 1,500. By 1866 it had dropped to 1,100, and to 651 in 1886. In 1911 there were 366 inhabitants, in 1934, 232. The population today is 399.

For further information:

*Gordes, notes d'histoire*, by Jean-Louis Morand, Éditions de la Mairie de Gordes, Cavaillon 1987

◄

Built on the edge of a steep promontory, Gordes is for many the perfect example of a former Ligurian stronghold on which a fortified village has developed during the Middle Ages. When André Lhote, 'discovered' Gordes in 1938, before it was made famous by the painter Vasarely, the village was in a pitiful state. Today the surge in tourism and the popular interest in villages have halted its decline. Some ruined houses may still be seen, however, notably in this spot under the cliff.

A few beautiful houses dating from the late 16th or early 17th century can still be found in Gordes. An example is the Palais Saint-Firmin, which opens on to the picturesque Rue du Four through this elegant portal.

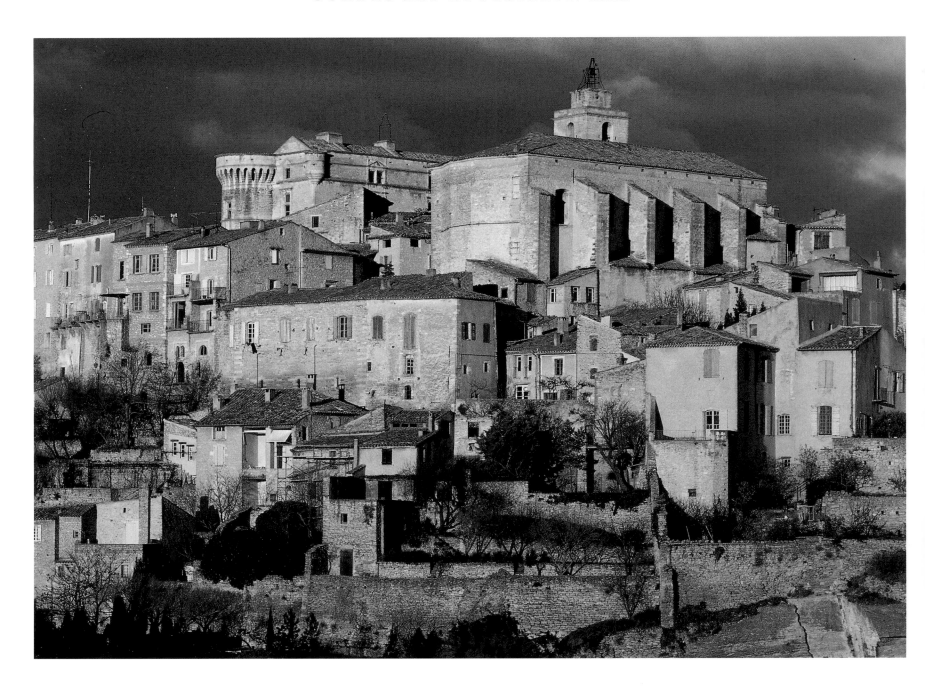

The ramparts were constructed along the contours of the landscape, giving the village its characteristic appearance. A description given in the 19th century of 'Gordes, a large walled *bourg*' corresponds to the postcards of the 1900s, which depict various fortifications now no longer extant. Here, the alleyway climbing towards the village leads to the Porte de Savoie, one of the last remaining traces of them.

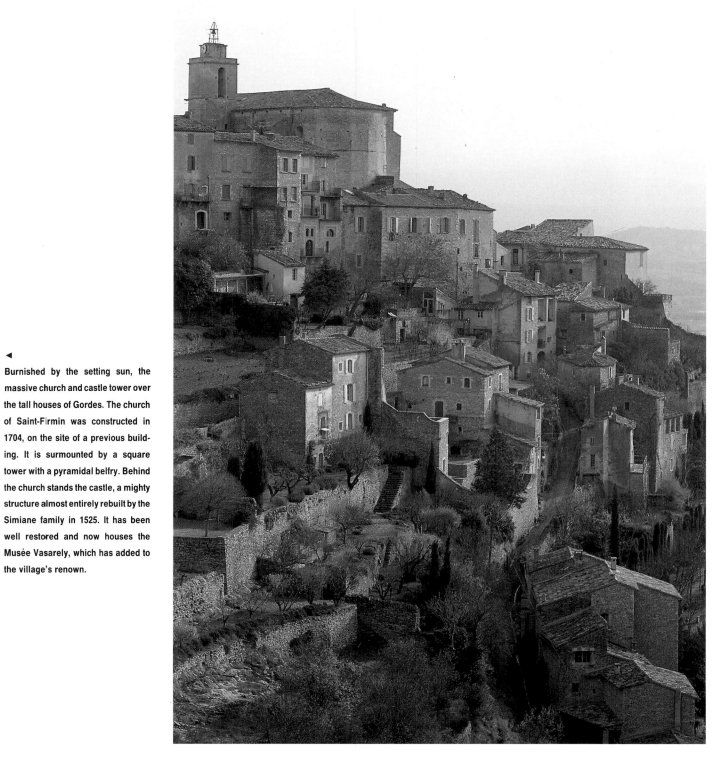

◄

Burnished by the setting sun, the massive church and castle tower over the tall houses of Gordes. The church of Saint-Firmin was constructed in 1704, on the site of a previous building. It is surmounted by a square tower with a pyramidal belfry. Behind the church stands the castle, a mighty structure almost entirely rebuilt by the Simiane family in 1525. It has been well restored and now houses the Musée Vasarely, which has added to the village's renown.

Roussillon, eight kilometres (about five miles) from Gordes, is one of the most picturesque villages in the Apt region. Standing on a rocky peak, it is a remarkable sight, surrounded by quarries and ochre-coloured cliffs. The roughcast stones of the houses reflect all the varying hues of the cliffs, from blood-red to bright yellow-gold, creating a harmoniously blended whole.　　　　　　　►

191

# PÉROUGES AIN

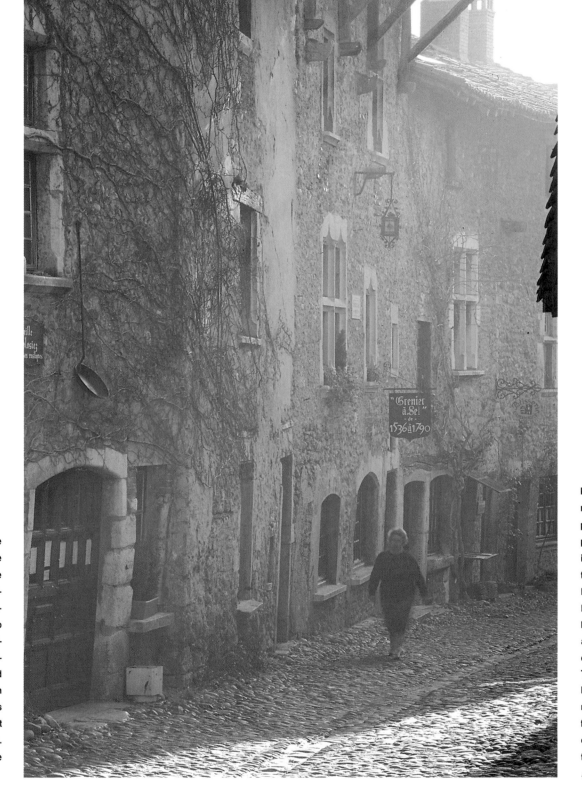

The Rue des Rondes has to a large extent retained its original pebble paving. The street runs all around the village, lined with houses built directly against the ramparts. The northeast section contains the finest group of well preserved buildings. The salt-store is particularly worthy of mention. It has been skilfully restored and has kept its outer covered way. From 1536 to 1790, this building served as the 'salt warehouse', an important annexe to the salt-store at Montluel. This provided the region of Bresse with salt from the Camargue.

Pérouges stands on the borders of the regions of Dombes, Bresses, Dauphiné and Lyonnais. The village is perched on an isolated promontory. It is only separated from Méximieux by this valley, along which flows the Longevent, a small stream. The village was formerly surrounded by double walls lined with a ditch. There was a castle, the last traces of which disappeared during the Revolution. The houses almost all date from the Renaissance and have been carefully restored. They form an exceptionally fine group, mainly due to the harmony of their architectural styles. Most of the village is in fact classed as a *monument historique.* ▶

The first mention of the village and castle of Pérouges occurs in about 1130, when Guichard I, lord of Anthon in the Dauphiné had received the castle as a fief from the comtes de Forez and Lyons. In the early 13th century the 'inhabitants and bourgeois' of Pérouges were presented with a charter granting them considerable privileges. This charter was confirmed and extended by various dauphins de Viennois in 1329, 1334 and 1343.

Pérouges passed from the d'Anthon family to that of Geneva: then came the battle of Varey (1325) between Savoy and the Dauphiné, after which it became part of the dauphin's estates. Pérouges was a Savoyard possession from 1355 to 1601, with a short interval between 1535 and 1559 (the period of wars with Italy), when it belonged to the French. This was the golden age of the village. It became a prosperous community with wealthy guilds (in particular the Guild of Weavers), frequented by 'French merchants passing through on their way from Lyons to Geneva'. Its walls were besieged by the Dauphinois in 1454, then by the French in 1468. These defences had undergone a yearly process of restoration since the 12th century.

From 1750, however, the main highways (Lyons-Geneva and Lyons-Strasburg) passed through the neighbouring town of Méximieux and Pérouges was gradually left deserted on its hilltop. By the dawn of the 20th century it had become a ghost village. The situation became worse than ever when an ill-advised

The market place in the heart of the community is no longer filled with busy crowds, as the old wooden market was destroyed by fire in 1839. It formerly stood in front of the house with a sundial. Seen in the centre of the square, the enormous lime tree whose spreading branches are covered with luxuriant foliage, is a genuine monument to the Revolution, planted in October 1792. ▶

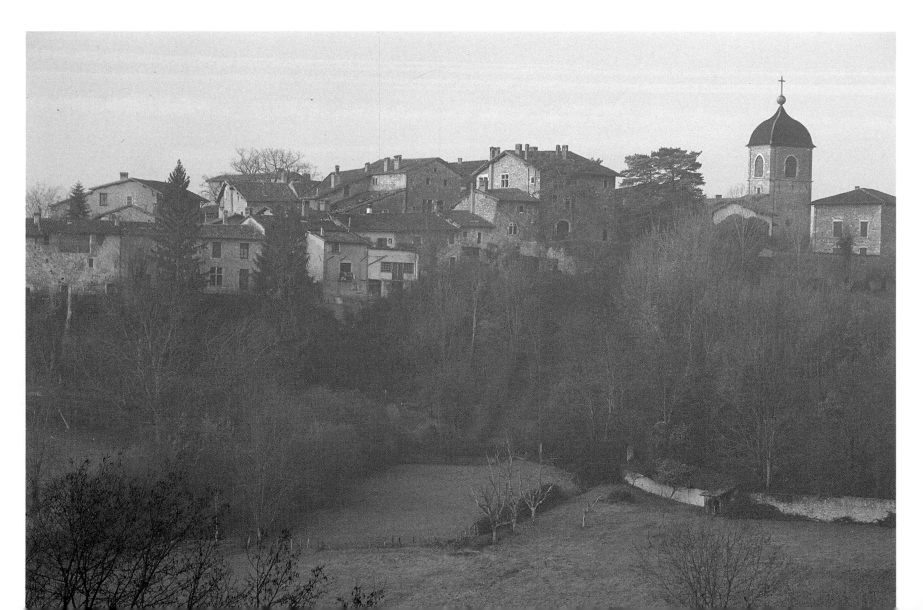

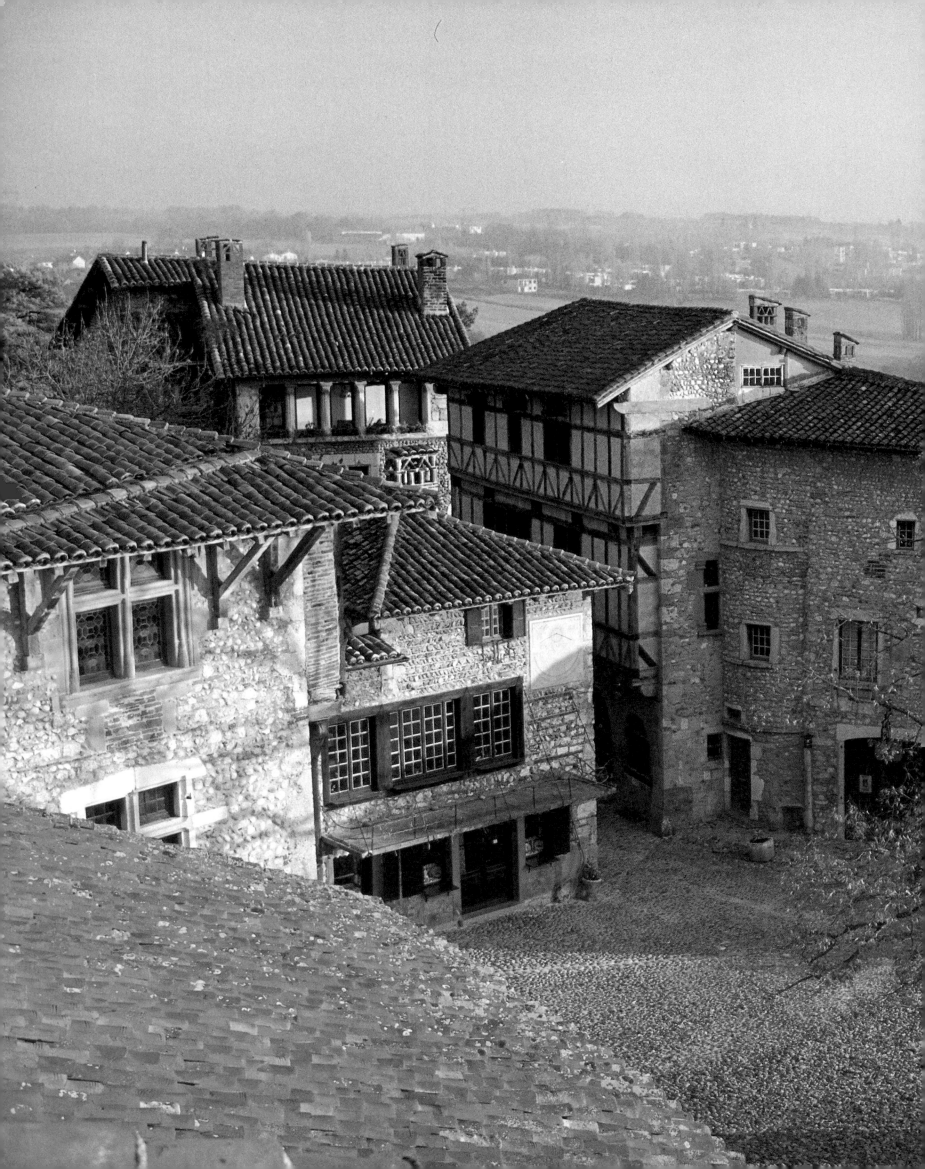

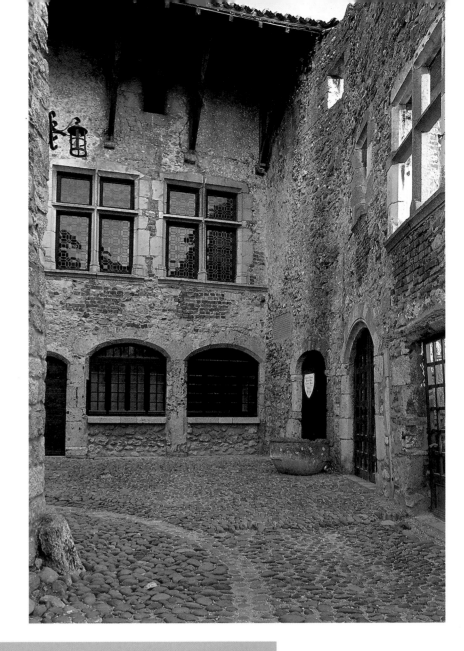

On the eve of the siege of 1468, the fortified church was destroyed in the course of its construction by the villagers themselves, who needed to reinforce their ramparts with all possible speed. Begun again in 1469, it was completed ten years later. It adjoins the Porte d'En-Haut, the main entrance to the village. This is surmounted by a square tower, the top of which can be seen here. In this part of the town (towards the right, just out of the picture) there were several beautiful 15th-century houses, demolished in 1910.

municipal decree of 1909 ordered house owners to 'repair or demolish' their residences. A whole area was immediately destroyed. The situation was saved by a dynamic local inhabitant, Anthelme Thibault, who managed to halt this 'irreparable outrage'. Shortly after the demolition, he founded a committee for the protection and preservation of old Pérouges. This organization still continues its mission to safeguard and restore the village.

The population of Pérouges numbered about 700 in 1435, reaching a peak in the mid-18th century with 1,000 inhabitants. In 1850 there were 396 inhabitants, but by 1921 the population had dropped to 52. Today the village has a population of 464.

For further information:
*Histoire de la cité de Pérouges*, by Adrien Favre, Montluel 1988

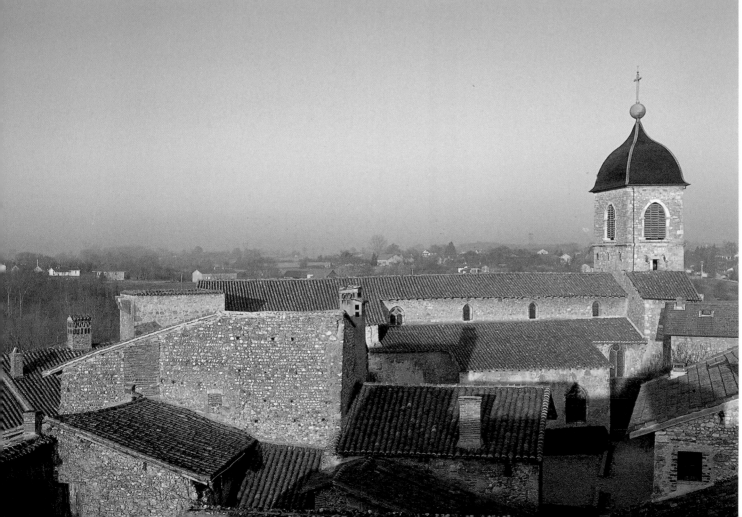

The village owes much of its charm to the tufa and pebbles used in the construction of houses, and the paving of streets. Now partially in ruins, this beautiful house known as the Maison du Prince (in the Rue du Prince) was built by the counts of Savoy. It served mainly as a lodging for their castellans. Its architectural features are typical of the local buildings – fine mullioned windows and, above, a large roof with supports, which juts out some way from the façade.

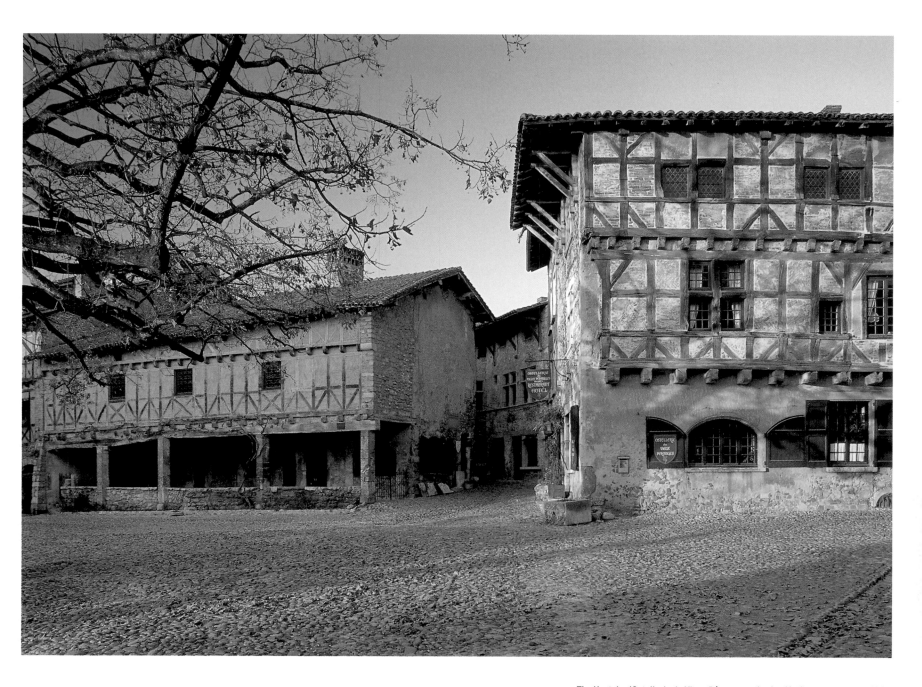

The Hostelry (Ostellerie du Vieux Pérouges) in the market square, is one of the most elegant buildings in the village. It was probably constructed in the 13th century, undergoing alterations in the 1400s. It was skilfully restored at the beginning of this century. In 1396 the house on the left belonged to Jean Escoffier, who was authorized in the same year to add the picturesque gallery overlooking the square. The Rue du Prince runs between these two houses. It was once the busiest street in the whole village, as it was used by the merchants.

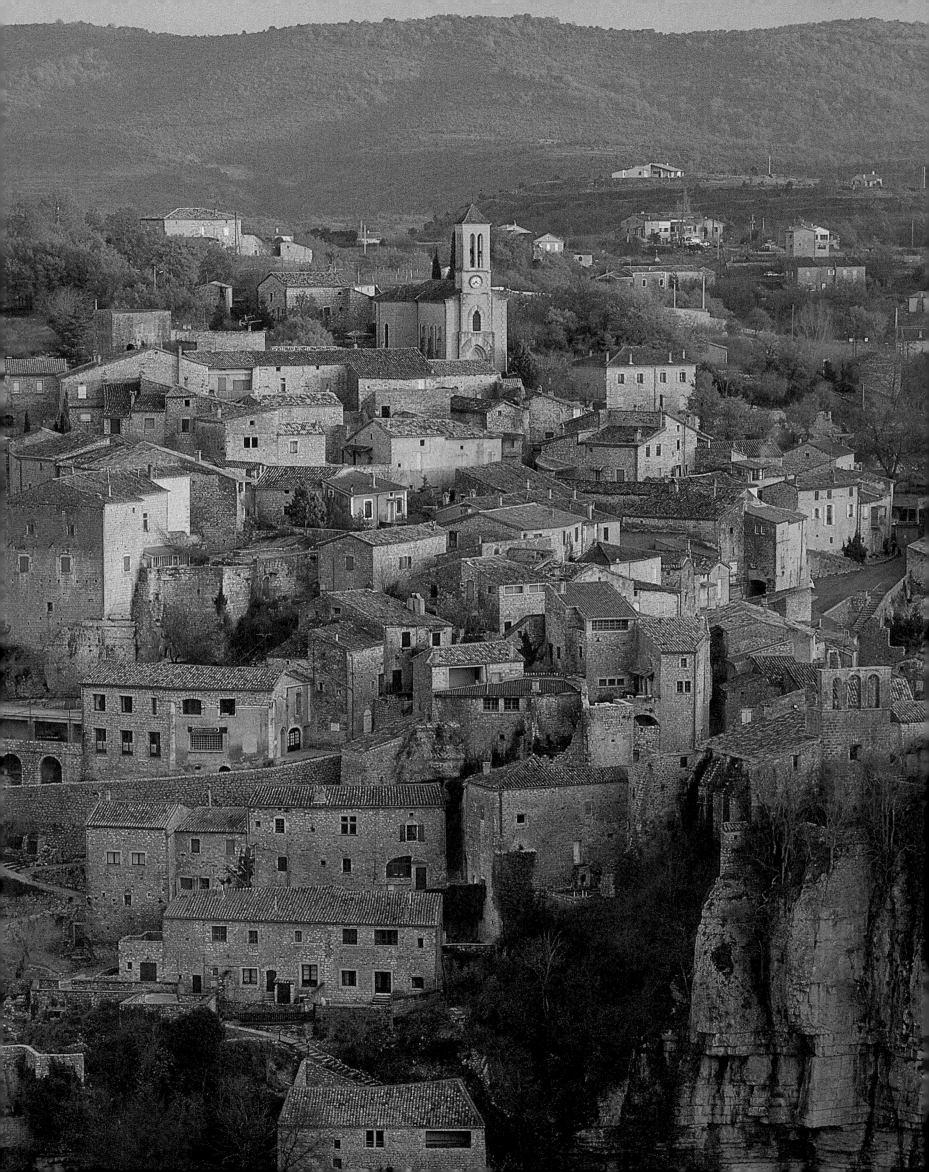

The earliest document to mention Balazuc dates from 1077. The village appears under the name of *Baladunum*, which has been translated as 'high rock'. Its most famous lord was Pons de Balazuc. He left for the Crusades, marching under the banner of Raymond de Saint-Gilles, Comte de Toulouse, and was responsible for a work entitled *Histoire des Français qui prirent Jérusalem*. Sadly, he perished at the siege of Arcos in the summer of 1099. By the early 16th century the line founded by Pons de Balazuc had long been extinct: the seigneurs no longer even lived in the village. As religious Reform spread through the region of Vivarais, most of the surrounding districts allied themselves to the Huguenot cause; Balazuc, however, became a Catholic stronghold. A few years prior to the Revolution, Balazuc was described as a poor village, whose inhabitants produced only a small quantity of wheat, a little wine, a little oil and silkworms.

The population of the village has been estimated at five or six hundred inhabitants in the second half of the 15th century. The breeding of silkworms led the community to experience a rise in prosperity in the early 19th century. The population rose from 576 in 1801 to 905 in 1851. During the years that followed Balazuc, in common with many other villages in the Ardèche, was stricken by two disasters. A disease known as *pébrine* destroyed the silkworms, whilst the vineyards succumbed to phylloxera. This meant ruin for many families who left for the towns: in 1881 there were only 684 inhabitants remaining. After the First World War the population dropped to 456; the breeding of silkworms was just managing to survive as an enterprise and the first peach orchards had appeared. From 1950 Balazuc began to realize its potential as a tourist-haunt. The current population is 275, 124 of whom live in the village itself.

For further information:

*Histoire de Balazuc*, by Jean Boyer, produced by the Association de la Roche-Haute de Balazuc

The old houses in the attractively situated village of Balazuc are arranged in rows on the edge of a cliff overhanging the left bank of the Ardèche. The village is still dominated by a solid Romanesque keep, with access to the upper storey. The higher section can be seen here, on the left. On the right, the old church built at the edge of the precipice probably dates from the 13th century, while the new church on the summit was built in 1892. Seen in the centre, the roadway which crosses the village was blasted out of the rock with dynamite in 1897.

The *bourg* was surrounded by ramparts, sections of which still stand today, as seen here on the right-hand side. However, the four medieval gateways have unfortunately disappeared. In the centre background, the large building with the little Gothic window known as Chastelvieil is mentioned in 15th-century texts. ▶

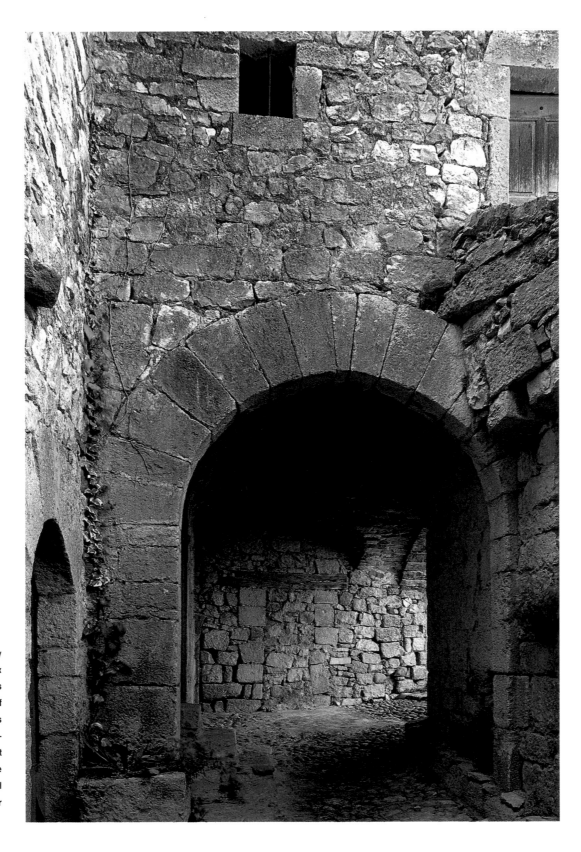

Although it now seems laughably small, the ancient Rue des Arceaux was formerly one of the main streets in the village. It ran along a section of the medieval ramparts, then wove its way between the houses, or sometimes below them, forming quaint vaulted passage-ways like the one shown here. As is the case with all medieval villages, the walls bear traces of countless alterations.

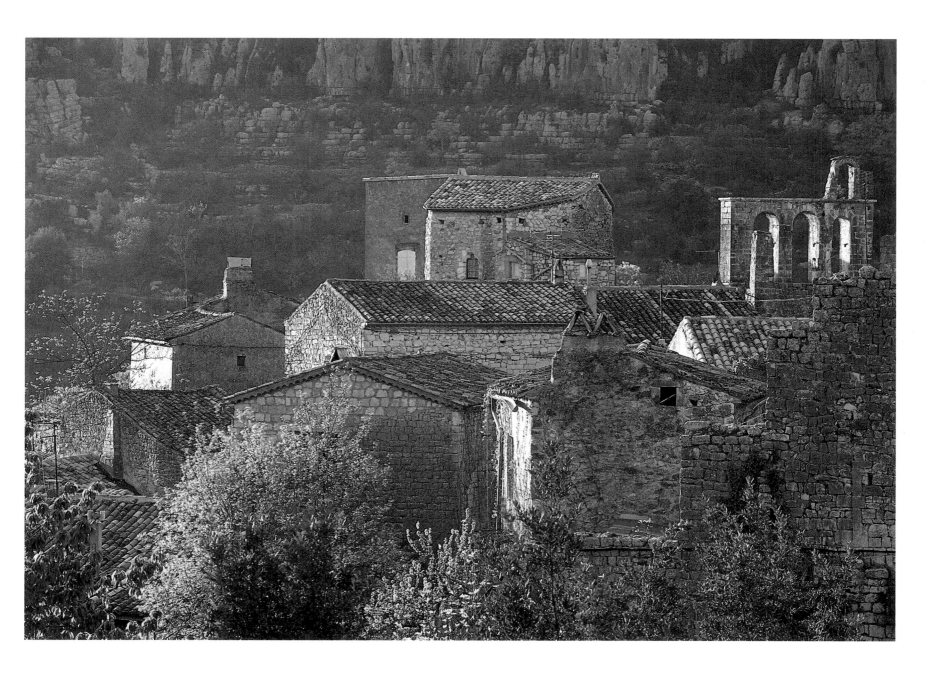

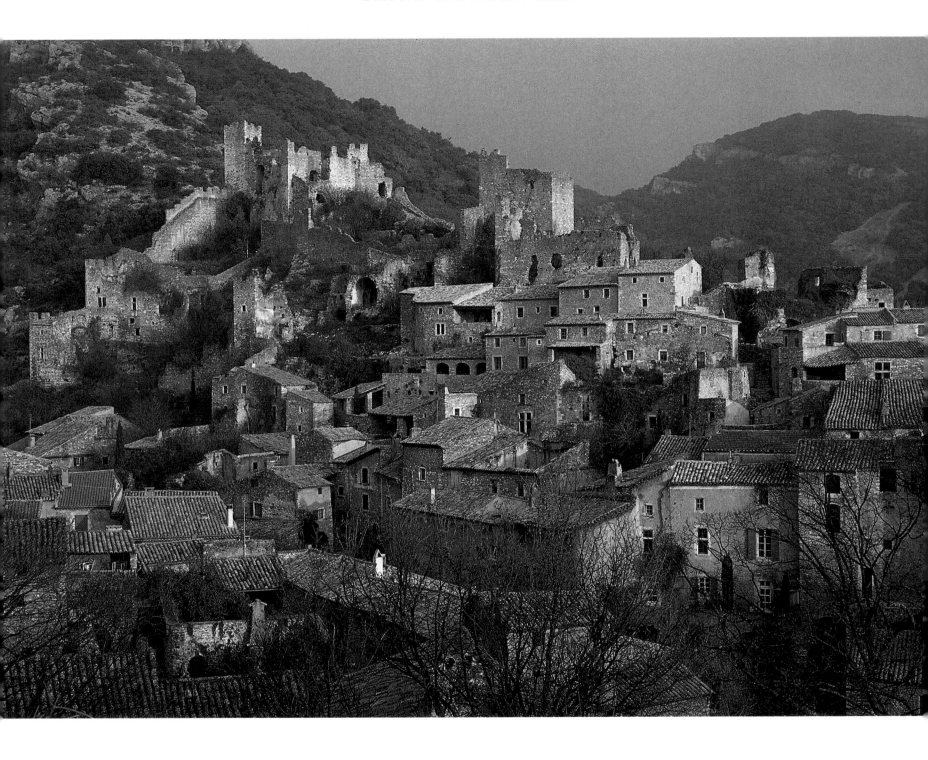

Saint-Montan is situated very near the Rhône valley, between Viviers and Bourg-Saint-Andéol. The village nestles in the confluence of the gorge of Val Chaud and the valley of the Lieux. It is possibly one of the most easily accessible sites in Bas-Vivarais, as well as one of the least known. It is dominated by the ruins of a feudal castle, which was declared uninhabitable in 1609. In the reign of Louis XVI it was described as ruined.

The name Saint-Montan perpetuates the memory of the hermit Montanus, who came here in the 5th century seeking peace and the contemplative life. He lived in a little *beaume*, or cave, in the rocky valley known as Val Cau, or Val Chaud.

We know little about this site during the medieval period, but the castle of Saint-Montan was already in existence by the late 12th century, as a document dated 2 November 1171 mentions its chapel. It appears that the fief was divided from an early date into a joint lordship, the dominant rulers being the bishops of Viviers. The charter has been lost, but during the 15th century Saint-Montan was represented in all the assemblies which gave rise to the States General of Vivarais. In the course of the Wars of Religion the parish church was destroyed by the Huguenots (1568) and in the spring of 1570 the army of Coligny (with 3,000 foot-soldiers and 300 cavalry) seized the castle

and the village. The church was reconstructed in 1580 and from 1586 onwards there were no more attacks.

Since 1970 this magnificent medieval village has been gradually reawakening under the guidance of the Association des Amis de Saint-Montan. The ruined houses have been painstakingly restored and now have new inhabitants. Young couples have settled in the community and the school has been saved. This revival is due to the enthusiasm engendered by the restoration of the old village as well as to the beauty of its location.

There were 1,092 inhabitants here in 1802. The population reached a peak in 1854, at 1,620: it then dropped to 764 in 1931 and rose again to 846 in 1962. Saint-Montan has 1,011 inhabitants today, 153 of whom live in the village itself.

For further information:

*Notes historiques sur Saint-Montan*, by Auguste le Sourd, Privas 1969 (2nd edition)

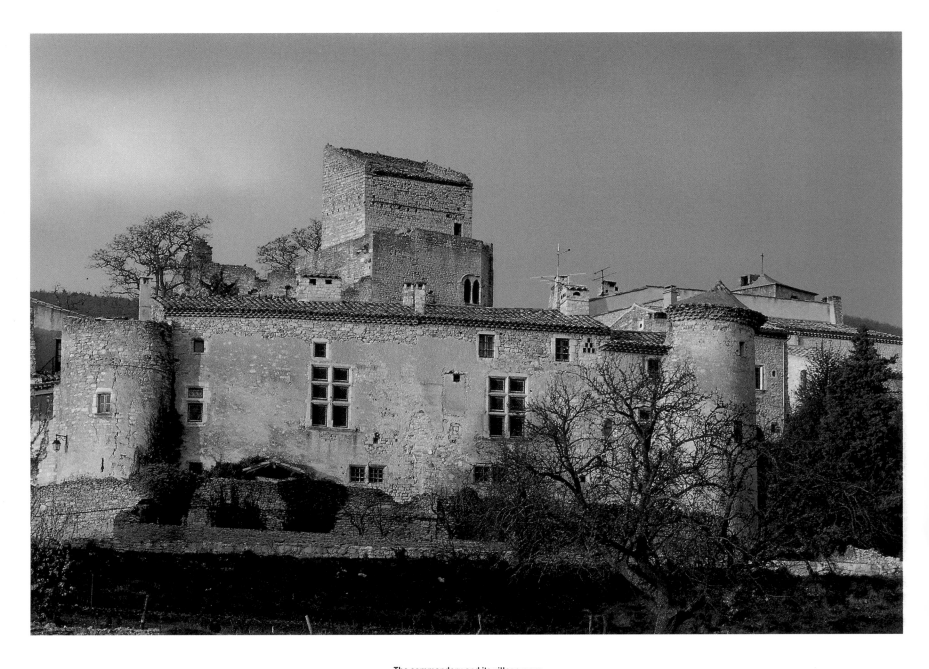

The commandery and its village were reconstructed towards the end of the 15th century. The archives do not state whether this work was occasioned by a disaster. Seen here, in the southwest corner of the ramparts, the vast structure flanked by two towers, known as the Salon des Commandeurs, was built during this period of reconstruction.

The former castle chapel, known as the chapel of Saint-Jean-des-Commandeurs, is a Romanesque building dating from the 12th and 13th centuries. Its condition has deteriorated considerably since the beginning of the century. It was transformed into a Protestant church, but subsequently returned to the Catholics during the 1620s, remaining the parish church until 1895. Seen on the right, the apse is surmounted by a bell-tower, which played its part in the defence of the walls around the castle. ▶

Le Poët-Laval was one of the numerous establishments founded in Southeast France by the Order of Saint John of Jerusalem. The date of its foundation is the 13th century at the very latest. In 1277 the inhabitants were granted a charter by the Grand Prior of Saint-Gilles. The community was governed by seigneurs who were partly monks, partly soldiers; members of this order were later to be known as the Knights of Malta. An agreement dated 20 January 1269 informs us that these seigneurs were themselves pledged to feudal overlords, the comtes de Valentinois. Towards the end of the 15th century Le Poët-Laval was one of the wealthiest commanderies attached to the priory of Saint-Gilles. During the Wars of Religion the village was besieged by both Catholics and Protestants (1563, 1573, 1574, 1587). The Protestants consolidated their fortifications here in 1621: the following year, however, Lesdiguières ordered them to be destroyed in the name of Louis XIII, 'so that this spot may never more be occupied by those who seek to disturb the public peace'. The last commander took office in 1746.

During the last century the village was gradually abandoned as people moved to the new community of Gougne, built along the main highway. In 1950 there were only 17 habitable houses in the village, compared to 96 in 1830. Since 1932 the village has been coming slowly back to life, thanks to the initiatives of the Association des Amis du Vieux Poët-Laval, which supervises its protection and restoration.

In 1474 there were about 160 inhabitants of Le Poët-Laval. The episcopal register compiled between 1685 and 1687 counted 650 inhabitants, 500 being 'of the

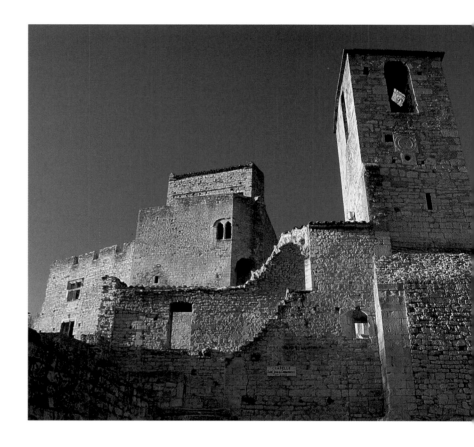

religion' and 150 former Catholics. In 1790 the population was 918, reaching a peak in 1836 with 1,241 inhabitants. In 1861 the population was 1,147, with 285 inhabitants residing in the village itself. A total of 792 earned their living from agriculture, 109 from the potteries and 65 from silk-making. The population decreased rapidly after 1872 and now numbers 565 inhabitants (66 in the village).

For further information:

*Le Poët-Laval, commanderie des Chevaliers de Malte*, by Léo Bertrand, produced by the Amis du Vieux Poët-Laval, Valence 1966

The village houses are set out in tiered rows on the southern slope of a hill overlooking the valley of the Jabron. They are dominated by the ruins of a medieval castle (12th–15th century), which was declared virtually uninhabitable in 1687, 'having been besieged and burned by the Protestants during the civil wars, and its fortifications demolished by order of the king according to the traditions of the land'. Built in the shadow of the castle, the village was created, by the very latest, at the beginning of the 13th century. Solid walls with towers were soon built around the community. One of the remaining towers can be seen here, emerging from the rooftops. During the peaceful second half of the 15th century, the village was able to extend beyond the walls. ▶

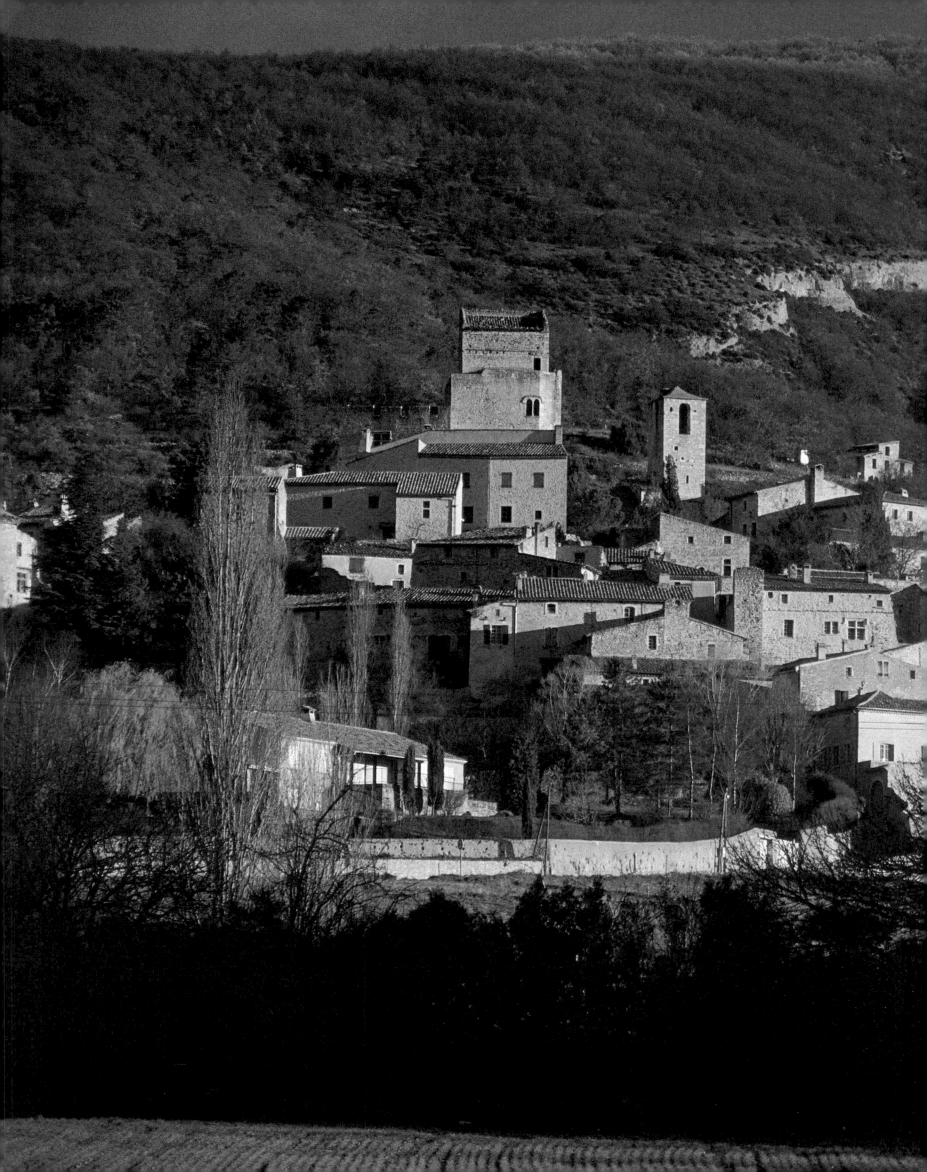

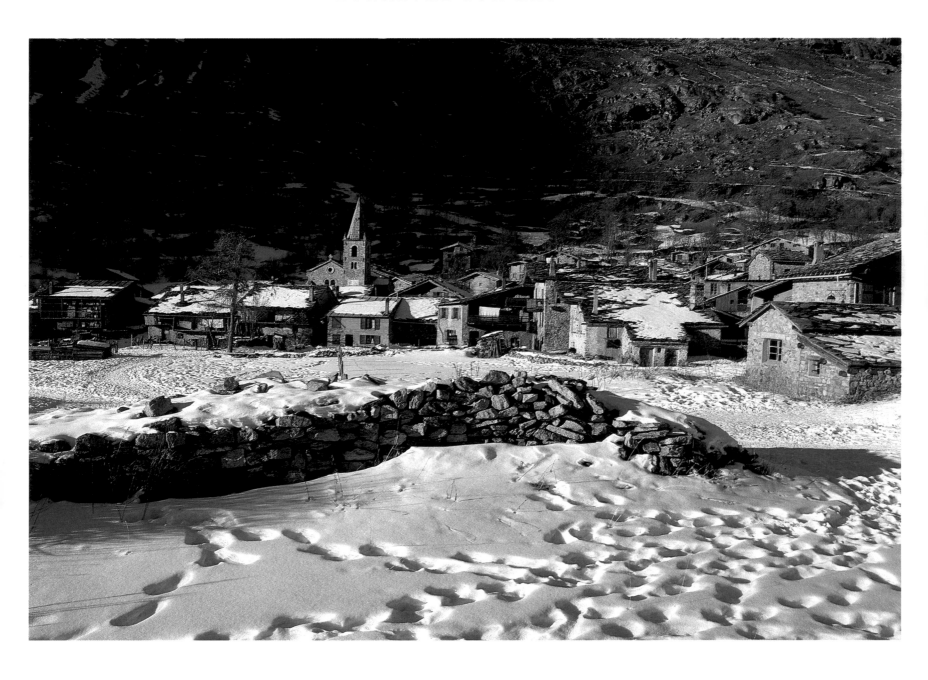

Bonneval is situated in the heart of the Maurienne region, near the source of the River Arc. It offers a remarkable example of traditional mountain building. The village is situated 1,790 metres (about 5,900 feet) above sea-level and this 'splendid isolation' has no doubt helped to preserve its old stone-roofed houses. These buildings are clustered around the church, with a characteristic Savoyard bell-tower.

Until 1761 Bonneval was a hamlet attached to Bessans, and for many years the two communities shared a common history. During the Revolution the region of Haute-Maurienne experienced much upheaval due to its frontier location. On 6 April 1794, following the French failure to occupy Mont-Cenis, the inhabitants of Bessans and Bonneval escaped deportation by bribing some French soldiers. On 4 June 1799, however, the two communities were put under a state of siege for having sheltered dissenting priests and for favouring contact with the 'rebels' of Piedmont. In 1860 the inhabitants of Haute-Maurienne unanimously voted to rejoin France.

Life was hard in Bonneval. Livestock and agriculture provided a basic income, but the soil was poor, and the winters long and harsh – it took the rye fourteen months to ripen. Moreover, wood was scarce and the inhabitants were obliged to share living quarters with their animals as a way of keeping warm. The beds, on the upper floor, were sometimes placed directly above the sheep-pen. As wood was in short supply, flat pieces of dried cattle-dung (known as *grobons*) were burned as fuel. These were left to dry on the picturesque wooden balconies, which give the village much of its appeal today. The charter of Bessans (dated 2 August 1567) reveals that it was already forbidden by then to melt iron-ore using local firewood. There were two mines for ore in operation at Bonneval until the 18th century.

A small resort for winter sports, separate from the village, has been developing here since 1968. This has helped to put new life into the area.

Bonneval had 403 inhabitants in 1561. In 1734 the population was 529; this included the 112 inhabitants who lived in the neighbouring hamlet of L'Écot. Between 1886 and 1962, Bonneval lost 60% of its population. Today there are 123 inhabitants. L'Écot (which is worth a visit) is inhabited only during the summer months.

For further information:

*L'histoire en Savoie, la Haute-Maurienne*, by Pierre Dompnier, in the *Revue trimestrielle de culture et d'information historique*, no. 23, published by the Société Savoisienne d'Histoire et d'Archéologie de Chambéry, September 1971

*Histoire des communes savoyardes*, Philippe Paillard ed., Éditions Horvath, Saint-Etienne 1983

*Le guide de la Maurienne*, by Marthe and Pierre Dompnier, Éditions La Manufacture, Lyons 1988

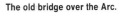

**The old bridge over the Arc.**

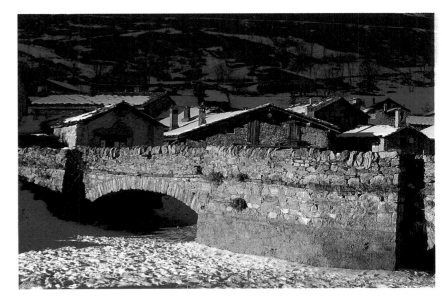

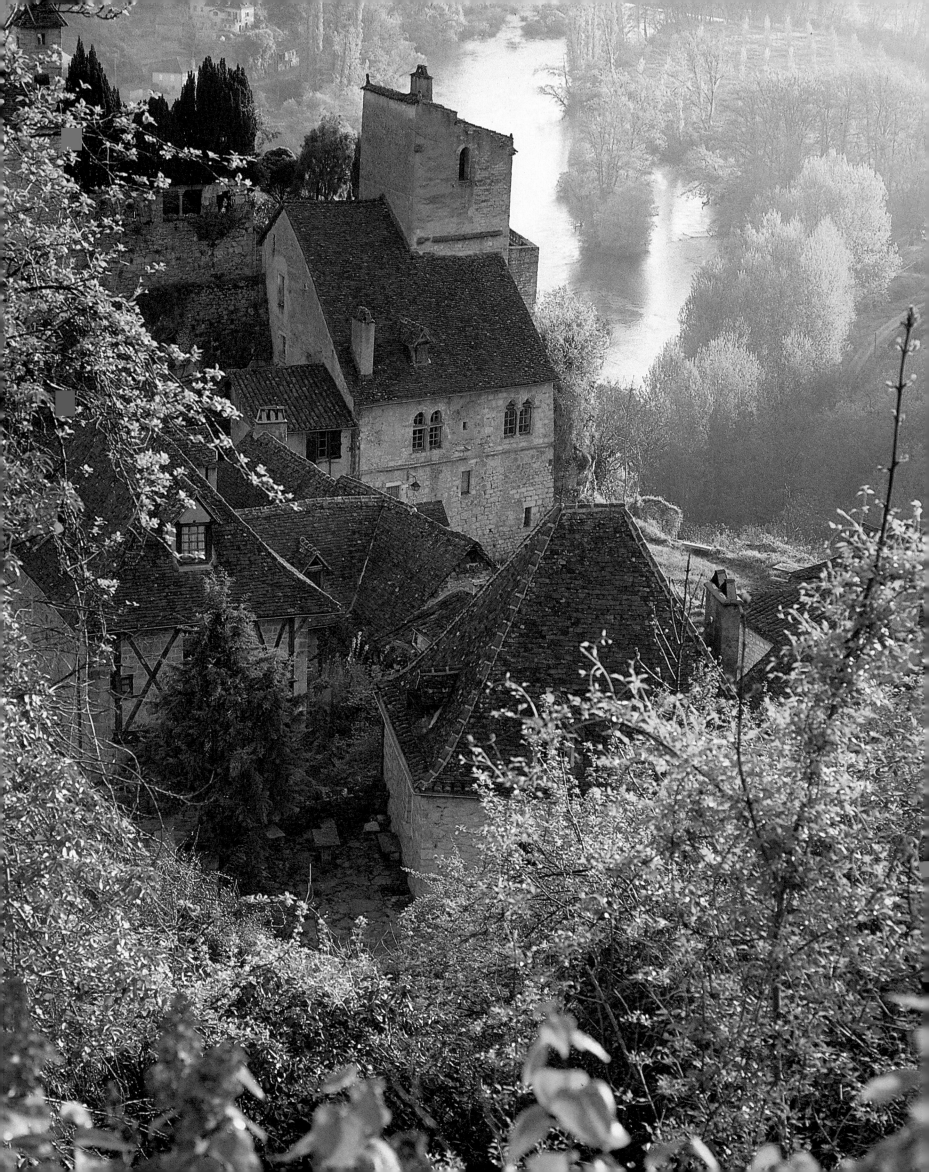

This building in Saint-Cirq-Lapopie, with its twinned windows, is thought to have been one of the inns patronized by the bargemen of the Lot. The river traffic was particularly brisk between Port-d'Agre (Aveyron) and Bordeaux, reaching a peak between 1847 and 1880. The construction of the railway, however, dealt a fatal blow to this form of transport. The beautiful building in this photograph was acquired in 1950 by the writer André Breton (1896–1966). One year after buying the property he wrote:

'Saint-Cirq has cast the only true spell on me, the kind that endures for ever. I have lost all desire to be elsewhere.'

# THE MOST BEAUTIFUL VILLAGES OF FRANCE

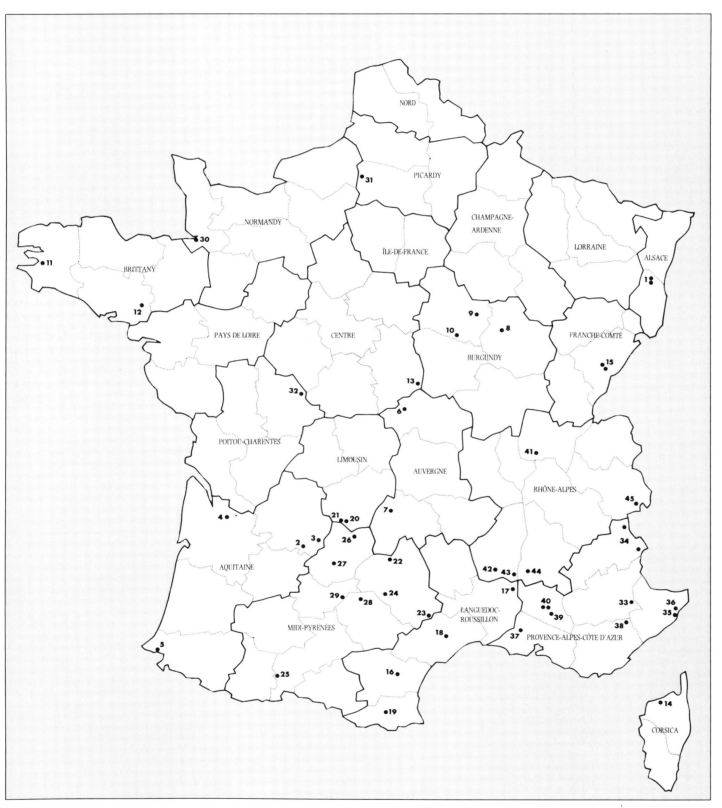

| | |
|---|---|
| **1** | Riquewihr and Hunawihr |
| **2** | Monpazier |
| **3** | La Roque-Gageac, Beynac and Domme |
| **4** | Saint-Émilion |
| **5** | Aïnhoa |
| **6** | Hérisson |
| **7** | Salers |
| **8** | Flavigny-sur-Ozerain |
| **9** | Noyers-sur-Serein |
| **10** | Vézelay |
| **11** | Locronan |
| **12** | Rochefort-en-Terre |
| **13** | Apremont-sur-Allier |
| **14** | Sant'Antuninu |
| **15** | Lods and Mouthier-Haute-Pierre |
| **16** | Lagrasse |
| **17** | La Roque-sur-Cèze |
| **18** | Saint-Guilhem-le-Désert |
| **19** | Villefranche-de-Conflent |
| **20** | Collonges-la-Rouge |
| **21** | Turenne |
| **22** | Conques |
| **23** | La Couvertoirade |
| **24** | Sauveterre-de-Rouergue |
| **25** | Saint-Bertrand-de-Comminges |
| **26** | Autoire |
| **27** | Saint-Cirq-Lapopie |
| **28** | Cordes |
| **29** | Bruniquel and Penne |
| **30** | Mont-Saint-Michel |
| **31** | Gerberoy |
| **32** | Angles-sur-l'Anglin |
| **33** | Entrevaux |
| **34** | Saint-Véran and Névache |
| **35** | Èze-Village |
| **36** | Peillon |
| **37** | Les Baux-de-Provence |
| **38** | Bargème |
| **39** | Bonnieux |
| **40** | Gordes and Roussillon |
| **41** | Pérouges |
| **42** | Balazuc |
| **43** | Saint-Montan |
| **44** | Le Poët-Laval |
| **45** | Bonneval-sur-Arc |

# PROTECTED VILLAGES

## THE PROTECTION OF THE VILLAGES

From the numerous laws for the protection of villages and hamlets, we have included in the list on pp. 219–29 (compiled on 1 January 1989) those which cover the most beautiful sites. The list contains all the places that fall within these categories:

1. Villages where most, or all of the buildings are listed M.H. and/or Inv.M.H. (For these classifications, see p. 217.)
2. Villages protected in their entirety, including or excluding their surroundings.
3. Villages in which the old quarters are protected.
4. Villages set in a protected landscape.
5. Villages in which the main square is protected, provided that this protection extends to the houses which surround it.

This list does not include:

– Protected villages in a community with a total population of over 1,050 (according to the census of 1982), or small hamlets.
– The numerous villages protected only in so far as they are situated in a large, protected natural area (a cirque, a valley or a stretch of coastline), and where the buildings are of no particular architectural interest.
– The very large number of villages which are only partially protected, the area in question being the upper or lower section, one particular side, the entrance to the village, its church, castle, groups of houses with their surrounding area, ramparts, main squares, streets, promenades and so on.
– Villages where the 'whole district of the commune' is protected.

**The church of Saint-Cirq-Lapopie owes its famous silhouette to its bell-tower, which is flanked by a narrow turret with a spiral staircase. The church is known to date from the first half of the 16th century, since it is recorded that in 1522 the civil and ecclesiastical authorities entrusted the building works to the master mason Guillaume Capelle, and that in 1540 he required a loan in order to meet his expenses. The 16th-century *Livre consulaire de Saint-Cirq* states that it was in this church that the names of the elected magistrates were solemnly proclaimed.**

### 1. *The villages where all (or most) of the buildings are classified as M.H. or Inv.M.H.*

These are the 'pearls': Pérouges (Ain), Mont-Saint-Michel (Manche), Villefranche-de-Conflent (Pyrénées-Orientales) and a few others. They are unquestionably exceptional, unique and extremely rare.

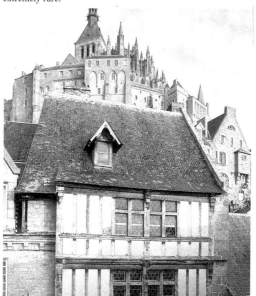

*2. Villages protected in their entirety, including or excluding their surroundings.*

**The site, the village and the abbey form a closely knit group, which together make Mont-Saint-Michel a world-famous attraction. It is now one of the busiest tourist centres in France. Most of the houses have been reconstructed (or considerably altered) since the end of the last century. The Grande-Rue, however, still contains some rare examples of civil architecture dating from the Middle Ages. This house, for example, has retained the corbelling and timbers of its façade, giving us an idea of the style of houses on the Mount during the later Middle Ages.**

These villages, as a rule, are the most beautiful of all, since most of them have retained their original appearance (the ancient layout and the majority of their old buildings). Moreover, many are set in a preserved landscape unspoilt by any modern construction. There are two categories of protection: S.Cl. and S.Ins. The category S.Cl. covers the most beautiful villages and their settings, for example, Apremont-sur-Allier (Cher), Bargème (Var), Saint-Cirq-Lapopie (Lot) and so on.

### 3. *Villages in which the old quarters are protected.*

This covers the ancient, medieval centre of a village, still enclosed within medieval ramparts, or by traces of them if they have disappeared. Outside the ramparts, the site has generally been transformed by modern development. This falls within the single type of protection, S.Ins. For example, Riquewihr, a superb village in Alsace, is partially surrounded by modern houses, but outside the medieval ramparts.

# PROTECTED VILLAGES

4. *Villages set in a protected landscape.*

The village and its setting combine to form a picturesque, and sometimes breathtaking sight. The most beautiful examples are classified as S.Cl. and are normally associated with protection category 2 (above). Examples are Vézelay (Yonne), Èze-Village (Alpes-Maritimes) and Saint-Guilhem-le-Désert (Hérault). On the other hand, those which are categorized simply as S.Ins. are usually of little interest, either because they have only a small number of old buildings, or because their buildings have been modernized and transformed. For example, Les Eyzies (in the Dordogne) has little to recommend it architecturally, yet the prehistoric cliffs surrounding it are spectacular.

5. *Villages in which the main square and its surrounding houses are protected.*

These squares are exceptional places, especially when they form the basis of the village structure, as in the case of the *bastides*. The loveliest squares are featured in this book: for example, the beautiful Place de l'Église at Locronan (Finistère), which is entirely classified as a M.H. Those of Monpazier (Dordogne), Réalville and Castelsagrat (Tarn-et-Garonne) are surrounded by houses categorized Inv.M.H. The vast majority of these squares are in *bastides*.

**Les Baux-de-Provence.**

# PROTECTED VILLAGES

## METHODS OF PROTECTING THE NATIONAL HERITAGE IN FRANCE

France has a system of legislation to protect and preserve those buildings which form part of its national heritage, being of particular historical, archaeological or architectural interest.

These buildings include castles, churches, abbeys and monuments of every description, but also houses, bridges, traces of fortifications (ramparts, towers, town gates etc.). There are also examples of the *petit patrimoine*, or 'small-scale heritage': fountains, washing-places, oratories wayside crosses, and so on. These are often remarkable and their surroundings, whether natural or built-up, may also be protected if this is justified.

There are four different categories of protection:

If a 'constructed landscape' is rare, unique, or in an exceptional state of preservation, it is all the more essential that it should be protected by efficient and rigorous laws. A building classified as M.H. is thus more rigorously protected than a building which is Inv.M.H.; and a S.Cl. has more official protection than a S.Ins.

The variety and importance of the different methods of preserving France's architectural heritage are the fruit of the long-felt need to ensure its protection. They have also been the result of the necessity to adapt this need to various different periods. The result is the division of these safeguards between three different ministries:

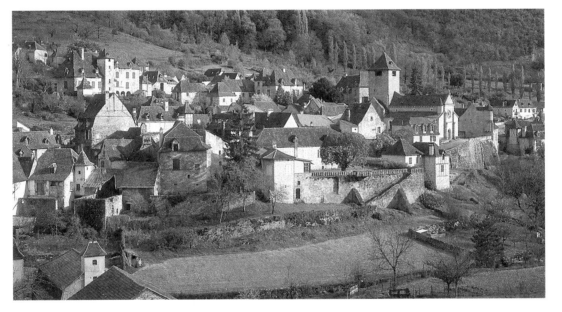

As is the case with most towns in the *vicomté* of Turenne, the village of Balazuc had a large number of residents belonging to the bourgeoisie, who enjoyed a comfortable existence provided by the revenue from their lands. Pictured on the left, the Château de Busqueilles is built on a large terrace overlooking the *bourg*. This enormous building dates from the late 16th century.

M.H. (*Monument historique*, or Historic Monument), which is only applied to buildings, and occasionally parks and gardens.
Inv.M.H. (*Inventaire supplémentaire des Monuments historiques*, or Supplementary Inventory of Historic Monuments). This is applied to buildings, but the laws governing their preservation or restoration are less stringent.
S.Cl. (*Site classé*, or Classified Site) is applied to natural or constructed landscapes whose beauty warrants conservation. The most notable examples are natural phenomena (Mont Blanc, the Cirque de Gavarnie, Gorges du Verdon or Golfe de Porto).
S.Ins. (*Site inscrit*, or Registered Site) is applied to natural or constructed landscapes that are of less importance than the above, but which have kept their original quality.

– The Ministère de la Culture (Ministry of Culture) is responsible for classified or registered historic monuments, and the protected area of 500 metres which surrounds them.
– The Ministère de l'Environnement (Ministry of the Environment) is responsible for classified and registered sites that are of natural origin. These include the large number of remarkable landscapes whose pattern and quality give France its exceptional touristic appeal.
– The Ministère de l'Équipement (Ministry of Supply) is responsible for urban classified and registered sites. This covers sites classed as exceptional, many parks and gardens, and above all registered sites such as villages and the ancient quarters or centres of towns.

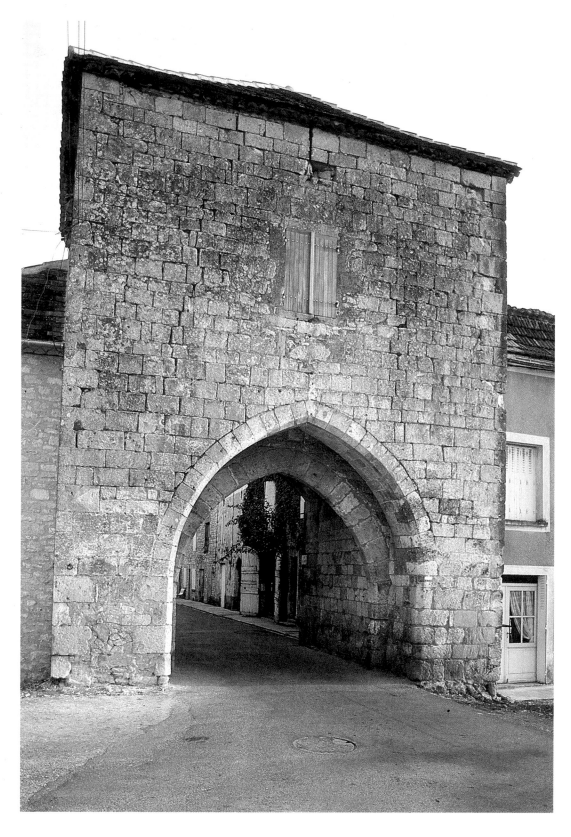

Monpazier. The town gate.

DEFINITIONS

*bastide*: a medieval planned urban development typical of the Southwest of France; see pp. 8ff.

*bourg*: a small market town or large village, in which a market is generally held for the neighbouring villages.

*cirque*: a deep, steep-walled natural amphitheatre.

The villages shown in *italics* are those which feature in the body of the book. The population figures in brackets are those of the principal village in the area, not those of the whole district. They are based on the 1982 census.

# ALSACE

## BAS-RHIN

Hoffen (pop. 404): village (S.Ins.)
Hunspach (pop. 541): village and its surroundings (S.Ins.)

## HAUT-RHIN

Gueberschwihr (pop. 727): village and its surroundings (S.Ins.)
*Riquewihr* (pop. 1018): old quarters (S.Ins.)

# AQUITAINE

## DORDOGNE

Annesse-et-Beaulieu (pop. 366): *bourg* (S.Ins.)
Badefols-sur-Dordogne (pop. 150): *bourg* (S.Ins.)
Berbiguières (pop. 185): *bourg* and its surroundings (S.Ins.)
Biron (pop. 51): village (S.Ins.)
Bourdeilles (pop. 410): village and banks of the Dronne (S.Ins.)
Bourniquel (pop. 78): *bourg* (S.Ins.)
Chancelade: hamlet of Les Andrivaux (S.Ins.)
Le Change (pop. 142): village (S.Ins.)
La Chapelle-Gonaguet (pop. 56): *bourg* (S.Ins.)
Le Coux-et-Bigaroque (pop. 209): village and its surroundings (S.Ins.)
Les Eyzies-de-Tayac (pop. 433): site of Les Eyzies comprising the built-up area and the cliffs of Les Grands Rochers and Cro-Magnon and their surroundings (S.Ins.)
Fanlac (pop. 147): *bourg* (S.Ins.)
Hautefort (pop. 350): *bourg* (S.Ins.)
Issigeac (pop. 499): *bourg* (S.Ins.)
Lanquais (pop. 390): village (S.Ins.)
Limeuil (pop. 95): village (S.Ins.)
Lusignac (pop. 192): *bourg* (S.Ins.)
Mauzens-et-Miremont: village of Miremont-Haut (S.Ins.)
*Monpazier* (pop. 533): old *bastide* (S.Ins.) and houses bordering the central square (M.H. and Inv.M.H.)
Montagrier (pop. 106): *bourg* (S.Ins.)
Montferrand-du-Périgord (pop. 61): village (S.Ins.)
Peyzac-le-Moustier: crag and village of Le Moustier (S.Ins.)
Pontours (pop. 164): *bourg* (S.Ins.)
Saint-Amand-de-Coly (pop. 301): village (S.Ins.)

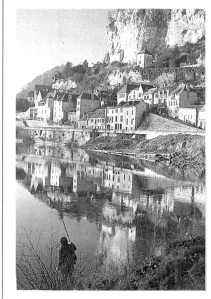

Beynac.

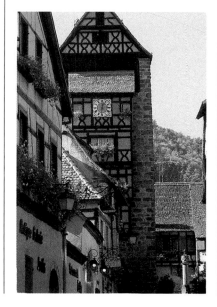

Riquewihr. Rue du Général-de-Gaulle.

Saint-André-d'Allas: hamlet of Bousseyrial (S.Ins.), site of Le Breuilh (drystone huts) (S.Cl.)
Saint-Aquilin (pop. 92): *bourg* (S.Ins.)
Saint-Avit-Sénieur (pop. 63): *bourg* and its surroundings (S.Ins.)
Saint-Barthélemy-de-Bussière (pop. 270): *bourg* (S.Ins.)
Saint-Jean-de-Côle (pop. 204): village and château of La Marthonie (S.Ins.)
Saint-Léon-sur-Vézère (pop. 59): village and château of Clérans (S.Ins.)
Saint-Martial and Saint-Aubin-de-Nabirat: *bourg* of Saint-Martial (S.Ins.)
Saint-Mayme-de-Péreyrol: *bourg* (S.Ins.)
Saint-Pierre-de-Chignac (pop. 344): village (S.Ins.)
Saint-Privat-des-Prés (pop. 206): *bourg* (S.Ins.)
Saint-Raphaël (pop. 82): *bourg* and its surroundings (S.Ins.)
Saint-Vincent-de-Cosse (pop. 314): *bourg* and its surroundings (S.Ins.)
Sainte-Eulalie-d'Ans (pop. 93): *bourg* (S.Ins.)
Salignac-Eyvigues (pop. 611): village of Salignac (S.Ins.)
Villefranche-du-Périgord (pop. 510): *bastide* (S.Ins.)
Villefranche-de-Lonchat (pop. 500): *bastide* and its surroundings (S.Ins.)
Vitrac: village of Montfort (S.Ins.)
The villages of *Beynac* (pop. 172), *La Roque-Gageac* (pop. 402) and *Domme* (pop. 395) are protected as part of the Dordogne valley; moreover there is a protection zone for Domme around the ramparts and the Front de la Barre

## GIRONDE

Asques (pop. 380): village (S.Ins.)
Castelmoron-d'Albret (pop. 62): village (S.Ins.)
Isles-Saint-Georges (pop. 337): *bourg* (S.Ins.)
Lège-Cap-Ferret: 8 oyster-farming villages: Les Jacquets, Le Grand Piquet, Piraillan, Le Canon, L'Herbe, La Douane, L'Escourre-de-la-Douane, Le Petit Piquet (S.Ins.)
Rions (pop. 863): village (S.Ins.)
*Saint-Émilion* (pop. 742): town and its surroundings (S.Ins.)
Sauveterre-de-Guyenne (pop. 892): arcaded square and houses around it (S.Ins.)
Verdelais (pop. 813): *bourg* (S.Ins.)

## LANDES

Hastingues (pop. 447): *bastide* (S.Ins.)
Labastide-d'Armagnac (pop. 424): Place Royale and its surroundings (S.Ins.)
Lubbon: village of Château Vieux (S.Ins.)
Saint-Justin (pop. 429): urban site (S.Ins.)

## LOT-ET-GARONNE

Aubiac (pop. 150): *bourg* (S.Ins.)
Allons: site of Goux (S.Ins.)
Cahuzac (pop. 81): *bourg* (S.Ins.)
Castillonès (pop. 931): site of the *bastide* (S.Ins.)
Caudecoste (pop. 373): *bastide* (S.Ins.)
Clermont-Dessous (pop. 594): part of the Haut-Bourg (S.Cl.) and protection zone
Clermont-Soubiran (pop. 230): village (S.Ins.)
Damazan (pop. 836): galleried square with its central market and the houses around it (S.Ins.)
Estillac (pop. 158): *bourg* and castle area (S.Ins.)
Frespech (pop. 69): village (S.Ins.)
Gavaudun (pop. 269): village and its surroundings (S.Ins.)

Hautefage-la-Tour (pop. 151): site of the village (S.Ins.)

Lacapelle-Biron: hamlet of Saint-Avit

Lamontjoie (pop. 206): old *bourg* (S.Ins.)

Moirax (pop. 111): *bourg* (S.Ins.)

Pujols (pop. 550): village (S.Ins.)

Puymirol (pop. 467): *bourg* (S.Ins.)

Saint-Front-sur-Lémance: village and château of Bonaguil (S.Ins.)

Saint-Pastour (pop. 138): *bourg* (S.Ins.)

Tournon-d'Agenais (pop. 499): town (S.Ins.)

Tourtrès (pop. 139): *bourg* (S.Ins.)

## PYRÉNÉES-ATLANTIQUES

*Aïnhoa* (pop. 209): village to the north of the River Alachuruta (S.Ins.)

Aldudes (pop. 177): village (S.Ins.)

Arnéguy (pop. 126): village (S.Ins.)

Bielle (pop. 364) and Castet (pop. 189): the two villages (S.Ins.)

Biriatou (pop. 142): village (S.Ins.)

Bougarber (pop. 208): *bourg* and its surroundings (S.Ins.)

Labastide-Clairence (pop. 332): Place des Arceaux and Rue Notre-Dame (S.Cl. and S.Ins.)

Lasseube (pop. 427): *bourg* (S.Ins.)

Louhossoa (pop. 366): church, cemetery, square, façade and their surroundings (S.Ins. and S.Cl.)

Lucq-de-Béarn (pop. 205): *bourg* (S.Ins.)

Ostabat: hamlet of Harambels (S.Ins.)

Saint-Étienne-de-Baïgorry: hamlet of Urdos (S.Ins.)

Saint-Palais: hamlet of Garris (S.Ins.)

Sarrance (pop. 114): Place de l'Église: ground and buildings around it (S.Ins.)

Urdos (pop. 137): fort of Urdos and its surroundings (S.Ins.)

Urrugne (pop. 807): square and its surroundings (S.Ins.)

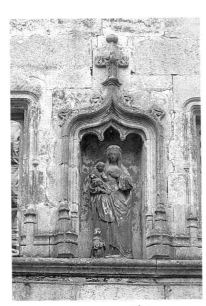

**Flavigny-sur-Ozerain. Rue de l'Église.**

**Salers. Place Tyssandier d'Escous.**

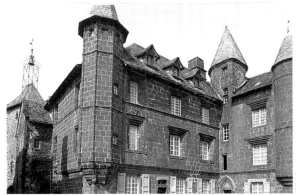

# AUVERGNE

### ALLIER

Billy (pop. 546) and Marcenat: *bourg* of Billy (S.Ins.)

*Hérisson* (pop. 658): *bourg* and valley of the Aumance (S.Ins.)

Montaigu-le-Blin (pop. 172): public square (S.Cl.)

Nassigny (pop. 150): *bourg* (S.Ins.)

### CANTAL

Laroquebrou (pop. 824): old *bourg* (S.Ins.)

*Salers* (pop. 407): urban setting (S.Ins.)

Tournemire (pop. 473): village and château of Anjony (S.Ins.)

### HAUTE-LOIRE

Boisset, Saint-André-de-Chalençon and Tiranges: village of Chalençon and valley of the Ance (S.Ins.)

La Chaise-Dieu (pop. 684): *bourg* and its surroundings (S.Ins.)

Lavaudieu (pop. 108): *bourg* and valley of the Sénouire (S.Ins.)

Pradelles (pop. 498): village and its surroundings (S.Ins.)

Roche-en-Régnier (pop. 76): *bourg* and its surroundings (S.Ins.)

Saint-Front: hamlets of Maziaux and Bigorre (S.Ins.)

### PUY-DE-DÔME

Cournols: hamlet of Randol (S.Ins.)

Montpeyroux (pop. 247): village and its surroundings (S.Ins.)

Saint-Saturnin (pop. 602): site of Saint-Saturnin (S.Cl.)

Saint-Yvoine (pop. 282): old village, rocky spur, traces of the old château and church (S.Ins.)

Villeneuve-Lembron (pop. 97): town and its surroundings (S.Ins.)

# BOURGOGNE (BURGUNDY)

### CÔTE-D'OR

Châteauneuf-en-Auxois (pop. 62): village and its surroundings (S.Ins.)

Chaudenay-le-Château (pop. 28): village and neighbouring hills (S.Ins.)

*Flavigny-sur-Ozerain* (pop. 394): village and its surroundings (S.Ins.)

Hauteroche (pop. 74): village and cliffs (S.Ins.)

Pernand-Vergelesses (pop. 334): village and its surroundings (S.Ins.)

Poncey-sur-l'Ignon (pop. 87): village (S.Ins.)

La Rochepot (pop. 225): village and château (S.Ins.)

### NIÈVRE

Bazoches (pop. 102) and Saint-Aubin-des-Chaumes (pop. 103): site of the two villages (S.Ins.)

Metz-le-Comte (pop. 60): site of the hill of Metz-le-Comte (S.Cl. and S.Ins.)

Saint-Amand-en-Puisaye (pop. 955): village and its surroundings (S.Ins.)

Saint-André-en-Morvan (pop. 328): village and mill (S.Ins.)

## SAÔNE-ET-LOIRE

Berzé-la-Ville (pop. 230): village (S.Ins.)

Saint-Gengoux-le-National (pop. 1049): *bourg* and its surroundings (S.Ins.)

Saint-Vérand (pop. 76): village (S.Ins.)

Sigy-le-Châtel (pop. 50): village (S.Ins.)

Solutré-Pouilly (pop. 204) and Vergisson (pop. 226): site of Solutré-Vergisson (S.Ins.)

# BRETAGNE (BRITTANY)

## CÔTES-DU-NORD

Kerbors (pop. 72): village and its surroundings (S.Ins.)

Loc-Envel (pop. 73): village (S.Ins.)

Moncontour (pop. 1013), Hénon, Plémy and Trédaniel: site of Moncontour and neighbouring valleys (S.Ins.)

Ploëzal-Runan: *bourg* of Runan (S.Ins.)

Plufur (pop. 166): *bourg* (S.Ins.)

## FINISTÈRE

Kerlouan: hamlet of Menez Ham and neighbouring coast (S.Cl.)

Locronan (pop. 429): Place de l'Église, old houses on the square and communal well (M.H.)

Plounéour-Ménez: village of Le Relecq and its surroundings (S.Cl.)

Port-Launay (pop. 472): site of Port-Launay (S.Ins.)

## YONNE

Druyes-les-Belles-Fontaines (pop. 177): village and its surroundings (S.Ins.)

Mézilles (pop. 323): village and the whole commune (S.Ins.)

Montréal (pop. 183): old walled village (S.Ins.)

*Noyers-sur-Serein* (pop. 668): walled town (S.Ins.)

*Vézelay* (pop. 383): hill and basilica (S.Cl. and UNESCO world heritage site), hill and its surroundings and walled town (S.Ins.)

## ILLE-ET-VILAINE

Champeaux (pop. 90): Place de l'Église, its well and the surrounding buildings (S.Cl.)

Châtillon-en-Vendelais and Montautour (pop. 77): hill of Montautour (S.Ins.)

## MORBIHAN

Arzal: site of Broël-sur-Vilaine (S.Cl. and S.Ins.)

Arzon and Saint-Gildas-de-Rhuis: hamlet of Tumiac and its surroundings, hamlets of La Saline and Kervert (S.Ins.)

Carnac: village of Saint-Colomban and surroundings, Pointe du Po (S.Ins.)

Quistinic: village of Poul-Fétan (S.Ins.)

The village of *Rochefort-en-Terre* (pop. 613) is partially protected (S.Ins.), as are certain houses (Inv.M.H.)

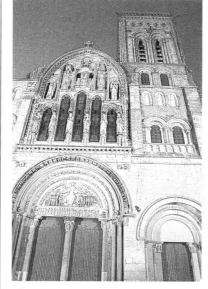

**Vézelay. Basilica of Sainte-Marie-Madeleine.**

# CENTRE

## CHER

*Apremont-sur-Allier* (pop. 55): *bourg* and château (S.Cl.)

Culan (pop. 895): site of Culan (S.Cl. and S.Ins.)

Lury-sur-Arnon (pop. 557): old village (S.Ins.)

Ménétréol-sous-Sancerre (pop. 361): *bourg* (S.Ins.)

Vesdun (pop. 300): old village and church (S.Ins.)

Villeneuve-sur-Cher (pop. 153): village (S.Ins.)

## EURE-ET-LOIR

Courtalain (pop. 593) and Saint-Pellerin (pop. 91): villages with the château and its park (S.Ins.)

Dampierre-sur-Avre (pop. 322): village and confluence of the Avre and the Meurette (S.Ins.)

Donnemain-Saint-Mamès: site of the hamlet of Dheury (S.Ins.)

La Ferté-Vidame (pop. 707): *bourg*, château and its park (S.Ins.)

## INDRE

Nohant-Vicq (pop. 178): village of Nohant (S.Ins.)

Palluau-sur-Indre (pop. 358): village (S.Ins.)

Rosnay: château and hamlet of Le Bouchet and their surroundings (S.Ins.)

Saint-Benoît-du-Sault (pop. 836): old village (S.Ins.)

## INDRE-ET-LOIRE

Crissay-sur-Manse (pop. 118): old *bourg* (S.Ins.)

Lerné (pop. 159): village (S.Ins.)

Luzé: hamlet of Bois-Aubry (S.Ins.)

Montrésor (pop. 452): village (S.Ins.)

Saché (pop. 301): village (S.Ins.)

## LOIR-ET-CHER

Lavardin (pop. 140): village (S.Ins.)

Mennetou-sur-Cher (pop. 819): *bourg* (S.Ins.)

Trôo (pop. 180): built-up area (S.Ins.)

## LOIRET

Chécy, Combleux (pop. 352), Orléans, Saint-Denis-en-Val, Saint-Jean-le-Blanc and Saint-Jean-de-Braye: site of Combleux (S.Cl.)

Langesse (pop. 68): *bourg*, water system, château and its park (S.Ins.)

Saint-Benoît-sur-Loire: hamlet of Le Port (S.Ins.)

**Rochefort-en-Terre.**

# CHAMPAGNE-ARDENNE

### AUBE

Bossancourt (pop. 143): village and
banks of the Aube (S.Ins.)
Étourvy (pop. 204): village (S.Ins.)

### MARNE

Outines (pop. 157): village (S.Ins.)
Saint-Thierry (pop. 556): village
(S.Ins.)
Trois-Fontaines (pop. 72): Place de
l'Abbaye and its surroundings (S.Cl.)

### HAUTE-MARNE

Reynel (pop. 171): village (S.Ins.)

# CORSE (CORSICA)

### HAUTE-CORSE

Brando: village of Erbalunga (S.Ins.)
Centuri (pop. 195): 'Marine de
Centuri' (S.Ins.)
Penta-di-Casinca (pop. 258): village
and its surroundings (S.Cl.)
Riventosa (pop. 119): village (S.Ins.)
*Sant'Antuninu* (pop. 75): village (S.Ins.)

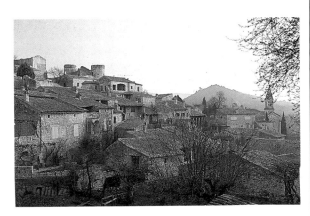

La Roque-sur-Cèze.

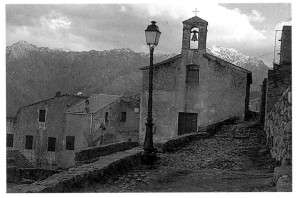

Sant'Antuninu.

# FRANCHE-COMTÉ

### DOUBS

Abbans-Dessus (pop. 237): village
(S.Ins.)
Moncley (pop. 204): village (S.Ins.)
*Mouthier-Haute-Pierre* (pop. 345):
village and its surroundings (S.Ins.)
Saint-Julien-lès-Montbéliard (pop.
153): village (S.Ins.)
The village of *Lods* (pop. 321) is
protected (S.Ins.) as part of the
upper and middle valley of the Loue

### JURA

Arlay (pop. 559): *bourg* and its
château as well as the hamlets of
Chaze, Corcelles, Saint-Vincent and
Juhans (S.Ins.)
Baume-les-Messieurs (pop. 120),
Granges-sur-Baume and Crançot:
site of Baume-les-Messieurs (S.Ins.)
Château-Chalon (pop. 146): village
and its surroundings (S.Ins.)
La Frasnée (pop. 47): village and its
surroundings (S.Ins.)
Frontenay (pop. 146): *bourg* and its
château (S.Ins.)
Toulouse-le-Château (pop. 117):
village (S.Ins.)

### HAUTE-SAÔNE

Chariez (pop. 175): village (S.Ins.)
Fondremand (pop. 111): village and
its surroundings (S.Ins.)
Le Haut-du-Them, Château-Lambert:
village of Château-Lambert and its
surroundings (S.Ins.)
Pesmes (pop. 966): *bourg* (S.Ins.)

### TERRITOIRE-DE-BELFORT

Réchésy (pop. 695): village (S.Ins.)

# ÎLE-DE-FRANCE

### ESSONNE

Dourdan and Saint-Cyr-sous-Dourdan:
hamlet of Rouillon and its
surroundings (S.Ins.)
Sermaise: hamlet of Blancheface
(S.Ins.)

### SEINE-ET-MARNE

Boissy-aux-Cailles (pop. 181), Noisy-
sur-École (pop. 477) and Le
Vaudoué (pop. 345): villages and
surrounding wooded zones (S.Ins.)
Doué (pop. 426): Butte de Doué (S.Ins.)
Flagy (pop. 359): hill of Flagy (S.Cl.)
Rampillon (pop. 433): hill (S.Ins.)
Saint-Loup-de-Naud (pop. 176):
the village and its surroundings
(S.Ins.)

### VAL-D'OISE

Asnières-sur-Oise: hamlet of Baillon,
the Bois de Bonnet and estate of
Royaumont (S.Ins.)
Chérence (pop. 123): village (S.Ins.)
Maffliers (pop.903): village (S.Ins.)
Le Perchay (pop. 263): village,
neighbouring fields (S.Ins.)

Plessis-Luzarches (pop. 147): village
(S.Ins.)

## YVELINES

Aigremont and Chambourcy: hamlets
of La Tuilerie and Montaigu, and
their surroundings (S.Ins.)
Gambaiseuil (pop. 31): village (S.Ins.)
Longvilliers: hamlet of Le Bouc
Étourdi (S.Ins.)

**Lods.**

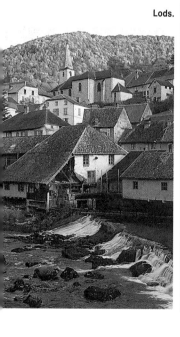

# LANGUEDOC-ROUSSILLON

## AUDE

Alet-les-Bains (pop. 465): built-up
area (S.Ins.)
Aragon (pop. 248): village and its
surroundings (S.Ins.)
Argens (pop. 209): village (S.Ins.)
Bages (pop. 369) and Peyriac-de-Mer:
built-up area and edge of the Étang
de Bages (S.Ins.)
Castans: hamlet of Quintaine (S.Ins.)
Cucugnan (pop. 102): village and its
surroundings (S.Ins.)
Embres-et-Castelmaure (pop. 191): old
village of Castelmaure (S.Ins.)
*Lagrasse* (pop. 612): protection zone
around the following classified
monuments: church, former abbey,
part of the house forming the angle
of the Rue Foy and courtyard,
12th-century bridge connecting the
village with the abbey, market
Laurabuc-et-Mireval (pop. 129): built-
up area of Mireval (S.Ins.)
Laurac-le-Grand (pop. 66): village
(S.Ins.)
Montjoi (pop. 34): village (S.Ins.)
Quintillan (pop. 71): site of Quintillan
(S.Ins.)
Rennes-le-Château (pop. 63): village
and its surroundings (S.Ins.)
Roquefère: hamlet of Cubserviès (S.Ins.)
Villerouge-Termenès (pop. 142):
village (S.Ins.)

## GARD

La Bastide d'Engras (pop. 158): village
(S.Ins.)
Bez-et-Esparon: hamlet of Esparon
(S.Ins.)
La Capelle-et-Masmolène (pop. 172):
château and village (S.Ins.)

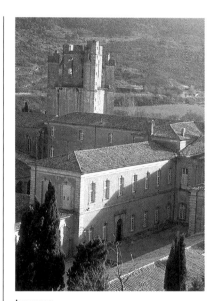

**Lagrasse.**

**Villefranche-de-Conflent.**

Cornillon (pop. 85): village (S.Ins.)
Dourbiès-et-Valleraugue: hamlet of
L'Espérou and slopes of L'Espérou
pass (S.Ins.)
Lédenon (pop. 593): village and
château (S.Ins.)
Lussan (pop. 128): village and its
surroundings (S.Ins.) and hamlet
of Le Roux (S.Ins.)
Montclus (pop. 53): village (S.Ins.)
Rochefort-du-Gard (pop. 889): village
(S.Ins.)
*La Roque-sur-Cèze* (pop. 118): village,
crag and wooded hill around it,
banks of the Cèze (S.Ins.)
Sabran (pop. 65): village and its
surroundings (S.Ins.)
Saint-Christol-lès-Alès: château and
hamlet of Montmoirac (S.Ins.) and
hamlet of Valz (S.Ins.)
Saint-Martial (pop. 171): village (S.Ins.)
Vézenobres (pop. 994): village (S.Ins.)
Villevieille (pop. 387): village and its
surroundings (S.Ins.)

## HÉRAULT

Combaillaux (pop. 65): village (S.Ins.)
Laroque (pop. 546): village (S.Ins.)
Les Matelles (pop. 661): village and its
surroundings (S.Ins.)
Minerve (pop. 69): village and plains
around it (S.Ins.)
Montouliers (pop. 187): village (S.Ins.)
Mourèze (pop. 73): cirque and village
of Mourèze (S.Ins.)
Olargues (pop. 488): built-up area and
its surroundings (S.Ins. and S.Cl.)
Pégairolles-de-Buèges (pop. 51):
village and its surroundings (S.Ins.)
Pégairolles-de-l'Escalette (pop. 124):
village and its surroundings (S.Ins.)

Roquebrune (pop. 384): built-up area
(S.Ins.)
Rosis: hamlet and church of Douch
(S.Ins.)
Saint-Étienne-de-Gourgas: cirque and
village of Gourgas (S.Ins.)
*Saint-Guilhem-le-Désert* (pop. 223):
site and village of Saint-Guilhem
(S.Cl. and S.Ins.)
Saint-Jean-de-Buèges (pop. 120):
village (S.Ins.)
Saint-Maurice-Navacelles: cirque and
hamlet of Navacelles (S.Cl. and
S.Ins.)
Saint-Pons-de-Mauchiens (pop. 337):
village (S.Ins.)
La Tour-sur-Orb: village of Boussagues
and its surroundings (S.Ins.)
Villeneuvette (pop. 75): old nucleus
(S.Ins.)
Viols-le-Fort (pop. 403): village (S.Ins.)

## PYRÉNÉES-ORIENTALES

Castelnou (pop. 52): village and its
surroundings (S.Ins.)
Eus (pop. 248): village (S.Ins.)
Prats-de-Mollo (pop.732): built-up
area and its immediate
surroundings (S.Ins.)
Valmanya (pop. 32): site of Valmanya
(S.Ins.)
*Villefranche-de-Conflent* (pop. 294):
ramparts, fortifications, houses and
church (M.H. and Inv.M.H.)
and their surroundings (S.Ins.)

## LOZÈRE

Arzenc-d'Apcher (pop. 44): village
and its surroundings (S.Ins.)

Chanac (pop. 710): château ruins and
walled village (S.Ins.)

Châteauneuf-de-Randon (pop. 414):
village and its surroundings (S.Ins.)

Fraissinet-de-Lozère (pop. 214):
ensemble of rural architecture
(Inv.M.H.)

Hures-la-Parade: village of Drigas
(S.Ins.)

Meyrueis (pop. 683): built-up area
and its surroundings (S.Ins.),

château and village of Ayres (S.Ins.)

Pourcharesse: hamlet of Pouget (S.Ins.)

Prévenchères: fortified hamlet of La
Garde-Guérin (S.Ins.)

Le Rozier: hamlet and crag of Capluc
(S.Ins.)

Saint-Pierre-des-Tripiers (pop. 69):
hamlet (S.Ins.)

Vialas: hamlet of Les Plots and its
immediate surroundings (S.Ins.)

# LIMOUSIN

## CORRÈZE

Affieux (pop. 57): village, church and
their immediate surroundings
(S.Ins.)

Chasteaux (pop. 391): village and its
surroundings (S.Ins.)

*Collonges-la-Rouge* (pop. 95): town and
its surroundings (S.Ins.)

Confolent-Port-Dieu (pop. 30): site of
Port-Dieu (S.Ins.)

Corrèze (pop. 866): *bourg* and valley
(S.Ins.)

Curemonte (pop. 99): village (S.Ins.)

Gimel-les-Cascades (pop. 55): site of
Gimel (S.Ins.) and falls (S.Cl.)

La Roche-Canillac (pop. 157) and
Saint-Martin-la-Méanne: site of La
Roche-Canillac and of the château
of Le Chazal (S.Ins.)

Saint-Augustin: hamlet of Tourondel
and its surroundings (S.Ins.)

Saint-Robert (pop.302): *bourg* and
surroundings (S.Ins.)

Ségur-le-Château (pop. 168): village
and its surroundings (S.Ins.)

Tarnac (pop. 220): *bourg*, church and
château (S.Ins.)

*Turenne* (pop. 264): *bourg* (S.Ins.)

## CREUSE

Ahun (pop. 803): site of the *bourg*
(S.Ins.)

Chambon-sur-Voueize (pop. 1011):
*bourg* (S.Ins.)

## HAUTE-VIENNE

Bonnac-la-Côte and Compreignac: site
of the village of Salesse (S.Ins.)

Mortemart (pop. 152): *bourg* (S.Ins.)

Rancon and Villefavard (pop. 86): site
of Villefavard and part of the valley
of the Semme (S.Ins.)

Saint-Sylvestre: village of Grandmont
(S.Ins.)

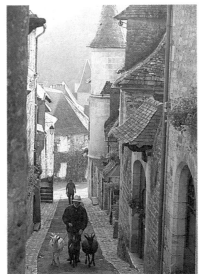

**Turenne.**

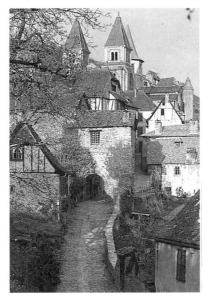

**Conques. Rue Charlemagne and Porte du Barry.**

# LORRAINE

## MOSELLE

Romécourt: old village within the
fortified enclosure (S.Ins.)

# MIDI-PYRÉNÉES

## ARIÈGE

Ercé: hamlet of Cominac (S.Ins.)

Montségur (pop. 131): village and its
surroundings (S.Ins.)

Saint-Lizier (pop. 822): town (S.Ins.)

Sainte-Foi (pop. 19): village (S.Ins.)

## AVEYRON

Belcastel (pop. 58): village, château
mound, water system of the
Aveyron, bridge and buildings on
both banks (S.Ins.)

Brousse-le-Château (pop. 65): village
and its surroundings (S.Ins.)

Calmont (pop. 65): village (S.Ins.)

Castelmary (pop. 190): village, its
ruins and its surroundings (S.Ins.)

Compeyre (pop. 223): village (S.Ins.)

Comprégnac: village of Peyre and its
surroundings (S.Ins.)

*Conques* (pop. 178): village and its
surroundings (S.Ins.)

*La Couvertoirade* (pop. 134):
commandery and its surroundings
(S.Ins.)

Estaing (pop. 470): village (S.Ins.)

Montrozier (pop. 565): village and
neighbouring meadowland (S.Ins.)

Mostuéjouls (pop. 97): village and
hamlet of Liaucous (S.Ins.)

Mur-de-Barrez (pop. 974): village and
its surroundings (S.Ins.)

Muret-le-Château (pop. 89): village
(S.Ins.)

Najac (pop. 339): old village (S.Ins.)

Nant: village of Cantobre and its
surroundings (S.Ins.)

Peyreleau: old village and tower (S.Ins.)

Peyrusse-le-Roc (pop. 100): traces of
medieval village (S.Ins.)

Rivière-sur-Tarn: crags and hamlet of
Peyrelade (S.Ins.)

Rodelle: village and its hill (S.Ins.)

La Roque-Sainte-Marguerite: crag,
ruins and hamlet of Saint-Véran
(S.Ins.)

Saint-Come-d'Olt (pop. 633): *bourg*
(S.Ins.)

Saint-Georges-de-Luzençon: hamlet
and chapel (S.Ins.)

Saint-Izaire (pop. 107): village (S.Ins.)

Saint-Jean-et-Saint-Paul (pop. 242):
fort of Saint-Jean-d'Alcas (S.Ins.)

Saint-Sernin-sur-Rance (pop. 504):
town and its surroundings (S.Ins.)

Sainte-Eulalie-de-Cernon (pop. 165):
*bourg* (S.Ins.)

Salles-la-Source (pop. 252): village
made up of four built-up areas:
Salles, La Croissé, Saint-Laurent
and Le Bourg (S.Ins.)

*Sauveterre-de-Rouergue* (pop. 371):
*bastide* and square with its well,
cross and arcaded houses (S.Ins.)

Sénergues: château and village of Montarnal and its surroundings (S.Ins.)

Thérondels: site of the hamlet of Laussac (S.Ins.)

## HAUTE-GARONNE

Cirès (pop. 11): village and banks of the Neste d'Oueil (S.Ins.)

Clermont-le-Fort (pop. 308): site of Clermont (S.Cl.)

*Saint-Bertrand-de-Comminges* (pop. 137): upper town and its hill (S.Ins.), and the commune as a whole (S.Ins.)

Saint-Félix-Lauragais (pop. 259): market square and houses around it (S.Ins.)

## GERS

Flamarens (pop. 168): village (S.Ins.)

Lagarde-Fimarcon (pop. 148): village and its surroundings (S.Ins.)

Lavardens (pop. 108): village (S.Ins.)

Montfort (pop. 259): Place de la Mairie: paving, fountain, market, church and its cross, houses around the square (S.Ins.)

Saint-Clar (pop. 748): Place de la Mairie, its old market and the houses around it (S.Ins.)

## LOT

Arcambal: hamlet and château of Béars (S.Ins.)

*Autoire* (pop. 109): village and its surroundings (S.Ins.)

Capdenac-le-Haut (pop. 463): village and its surroundings (S.Ins.)

Cardaillac (pop. 258): village (S.Ins.)

Carennac (pop. 171): village (S.Ins.)

Carlucet (pop. 148): village and its surroundings (S.Ins.)

Fons (pop. 112): village and its surroundings (S.Ins.)

Lherm (pop. 228): *bourg* and its surroundings (S.Ins.)

Lhospitalet (pop. 134): village (S.Ins.)

Loubressac (pop. 150): village and its surroundings (S.Ins.)

Martel (pop. 1004): old town (S.Ins.), village of Gluges, cliffs and course of the Dordogne (S.Ins.)

Montbrun (pop. 61): village (S.Ins.)

Montvalent (pop. 68): village and its surroundings (S.Ins.)

Puy-l'Évêque: hamlet of Martignac (S.Ins.)

Rocamadour (pop. 89): site of Rocamadour (S.Cl. and S.Ins.), village of Mayrinhac-le-Francal (S.Ins.)

*Saint-Cirq-Lapopie* (pop. 179): village (S.Cl. and S.Ins.)

Saint-Denis-Catus: village and Étang d'Escarrié (S.Ins.)

Vayrac: village of Mézels (S.Ins.)

## HAUTES-PYRÉNÉES

Campan (pop. 477): market square with the old houses around it (S.Ins.)

Saint-Savin (pop. 172): *bourg* and Place du Castet (S.Ins.)

## TARN

Ambialet (pop. 405), Courris and Saint-Cirgue: village of Ambialet, ruins overlooking it, priory and loop of the Tarn (S.Ins.)

Ambres (pop. 626): village (S.Ins.)

Castelnau-de-Lévis (pop. 570): village (S.Ins.)

Castelnau-de-Montmiral (pop. 322): village (S.Ins.)

*Cordes* (pop. 852): town and surrounding landscape (S.Ins.)

Ferrières (pop. 196): site of Ferrières (S.Ins.)

Giroussens (pop. 434): public square

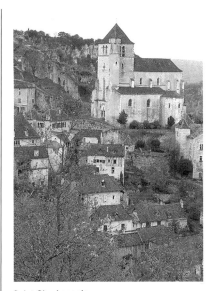

**Saint-Cirq-Lapopie.**

and houses around it (S.Ins.)

Lautrec (pop. 637): market square with arcaded houses around it (S.Ins.)

Monestiès (pop. 486): village (S.Ins.)

Montdragon (pop. 96): public square and galleried houses (S.Ins.)

*Penne* (pop. 108): village (S.Cl. and S.Ins.)

Puycelci (pop. 107): village (S.Cl. and S.Ins.)

Saix (pop. 732): village (S.Ins.)

Sorrèze (pop. 867): old town (S.Ins.)

Tanus: abandoned village of Lasplanques (S.Ins.)

## TARN-ET-GARONNE

Auvillar (pop. 573): village and its surroundings (S.Ins.), and houses surrounding the corn-market square (Inv.M.H.)

*Bruniquel* (pop. 150): village and its surroundings (S.Ins.)

Caylus (pop. 476): large square with the market and houses around it (S.Ins.)

Castelsagrat (pop. 178): houses

around the square (Inv.M.H.)

Faudoas (pop. 50): village (S.Ins.)

Gramont (pop. 170): village (S.Ins.)

Lauzerte (pop. 633): village (S.Ins.)

Maubec (pop. 191): village (S.Ins.)

Montjoi (pop. 221): village and its surroundings (S.Ins.)

Montpezat-de-Quercy (pop. 657): village (S.Ins.) and Place de l'Hôtel de Ville with the buildings around it (S.Ins.)

Montricoux (pop. 268): village (S.Ins.)

Réalville (pop. 533): Place Nationale: covered galleries (S.Ins.) and the ground and buildings as a group (Inv.M.H.)

**Sauveterre-de-Rouergue.**

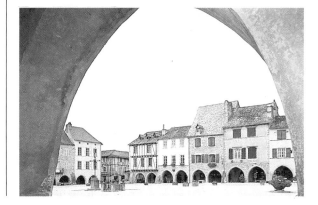

**Bruniquel.**

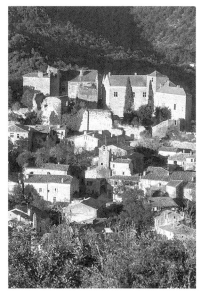

# NORMANDIE (NORMANDY)

## MANCHE

*Mont-Saint-Michel* (pop. 65): church, abbey and auxiliary buildings, fortified enclosure and houses of the village (M.H. and Inv.M.H.) and their surroundings (S.Ins.)

## ORNE

*Condeau*: church, château and *bourg* of Villeray (S.Ins.)
*Dompierre* (pop. 122): old *bourg* (S.Ins.)
*Mortagne-au-Perche*: *bourg* of Loisé and its surroundings (S.Ins.)
*La Perrière* (pop. 271): *bourg* and its surroundings (S.Ins.)

*Saint-Céneri-le-Gérei* (pop. 71): site of Saint-Céneri (S.Ins.)

## EURE

*Dampsmesnil*: hamlet of Aveny (S.Ins.)
*Dangu* (pop. 484): village (S.Ins.)
*Port-Mort*: hamlet of Châteauneuf and its surroundings, and ruins of the château of La Roque (S.Ins.)

## SEINE-MARITIME

*Auzouville-Auberbosc* (pop. 112): village (S.Ins.)
*La Chapelle-sur-Dun* (pop. 241): village and its surroundings (S.Ins.)
*Ermenonville* (pop. 177): village (S.Ins.)

# PAYS DE LOIRE

## LOIRE-ATLANTIQUE

*Batz-sur-Mer*: marsh villages of Kervallet and Trégate (S.Ins.)
*Guérande*: villages of Clis, Kerignon, Queniquen and Kerbezo (S.Ins.)

## MAINE-ET-LOIRE

*Champteussé-sur-Baconne* (pop. 96): village (S.Ins.)
*Cornillé-les-Caves* (pop. 131): village and its surroundings (S.Ins.)
*Daumeray*: hamlet of Saint-Germain (S.Ins.)
*Denée* (pop. 729): urban site (S.Ins.),

hamlet of Mantelon (S.Ins.)
*Faveray-Machelles* (pop. 207): *bourg* and cemetery of Faveraye (S.Ins.)
*Fontevrault-l'Abbaye* (pop. 946): urban site (S.Ins.)
*Huillé* (pop. 216): *bourg* and its surroundings (S.Ins.)
*Passavant-sur-Layon* (pop. 99): *bourg*, château and pond (S.Ins.)
*Saint-Aubin-de-Luigné*: site of the hamlet of La Haye-Longue (S.Ins.)

## MAYENNE

*Hambers*: site of Montaigu (S.Cl.)
*Sainte-Suzanne* (pop. 632): *bourg* (S.Ins.)

**Mont-Saint-Michel. The Grande-Rue.**

## SARTHE

*Parcé-sur-Sarthe* (pop. 953): *bourg* (S.Ins.)
*Saint-Léonard-des-Bois* (pop. 157): *bourg*, the hill of Narbonne and its surroundings (S.Ins.)

## VENDÉE

*Jard-sur-Mer and Saint-Hilaire-de-Talmont*: villages of Les Hautes-Mers, Les Eaux, La Guittière-d'Ilaude, La Vinière and the marshes of Le Veillon, La Guittière and La Vinière (S.Ins.)
*Vouvant* (pop. 460): small town and valley of the Mère (S.Ins.)

**Entrevaux. Pont de la Porte Royale.**

# PICARDIE (PICARDY)

## AISNE

*Bourguignon-sous-Montbavin* (pop. 141) *and Royaucourt-et-Chailvet* (pop. 106): villages and their surroundings (S.Ins.)
*Septmonts, Noyant-et-Aconin, Rozières-sur-Crise*: village of Septmonts (S.Ins.)
*Vorges* (pop. 333): village (S.Ins.)

## OISE

*Gerberoy* (pop. 77): village (S.Ins.)

## SOMME

*Suzanne* (pop. 143): village, château and its park, church and tombs (S.Ins.)

**Névache. La Ville Haute.**

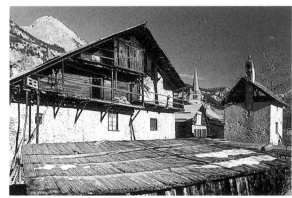

# POITOU-CHARENTES

### CHARENTE

Aubeterre-sur-Dronne (pop. 381): *bourg* (S.Ins.)
Les Essards: village of Puychaud and its surroundings (S.Ins.)
Le Tatre and Reignac: hamlet of Les Chaussades (S.Ins.)
Tusson (pop. 370): village (S.Ins.)

### CHARENTE-MARITIME

Hiers-Brouage (pop. 223): fortifications (M.H.), area of the ramparts (S.Ins.) and fortress (S.Ins.)
Port-d'Envaux: Place de Saint-Saturnin-de-Séchaux and monuments around it (S.Cl.)

Saint-Sauvant (pop. 401): *bourg* (S.Ins.)
Talmont-sur-Gironde (pop. 79): *bourg* (S.Cl.)

### DEUX-SÈVRES

Exoudun (pop. 281): *bourg* (S.Ins.)

### VIENNE

Angles-sur-l'Anglin (pop. 322): site cf Angles-sur-l'Anglin, village and valley of the Anglin (S.Ins.)
Curçay-sur-Dive (pop. 128): village (S.Ins.)

# PROVENCE-ALPES-CÔTE D'AZUR

### ALPES-DE-HAUTE-PROVENCE

Castellet-lès-Sausses (pop. 114): village and its surroundings (S.Ins.)
Colmars (pop. 225): fortified enclosure (M.H.) and village (S.Ins.)
Dauphin (pop. 232): village and its surroundings (S.Ins.)
Digne: hamlet of Courbons and its surroundings (S.Ins.)
Entrevaux (pop. 308): fortifications (M.H.) and their surroundings (S.Ins.) and village (S.Cl.)
Lurs (pop. 80): village (S.Ins.)
Moustiers-Sainte-Marie (pop. 441): village and its surroundings (S.Ins.)

Saint-Maime (pop. 342): village (S.Ins.)
Val-de-Chalvagne: village of Castellet-Saint-Cassien and environs (S.Ins.)

### HAUTES-ALPES

La Grave: hamlets of Le Chazelet, Les Terrasses, Les Hières and Ventelon, and their surroundings (S.Ins.)
Mont-Dauphin (pop. 83): crag and village (S.Ins.)
Névache (pop. 167): village made up of La Ville Haute and the three hamlets of La Ville Basse, Le Château and Le Cros (S.Ins.), hamlet of Sallé, chalets of Fontcouverte and Le Jadis, Lacou. Lacha and Laval (S.Ins.)

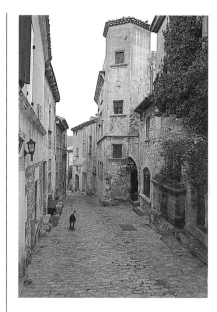

**Les Baux-de-Provence.**

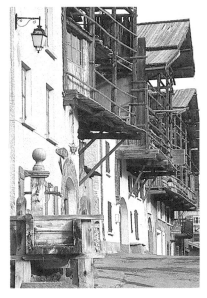

**Saint-Véran. Le Châtelet.**

Saint-Véran (pop. 213): village (Le Raux, Pierre-Belle, Le Villard, Le Châtelet, La Ville, Les Forannes) and its surroundings (S.Ins.)
Tallard (pop. 869): *bourg* (S.Ins.)
Vars: hamlet of Sainte-Catherine and its surroundings (S.Ins.)

### ALPES-MARITIMES

Auribeau-sur-Siagne (pop. 252): village and its surroundings (S.Ins.)
Caille (pop. 144): village and its surroundings (S.Ins.)
Carros-Village: village and its surroundings (S.Ins.)
Castellar: ruins of old Castellar (S.Cl.)
Châteauneuf-de-Contes: ruins of the old village and of the feudal château (S.Cl.)
Châteauneuf-Grasse (pop. 304) and Opio (pop. 671): villages and their surroundings (S.Ins.)
Èze-Village (pop. 143): site of old Èze (S.Ins.) and its surroundings (S.Cl.)
Gattières (pop. 532): village and its surroundings (S.Ins.)
Ilonse (pop. 55): village (S.Ins.)
Marie-sur-Tinée (pop. 50): village (S.Ins.)
Peillon (pop. 372): village and its surroundings (S.Ins.)
Pierrefeu (pop. 114): village and its surroundings (S.Ins.)
Saint-Dalmas-le-Selvage (pop. 92): village and its surroundings (S.Ins.)
Saint-Jeannet (pop. 905): village (S.Ins.)
Sainte-Agnès (pop. 103): village and its surroundings (S.Ins.)
Saorge (pop. 276): village and its surroundings (S.Ins.)
Valbonne (pop. 822): village (S.Ins.)

### BOUCHES-DU-RHÔNE

Les Baux (pop. 62): village (S.Cl. and S.Ins.) and surrounding sites (S.Cl.)
Eygalières (pop. 556): old village and its surroundings (S.Ins.)
Ventabren (pop. 857): village and its surroundings (S.Ins.)
Vernègues: ruins of the old village (S.Ins.)

### VAR

Ampus (pop. 258): village and its surroundings (S.Ins.)
Bargème (pop. 74): village (S.Cl. and S.Ins.) and protection zone around it
Callian (pop. 603): village and its surroundings (S.Ins.)
Châteaudouble (pop. 139): village and its surroundings (S.Ins.)
Cotignac (pop. 987): village and its surroundings (S.Ins.)
Entrecasteaux (pop. 304): village and its surroundings (S.Ins.)
Évenos (pop. 342): village and its surroundings (S.Cl.)
Fayence (pop. 1050) and Tourrettes (pop. 349): villages and their surroundings (S.Ins.)
Figanières (pop. 564): village and its surroundings (S.Ins.)
Gassin (pop. 192): village and its surroundings (S.Ins.)
Grimaud (pop. 643): village and its surroundings (S.Ins.)
Mons (pop. 147): village and its surroundings (S.Ins.)
Montauroux (pop. 679): village and its surroundings (S.Ins.)
Ramatuelle (pop. 520): village (S.Ins.)
Saint-Martin-des-Pallières (pop. 116): village and château (S.Ins.)
Seillans (pop. 963): village and its surroundings (S.Ins.)

Sillans-la-Cascade (pop. 118): village
and its surroundings (S.Ins.)

Tourtour (pop. 245): village (S.Ins.)

## VAUCLUSE

Ansouis (pop. 239): village (S.Ins.)

Aurel (pop. 53): village and its
surroundings (S.Ins.)

Le Beaucet (pop. 87): village (S.Ins.)

*Bonnieux* (pop. 501): village (S.Ins.)

Buoux (pop. 103) and Bonnieux: site
of the village of Buoux (S.Ins.)

Crestet (pop. 326): village (S.Ins.)

Crillon-le-Brave (pop. 69): old village,
château and chapel (S.Ins.)

Gigondas (pop. 129): village (S.Ins.)

*Gordes* (pop. 399): village and its
surroundings (S.Ins.)

Lacoste (pop. 118): château and
village (S.Ins.)

Lagnes (pop. 369): village (S.Ins.)

Lourmarin (pop. 378): village and
château area (S.Ins. and S.Cl.)

Ménerbes (pop. 242): village (S.Ins.)

Méthamis (pop. 326): old village (S.Ins.)

Mornas (pop. 353): village and its
surroundings (S.Ins.)

Oppède-le-Vieux (pop. 138): château
and village (S.Ins.)

La Roque-sur-Pernes (pop. 138): *bourg*
and its close vicinity (S.Ins.)

*Roussillon* (pop. 442): village and
surrounding landscape with the
ochre cliffs (S.Ins.)

Saignon (pop. 146): crag and village
(S.Cl.)

Sérignan-du-Comtat (pop. 734):
village (S.Ins.)

Les Taillades: church, old village and
their surroundings (S.Ins.)

Viens (pop. 191): old village and its
immediate surroundings (S.Ins.)

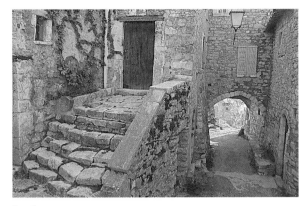

**Bargème.**

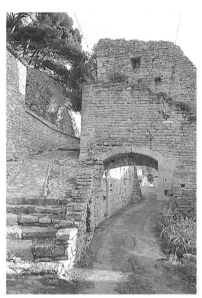

**Bonnieux.**

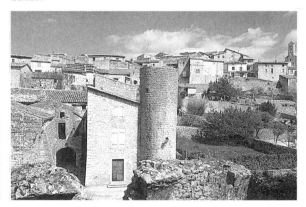

**Balazuc.**

# RHÔNE-ALPES

## AIN

Oncieu (pop. 59): site of Oncieu
(S.Ins.)

*Pérouges* (pop. 464): M.H. and
Inv.M.H. and protection zone on the
edge of the village

## ARDÈCHE

*Balazuc* (pop. 124): village and its
immediate surroundings (S.Ins.)

Désaignes (pop. 478): old village (S.Ins.)

Labastide-de-Virac (pop. 128): village
(S.Ins.)

Labeaume (pop. 405): village and
gorges of Labeaume (S.Ins.)

Malarce-sur-la-Thines (pop. 204):
village and its surroundings (S.Ins.)

Mirabel (pop. 68): village and basalt
rock ledge (S.Ins.)

Saint-Laurent-sous-Coiron (pop. 120):
village and basalt rock ledge (S.Ins.)

*Saint-Montan* (pop. 153): village (S.Ins.)

Saint-Thomé (pop. 171): village and
its surroundings (S.Ins.)

Saint-Vincent-de-Barrès (pop. 73):
village (S.Ins.)

Sceautres (pop. 96): crag and village
(S.Ins.)

Ucel: hamlet of Le Grand Village
d'Ucel (S.Ins.)

Vogüé-sur-Ardèche (pop. 221): village
(S.Ins.)

## DRÔME

Autichamp (pop. 115): château and
village (S.Ins.)

Beaufort-sur-Gervanne (pop. 212): old
village and its surroundings (S.Ins.)

La Garde-Adhémar (pop. 641): village
(S.Ins.)

La Laupie (pop. 208): village and its
surroundings (S.Ins.)

Mirmande (pop. 115): village and its
immediate surroundings (S.Ins.)

Montbrun-les-Bains (pop. 267): old
village (S.Ins.)

*Le Poët-Laval* (pop. 66): village and its
surroundings (S.Ins.)

Le Poët-Sigillat (pop. 47): old village
(S.Ins.)

Saint-Jalle (pop. 148): old village
(S.Ins.)

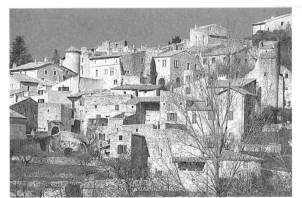

**Le Poët-Laval.**

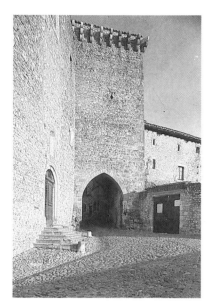

**Pérouges.**

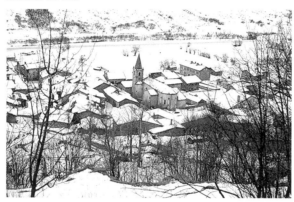

**Bonneval-sur-Arc.**

## ISÈRE

Besse-en-Oisans (pop. 117): village and hamlets of Bonnefin and Le Sert (S.Ins.)

Mens (pop. 856): market square and church, market, fountain and houses on the edge of the square (S.Ins.)

Monestier-de-Clermont (pop. 722): château, square and houses around it (S.Ins.)

Saint-Antoine (pop. 258): *bourg* and area of the abbey (S.Ins.)

Saint-Christophe-en-Oisans (pop. 103): hamlets of Champebran, Champhorent, Pré-Clot and Le Puy (S.Ins.), and hamlets of La Bérarde and Les Étages and their surroundings (S.Ins.)

Saint-Michel-les-Portes (pop. 96): village and its surroundings (S.Ins.)

Saint-Paul-lès-Monestier (pop. 97): village and its surroundings (S.Ins.)

La Salette-Falavaux: village of La Salette (S.Ins.), village of Saint-Julien (S.Ins.)

Villard-de-Lans: hamlet of Les Bouchards (S.Ins.), hamlet of Les Ponteils and its surroundings (S.Ins.), valley and village of Valchevrière (S.Ins.)

## LOIRE

Cervières (pop. 111): village and its surroundings (S.Ins.)

Chambles: hamlet of Les Camaldules and ruined tower (S.Ins.)

Montarcher (pop. 54): village and its surroundings (S.Ins.)

Pommiers (pop. 116): *bourg* and its surroundings (S.Ins.)

Sail-sous-Couzan: château area and village of Couzan (S.Ins.)

Saint-Paul-en-Cornillon: site of Cornillon (S.Ins.)

Saint-Laurent-Rochefort: site of Rochefort (S.Ins.)

**Gordes. The castle.**

## RHÔNE

Chambost-Allières (pop. 443): old *bourg* (S.Ins.)

Chamelet (pop. 270): old village (S.Ins.)

Charnay (pop. 382): public square and houses around it, and château and church (S.Ins.)

Oingt (pop. 195): old village

Poule-lès-Écharmeaux: pass and hamlet of Les Écharmeaux (S.Ins.)

Riverie (pop. 191): *bourg* (S.Cl.)

Ternand (pop. 63): old village (S.Cl.)

Ternay: village and château of La Porte (S.Ins.)

## SAVOIE

Albertville: old nucleus of Conflans (S.Ins.)

La Bâthie: ruins of the château and hamlet of Chantemerle (S.Ins.)

Beaufort-sur-Doron: hamlet of Boudin (S.Ins.), built-up area of Roselend and hamlets of Fontaines and Les Granges (S.Ins.)

*Bonneval-sur-Arc* (pop. 123): village (S.Ins.), hamlet of L'Écot (S.Ins.)

Bourg-Saint-Maurice: hamlet of Les Chapieux (S.Ins.)

Hauteluce (pop. 200): village (S.Ins.), hamlet of Annuit and its surroundings (S.Ins.), hamlet of Belleville and its surroundings (S.Ins.), hamlet of Entre-deux-Nats (S.Ins.), hamlet of Le Praz and its surroundings (S.Ins.), hamlet of Le Pré (S.Ins.)

Pralognan-la-Vanoise: hamlet of Bieux (S.Ins.), inner square of the hamlet of Barioz with the fountain, chapel and houses surrounding it (S.Ins.), hamlet of La Croix (S.Ins.), hamlet of Les Fontanettes (S.Ins.)

Saint-Martin-de-Bellèville (pop. 192): villages of Saint-Martin and Villarencel (S.Ins.)

Saint-Pierre-d'Albigny: château and hamlet of Miolans (S.Ins.)

Sainte-Foy-Tarentaise: site of the hamlet of Monal (S.Cl.)

Ugine: village of Héry-sur-Ugine and its surroundings (S.Ins.)

Valloire (pop. 376): *bourg* and its surroundings (S.Ins.), hamlet of Bonnenuit (S.Ins.), hamlet of Borgé and its surroundings (S.Ins.), hamlet of Les Étroits (S.Ins.), hamlet of Tigny and its immediate surroundings (S.Ins.) and the following built-up areas: Grande and Petite Charmette, Plan-Lanchat, Les Choseaux, Les Granges, La Rivine, Pratier, La Ruaz and Les Verneys

## HAUTE-SAVOIE

Alby-sur-Chéran (pop. 742): square of the *bourg*, including the buildings giving on to it (S.Ins.)

Chamonix-Mont-Blanc: hamlet of Trélechamps and its surroundings (S.Ins.)

Le Grand-Bornand: hamlet of Chinaillon (S.Ins.)

Publier: old village of Amphion and its surroundings (S.Ins.)

Pringy: château and hamlet of Proméry and their surroundings (S.Ins.)

Sixt-Fer-à-Cheval: hamlet of Passy (S.Ins.)

Saint-Jean-de-Sixt: hamlet of Les Éculés and Pont des Étroits (S.Ins.), hamlet of Le Villaret (S.Ins.)

The villages are listed in the order in which they appear in the book. Nearby places not featured in the texts and photographs are indicated by ◇. The information and prices were compiled in January 1993 and are subject to modification.

## *ALSACE*

● RIQUEWIHR
*Hôtel-restaurant Le Sarment d'Or* ** – 4, rue du Cerf. Tel. 89 47 92 85. Closed 1 Jan./4 Feb. and 1/7 Jul.; restaurant closed Sun. eve. and Mon. off-season. Rooms: 260/420 F. Menus: 90/150/250 F. Very good regional cooking.
◇ Ribeauvillé
*Hôtel du Mouton* ** – Place de la Sinne. Tel. 89 73 60 11. Closed Tues. eve., Wed. and end Nov./mid-Jan. Rooms: 140/270 F. Menus: 95/160 F. 14th-c. house.
*Brasserie de la Poste* – 1, place de la 1ère Armée. Tel. 89 73 60 93. Closed Mon., end June/mid-Jul. Menus: 65/80 F. Traditional cooking.
◇ Kaysersberg
*Auberge de la Cigogne* – 73, route de Lapoutroie. Tel. 89 47 30 33. Closed Fri. and Sun. eve. Menu: 85 F. Good cooking.

● HUNAWIHR see RIQUEWIHR

## *AQUITAINE*

● MONPAZIER
◇ Beaumont (c. 20 km/12 mi. 13th-c. principal English *bastide*, 18th-c. square)
*Restaurant La Bohème* – La Tricherie. Tel. 49 85 51 74. Menus: 55/90/130 F. Traditional cooking.

● LA ROQUE-GAGEAC see BEYNAC

● BEYNAC
◇ Beynac-et-Cazenac (10 km/6 mi. from Sarlat)
*Hôtel Bonnet* ** – Le Bourg. Tel. 53 29 50 01. Closed 15 Oct./10 Apr. Rooms: 215/280 F. Menus: 120/180/240 F. Nice interior decoration. Fine panorama.
◇ Sarlat (13 km/8 mi. from La Roque-Gageac)
*Hôtel Le Mas de Castel* ** – Sudalissant. Tel. 53 59 02 59. Closed 11 Nov./Palm Sun. Rooms: 190/210 F. Large garden, swimming-pool.
*Hôtel-restaurant La Couleuvrine* – 1, place de la Bouquerie. Tel. 53 59 27 80. Closed 15/30 Nov. and 10/31 Jan. Rooms: 250/340 F. Menus: 95/190 F. Beautiful house.
*Hôtel-restaurant Le Commerce* ** – 4, rue Albéric-Cahuet. Tel. 53 59 04 26. Rooms: 300 F. Menus: 55/165 F.
*Restaurant La Rapière* – Place de la Cathédrale. Tel. 53 59 03 13. Closed Sun. off-season. Menus: 80/300 F. 16th-c. house. Specialities.
*Auberge La Salamandre* – 6, rue des Consuls. Tel. 53 31 04 41. Menus: 85/100/130 F. Beautiful 16th-c. house. Country cooking.
◇ Marquay
*Hôtel-restaurant des Bories* ** – Le Bourg. Tel. 53 29 67 02. Closed mid-Nov./mid-Mar. Restaurant closed Mon. lunch. Rooms: 210/230 F. Menus: 140/180 F. Gastronomic restaurant. Large garden, swimming-pool and fine panorama.

● DOMME see BEYNAC

● SAINT-ÉMILION
*Auberge de la Commanderie* ** – Rue des Cordeliers. Tel. 57 24 70 19. Closed Dec./Mar. 15 rooms: 200/350 F. Restaurant, cheapest menu: 105 F.
*Hôtel Palais Cardinal* *** – Place du 11-Novembre-1918. Tel. 57 24 72 39. Closed Dec./Apr. Rooms: 315/375 F. Cheapest menu: 78 F. Garden, swimming-pool.
*Restaurant L'Envers du Décor* – Rue du Clocher. Tel. 57 74 48 31. Closed Sun. Very good wines.
*Restaurant Le Tertre* – Rue du Tertre-de-la-Tente. Tel. 57 74 46 33. Closed Wed. and Sun. eve. off-season, and 15 Nov./5 Jan. Menus: 85/115/185 F. Plain cooking.

● AÏNHOA
*Hôtel-restaurant Ithuria* *** – Tel. 59 29 92 11. Closed 11 Nov./end Mar. and Tue. eve., Wed. except school holidays and public holidays. Rooms: 450/600 F. Menus: 160/260 F. Garden, swimming-pool.
◇ Espelette
*Hôtel Euzkadi* ** – Rue Principale. Tel. 59 93 91 88. Closed Mon. and Tue. off-season. Menus: 85/170 F. Rooms: 240 F. Garden, swimming-pool. Good regional cooking.

## *AUVERGNE*

● HÉRISSON
◇ Cosne-d'Allier
*Auberge du Pont des Chèvres* – 1, route de Montluçon. Tel. 70 07 56 93. Closed Mon. eve. and Tue. eve. Menus: 65/95/160 F.
◇ Montluçon
*Hôtel des Bourbons–Restaurant Aux Ducs de Bourbon* ** – 47, avenue Marx Dormoy. Tel. 70 05 22 79. Restaurant closed Sun. eve. and Mon. except public holidays. Rooms: 140/230 F. Menu: 105 F. 18th-c. house.

● SALERS
*Hôtel du Beffroi* ** – Rue du Beffroi. Tel. 71 40 70 11. Closed Nov./Feb. 10 rooms: 180 F. Copious regional menus from 59 F.
*Restaurant Le Drac* – Place Tyssandiers-d'Escous. Tel. 71 40 72 12. Closed All-Saints Day/Christmas. Cheapest regional menu: 70 F. 16th-c. house.

## *BOURGOGNE (BURGUNDY)*

● FLAVIGNY-SUR-OZERAIN
◇ Semur-en-Auxois (16 km/10 mi. One of the most beautiful towns in Burgundy)
*Hôtel-restaurant de la Côte-d'Or* ** – 3, place Gaveau. Tel. 80 97 03 13. Closed Wed. and 24 Nov./11 Jan. 15 rooms: 195/270 F. Menus: 90/130/210 F. Burgundy specialities.

● NOYERS-SUR-SEREIN
*Restaurant de la Vieille Tour* – Rue de la Porte Peinte. Tel. 86 82 87 69. Rooms available Easter/Oct.: 160/250 F. Cheapest menu: 60 F. Peaceful.

● VÉZELAY
*Hôtel de la Poste et du Lion d'Or* *** – Place du Champ-de-Foire. Tel. 86 33 21 23. Restaurant closed Mon. and Tue. lunch. Hotel closed Nov./Apr. Rooms: 250/350 F. Menus from 110 F. Old posting-house, beautiful architecture.
*Restaurant Le Bougainville* – 26, rue Saint-Étienne. Tel.: 86 33 27 57. Closed Mon. and Tue. off-season, Tue. and Wed. lunch tourist season and 1 Dec./1 Feb. Menus: 98/115/155 F. Nice interior and good cooking.
◇ Avallon (old town should be seen).
*Restaurant Le Gourmillon* – 8, rue de Lyon. Tel. 86 31 62 01. Closed Sun. eve., Mon. and Jan. Cheapest menu: 80 F. Attractive décor.
◇ Clamecy
*Hostellerie de la Poste* *** – 9, place Émile-Zola. Tel. 86 27 01 55. Closed Sun. eve. and Mon. Rooms from 240 F. Menus: 95/170 F. Fine house, nice décor.
*Restaurant L'Angélus* – 11, place Saint-Jean. Tel. 86 27 23 25. Closed Wed. eve., Thu. off-season, Feb. and Oct. Menus: 75/140/220 F. Fine house.

## *BRETAGNE (BRITTANY)*

● LOCRONAN
*Hôtel du Bois de Nevet* ** – Route du Bois-de-Nevet. Tel. 98 91 70 67. Rooms: 280 F. Menus: 80/110/160 F. Garden. Peaceful.
◇ Douarnenez
*Auberge de Kerveoc'h* – Route de Kerveoc'h. Tel. 98 92 07 58. Closed 1 Oct./Easter. Rooms: 235/245 F. Cheapest menu: 100 F. Attractive interior decoration.
*Restaurant Le Tristan* – 25 bis, rue du Rosmeur. Tel. 98 92 20 17. Closed Wed. and Sun. eve. off-season. Menus: 80/270 F. Very good cooking.

● ROCHEFORT-EN-TERRE
◇ Malestroit
*Restaurant Le Canotier* – Place du Docteur-Queinnec. Tel. 97 75 08 69. Closed Sun. eve., Mon. and 15 Oct./15 Apr. Menus: 70/200 F.
◇ Redon
*Hôtel de France* ** – 30, rue Du Guesclin. Tel. 99 71 06 11. Rooms: 145/250 F.

## *CENTRE*

● APREMONT-SUR-ALLIER
◇ Nevers (39 km/24 mi. Faience museum, various churches, ducal palace)
*Villa du Parc* ** – 16 ter and 18, rue de Lourdes. Tel. 86 61 09 48. Rooms: 100/185 F. Peaceful.
*Restaurant aux Choeurs de Bacchus* – 25, avenue du Général-de-Gaulle. Tel. 86 36 72 70. Closed Sat. lunch, Sun., Christmas school holidays and 8/24 Aug. Cheapest menu: 79 F. Gastronomic restaurant.

# CORSE (CORSICA)

● SANT'ANTUNINU
◇ Calvi (c. 30 km/19 mi.)
*Hôtel Belvédère* ** – Place Christophe-Colomb. Tel. 95 65 01 25. Closed Oct./Feb. Rooms from 200 F.
◇ Lavatoggio (15 km/9 mi. from Calvi)
*Ferme-Auberge Chez Edgard* – Tel. 95 61 70 75. Closed Oct./ Apr. Menu: c. 160 F. Copious and inventive cooking.

# FRANCHE-COMTÉ

● LODS see MOUTHIER-HAUTE-PIERRE

● MOUTHIER-HAUTE-PIERRE
*Hôtel de la Cascade* *** – Route des Gorges-de-Noailles. Tel. 81 60 95 30. Closed 25 Nov./15 Feb. Rooms from 250 F. Menus: 102/270 F. Fine panorama.
◇ Ornans (20 km/12½ mi.)
*Hôtel-restaurant Le Progrès* * – 11, rue Jacques-Gervais. Tel. 81 62 16 79. Closed Sun. eve. in winter. Rooms: 230 F. Menu: 70 F.

# LANGUEDOC-ROUSSILLON

● LAGRASSE
◇ Lézignan-Corbières
*Hôtel-restaurant Le Tassigny* ** – Rond-point de-Lattre-de-Tassigny. Tel. 68 27 11 51. Restaurant closed Mon. Rooms: c. 220 F. Menus: 66/115 F. Copious cooking.
◇ Narbonne
*Hôtel-restaurant Le Lion d'Or* ** – 39, avenue Pierre-Semard. Tel. 68 32 06 92. Closed off-season Sun., Jan. and Feb. Rooms: 234 F. Menus: 75/85/120 F. Old-fashioned cooking.
*Hôtel-restaurant La Daurade* ** – 44, rue Jean-Jaurès. Tel. 68 32 65 95. Rooms: 270/300 F. Cheapest menu: 98 F. Fine house.
◇ Carcassonne
*Hôtel Terminus* *** – 2, avenue du Maréchal-Joffre. Tel. 68 25 25 00. Rooms: 280/390 F. Modern-style palace.
*Hôtel du Donjon* *** – 2, rue du Comte-Roger. Tel. 68 71 08 80. Rooms: 340/550 F. Rich medieval house. Garden.
*Auberge de Dame Carcas* – 3, place du Château. Tel. 68 71 23 23. Closed off-season Mon. and Tue. lunch and mid-Jan/ mid-Feb. Menus: 85/100 F. Good regional cooking.

● LA ROQUE-SUR-CÈZE
◇ Les Vans (a short walk away in the valley of the Cèze. Southern *bourg* at the foot of the Cévennes)
*Restaurant Chez Vincent et Michèle* – Les Lauzasses de Casteljau. Tel. 75 39 35 33. Closed Jan./Mar. Closed for lunch except Jul., Aug., Sun. and public holidays. Menus: 88/140 F. Swimming-pool. Wonderful place.

● SAINT-GUILHEM-LE-DÉSERT
◇ Montpellier
*Hôtel Les Arceaux* ** – 33/35, boulevard des Arceaux. Tel. 67 92 03 03. Rooms: 230/320 F. Garden.
*Le Guilhem* *** – 18, rue Jean-Jacques-Rousseau. Tel. 67 52 90 90. Rooms: 300/550 F. Garden.

● VILLEFRANCHE-DE-CONFLENT
◇ Prades
*Restaurant El Patio* – 19, place de la République. Tel. 68 96 02 84. Closed Sun. eve. and Mon. except Jul. and Aug. Menus: 95/140 F. Specialities.
◇ Mont-Louis
*Lou Roubaillou* – Tel. 68 04 23 26. Closed Nov./May (except Feb. holidays). Rooms: 200 F. Menus: 100/200 F. Rustic and comfortable house. Very good cooking.
◇ Perpignan
*Hôtel Athéna* ** – 1, rue Quéya. Tel. 68 34 37 63. Rooms: 130/340 F. 16th-c. house. Swimming-pool.
*Park Hôtel* *** – 18, boulevard Jean-Bourrat. Tel. 68 35 14 14. Restaurant closed Sun. Rooms: 280/480 F. Cheapest menu: 180 F.
*Restaurant La Passerelle* – 1, cours Palmarole. Tel. 68 51 30 65. Closed Sun. and Mon. lunch. Fish specialities.
*Restaurant Opéra-Bouffe* – Impasse de la Division. Tel. 68 34 83 83. Closed Sun., Mon. lunch and Feb. Good cooking and good wines.

# LIMOUSIN

● COLLONGES-LA-ROUGE see TURENNE

● TURENNE
Visit Collonges, Brive, and also Beaulieu-sur-Dordogne (c. 25 km/ 16 mi.): 12th-c. abbey, fine example of Romanesque architecture.
◇ Brive-la-Gaillarde
*Hôtel Le Montauban* ** – 6, avenue Édouard-Herriot. Tel. 55 24 00 38. Closed Mon. lunch and Feb. Rooms: 115/210 F. Menus: 85/120 F. Good regional cooking.
*Hôtel-restaurant La Crémaillère* ** – 53, avenue de Paris. Tel. 55 74 32 47. Closed Sun. eve. and Mon. Rooms: 200/240 F. Menus: 140/240 F. Garden. Traditional cooking.
*Restaurant Le Ruthène* – 2, rue Jean-Maistre. Tel. 55 23 08 66. Menus: 58/80/140 F. Traditional cooking.

# MIDI-PYRÉNÉES

● CONQUES
*Auberge Saint-Jacques* ** – Rue Principale. Tel. 65 72 86 36. Closed Jan. and Mon. off-season. Rooms: 180/330 F. Menus: 75/160 F. Good cooking.

● LA COUVERTOIRADE
◇ Millau
*International Hôtel* *** – 1, place de la Tiné. Tel. 65 60 20 66. Rooms: 250/425 F. Menus: 100/138 F. Good restaurant. Fine panorama.

● SAUVETERRE-DE-ROUERGUE
*Auberge du Sénéchal* ** – Le Bourg. Tel. 65 47 05 78. Restaurant closed Sun. eve. and Mon.; hotel closed end Oct./Easter. Rooms: 260 F. Menu: 150 F. Very good cooking.
◇ Rodez (40 km/25 mi.)
*Hôtel de la Tour-Maje* *** – Boulevard Gally. Tel. 65 68 34 68. Rooms: 270 F. Quiet. Comfortable.
*Restaurant Goûts et Couleurs* – 38, rue Bonalde. Tel. 65 42 75 10. Closed Sun., Mon., 3 weeks Jan. and Feb. and 1 week Sep. Menus: 80/195 F. Inventive cooking.

● SAINT-BERTRAND-DE-COMMINGES
*Hôtel-restaurant L'Oppidum* ** – Rue de la Poste. Tel. 61 88 33 50. Closed Wed., 26 Nov./17 Dec. and 11/25 Jan. Rooms: 220 F. Cheapest menu: 75 F.

● AUTOIRE
◇ Saint-Céré (should be seen – old houses)
*Hôtel-restaurant Le Victor Hugo* ** – 7, avenue du Maquis. Tel. 65 38 16 15. Closed Mon., 1/21 Oct. and 1/15 Mar. Rooms: 220 F. Menus: 55/135 F. Nice house. Garden.
*Hôtel de France* *** – 181, avenue François-de-Maynard. Tel. 65 38 02 16. Closed Sun. eve. and Mon. off-season, and Nov./Mar. Rooms: 250/340 F. Menus: 100/140/180 F. Very comfortable. Large garden. Very good cooking.

● SAINT-CIRQ-LAPOPIE
*Auberge du Sombral* ** – Place du Sombral. Tel. 65 31 26 08. Closed Tue. eve. and Wed. except school holidays. and 11 Nov./1 Apr. Rooms: 350 F. Menus: 95/145 F. Good cooking. Attractive interior decoration.
*Hôtel-restaurant La Pélissaria* *** – Rue de la Pélissaria. Tel. 65 31 25 14. Closed 15 Nov./10 Apr. Restaurant closed for lunch and Thu. Rooms: 400 F. Restaurant: 150 F. Fine 13th-c. house. Very good cooking.

● CORDES
*Auberge Cathare* ** – Route des Cabannes. Tel. 63 56 01 13. Closed Wed. off-season. Rooms: 180/300 F. Swimming-pool.
*Hostellerie du Parc* ** – Les Cabannes. Tel. 63 56 02 59. Closed Mon. off-season. Rooms from 220 F. Menus: 80/ 110/140/180 F. Good traditional cooking.

● BRUNIQUEL AND PENNE
◇ Caussade
*Hôtel Larroque* ** – Avenue de la Gare. Tel. 63 93 10 14. Closed 21 Dec./15 Jan. Restaurant closed off-season, Sat. lunch and Sun. eve. Rooms: c. 220 F. Menus: 78/115/160 F. Garden, swimming-pool. Good cooking.

# NORMANDIE (NORMANDY)

● MONT-SAINT-MICHEL
*Hôtel-restaurant Le Mouton Blanc* ** – (within the walls). Tel. 33 60 14 08. Closed mid-Nov./mid-Feb. Rooms: 275/500 F. Cheapest menu: 90 F.
*Restaurant La Mère Poulard* – Grande-Rue. Tel. 33 60 14 01. Speciality, omelette cooked over a wood fire: 150 F. Menu: 180 F.

# PICARDIE (PICARDY)

● GERBEROY
◇ Beauvais (cathedral)
*Hôtel La Résidence* ** – 24, rue Louis-Borel. Tel. 44 48 30 98. Rooms: 180/210 F. Garden. Peaceful.
*Restaurant Le Marignan* – 1, rue de Malherbe. Tel. 44 48 15 15. Menus: 62/98/190 F.
*Auberge des Vieux Marais* – 186, rue Saint-Just-des-Marais. Tel. 44 48 04 12. Menus: 120/170 F. Gastronomic restaurant.

## POITOU-CHARENTES

● ANGLES-SUR-L'ANGLIN
◇ Chauvigny (ruins of the castle; ancient seat of the bishops of Poitiers. Should be seen)
   *Hôtel-restaurant Le Lion d'Or* ** – 8, rue du Marché. Tel. 49 46 30 28. Closed 15 Dec./15 Jan. and Sat. in winter. Rooms: 140/240 F. Menus: 75/120/190 F.

## PROVENCE-ALPES-CÔTE D'AZUR

● ENTREVAUX
◇ Annot
   *Hôtel de l'Avenue* ** – Avenue de la Gare. Tel. 92 83 22 07. Closed 1 Nov./1 Apr. Restaurant closed 30 Nov./1 Apr. Rooms: 250 F. Menus: 85/95/160 F. Copious cooking.

● SAINT-VÉRAN AND NÉVACHE
◇ Briançon (built by Vauban)
   *Hôtel Edelweiss* ** – 32, avenue de la République. Tel. 92 21 02 94. Closed Nov. Rooms from 250 F. Peaceful.
   *Restaurant Les Écrins* – 11, place du Champ-de-Mars. Tel. 92 20 35 16. Closed Mon. and Sun. eve. Cheapest menu: 55 F. Good cooking.

● ÈZE-VILLAGE
   *Auberge des Deux Corniches* ** – Tel. 93 41 19 54. Closed Fri., Nov./15 Dec. and Jan. Rooms: 310 F. Garden.
   *Hôtel du Golf* ** – Place de la Colette. Tel. 93 41 18 50. Closed Jan. Rooms: 150/250 F. Menus: 55/75/115 F.

● PEILLON
◇ Beausoleil
   *Hôtel Diana* ** – 17, boulevard du Général-Leclerc. Tel. 93 78 47 58. Rooms: 240/290 F.

● LES BAUX-DE-PROVENCE
   *Hostellerie de la Reine Jeanne* ** – Tel. 90 97 32 06. Closed mid-Nov/mid-Dec. Rooms: 280/320 F. Menus: 100/150 F. Very good cooking. Fine view.

● BARGÈME
◇ Fayence
   *Auberge de la Fontaine* ** – Route de Fréjus. Tel. 94 76 07 59. Rooms from 210 F. Menus: 80/98 F. Garden.
   *Hôtel La Sousto* – 4, rue du Paty. Tel. 94 76 02 16. Rooms: 230/270 F.
   *Restaurant Patin Couffin* – Placette de l'Olivier. Tel. 94 76 29 96. Closed Mon., 10/25 Jan. and 10/25 Nov. Menu: 110 F. Good traditional Provençal cooking.

● BONNIEUX
   *Hôtel César* * – Place de la Liberté. Tel. 90 75 80 18. Closed 2 weeks Dec., Feb. and Wed. Rooms from 210 F. Menus: 98/170 F. Traditional Provençal cooking.

● GORDES
   *Hôtel-restaurant La Mayanelle* *** – 6, route de la Combe. Tel. 90 72 00 28. Closed Tue. and 3 Jan. Rooms: 310/420 F. Restaurant from 200 F. Good table and fine views.
   *Hôtel-restaurant La Renaissance* – Place du Château. Tel. 90 72 02 02. Closed Jan. and Feb. Rooms from 250 F. Menu: 110 F.

● ROUSSILLON
◇ Vienne
   *Hôtel de la Poste* ** – 47, cours Romestang. Tel. 74 85 02 04. Rooms: 260 F. Cheapest menu: 70 F. Traditional.
   *Restaurant L'Estancot* – 4, rue de la Table-Ronde. Tel. 74 85 12 09. Closed Sun. and Sat. lunch, and 15 days Aug. Menu: 69 F. Inventive cooking.

## RHÔNE-ALPES

● PÉROUGES
   *Auberge du Coq* – Rue des Rondes. Tel. 74 61 05 47. Closed Sun. eve. Mon. and Feb. Menus: 78/105/110/175 F.

● BALAZUC
◇ Saint-Alban-Auriolles
   *Hôtel Douce France* ** – Tel. 75 39 37 08. Closed end Oct./Easter. Rooms: 220/270 F. Garden, swimming-pool.

● SAINT-MONTAN
◇ Baix (40 km/25 mi. up the Rhône valley)
   *Hôtel-restaurant La Cardinale* *** – Tel. 75 85 80 40. Closed Jan. 15 rooms and suites: 750/1650 F. Menus: 195/420 F. Swimming-pool.

● LE POËT-LAVAL
◇ Privas
   *Restaurant Astic la Calade* – 7, avenue de Chomerac. Tel. 75 64 25 88. Closed Sun. and Mon. Cheapest menu: 85 F.

● BONNEVAL-SUR-ARC
   *Hôtel-Restaurant La Bergerie* ** – Tel. 79 05 94 97. Closed Oct., Nov. and Dec. Rooms: 160/230 F. Cheapest menu: 59 F. Fine view.

*ACKNOWLEDGMENTS*

I would like to thank all the people who have shared their villages with me, in particular the parish priests and mayors who have so often entrusted me with the keys to their churches. I am also indebted to the villagers, who contributed to this book by allowing me access to their homes – and sometimes by moving their cars for the sake of the photograph. I am equally grateful to the authors of the works listed under the heading 'further information', who provided me with a basis for the text, to the Hachette *Guides Bleus* and to M. Jean Kuypers of the Ministère de l'Équipement for their invaluable expertise.

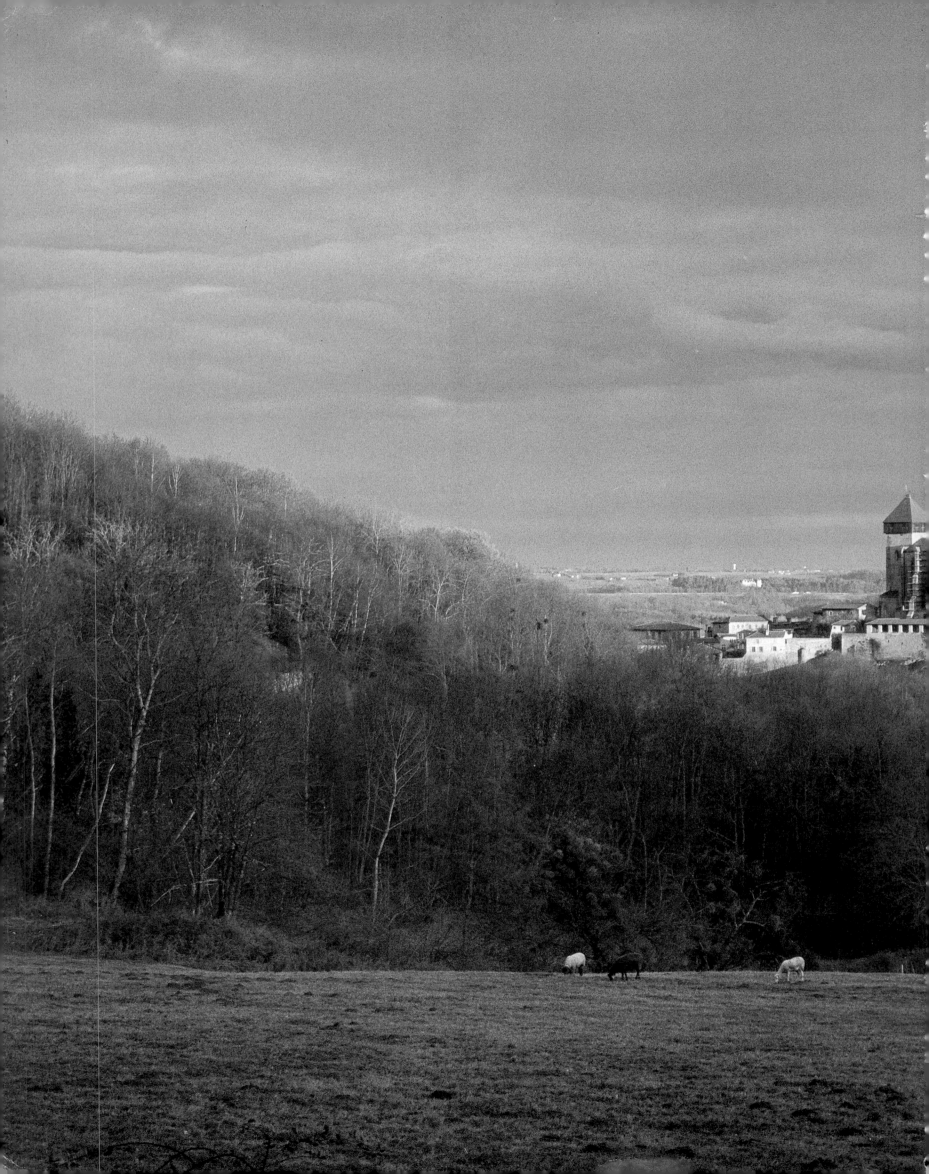